MW01005156

BROOKLYN HEIGHTS

BROOKLYN ☆ HEIGHTS

The Rise, Fall and Rebirth of America's First Suburb

ROBERT FURMAN

BRIAN MERLIS, CONTRIBUTOR

THE
History
PRESS

Published by The History Press
Charleston, SC 29403
www.historypress.net

Front cover, top: Unveiling of the plaque on October 24, 1929, about the Philip Livingston House that formerly graced 277 Hicks Street. *Brian Merlis Collection*; *bottom*: Brooklyn Heights and the Brooklyn Bridge from a roof of Montague Street, circa 1915. *Brian Merlis Collection*.
Back cover, top center: Montague Street looking west from Henry Street, 1951. *Brian Merlis Collection*.

First published 2015
Second printing 2016

ISBN 978.1.54021.371.6

Library of Congress Control Number: 2014958081

Notice: The information in this book is true and complete to the best of our knowledge. It is offered without guarantee on the part of the author or The History Press. The author and The History Press disclaim all liability in connection with the use of this book.

CONTENTS

ACKNOWLEDGEMENTS

I wish to thank the following who have generously contributed their time and knowledge:

Debby Applegate, who challenged me
Richard B. Bernstein, who provided historical insight
Jane McGroarty, architect and former president of the BHA
Fergus M. Bordewich, an old friend and slavery expert
Francis Morrone, a great architectural historian at New York University
Seth Faison, who saved and opened up the Heights Casino
Phoebe Neidl at the *Brooklyn Eagle*, a good Brooklyn historian
Avrah S. Furman, who grew up there and remembers
Otis Pratt and Nancy Pearsall, without whom there would be no historic
 district
Alex Herrera of the New York Landmarks Conservancy
Alan Redner, who knows every building in Brooklyn
Professor Graham Hodges of Colgate University
Lois Rosebrooks and Frank Decker, historians of Plymouth Church
The staff of the Brooklyn Collection at the Brooklyn Public Library at the
 Main (Grand Army Plaza) Branch, who have the goods
Martin Schneider, author of *Fighting for Brooklyn Heights*
Ron Schweiger, the official Brooklyn historian
Henrik Krogius, who might be the longest-living Heights resident
Ms. Franklin Stone of the Heights Casino

Acknowledgements

The late John Loscalzo, webmaster at Brooklynheightsblog.com
David A. Weiss, author of "From the Brooklyn Aerie," a regular column
 in the *Brooklyn Eagle*
John Manbeck, former borough historian and prolific author
Jonathan Weld of the White family

INTRODUCTION

This is a new kind of history. It is not a picture book about Brooklyn Heights. It is a history of the neighborhood that regards images as exciting information sources. A great picture is not only interesting in itself—something that gives you a feeling for its time and the people involved—but also a data source that informs us about what was. Maps are also revealing—they let us know where things were and how they changed over the years. Sometimes a site plan is the only information we have about a place.

This book is a product of interest in Brooklyn history, but it is also a product of spending many hours as a youngster reading *Life* magazines from the 1930s and 1940s in the Donnell Library Center on West Fifty-third Street to try to understand the history of that miserable period. While there were newsreels and documentaries of the era, I found the detail available in still photographs enthralling. The magnificent work of the likes of Alfred Eisenstaedt communicated world events in a way that commanded one's attention. I have tried to create a history book in the style of *Life*.

This is part of a larger work entitled "Before and After Brownstones," an overall history of Brooklyn. I am publishing what is perhaps the most compelling part of that book, *Brooklyn Heights: The Rise, Fall and Rebirth of America's First Suburb*, because it best illustrates Brooklyn's urban dynamic.

In February 2010, the *New York Times* reported that Old London Foods, Inc., best known as the manufacturer of Melba Toast, favored by the diet company Weight Watchers, would move from 1776 Eastchester Road in the Bronx to North Carolina. It wasn't that the company wanted to leave New

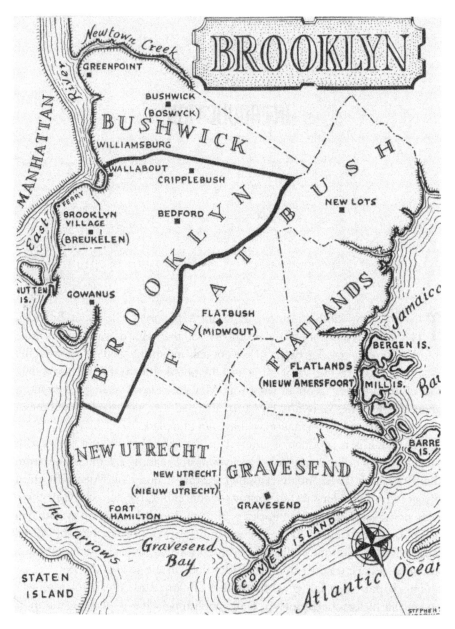

Figure 1. The six towns of Kings County were established by the Dutch and persisted into the nineteenth century. This map indicates the status of the county in 1850, when there were seven (New Lots was added) and two cities (Brooklyn and Williamsburgh). The Town of Brooklyn was coterminous with the original City of 1834. Note the changes in the barrier islands caused by hurricanes. Also, note that the boundary with northern Queens is a straight line. It was later made to zigzag to include and exclude entire blocks. *Brian Merlis Collection.*

York but rather that its business was growing and required a larger, more modern plant—one located on a single floor—and this type of space is rare in the city today.

The same year, Brooklyn Brewery, a successful microbrewer, planned to leave Brooklyn until the New York City Economic Development Corporation found it a similar large space. It, too, needed an expanded plant on one floor, as reported in the press and personally to the author by the principal owner, Steve Hindy, a Park Slope resident.

This scenario should be familiar to New Yorkers, who have seen it repeated thousands of times as a city economy based on shipping and light manufacturing disappeared over the past century. What they may not realize is that this problem, which goes back to at least the 1920s, was caused by the same sort of forces that created the city: new transportation technologies. But in the twentieth century, the ferries, rails and canals that had built the city were replaced by trucks and cars, which moved both industry and people out of the cities. This rather obvious fact is actually determinative. It is the principal (but not sole) reason that New York and all of the other old industrial cities declined in the mid-twentieth century. The other major factors were the cutting off of foreign immigration in the 1920s (cities have always been the first haven of immigrants) and the advent of modern design. So while the newcomers of 1900 moved away, they were not replaced by ambitious foreigners, and high-rise apartment buildings of unornamented design displaced Victorian townhouses in the public mind as the epitome of luxury. But it was the car and truck that really killed the old cities: their manifestation, the single-family suburban house and the one-story spread-out factory and warehouse, all reached by freeway, were the "American dream" of the 1950s.

Brooklyn Heights went from farmland in 1800 to a proto-industrial area in 1840 to a wealthy, residential neighborhood in 1860 and into decline from the 1900s to 1950s for precisely the reasons cited here. This book will demonstrate this process, how government action to save the neighborhood actually made the situation worse and that the area was saved by citizen action often opposed by the authorities.

Brooklyn was one of the six towns in Dutch Long Island that became Kings County under the British in 1664. Settlement began in 1640. In 1776, New York City (Manhattan from the Battery to Chambers Street) was recognizably what it is now: the financial and commercial center of a burgeoning nation. Brooklyn, and all of Kings County, was farms, except for unusable hills and marsh. But within five years of the 1783 British evacuation

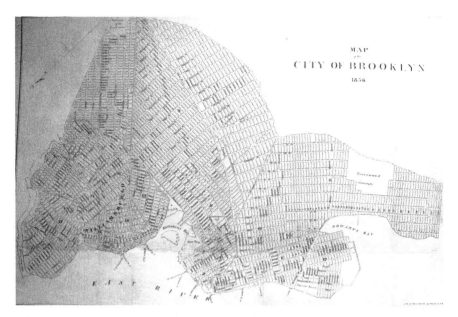

Figure 2. Hayward's Map of the City of Brooklyn (and Williamsburg) in 1856. This map does not possess normal north/south orientation but delineates exact political boundaries. *Brian Merlis Collection.*

of a place they had made desolate, plans were afoot to develop a new city to be called Olympia. How Brooklyn went from agricultural use to suburb, city and New York State's second business and government center after Manhattan, its second-most populous city (and the nation's fourth, which it remains), within a few years has much to do with the American Revolution and its aftermath.

For better or worse, wars usually create massive change and dislocation. The Revolution caused a population influx into Kings County of soldiers, first American and, perhaps more significantly, later British and Loyalist, as it became a major headquarters for their military operations. A little-known fact of the war is that New York was the principal British base in the country and the last one evacuated, on November 25, 1783. Brooklyn was part of this and had major forts, which served as fire support, headquarters and troop quarters. There were camps and wagon stations, from which the British dominated and controlled western Long Island. While these soldiers were temporary residents who, in fact, did leave, their presence created a city-in-readiness that set the stage for later actual civilian urban development, which began to occur just a year after the evacuation.

Cities and forts are sited to take advantage of strategic locations, and such defenses often become the basis of urban areas. What is an invasion route in time of war becomes a trade route in time of peace. Being located on a confluence of rivers, where they meet the sea, where railroads intersect or even where plains abut mountains has led to the founding of Pittsburgh, New York, Dallas and Denver, respectively. In fact, Pittsburgh's location where the Allegheny and Monongahela Rivers mingle their waters to form the Ohio was previously exploited during the French and Indian War of the 1760s by the French at Fort Duquesne at what is now Three Rivers Park. Quebec's strategic location above the St. Lawrence River made the Plains of Abraham the climactic focus in that struggle between France and Great Britain for domination of North America. The cities of Europe also began this way, and many, such as Vienna, still had city walls as late as the nineteenth century, when they were long obsolete, because of ancient fear of attack.

New York is the island at the center of a splendid sheltered harbor. As it grew, Brooklyn's strategic location right across what we call the East River (it is actually a tidal channel and not a river at all) from lower Manhattan, which was the city in 1776, became first militarily crucial and then an opportunity for growth. Forts were placed on the Heights for the same reason that it became the first exclusive residential district in Brooklyn: its location on a bluff high above the water.

The planning of Olympia began Brooklyn's urbanization. Just as the black plague created opportunities for growth by decimating Europe, so did the exile of thousands of Tories from the United States. The exiles left because they were disgraced or had had their lands seized by the States—an understandable act that nevertheless offends our democratic sensibilities. But we should bear in mind that unlike in Revolutionary France, the defeated were not guillotined en masse, a factor responsible for our Revolution producing a heritage of pluralism and democracy, not totalitarianism.

Mr. and Mrs. John Rapalye, who owned what is now Downtown Brooklyn north of Tillary Street, including today's DUMBO and Vinegar Hill, were farmers and merchants at Brooklyn Ferry who prospered during the occupation. Their property was (legally) confiscated by the state during the occupation (its authority began in what are now the northern suburbs) and was purchased at auction by Comfort and Joshua Sands on July 13, 1784, less than eight months after the evacuation. In 1788, they surveyed and began to develop the first city in Brooklyn: Olympia. John Rapalye, descendant of the first settler in Brooklyn, and his wife went into exile in England.

The Sands brothers had migrated from what is now Nassau County and supplied the Continental army during the war, from berths both inside and outside the military, and prospered. They represented a new class of men: entrepreneurs who were willing to take a risk in the hope of accruing great rewards.

Many of the leading Revolutionaries were men of this type. While George Washington was a wealthy gentleman farmer and slave owner, Alexander Hamilton, the only major founding father from New York, who set the nation on its course of business and freedom, was a self-made West Indian immigrant of dubious origins who achieved glory, wealth and power by his own efforts and without family connections. Ben Franklin, the quintessential Enlightenment man who was a leading scientist as well as a founding father and businessman, was similar. This was another difference between the Patriots and the Tories and British, and it was the essence of America. Tory power was based on aristocracy, and their government would not cater to pretenders who sought wealth. The United States would.

Upon the achievement of independence, local leaders in Brooklyn took advantage of their freedom to harness new technologies to transform what had been farms into America's third-largest city in 1860. By 1840, New York was number one, and two and three were Philadelphia and Boston. Today, Los Angeles is number two and Chicago number three. The Borough of Brooklyn, counted separately, is number four. It is amazing to consider that starting from the British evacuation of 1783, when the entire area was occupied and despoiled, a great city rose from the countryside and grew into a metropolis within seventy-seven years. From the organization of the first urban area in Kings County—the Village of Brooklyn in 1816—to its expansion into a city in 1834 and the addition of the formerly independent city of Williamsburgh and town of Bushwick in 1855, to 1860 is only forty-four years.

The 1860s would mark Brooklyn's greatest flowering, with the founding of Prospect Park, the Academy of Music and the Brooklyn (then Long Island) Historical Society. By freeing the enterprise and spirit of the people from the heavy hand of British mercantilism (under which the colonies only existed to benefit the mother country), the Revolution created the first and so far only successful nation based not on race, religion, place, blood and history but on the eighteenth-century Enlightenment idea and ideal of democratic pluralism and generated its ultimate mythic city: Brooklyn.

While doing the research for this book, it occurred to me that the story of the Revolution in Kings County is the story of how Brooklyn became a

city—that the making of American values tangible in a place created a new city that could not have otherwise been. Brooklyn as it is—the quintessential American city, the haven for refugees and the ambitious poor—was farms, hills, forest and marsh in 1788. One could not have even imagined the Brooklyn of 1883 in 1783. While the Dutch created the paradigm for New York, the ultimate trading city, Brooklyn—the place where people live, commute and work; the borough of churches, schools and ethnic neighborhoods, which was until a few years ago the butt of jokes about crime and coarseness made mostly by the children of immigrants attempting to escape their own origins—was made by Americans. As Brooklyn has come to resemble Manhattan, it has become more respectable. But it is an original American idea, just as Prospect Park is an American place of recreation and respite while Central Park is London in Manhattan.

This is the story of how Brooklyn went from farm to city, rivaled Manhattan and originated a different niche: that of urban suburb. But Brooklyn also was the industrial and mercantile heartland of New York State and a vital element of its great port. Proximity to Manhattan and the availability in 1814 of reliable commutation via steam ferry from what is now Fulton Ferry Landing melded with the liberation of enterprise to create America's first suburb: Brooklyn Heights, begun just before the founding of the village and city. But in nineteenth-century America, a suburb was different from what it is today. It was based on public transportation (ferries, horsecars, trolleys and elevated railroads), and to get to these from your house, you had to walk or take a streetcar. Crucially, the old cities are walking cities, and when you walk you see not just buildings but also other people, who become your neighbors and friends and thereby are less threatening. Moreover, you might have a stoop (an old Dutch word) on which you might sit and interact with your neighbors and the letter carriers and merchants of the neighborhood.

The 1939 *WPA New York City Guide*, written and published by the Federal Writers' Project, described Brooklyn as follows, at a time when it was close to its apogee as an industrial city:

> *So integrated is the borough with the metropolis that it is startling to realize that it is comparable to Chicago in size. Its population of about 2,800,000* [the 1940 census reported a population of 2.7 million], *like that of the midwestern city, occupies a vast area, some eighty square miles. Brooklyn is one of the greatest maritime and industrial centers of the world. About forty per cent* [sic] *of the foreign commerce moving out of the port of New York clears through Brooklyn's thirty-three miles of developed water*

front [sic]. *Seventy steamship freight lines, fourteen trunk railways, and a series of huge shipping terminals, of which Erie Basin and Bush Terminal are the most notable, serve this traffic. Most startling of all, to people who have been led to think of New York City as relatively unproductive, Brooklyn as a manufacturing center ranks fifth in the country.*

One-third of the borough's residents are foreign born. It is estimated that the borough has more than twenty separate and distinct Jewish communities, of which Brownsville is the leading one. The 1930 census listed nearly two hundred thousand Italian-born.

Ridgewood rivals Manhattan's Yorkville as a German center. In smaller numbers are groups of Scandinavians, Poles, and other nationalities; in the Red Hook vicinity [the western section of Atlantic Avenue; at the time, the entire area south of the Heights was called Red Hook or South Brooklyn] *there are many Arabs and Syrians. It is anomalous that Brooklyn, the borough of homes and churches, should have some of the worst slums (Williamsburg, Brownsville, Red Hook) of the nation, yet such is the case.*

How much has changed in the seventy-plus years since this was written. Most notable is the decline in population, which by 1980 was closer to 2 million than 3. The 1950 population of 2.7 million is most notable because the city had 7.5 in total, principally because Queens and Staten Island were mostly country, along with much of southern and eastern Brooklyn (Canarsie is described in 1939 as an area of truck gardens). By 2010, Brooklyn's population had recovered to 2,504,700, and the Census Bureau's 2013 estimate is 2,592,149, an increase of 3.5 percent in three years. At this rate (not at all guaranteed), the borough's population will reach 2,796,197 in 2020, an all-time high.

The freight port is gone, along with most of the industry. While perhaps one-third of the borough's population is foreign-born, they are from different parts of the world—the only groups that are still recognizably present are Russian Jews, East Asians and Arabs, who compose major elements of both the old and new immigration. Williamsburg and Red Hook are no longer slums.

The industrial city was lost when cars and trucks superseded public transportation for moving both freight and people. Trucks don't need rails to get to manufacturers, distributors and customers—only improved roads—and are infinitely more flexible in terms of size of load. The whole nation was remade to accommodate them, especially by the construction

of the interstate highway system, which has largely replaced the railways as the national transportation web.

Cars enable people to easily reach suburbs distant from central cities served by passenger trains and created the modern suburb and exurb that have come to dominate America. Originally meant to facilitate commutation into the city, they have caused business to move away. This tale is too well known to repeat here.

But after the advent of cars and trucks, cities all over America and the world went into decline. In some quarters this is blamed on discriminatory banking policies and federal legislation that favored highway building and new construction over rehabilitation. There is some truth to this, but the overwhelming fact is that starting in the 1920s, modernism—as defined by the automobile, airplane and the new architects and artists—took over. And while it is easy to blame Robert Moses's wrongheadedness for this (he refused to build the Second Avenue Subway even when funds were appropriated for it), this is an overreach. Moses was only expressing the general will, which loved the mobility that cars, parkways and, later, the expressways and freeways built for them promised. Most of America still does: the majority of Americans live in suburbs.

The chart on page 19 shows U.S. census population figures from 1900 to 2010 for Brooklyn, Manhattan and all of New York City (earlier than this there was no consolidated city, and county listings confuse the figures).

It is clear that both Brooklyn and all of New York City were in the midst of a major population upswing at the time of the first census after consolidation, in 1900, which continued until after the 1950 census. At this time, population began to drop until after the 1980 census, when it began its current post-industrial increase. Notably, the greatest gain in Brooklyn's population was in the 1920s, when it gained more than 500,000, while the entire city increased by more than 1.3 million, making that the greatest period of growth. In-city suburbia mushroomed, especially in Queens and southern Brooklyn. Between 1940 and 1950—the period of World War II and the beginning of the suburban exodus—Brooklyn gained a mere 40,000, reaching its maximum population, while the entire city picked up another 437,000.

It is not well known that Manhattan's population has substantially declined since 1910, when it reached its all-time high of 2,331,542— this in spite of the development of upper Manhattan from Harlem northward from that time on and the high-rise redevelopment of the East and West Sides. The beginning of subway service to Brooklyn in 1906

and the Manhattan and Williamsburg Bridges allowed refugees from the massively overcrowded Lower East Side to settle in new neighborhoods in Brooklyn like Williamsburg, Bushwick, Crown Heights, East New York and Brownsville. Thus, Brooklyn became the most populous borough at the 1930 census, after the explosive growth of the 1920s.

The year 1980 was the city's demographic and existential low point, which is generally conceded in the popular view of 1977 as the trough, with the citywide blackout and riots, the crack plague and the Son of Sam and Bernard Goetz cases. But while 1980 was the low for Brooklyn, when rioting depopulated Bushwick, the entire city's population rose in the 1980s in spite of that. What happened? Brownstone Brooklyn was prospering, and outlying areas were experiencing both new construction and the first significant foreign immigration.

Brooklyn boasted a third of the total population of the city in 1900. The percentage rose to 36.9 in 1930 after the massive expansion of the 1920s but has been declining ever since. The 2010 census marks its low point for the entire period: 30.6 percent. The Bronx has lost much of its population, while Queens and Staten Island have been the big winners. Queens may surpass Brooklyn as the most populous borough within twenty years. While Manhattan's population has decreased from about 2.3 million in 1910, because of the depopulation of its most crowded ghettos and the expansion of midtown, it remains dominant not only because it contains the wealthiest people and businesses in the city but also because it reformed its politics in the 1960s and has thus produced consistently higher-quality, less corrupt candidates than the rest of the city.

Bill de Blasio of Park Slope is the first mayor from Brooklyn since Abe Beame, who presided over the fiscal crisis of 1975 (which was successfully overcome by Governor Hugh Carey, the latter two also from the Slope). De Blasio's ascent may mark a demographic and ideological sea change in the city's politics.

It is also necessary to put New York City's population figures into a national context. In 1940, our 7.5 million people represented a larger population than that of any state in the union, including the rest of New York, which was then the largest. Today, New York is the third largest and headed for fourth (Florida is expected to be third largest in the next census) place in a nation that has doubled in population since then, from 140 to 309 million people. So, at a time when New York City and State have essentially retained their populations and not grown, their share of the nation has halved. The fact that California has nearly twice as many residents as New York, that

CHART 1.

Year	Brooklyn	# +/-	%+/-	% Brooklyn
1900	1,166,582	+33.9		
1910	1,634,351	+467,769	+40.1	34.3
1920	2,018,356	+384,005	+23.5	35.9
1930	2,560,401	+542,045	+26.9	36.9
1940	2,698,285	+137,884	+5.4	36.2
1950	2,738,175	+39,890	+1.5	34.7
1960	2,627,319	-110,856	-4.2	33.8
1970	2,602,012	-25,307	-1.0	33.0
1980	2,230,939	-371,073	-14.3	31.5
1990	2,300,939	+69,725	+3.1	31.4
2000	2,465,326	+164,662	+7.2	30.8
2010	2,504,700	+39,374	+1.6	30.6

Year	Manhattan	# +/-	% +/-	New York City	# +/-	% +/-
1900	1,850,093			3,437,202		
1910	2,331,542	+480,449	+25.0	4,766,883	+1,329,861	+38.7
1920	2,284,103	-47,339	-2.0	5,620,048	+853,165	+17.9
1930	1,867,312	-416,791	-18.2	6,930,446	+1,310,398	+18.9
1940	1,889,924	-77,388	-4.1	7,454,995	+525,549	+7.6
1950	1,960,101	+70,177	+3.7	7,891,957	+436,932	+5.9
1960	1,698,285	-261,816	-13.4	7,781,984	-109,973	-1.4
1970	1,539,233	-359,052	-21.1	7,894,862	+112,878	+1.5
1980	1,428,285	-110,948	-7.2	7,071,639	-823,223	-10.4
1990	1,487,536	+59,251	+4.1	7,322,564	+250,925	+3.5
2000	1,537,195	+49,659	+3.3	8,008,278	+685,714	+9.4
2010	1,585,873	+48,678	+3.2	8,175,133	+166,855	+2.1

Texas has outstripped it, that Los Angeles is the second-largest city and that Houston, San Antonio and Dallas/Fort Worth are on the list of the ten largest cities means that New York is no longer the center of the country it was sixty years ago. This is the effect of suburbanization and the growth of the Sunbelt, enabled by cars, freeways and air conditioning—again, technological change determining demographics.

Starting in the 1900s, all private homes began to feature garages, or at least driveways, as Henry Ford revolutionized the country with cheap and reliable Model-Ts. You can see these period houses—many quite stylish—in Flatbush and Midwood. At the same time, Art Nouveau, Art Deco and Art Moderne—which were organic-looking and based on the necessity for planes, trains and cars to be streamlined—replaced the relatively Baroque-appearing Victorian styles of the brownstone neighborhoods, rendering them instantly obsolete. Palaces were torn down to build high-rise apartment buildings (enabled by steel-beam construction and elevators, another transportation technology), and the epitome of urban elegance (think *The Thin Man* films) became the doorman building on Park Avenue. The effect of this on the older neighborhoods was devastating.

The event that presaged and caused the decline of the cities was the New York World's Fair of 1939–40, which was in itself a display of the "radiant city" professional planners hoped to create worldwide based on the theories of Le Corbusier and the practice of Robert Moses, which foretold the coming of a new world based on the automobile and rational planning instead of random growth. And while the vision was of precast concrete rather than glass and steel, the vision has largely been accomplished both in the new office towers in Manhattan and the suburbs that sprouted (urbanites would add "like weeds") after World War II.

The most popular pavilion at the fair, certainly one of the best of these bygone institutions, was the General Motors Pavilion, designed by Norman Bel Geddes. It featured a new type of city as suburban office park that featured high-rise buildings connected by highways in the sky. You see a version of this today in edge cities like White Plains and Stamford. However, there was an expiration date on this type of thinking. When Robert Moses attempted to build highways in the sky in the 1960s in the form of the Lower Manhattan and Mid-Manhattan Expressways, which might have become its apotheosis, he was soundly rejected.

This still represents a futuristic image today, but its power at the end of the Great Depression was awesome. Le Corbusier, a Swiss architect and city planner, converted the concepts inherent in the German Bauhaus school of

architecture and interior design, which invented architectural modernism, into an intellectual system. Bauhaus students invented the idea of "form follows function" and took advantage of modern building materials and engineering to strip away ornament and transform buildings into conceptually unified shapes. Modernism was further enabled by new technologies such as prefabrication, elevators and steel-and-glass construction. Le Corbusier's ideas, which may be viewed either as rational planning or as totalitarianism incarnate, were first implemented by Robert Moses in New York City. The product may be viewed in Manhattan, where midtown and the Upper East Side have been transformed by these concepts into facts on the ground, without the highways in the sky.

Modernism itself is both resented and forgotten today. In its time, however, it represented a hope for a rationally planned and perfect world and was wildly popular among those who sought to assimilate, escape tradition and free themselves from Victorian repression, the carnage of two world wars and the economic devastation of the Great Depression. But its impact on the old industrial cities was devastating. While Manhattan was remade and benefited, the outer boroughs and most of the rest of the country's urban areas went into steep decline for reasons that were in part aesthetic. In the 1950s, Brooklyn became a standing joke, so aspirants moved away, joined by the hippies in the 1960s.

After World War II moved massive numbers of servicemen and some women to the West to fight a war in the Pacific, the aircraft industry grew not only in California and Washington State but also on Long Island. Trucks were more flexible than railroads, so new highways were built, and industry moved en masse to suburban areas that included tract houses and, later, shopping malls. By the 1960s, Green Acres and Roosevelt Field in Nassau County and the Cross County Shopping Center in Westchester were all the rage, and it seemed that the cities would become totally obsolete.

By 1954, the number of cars on Brooklyn's streets grew overwhelming, putting an end to the playing of the mythic game of stickball. Streetcars, while clean, were unsightly and dangerous because of overhead electric wires, and one stalled auto on the tracks could shut down an entire line. Cities replaced them with gasoline and diesel buses. Rochester, New York, went so far as to shut down its subway system and convert the roadbed into a highway—an unparalleled act of civic vandalism.

Since factories and shipping, along with ports, were moving to the suburbs, new immigrants could no longer find jobs. Blacks drawn north by the fact that their labor was needed during World War II found themselves

unemployed afterward. Moreover, unions were strong, and they pushed wages up. Members sought to give their children and relatives jobs, which began to look like racial discrimination. Semi-skilled jobs were now highly sought after as their numbers declined but their wages increased. While European and Asian immigration was largely cut off, Puerto Ricans could come here because they were Americans, but they ran smack into the same problems compounded by a language difficulty. While they were peasants like the Irish, Italians and Germans who had preceded them, the difference here was that their labor was unneeded, and so traditional American racism and resentment of foreign-speaking people took hold.

New York's economy shifted to corporate headquarters, Wall Street, banking, communications and the arts. But this did not make up for the loss of manufacturing and shipping jobs as container technology in the 1960s demoted the importance of Manhattan and Brooklyn's port facilities. Jobs increasingly required literacy and numeracy, but the newcomers, like the others before them, came from peasant backgrounds and would be slow to learn the lessons of the new city.

The great events of decline are well remembered: the closing of the *Brooklyn Eagle* in the face of suburbanization and decline and competition from television that put the movie business into a free fall from which it never recovered. (There were more paid admissions to movie theaters in 1946 than in any year since then although the population was half of what it is now. Attendance has fallen steadily, but this has been disguised by increased ticket prices.) The shift of the Brooklyn Dodgers to Los Angeles occurred in 1958 as the West opened up and heavily subsidized such businesses. In 1950, there was one baseball team west of the Mississippi River: the Kansas City Athletics, now in Oakland, California, and originally based in Philadelphia. In 1966, the Brooklyn Navy Yard (properly the New York Naval Shipyard) closed because the navy also wanted more space and centralized its reduced operations in Norfolk, Virginia. The yard that had commissioned the USS *Monitor, Maine* and *Missouri* became history.

Pete Hamill, who was a young adult in the 1950s, describes the decline of his old neighborhood, South Park Slope, in his memoir *A Drinking Life*:

> *The Neighborhood, its streets already emptied at night by television, began to reel from departures to the new suburbs, and the arrival of the plague of heroin. When I visited 378 [Seventh Avenue], my mother talked for the first time about danger. Standing with my father at the bar in Rattigan's, a full-member now of the fraternity, I heard about muggings and overdoses.*

A few men died of cirrhosis from drinking, but compared to a needle in the arm, that was an honorable death. In tenements where once there was nothing worth stealing, people now started locking their doors.

The Eisenhower era bragged of the good life for all, but it didn't touch the neighborhood. The prosperous were gone to the suburbs, among those who stayed, money was still short. Everywhere in the city, factories were closing. Globe Lighting, where my father worked, moved from the Neighborhood to Flushing and, later, to Georgia. In the daytime there were more men in the bars, drinking in silence and defeat. The city was changing: gradually, almost imperceptibly in some ways, gradually in others.

As a personal note on the heroin plague, in the early 1970s, I worked in a drug treatment and prevention program that served Hamill's old neighborhood. It was located in the Cronin-Higgins Mansion, a city landmark at 271 Ninth Street between Fourth and Fifth Avenues that is now a music school. It had been the residence of Charles Higgins, founder of the Higgins Ink Company, manufacturer and inventor of India ink, and was then the company's offices for its factory behind the house until it moved away. The Ansonia Clock Company was the largest factory in the neighborhood until it went bankrupt in 1929, and its assets were sold to and moved to the Soviet Union.

Another anti-Brooklyn influence was the hippie movement, which posited suburban California as paradise while raising it to cultural paradigm for the first time. The baby boomers, the largest cohort in American history, left the older cities in massive numbers, especially Brooklyn, and headed to the reputed heavens of Haight-Ashbury in San Francisco and Topanga Canyon in Los Angeles. Listening to a representative selection of classic rock songs reveals that eastern cities were considered repressive and the death of spirit, and by 1970, California was the most populous state in the union.

Famous Brooklynites who migrated west at that time include the Brooklyn pop music icons Barbra Streisand, Carole King (née Klein) and Neil Diamond and entertainment mogul David Geffen. But this was an old story: New Yorkers in the arts have been moving west since the movie industry exploded in the 1920s. There were others earlier and later. Helen Gahagan grew up in Park Slope, married the actor Melvyn Douglas (né Hesselberg), became a Hollywood actress and, as Helen Gahagan Douglas, served as a Democratic representative in Congress whose political career ended in 1950 when she was defeated for the U.S. Senate by native Richard Nixon. One Barbara Levy attended Madison High School and as Barbara Boxer now

serves in the U.S. Senate from California. Mary Tyler Moore was born in Brooklyn Heights in 1933, moved to California as a child and became a TV star. She now lives in Manhattan.

Since then, a hazy pall of nostalgia has settled over the first half of the urban twentieth century. In some ways it was a good time, but few remember that this stability was the result of federal legislation in the 1920s that cut off the immigration of the groups that were overwhelming old-stock America and had given cities new, dynamic populations. This is largely depicted as the result of prejudice, which is true to some extent, but the factor that is hardly ever discussed is the wave of anarchist bombings and communist-led strikes between 1919 and 1921 that led middle-class and old-stock Americans to see southern and eastern European immigrants as dangerous.

This is a third major influence on the city. Much of the decline of the 1940s through the '70s may be traced to the inability of ambitious foreigners to come to America and make new lives for themselves in the older cities that, like Brooklyn, had always welcomed them. This is clear here now that the influx has resumed, and the human tide is reviving some of the almost moribund small cities upstate, like Utica and Buffalo, which are prospering simply by having Indian newcomers move there.

An effect of all of this has been to inhibit incisive historiography, partly out of a fear of offending the immigrants of the 1940s and '50s. Thus, most New York history ends in 1945, becomes so politically correct as to be grossly inaccurate and meaningless or else scapegoats Robert Moses, whose highways were only adapting the city to the obvious future. Immigration has always been the story of our lives: the older groups rise, make it and mostly leave and are replaced by new ones. What matters in their success is the economic opportunities available to them, and in the 1940s through the '70s, those were few and far between, more because of technology than bigotry.

The epilogue to *Brooklyn: An Illustrated History*, written for the Brooklyn Historical Society by Ellen Snyder-Grenier, presents the orthodox academic left historical explanation for Brooklyn's decline and is symptomatic of a refusal to accept the fact that cars and trucks represented a superior technology, that the cutting off of foreign immigration was a crucial factor in the city's becoming poor and that upward mobility has always led immigrants to leave the cities. What is substituted is lazy sentimentality:

> *Brooklynites who lived in the borough during the 1950s often look back with nostalgia on the days of the Dodgers, egg creams, the corner drugstore and a lifetime lived in one neighborhood, on one street or even in one building, with*

grandparents, aunts, uncles and cousins a few blocks away. To many, the decade was movies at the Paramount and walking along Ocean Parkway on a warm summer night with the lights of Ebbets Field in the distance and the roar of the crowd in the air like the rise and fall of surf.

But in spite of the stability many recall, the 1950s was a decade of upheaval in Brooklyn, as it was for many other older urban areas in the country, and the Dodgers' departure seemed to symbolize these changes. Much of Brooklyn's middle-class population was also moving to new suburbs in New Jersey and Long Island, leaving behind aging buildings and an outworn urban infrastructure. The hopeful, largely black working-class population that moved in looking for new opportunities often faced fear and hostility. Racial bias made it difficult for newcomers to obtain homeowner loans, mortgages and employment. As neighborhood disinvestment took place, city services declined. Urban renewal projects sometimes failed. Neighborhoods began to decay.

Industry and shipping were getting out of town as well, along with the first step up the socioeconomic ladder they had represented for earlier generations of Brooklynites. Encouraged by new government policies, companies moved to newer, cheaper facilities in New Jersey and the South, where manufacturing was less expensive. Longtime retail anchors like Namm's and Loeser's (pronounce Low-shers) shipped out too, and local shopping strips suffered as residents departed and massive highway projects like the Brooklyn-Queens Expressway cut through neighborhoods and destroyed their coherence.

What reasons are presented here for Brooklyn's decline, and how do they measure up against reality? While the causes are not explicitly spelled out, they are loudly implied. The old white working class moved to the suburbs and was replaced by blacks who encountered racism. The urban infrastructure was worn out. City services declined. Urban renewal didn't work. Industry left town because of the development of the interstate highway system and Veterans Administration and FHA mortgages, but mostly because the suburbs were cheaper. Robert Moses's highways divided neighborhoods.

The cause (the flexibility of trucks and cars) is treated as a symptom, and the symptom (building highways for them and subsidizing suburban housing in the midst of a housing shortage) is treated as the cause. This is rather like arguing that railroads shouldn't have been subsidized because they destroyed the canal culture of western New York State. But the fact is that like the trucks that have largely replaced them, they flourished because

they were a superior (meaning cheaper and more flexible) technology than the canals they supplanted.

Blacks came north in large numbers during World War II to get the defense jobs that had opened up to them partly because the Roosevelt administration, responding to both the labor shortages that created Rosie the Riveter and political pressure, required that 10 percent of the jobs in defense plants be reserved for blacks (the first racial quota). But when the troops came home, the newcomers were unneeded because the white ethnics reclaimed their old jobs and many unskilled and semiskilled labor jobs no longer existed or had moved to the South and suburbs.

This was compounded by the civil rights movement and the consequent white racist backlash against it. But the racism would have been nowhere as virulent if many of the new arrivals had been employed rather than welfare cases and criminals, much of this caused by the explosion of heroin addiction. Before the modern growth of the service sector, there were few jobs for uneducated men in postwar urban America. Was the infrastructure worn out and was it not replaced? Not really. The school and park systems were all expanded in the 1950s and '60s, massive amounts of new public housing were built and the older projects' tenants switched from the old working class to the new dispossessed. The projects in Fort Greene that had housed Brooklyn Navy Yard workers held poor people after the yard's closure. In many cases, urban renewal didn't work, as we discuss here.

Other older industrial cities in the North and Midwest have suffered more than New York. Cleveland was once a major center, but its population has been cut in half, and growth has been transferred to its edge cities, a phenomenon significant in Detroit, Washington, Baltimore, Boston and Pittsburgh. Some of these cities, like Camden and East St. Louis, are almost dead. They were depopulated by air conditioning and the cheap power and gasoline that enabled it and made the heat of Los Angeles, Texas and Florida tolerable—but not midwestern cold and snow. But in the New York metropolitan area, no one would compare Stamford, Garden City or White Plains to the Big Apple, even in the darkest days of 1977. Southfield, Michigan—the largest edge city in the Detroit area—now has a larger population.

In the 1950s, suburbia was perceived as utopia by the ethnics fleeing their identity and rushing headlong into what they perceived as assimilated Americanism. This mythology was enshrined in our movies, such as *Miracle on 34ᵗʰ Street*, in which the single career woman mother remarries and leaves New York City for the suburbs with her new husband and daughter.

The suburban paradigm reached its apotheosis in the 1950s with television sitcoms such as *Leave It to Beaver*, *Father Knows Best* and *The Donna Reed Show*, which were set in the suburbs and created and reflected a new dominant mythology: that the suburbs offered safety, clean air, good schools and a better way of life, which they do until they get older. As significantly, they semiconsciously promised that clean streets and orderly, detached houses with lawns would expunge the darkness of the soul that afflicts humanity. Movies had always held up suburban houses as the American ideal, but with the advent of television, shows in urban settings became the butt of jokes—such as Jackie Gleason in *The Honeymooners*, set in Brooklyn—for the (male) characters' stupidity and coarseness.

This element of popular culture also followed and encouraged another demographic trend: women leaving the workforce and becoming stay-at-home mothers. While not universal (mine worked full time, which enabled me to have a middle-class upbringing), it was both a trend and ideal.

At this time, Los Angeles emerged as the quintessential suburban city. I remember a TV special in 1960 called *The Fabulous Fifties* that attempted to present social trends as entertainment and had a female star state repeatedly, as a sort of refrain, that Anaheim, California, was the fastest-growing city in America. She kept repeating "Anaheim?" as in, "Who would want to live in Disneyland?" (which had opened in 1955).

And while Anaheim never became a major city, it is typical of the smaller cities of suburban America. The Los Angeles metropolitan area, of which it is a part, is the second largest in the country, and San Francisco, once California's largest city, is less populous than nearby suburban San Jose.

Friends from Los Angeles tell me that they don't feel safe until they enter their own homes and offices. How could they feel otherwise? There is no street life. They never meet their neighbors. Those without cars are poor, and while there is an excellent bus system there, as well as a new subway and a light-rail system, the area is therefore ghettoized. The distances between classes and ethnic groups is increased by transportation, rather than bridged. This is effectively dramatized in the film *Crash*, which won the Oscar for Best Picture in 2006. L.A. is depicted as full of people who are isolated and who therefore ethnically stereotype their neighbors, leading to racism in an environment where human sympathy is rare. Thus New York, the most public transportation–oriented city in America and one of its most ethnically and economically diverse, is also its least racist, in spite of such nasty episodes as the Civil War draft riots and more recent troubles.

At the same time, a new genre of filmmaking emerged: L.A. noir, which suggested that underneath the neat lawns, the same darkness of spirit and practice existed as did back east, perhaps worse. Starting with the Sam Spade films and continuing into recent times with *Chinatown* and *Crash*, racism and corruption were depicted as worsened by Hollywood narcissism and as poisonous as anything that existed elsewhere. Reality, in the form of the 1993 riots, did not help the city's image.

What has also occurred, despite regionalization, is specialization within metropolitan areas. Whereas nineteenth-century industrial areas—such as the northern part of Downtown Brooklyn—contained factories, houses and churches, since then localities have specialized in the face of zoning regulations and people's insistence on improved lives. Residential areas today are not also factory and warehouse districts. Fulton Ferry Landing and DUMBO, formerly manufacturing and warehouse areas, are now residential, with old warehouses becoming condos.

Today, residential and commercial areas are usually far from each other, perhaps at opposite ends of the metropolitan area, since cars theoretically promise easy commutation over long distances. What is indisputable about New York is that while its population has varied over the years, there has been explosive growth at the edges, so that today eastern Pennsylvania (especially the Poconos), all of Suffolk County, upstate as far as Dutchess County and Connecticut as far as New Haven, Danbury and Hartford look toward Gotham, and many people commute and do business here.

The next question that must be asked is if the suburban model is still dominant, why have certain older cities (like New York, San Francisco, Boston, Washington, Chicago and Pittsburgh) recovered and become expensive and desirable? There are several answers. As indicated above, New York shifted its economy, principally to Wall Street, banking, publishing, communications, law and news production and, later, to film production and tourism. The distribution and production functions that left the city and moved to the suburbs augmented the metropolitan area. Similar phenomena have occurred elsewhere.

But eventually, as some of the older cities got their domestic houses in order, redefined their economies and became tourist destinations and cultural centers, they began to seem much more interesting than suburbia, especially as young people who grew up in ticky tacky revolted against their hometowns (as most do) and decided that cities were cool.

While it may be too early to analyze the effects of the new economy on cities, some guesses may be made. Suburbanization took place toward the

end of the industrial era and revolutionized the way goods are manufactured and transported. The new economy is based on electronic communications. It may be that cities are friendlier than suburbs to this function, or at least not contradictory to it. Although the dominant areas of the computer revolution are the suburbs of San Francisco (Silicon Valley, home to Intel and Apple), Seattle (Microsoft), Boston (for medical devices) and Austin (Dell), the production of content for computers has created a Silicon Alley in New York. After all, the current mayor, Michael Bloomberg, made $25 billion in the electronic distribution of financial information (not by using it), sort of like Levi Strauss, who got rich selling blue jeans to prospectors during the California gold rush of 1848, not by panning for the mineral.

The advantage cities possess in this field is that they make networking easier. The proximity of large numbers of professionals in these areas makes cross-fertilization of ideas much easier than on a suburban office campus where you only meet the same colleagues who drive home after work. And while e-mail, phones and teleconferencing help, they do not constitute a viable alternative to genuine human contact.

It has also become clear that while suburbs do have advantages, they are no panacea for the ills that affect human life. In short, they went from new and pioneering to old and routine. If the schools are better, you have to pay high taxes to a bewildering array of overlapping jurisdictions. If you can go anywhere by car, traffic jams are monstrous. If you are safe, you are isolated and bored. And if they looked good when new, most have aged badly, unlike their urban cousins, where older townhouses and apartment buildings were better designed and more solidly and stylishly built before the era of prefabrication and have therefore aged better. And the latter's decline became an asset, since at one time they were so inexpensive that you could buy a rundown house on the cheap and restore it to its former glory.

At the same time, modernism became tired and stale. It was replaced by retro postmodernism in the 1980s because it had begun to stink of totalitarianism or at least sterility as the anti-human nature and death throes of communism in the Soviet Union and China became too obvious to ignore.

Why should non-Brooklynites (or New Yorkers for that matter) care about Brooklyn history? Because it encapsulates the history of cities all over America and much of the world. The reasons cities rise and fall and rise again is a response to technology and historical forces. This was largely invisible in Manhattan, the subject of most New York City historiography, but was painfully clear in Brooklyn. Manhattan largely prospered during the period of the decline of the old industrial cities like Brooklyn. Except for the

Lower East Side and Upper West Side, which began to come back during the 1960s, decline was masked as Manhattan was successfully redeveloped by the government and the private sector, with the removal of the Third Avenue el; the construction of Lincoln Center, the U.N. and Stuyvesant Town; the office building boom on Wall Street and midtown; and new luxury apartment construction on the Middle and Upper East Side from the 1950s on. The World Trade Center project was a major element of this effort.

Studying Brooklyn's history has brought me to a new theory of the dynamics of urban development: that cities rise and fall according to the predominant transportation technologies. It is well known that Robert Fulton's steam ferry was instrumental in pushing forward Brooklyn's development. The Olympia project failed for lack of it. But the Erie Canal and its mule-drawn barges made Red Hook a major oceangoing and domestic port. Later, streetcars on rails, both horse-drawn and later electrical, opened up new areas, as elevated steam trains and later electric powered cars provided rapid transportation. The three great East River bridges and then the subway system pushed development far from Manhattan and provided the impetus that made Brooklyn a city of 2.738 million by 1950. But areas reached early by the subway also lost their exclusivity, so Brooklyn Heights went into decline.

Technology is the great unknown moving force of history. Only in military history is it properly appreciated because one cannot ignore the decisive effect it has on who wins and loses. From the crossbow to the dreadnought battleship, the aircraft carrier, radar and sonar, new ways of fighting have always determined the outcome. So it is in other human pursuits. We have made the case here that transportation was responsible for both the rise and fall of Brooklyn and the other older industrial cities. Steam ferries, horsecars, streetcars, elevated railroads, suspension bridges and subways made Brooklyn. The car, truck and high-speed freeway unmade it.

But there are other technological determinants. The most important one for our purposes is air conditioning, which made the Sunbelt habitable and is most responsible for it being the nation's growth area. Another major transportation technology is the jet aircraft, which made it cheap and easy to go thousands of miles and has contributed to the nomadic lifestyle in America and the modern world that reduces loyalty to place.

Another major factor that caused the development of the city of Brooklyn was the abolition of slavery in Brooklyn. There is a reason that the major cities in the country in 1860 were all in the North: they embodied the new industrial model, and there was no room in a major city for slavery because business requires a large, flexible labor pool capable of responding to its

needs. Obviously, slaves, who are owned by farmers, cannot so respond. This is a major reason that the North won the Civil War and the explanation for why the South could not rival the North until it abandoned at least the worst aspects of racism by 1970 and embraced the industrial model.

It was during a ranger tour of Prospect Park that I learned that slavery existed in New York until 1827. My reactions went from rage at the black ranger (a form of denial) to curiosity. Finally, I decided that I was ashamed not only that this had been the case but also that the story of the abolition of slavery is a major part of how Brooklyn—which once had as many slaves per capita as Charleston, South Carolina (Charleston was a city, but Brooklyn was farmland with a total population of 4,500 in 1790)—went from farms to city. This is also a story that is little known, probably out of displaced guilt feelings in people whose ancestors themselves mostly came here from 1845 on. We humans tend to feel guilty not just about what we ourselves do, which is proper, but also about what our ancestors or those who lived in the same place did, which is not. (My daughter, who was raised in Brooklyn, feels guilty that her southern ancestors were slave owners.) Moreover, when studying the Revolution in Kings County, it becomes clear that slaves played a role in it, whether as messengers from the Rapalyes+ (+ denotes names used for modern streets) to the British or as assistants in helping the Lefferts+ family flee war. You cannot tell this story fairly and ignore them.

I have therefore decided to tell the story of slavery in Kings County from 1770 to 1825—its abolition and the consequent Underground Railroad; what it was like for slaves and for their owners to live through military occupation and its predations and, yes, opportunities; what "normal" life was like; and how the "peculiar institution" ended in New York and Kings County. This is also a story that is not sufficiently known.

It is often stated that New York was the last state in the North to enact abolition, since slavery officially ended only in 1827 (Weeksville dates from 1828). But this is a misleading—although technically accurate—statement. Bondage was gradually ended by law in 1799, by specifically authorizing owners to manumit their workers and with a proviso stating that newborn children of slaves would owe their masters their labor until age twenty-five for women and twenty-eight for men. But, in fact, it ended years earlier since slave owners literally fell all over one another to be the first to demonstrate their faith in freedom. Also, it is impressive that within sixteen years of the evacuation of the British on November 23, 1783, we managed to create a constituency for freedom.

This is no small point. Two states abolished bondage during the conflict, but they did not have their most important cities (and New York was that, even then) occupied by the enemy. It should be pointed out that the two other principal northern cities, Boston and Philadelphia, were free from British rule for most of the war.

When young people want to describe someone as no longer important, they say "they're history." This reflects an opinion that the past is not relevant to their lives. But those of us who love history know that this is not true. It has just been badly taught and overwhelmed by popular culture and the rise of technology. What brought me to history was a need to understand my world, especially the Second World War. And I still believe that without knowing the past there is only ignorance of the present and the future. Why, then, is the Revolution important to us today in a modern, multi-ethnic city? If the Revolution created Brooklyn, then to ignore it is to not know our own past. To not know your past is to misunderstand the present and future.

It is difficult today to imagine what liberation from colonial rule felt like. To us, it seems like a cliché, or perhaps something experienced by others achieving their independence or the end of World War II. But it was a wonderful thing, sort of like the feeling of liberation brought on by the 1960s in its good times. Besides self-government and democracy, the country was suffused with a democratic spirit—aristocracy would no longer rule, and all would be equal before the law and have a chance in life. Despised groups would also have a chance, and although the unresolved issue of slavery would lead to civil war, in the North, it was the Revolutionary spirit of freedom that led the newly freed states to outlaw it.

One of the first expressions of the new spirit was the development of public, secular schools. Previously, most education had been provided by churches. Immediately, the new Americans started secular schools to teach democratic values. In Brooklyn, the best known is Erasmus Hall, significantly named for the great Dutch humanist. Its founding was a major event, and two of the initiators of the project were Alexander Hamilton and Aaron Burr of Manhattan. That they would venture to Flatbush to endow an institution is significant. And although it was a private school, it was a secular high school, the first in the nation, which evolved into a public school.

Kings County was once a land of brooks; hills; pols (low-lying islands in shallow bays); tidal creeks, such as the Gowanus and Newtown; and marshes. The marshes and pols are still visible along the shores of and within Jamaica Bay. The brooks are gone, as are most of the hills, although a man-made watercourse flows through Prospect Park. Red Hook is the

most extensively altered part of the city. Today, its map looks nothing like what it looked like in its relatively natural colonial-era state. It was leveled and its ponds were filled when it was urbanized in the 1830s and became the port for the Erie Canal.

If the transition from farm to city is a principal reason that people lost touch with the Revolution, since the places where these great events took place had irretrievably changed (except for Battle Pass in Prospect Park), along with the entire physical context of Kings County, there are also many other factors.

In the rush to urbanization in the nineteenth and early twentieth centuries, much was lost that should have been preserved. When the suburban paradigm that produced Los Angeles and the Sunbelt became dominant after 1945, and high-rises and modern detached suburban homes with garages became the preference of those to whom leaving the old neighborhood meant abandoning brownstones, more still was lost as Brooklyn expanded its downtown in an overwhelmingly successful effort to remain economically relevant and dynamic.

Studying the American Revolution is a portal allowing us to enter the world of eighteenth-century Dutch farmers that was Brooklyn before brownstones. We think of Brooklyn history in terms of townhouses, 1920s apartment houses, the Dodgers and our own forebears of the nineteenth and twentieth centuries, but the few of us of British or Dutch descent, and those interested in the Revolution, know about what Brooklyn was like in 1776 and before. Today most people think of portals as entrances to other dimensions, but this one is an intellectual door through time that allows us to enter and clearly perceive the past—how people lived and what their world and the events they lived through were like.

Today, without having read her, we embrace Jane Jacobs's worldview in *The Death and Life of Great American Cities*, that the old is good, but we also accept a mix of tradition and modernism to prevent rot from setting in. Paradoxically and ironically, the brownstone and preservationist movements—begun in Brooklyn Heights and Greenwich Village in the 1950s in efforts to resist the modern planned and automobile-oriented city, and whose ideology was first enunciated by Jane Jacobs and by Robert A. Caro in *The Power Broker: Robert Moses and the Fall of New York*—emphasized what had been lost when elegant townhouses replaced country houses, hills and wilderness.

Among the people featured in this history are Walt Whitman and Emily Dickinson, who are considered the prophets of modern poetry, who freed it from rhyming and formal versification and transformed it into a humane art whose conversational, confessional and personal tone would lead to other American geniuses such as T.S. Eliot, Wallace Stevens, Allen Ginsberg and Bob Dylan.

What is remembered about Whitman is his enthusiasm for life, connectedness with the universe and homosexuality, which identifies him with the outsiders and oppressed of the world. But Whitman was an unabashed patriot of America and Brooklyn who moved from Suffolk County to Brooklyn to find the freedom cities promise. It is because of him that we remember Brooklyn's vanished hills and newspapers. He enunciated a democratic and life-affirming vision in the mid-nineteenth century based on the values of the Revolution, which would reach its apotheosis in the Civil War. He was also a political artist who was fired as editor of the *Brooklyn Eagle* for his vocal opposition to slavery (the paper was Democratic and conservative) and who translated his values into civic action by helping found Washington Park, which we now call Fort Greene Park, to preserve one hill he loved on which forts had been built in 1776 and 1812.

This part of him is forgotten because the United States is the world's superpower rather than a small, struggling nation, so patriotism today has often changed from an honest enthusiasm into a partisan weapon and club with which to beat dissenters. But Whitman and the people of his time saw no contradiction between freedom and war. He was no pacifist. He remembered the wars his parents and grandparents had fought for their own freedom. His generation and its children would fight the most traumatic struggle in our history to end slavery and create a unified nation. To nineteenth-century Americans, war was what we would now call an act of creative destruction. It would take the nihilism of two world wars, ethnic genocide and the specter of nuclear holocaust, as well as the first faltering successes of Wilsonian internationalism, to begin to change people's attitudes.

We recount here the great and small events in the history of Brooklyn, which explain what it was and is; how the ferries enabled commutation to take place; how the city rose and became a major manufacturing, warehousing and shipping center; how streetcars and els brought people far from the ferries; how this process was accelerated by bridges and subways; and how this process of urbanization drove the old settlers away and led to their replacement by the nineteenth-century immigrants whose stories are well known.

Then this cohort began to depart in the cars of the post-1945 prosperity for Flatlands, Mill Basin and Marine Park—but also for Nassau County, New Jersey and California—and was replaced by domestic immigrants whose labor was unneeded and who were consequently unwanted by many. It would take years of struggle and adaptation for them to become productive New Yorkers. In the meantime, urban pioneers picked up the slack of the old population and redeveloped the old houses and neighborhoods increasingly written off by urban planners whose solution—urban renewal—while

somewhat effective, was also massively destructive. With the entry of new immigrants from 1966 onward, the old New York paradigm again took effect, and this, combined with the new popularity of cities and their economic adaptation, has created cost problems for middle-class Brooklynites.

This, then, is a history of Brooklyn Heights that has a point of view about how it got started and grew, why it declined and how it was reborn and tells what happened within the context of that argument.

The story of Brooklyn is the story of the people of America, how they came here from other faraway lands, some involuntarily, some as refugees from poverty and oppression, and created a new place whose promise of freedom and success remains a bright promise throughout the world. Something like an eighth of America has passed through Brooklyn as a first stop after Ellis Island or Kennedy Airport. So they depart but always leave something of themselves behind. And it is up to us to recapture and treasure these remnants of the past.

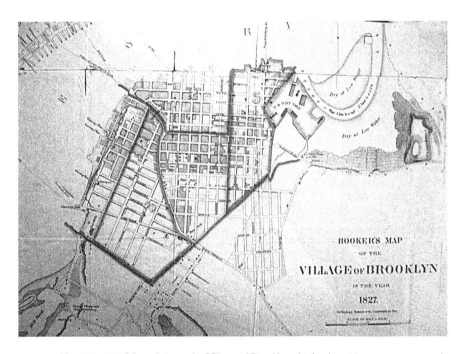

Figure 3. Hooker's 1827 Map of the entire Village of Brooklyn. At the time this map was surveyed, only the shaded blocks existed, and the few buildings are shown as dark rectangles. District Street, the southern boundary, was realigned as Atlantic Street (later Avenue) to line up with the streets in the Heights. The Cobble Hill fort was on the large block above it. The village's eastern boundary, the proposed extended Red Hook Lane, goes almost to the navy yard. Moser, Waring and West Jackson Streets were legally opened but never broken through. Note the numerous ropewalks downtown, the Glass Works and the "Contemplated New South Ferry" at lower left. Hooker's December 1827 "Pocket Guide" shows the modern streets south to Amity and west of Red Hook Lane (as mapped but not yet opened) instead of District Street. *Robert Furman Collection.*

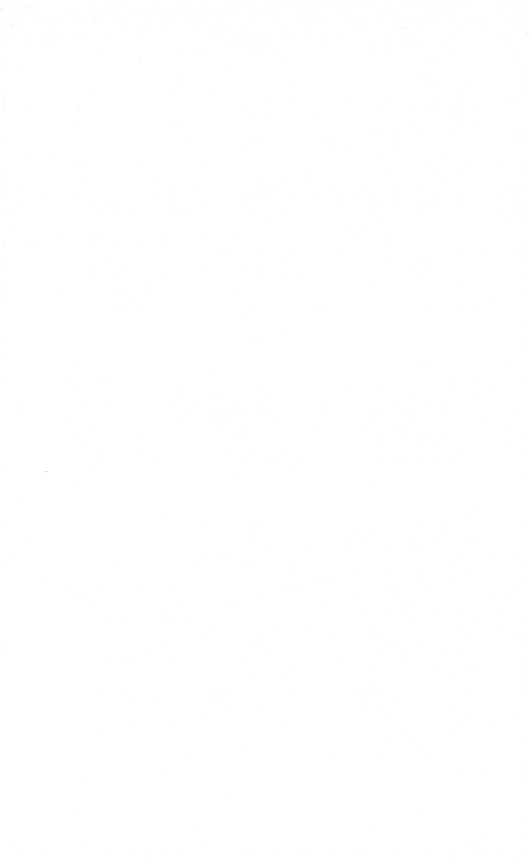

Chapter 1

THE DAY OLD BROOKLYN DIED

October 24, 1929

On October 24, 1929, 100,000 people gathered for a grand procession sponsored by the Brooklyn Bridge Plaza Association. It wended its way from Grand Army Plaza in Park Slope, through Downtown Brooklyn and Brooklyn Heights to Fulton Ferry Landing. The association was organized to erect an Art Deco–style gateway honoring George Washington near the Brooklyn Bridge on Fulton Street (figure 1) as part of the adaptation of the bridge to increased automobile traffic. It continued its work into the 1930s.

Three new plaques sponsored by the Daughters of the American Revolution, the Sons of the Revolution and the Brooklyn Bridge Plaza Association were unveiled. Two—the ones at Fulton Ferry Landing and at the Four Chimneys site—are where they originally were (although replaced). The one on St. Charles Hospital for Crippled Children at 277 Hicks Street, south of Joralemon Street (figure 2), for the Philip Livingston+ House (figures 3 and 4) is gone.

The hospital is now an apartment house, but the holes and anchors that held the plaque are still visible on its south side (figure 5). It was inadequate and inaccurate. Livingston didn't reside there; it was his country house. And no mention is made of the Council of War, which was assigned to Four Chimneys by the celebrants and many others. Nevertheless, any marking is better than none, which is the case today.

The marchers returned home to their radios and evening newspapers to discover that the stock market had crashed. In spite of reassurances from business leaders and President Herbert Hoover, over the next few months it

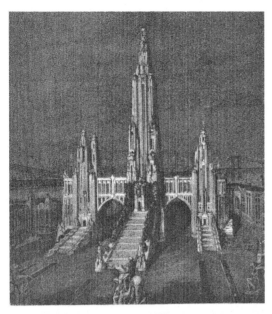

PROPOSED
WASHINGTON MEMORIAL PORTAL
TO
BROOKLYN BRIDGE

Left: Figure 1. The Art Deco gate proposed for Fulton Street was beautiful but impractical since it would not have allowed for increases in traffic volume. *Robert Furman Collection.*

Below: Figure 2. The building at 277 Hicks Street is the former St. Charles Hospital for Crippled Children, which held the Livingston plaque. *Robert Furman photograph.*

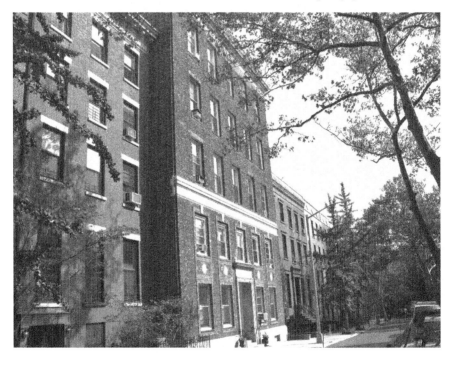

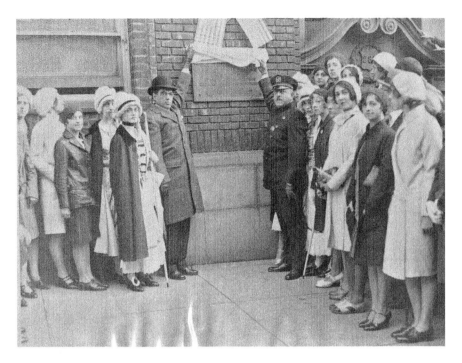

Figure 3. The unveiling of the plaque at 277 Hicks Street on October 24, 1929. *Brian Merlis Collection.*

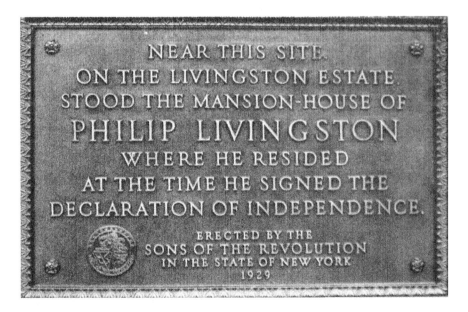

Figure 4. The Livingston plaque was unveiled on October 24, 1929. Its fate is unknown. *Robert Furman Collection.*

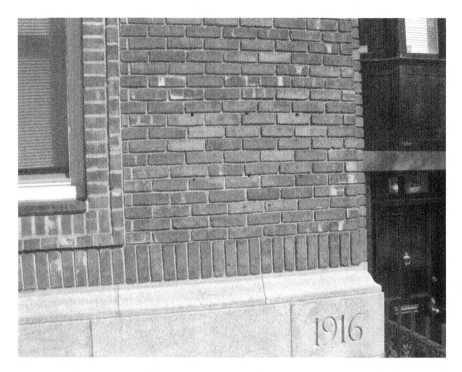

Figure 5. The wall on 277 Hicks Street today, where the Livingston plaque was once mounted. *Robert Furman photograph.*

became clear that the Great Depression had begun and that New York City would be particularly hard hit by this economic catastrophe that forever changed the world (it brought Hitler to power in Germany) and the way government builds public improvements. October 24, 1929, is known to history as Black Thursday, and it is the day old Brooklyn died.

In 1965, under the leadership of the Brooklyn Heights Association, Otis Pratt Pearsall and Clay Lancaster, Brooklyn Heights became the first neighborhood to be designated a New York City historic district because of its splendid nineteenth-century residences, offices and churches. Yet in the development of the area after the incorporation of the Village and, later, the City of Brooklyn, its Revolutionary War heritage was thoughtlessly swept away, so that today not one building remains from that time when so many crucial events occurred there.

In 1816, the Village of Brooklyn (introduction, figure 3, and chapter 4, figure 3) was established to facilitate the development anticipated from the inauguration of reliable steam ferry service by William Cutting, Hezekiah

Pierrepont+ and Robert Fulton+ from Brooklyn Ferry in 1814. Brooklyn Heights was quickly transformed into America's first suburb, especially after the incorporation of the larger City of Brooklyn in 1834.

But the structures that saw the Revolution were lost. The British "Brooklyn Fort" was gradually taken apart and its elements used to build new houses. By the time the First Unitarian Church of the Saviour was raised at Monroe Place and Pierrepont Streets in 1846, the fort's footings, its only surviving element, were used to underlie it. When what became Montague Street was cut through to the shoreline in 1846, Four Chimneys', which had been Washington's local headquarters, destruction was ordained since it actually sat in the middle of the new street (chapter 4, figure 3). Philip Livingston's house, where a Council of War was held, and Fort Stirling on the bluff at Clark Street were all gone, remembered, if at all, by a few plaques.

Chapter 2

BEFORE THE REVOLUTION

10,000 BCE to 1776

L ike the rest of northern Long Island, Brooklyn Heights and the rest of what is now the New York metropolitan area was formed by the Wisconsin glacier that covered the northern United States twelve thousand years ago. It stopped its forward movement at that time, began to melt and recede and left massive amounts of rubble in front of it in the form of large and small rocks and boulders. These formed hills, one of which was the small plateau that is the Heights. The glacier is the reason that the northern half of Brooklyn and the rest of Long Island is hilly, while the southern part is flat because the glacier had never covered it.

Figure 1. Typical Canarsee Indian longhouses. From *The Eagle and Brooklyn*, 1898.

While everyone is familiar with the neighborhood's western border—the bluff down to what we call the East River, which is actually a tidal channel connecting Upper New York Bay, Long Island Sound and the Harlem River (its conduit to the Hudson River)—the Heights' eastern border is less apparent. To see it today, one must walk up Tillary+ Street from downtown at Johnson Street near NYC Technical College, where the slope is evident. But in its natural state, the rise was much more obvious. Figure 2 shows the area in Dutch colonial times, and the outlines of the rise are plainly discernible.

THE LENAPE

During Indian times, the area was called Ihpetonga, meaning "the high sandy bank." Little is known for certain about the Native American populations in the New York area, and what is stated here is based on Eric Sanderson's *Mannahatta: A Natural History of New York*, which is itself drawn from information about other Lenape groups, archaeological evidence, historical anecdotes and folk etymologies; therefore, very little is certain. The Lenape, or Delawares, dwelt from Connecticut to Delaware, called Lenapehoking, beginning in about 4,000 BCE. Their societies were based on clans called phatries, which were enate (they passed through the maternal line). Each community contained family groups or clans called wolves, turtles and turkeys, and one had to marry outside the clan to avoid incest.

A branch of the Canarsee tribe of the Lenape nation lived in Brooklyn, which they called Paumanack (Walt Whitman used the term), and may have been related to the Manahates (the derivation of the name "Manhattan"). Other groups are known throughout the New York area whose names survive as town and river names such as Chappaqua, Massapequa, Raritan, Hackensack and Rockaway, the group in southern Brooklyn. They were not a permanent population but nomadic hunter-gatherers who also farmed and who migrated according to the season and the availability of food, much as the animal populations around them did. They consequently owned only what could be carried with them. They had no concept of money or ownership of land because of their migratory lifestyle. Wampum, shell beads bored from clamshells, was not money but a gift given to mark respect. What they did treasure was their reputation for generosity and respect for others, especially their elders.

They were fond of Gowanus Creek oysters and left huge piles of shells on the banks of the creek, called middens, which were evident until that area was built up in the late nineteenth century. They were also farmers and raised maize (corn), squash and beans to preserve the soil. They lived near the sea in wigwams during the spring and summer to collect its bounty and to farm but transferred to winter quarters inland in the fall. Wigwams were smaller, round versions of their winter dwellings, twenty- to sixty-foot-wide by one-hundred-foot-long lodges of hickory saplings bent over to form a peak and lashed together (figure 1) with horizontal crossbeams and bark covering the outside. The houses were closed against the elements without windows; sunlight only entered through doors and holes in the roof that served as chimneys but could be covered as protection against rain and snow. Family groups had a space of about fifty square feet, separated by leather sheets. Several levels of platforms were built into the sides of the lodges for sleeping and storage. Food was stored in pits in the ground lined with grass and covered with stones or perhaps hung from the rafters in baskets. A cooking pot would generally be going all the time, both indoors and out.

This branch of the tribe spent much of their time outdoors and used sweat lodges and logs set out for use as mortars to crush corn and nuts. Women seem to have done most of the work necessary for survival, including maintaining the lodges, cooking, making clothes (including tanning hides), making pottery, most of the farming and gathering wood and useful plants. The men hunted and fished, felled trees, built the houses and canoes, crafted tools and grew tobacco. As coastal people, they lived primarily on hunted and gathered food rather than on farm produce.

They altered their environment by controlled burning to clear forests for farmland; they felled the trees and burned the underbrush, which fertilized the soil. In spring, the women built mounds and planted maize seeds on them and, later, squash and beans between them.

The Lenape were described as follows by a Van der Donck Dutch settler: "The natives are generally well-set in their limbs, slender around the waist, broad across the shoulders and have black hair and dark eyes…The men have no beard, or very little, which some even pull out." Isaak de Rasieres added, "The women are fine looking, of middle stature, well proportioned and with finely cut features…with black eyes set off with fine eyebrows." William Penn of Quaker Philadelphia noted, "For their Person, they are generally tall, straight, well-built and of singular Proportion; they tread strong and clever and mostly walk with lofty chin." They often tattooed themselves with designs representing animals, birds, snakes and geometric

shapes. They also routinely painted their faces, not solely as war paint but for any special occasion such as festivals, mourning periods or ceremonies. The men painted their chests, thighs and faces with bloodroot for red, ocher for yellow and charcoal for black and sometimes colored half their faces in red and the rest in black or their entire heads red with black dots. They also oiled their skins.

Spiritually, the Lenape saw themselves as an integral part of creation, not above it, as many westerners do today. A society's creation myth is usually very telling about its basic ethic, and the Native Americans' version was that a Great Spirit called Kishelemukong generated the Keepers of Creation: Rock, Fire, Wind and Water (also known as the Grandfathers of the Four Directions) from his imagination. These were similar to the elements in the ancient Greek "scientific" scheme (earth, air, fire and water), indicating their universality. They helped the Great Spirit create Father Sun, Grandmother Moon and Kukna, Mother Earth. Together, all of them made the plants and animals with special powers and abilities and placed them where they could be useful. They also created Matantu, the Evil Spirit, who placed poisonous plants among the edible ones, put thorns on blackberries and created destructive insects like flies and mosquitoes.

Humans were created twice. Grandmother Moon and Grandfather Thunder had two children, a man and a woman. Grandmother Moon gave them the power to imagine and nurtured them until they were grown and then returned to the Spirit World, promising to watch over them. After a great flood, Nanapush, a powerful spirit, after his adventures, reclaimed a small patch of earth at the bottom of the sea, which he placed on the back of a turtle. A tree grew from this turtle island, and two of its leaves became man and woman. Flood myths are also clearly universal.

The parallels with the creation tale in Genesis are rather shocking. All in all, it is a very human and ethnocentric view that makes us regret their extirpation.

Mesingw, the Keeper of the Game, was responsible for the welfare of forest creatures and patrolled the woods from the back of a large buck. It was his responsibility to reconcile the human need to hunt with the deer's fears of being killed. Hunters understood that they could not take more than needed and were to release the spirits of the dead animals to be reborn and replenish the population.

The last of the Brooklyn Native Americans is thought to have died around 1800, but many of them probably permanently migrated away from areas of European settlement due to the inevitable clash of cultures.

THE DUTCH

The Dutch bought most of western Long Island, including the Heights, from the Indians between 1630 and 1640. Settlers thereafter purchased the land for farms, thereby obtaining "patents" for the land (figure 2). Some were obtained from the Native Americans themselves. The Indians were mostly accepting of the loss of their lands, but there was a threat of hostilities in 1644. This probably arose from the fact that the parties had contradictory concepts of what was occurring. The Dutch considered that they were purchasing exclusive use of the property, but the Indians thought that the Europeans only wanted to share it.

In the mid- to late seventeenth century, they organized six towns in what is now Kings County: Breuckelen in 1657, Bostwyck (Bushwick, which extended into Queens), Flatbush (Vlatbos), Flatlands (Nieuw Amersfoort), Nieuw Utrecht and Gravesend, begun by the English Anabaptist Lady Deborah Moody.

From that time until urbanization, the Heights consisted of apple and pear orchards, grazing lands and vegetable gardens, dotted with a few country

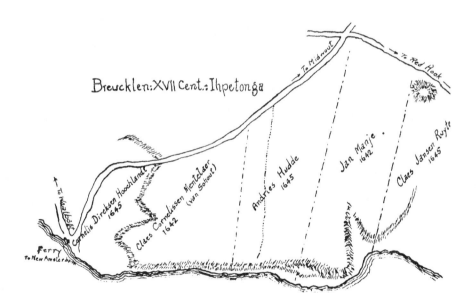

Figure 2. By 1645, Dutch landowners had already completely divided up the Heights. They included Cornelius Dirksen Hoochlandt, Claes Mentelaer, Andries Hudde, Jan Manje and Claes Jansen Ruyter. Note that the bluff continued beyond the shorefront as a hill: the Terminal Moraine. *Robert Furman Collection.*

mansions, as shown on the Ratzer map (figure 3), and its primitive state may be seen in the fact that of all the streets that exist there today, only Joralemon Street (then the River Road, a ravine in the state of nature), Cadman Plaza West (then the Ferry Road and later Fulton Street), Red Hook Lane and Love Lane (which then ran from the bluff to the Ferry Road), along with a primitive version of Atlantic Avenue known as Patchen's Lane, were then in place. At the time, the area's economic life centered on raising fruits and vegetables for sale in New York City's Fly Market.

The *Brooklyn Eagle* carried a poetic vision of nature and agriculture on the Heights on November 21, 1886, when it was long gone:

> *The whole slope of the Heights from Furman Street was overgrown with stunted cedars, while the top was level ground in clover, save where the*

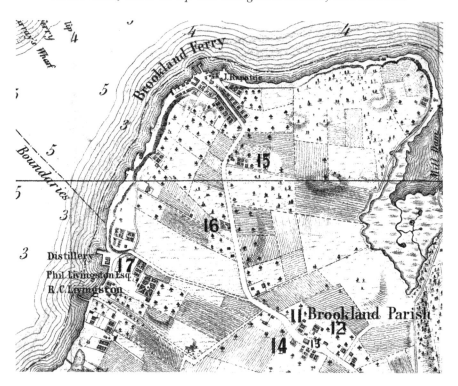

Figure 3. Brooklyn Heights on the Ratzer map of 1767. Philip Livingston's House, garden and distillery are at left, and his cousin Robert G.'s land with its house and garden are below that. Four Chimneys is at upper left at the end of a narrow lane. Cobble Hill is at bottom center near Red Hook Lane, which meets Patchen's Lane. The Ferry Road is at right, and what would become Joralemon Street traverses the center. The area is mostly farm fields. *Brian Merlis Collection.*

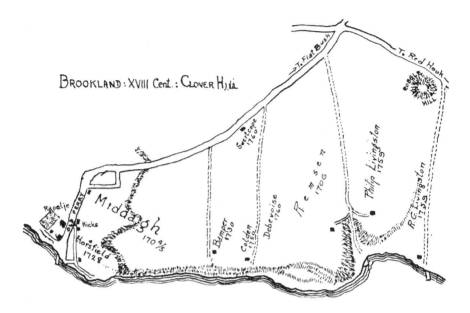

Figure 4. Under British rule in the first half of the eighteenth century, the area was known as Clover Hill. Paths or trails had been opened to residences, which later became, in most cases, streets. What would become Joralemon Street traverses the hills. *Robert Furman Collection.*

gardens blossomed and smiled around the mansions. Behind the gardens there were great stretches of orchards filled with fruit trees, apples, pears, plums, apricots, cherries and grape vines which reached to the Flatbush trackway or spoorweg [the Flatbush spoor or spoorweg was the Dutch name for the Flatbush Road] *which was itself beyond question founded upon an Algonquin trail.*

Beyond the Flatbush spoor and along the King's Highway stretched the primeval woods of Long Island, cedar and pine in the sandy parts, and hard woods in the bottoms, while around the Wallabout and Gowanus swamps flourished the maple, the sweet gum and the peperage. Red leafed sumachs grew everywhere.

The largest colonial-era landowners in the Heights were the Robert Benson and Middagh+ families, Jacobus Debevoise (Pierrepont-Clark) and Henry Remsen+ (figure 4), farmers who traced their roots to the seventeenth century. The Brooklyn Ferry property of the Ludlow and Hicks families extended into the north Heights.

The north Heights was part of the first Dutch patent or grant of land from the Dutch West India Company to Claes Cornelissen van Schouw in 1642, which extended roughly from Clark Street to DUMBO. South of that was the patent to Hudde. Administratively, the Heights was part of Het Veer, the Dutch village, which extended from the Ferry to Joralemon Street.

THE BRITISH

In 1690, Dirck Wortman purchased the early Dutch patents and became owner of the entire area. In 1706, he deeded his land to his son-in-law Jeris or James Remsen+, who built himself a house on the future site of Grace Church. It served as a British hospital during the occupation. Afterward, it passed out of the family and was occupied by William Cutting, Robert Fulton's partner in the Fulton Ferry. Thereafter it was sold to

Figure 5. Jacob Patchen was a wealthy colonial-era landowner who lived in Cobble Hill but owned the south Heights. He is shown here in his trademark homespun leather suit. From *The Eagle and Brooklyn*, 1898, pp. 72.

Fanning Tucker, Esq., and then to Jonathan Trotter, who transferred it to William Packer (see chapter 4). In the 1840s, the house was moved to 25–27 Joralemon Street when that was still a ravine with a well on the site of the old St. George's Ferry Terminal (see chapter 4). It was a long, low double-wooden house with yellow shutters entered via a gate at Hicks Street and was finally demolished early in the twentieth century.

British rule, definitively established in 1664, did not alter the warp and woof of day-to-day life, as a consequence of a political decision to maintain stability. Names, however, were changed. The town and area name evolved from the Dutch Breuckelen to the English Brookland and then Brooklyn.

The British organized the six Dutch towns into what they named Kings County and established Brooklyn Village, including the Heights and the Borough Hall area, in 1748.

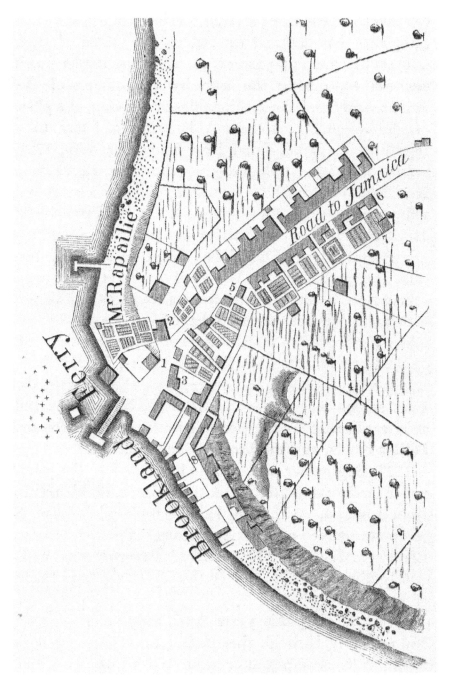

Figure 6. Brookland Ferry (a British name) and the north Heights in 1767 (from Ratzer). What is most noticeable is the expansion of the shoreline via landfill, especially on the DUMBO side. From Henry B. Stiles's *History of Kings County*, 1884, pp. 95.

The Middagh+ Mansion was located at the northwest corner of Henry and Poplar Streets. It was built by Garret Middagh in the mid-seventeenth century. His father, Aert Anthonize Middagh, arrived here in 1654. The mansion was inherited by the Hicks brothers, and its yard served as a burial ground for British soldiers during the occupation while its barn was the first home of the Episcopal or English church (see chapter 6). Teeth were reportedly extracted from corpses buried here for reuse by local dentists. The building was replaced by the Henry House Hotel (figure 7) in the mid-nineteenth century. It originally catered to sailors but deteriorated into a flophouse by the 1930s.

Much of the waterfront was owned in 1729 by Tim Horsfield, who brought cattle over from New York by ferry for slaughtering and dressing. Lodewyk Bamper owned the land between Clark and Cranberry Streets in 1730 and lived in a great house complete with servants and grand dinners. He made his living from a glassware factory that he appears to have founded on what would become State Street that moved to upstate New York in 1868 as Corning Glass Company (see chapter 8).

The Cary-Ludlow estate was carved out of this property in the 1700s. The house Mr. Ludlow lived in was called the Old Stone House and was reached via a right-of-way from Fulton Street up Doughty Street through a gate from Fulton Street that featured two whale jawbones above it. Mr. Ludlow was a prominent New York merchant.

In the early 1800s, Ludlow's property was divided between Samuel Jackson+ and Henry Waring+. Jackson is best known for selling the property that became the Brooklyn Navy Yard to the U.S. government, but he was an old New York merchant of British Quaker stock. Born and raised on Long Island, he moved to Brooklyn after the death of his brother-in-law who was also his business partner.

Jackson later turned his attention to gardening on his large property. His residence was a country house (chapter 6, figure 14) on Hicks Street approached from Willow Street by a lane bordered by poplar trees and several gardens (see chapter 4). After his bankruptcy, it served as the Brooklyn Orphans Asylum and then as the Female Academy, the predecessor of Packer Institute. A site plan is on the Colton Map of 1849, and his property is shown on the 1816 Lott Map (chapter 4, figure 3).

Opposite: Figure 7. The north Heights in 1816, before urbanization, resembled its country town past. The old estates are shown by large numerals. No. 1 persisted into the urban period. From Henry Stiles's *A History of Kings County*, 1884.

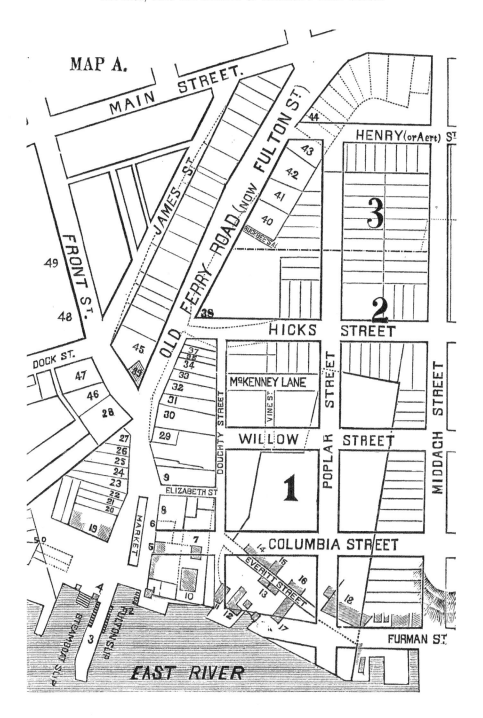

MAP A.

MAIN STREET.

JAMES ST.

OLD FERRY ROAD (NOW FULTON ST.)

HENRY (or Aert) S.

44

43

42

41

40

BUCKBEE S.

3

2

FRONT ST.

49

48

HICKS STREET

DOCK ST.

45

35

37
36
34
33
32
31
30
29

McKENNEY LANE

VINE ST.

POPLAR STREET

MIDDAGH STREET

DOUGHTY STREET

47

46

28

27
26
25
24
23
22
21
20

19

9

ELIZABETH ST

8

6

5

MARKET

7

WILLOW STREET

1

COLUMBIA STREET

50

14

15

16

EVERITT STREET

12

1

10

13

17

18

FURMAN ST.

A

STEAMBOAT SLIP

FULTON SLIP

3

EAST RIVER

Chapter 3

THE REVOLUTION AND THE HEIGHTS: 1776-1783

The Battle of Brooklyn

Fought a month and a half after the signing of the Declaration of Independence, the Battle of Brooklyn (Long Island) was what some consider the first engagement of the United States Army. The British mounted the largest seaborne invasion before D-Day in an attempt to end the American Revolution by dividing the southern and northern colonies and destroying the Continental army.

While no combat took place in the Heights, we should remember that its possession was the British goal. From there, the British could bombard New York City into submission with cannons sited on the bluff (the city then constituted only Manhattan below Chambers Street).

In July 1776, the British brought to New York a force of thirty thousand soldiers and sailors, which was commanded by two brothers: the navy by Admiral Lord Richard Howe and the army by Lord William Howe, facilitating coordinated action. The army encamped on Staten Island and in August landed in Bay Ridge and Gravesend in Kings County. They formed up into three columns—a left, center and right—and put a grand plan into effect at midnight on August 27. The left marched up the Shore Road and engaged the American right in the vicinity of today's Green-Wood Cemetery and the Old Stone House. The center encamped near the Flatbush Dutch Reformed Church, facing the American Center in Prospect Park. The previous evening, the right had marched to the area of Broadway Junction and then west along the Jamaica Road (Atlantic Avenue) to the Flatbush Road near Atlantic Terminal and then southeast toward

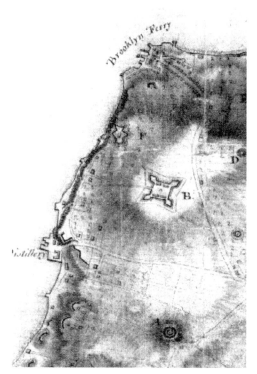

Figure 1. Brooklyn Heights on George Sproule's *A Plan of the Environs of Brooklyn*, showing elements of both 1776 and 1780. "F," Fort Stirling, is at upper left; "B," the Citadel, is at center; and "A," the Cobble Hill Fort, is at bottom center. "C" and "D" are British redoubts (small earthworks) downtown, and "E" is a British fort on McKenzie's One Tree Hill. Note the previously unreported American defenses running south from the distillery. *Clements Library, University of Michigan.*

what is now Prospect Park. This allowed their center and right to attack the American center established at Flatbush or Battle Pass on what is now the park's East Drive from in front and behind in a coordinated effort.

THE FORTS IN THE HEIGHTS: THE COBBLE HILL FORT

Fort Corkscrew (figures 1 and 2), also known as the Cobble Hill Fort, the Ponkiesbergh Fortification and Smith's Barbette, was constructed on Cobble Hill, a sixty- to eighty-foot conical rise near Red Hook Lane. It is commemorated by a 1926 plaque (figure 3) on the Trader Joe's former bank building at Court Street and Atlantic Avenue (figure 4), which covers the site of the fort. The Wheeler map shows its ground plan, including approach paths. The Sproule map (figure 1) indicates that it was an oval about two hundred feet long. It was a four-gun position manned by Massachusetts troops. It was built there because the hill commanded the surrounding countryside and bay. It did not see action.

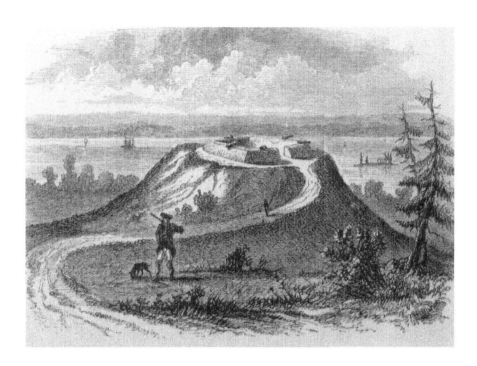

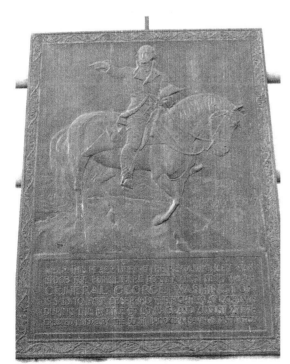

Above: Figure 2. The Cobble Hill Fort was demolished by the British, who lowered the hill, but it was reconstructed by the Americans in 1812 as Fort Swift. *Robert Furman Collection.*

Left: Figure 3. The Cobble Hill Fort bronze bas relief on Trader Joe's showing George Washington. *Robert Furman photograph.*

Figure 4. The former South Brooklyn Savings Institution (now Trader Joe's) at Court Street and Atlantic Avenue with the Cobble Hill Fort plaque. *Robert Furman photograph.*

The Sproule map is a military topographical map by loyalist engineer George S. Sproule, who was on the staff of Sir Henry Clinton, who succeeded Lord Howe as British commander in America. It is the only colonial-era topographical map of much of the town of Brooklyn and also shows all of the fortifications built by both sides. It was purchased from the descendants of Lord Clinton by Michigan industrialist William L. Clements and is part of the collection of the Clements Library of the University of Michigan.

During the battle, Washington rode from his headquarters at the Cornell House (figure 5) to the Cobble Hill Fort, possibly down the River Road (Joralemon Street) and Red Hook Lane (there was an alternative route along the shore). He climbed to the top of the hill to observe the fighting at the Old Stone House and was overheard to blurt out in his anguish at the sacrifice of the Marylanders, "Ah, what brave fellows I must this day lose." A plaque at the Montague Street entrance to the Brooklyn Heights Promenade honors the Cornell House (figure 6) and commemorates its use by Washington but inaccurately sites the Council of War there.

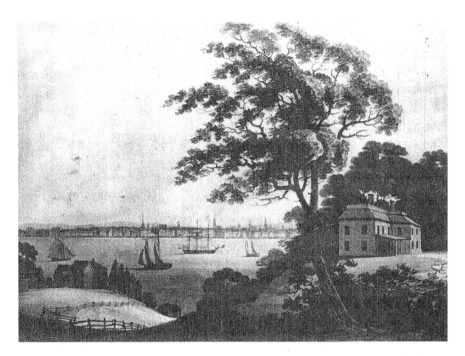

Figure 5. This 1796 watercolor is inscribed, "Drawn by Archibald Robertson my father, Andrew J. Robertson." It shows the Cornell House before it was enlarged by Hezekiah Pierrepont into "Four Chimneys" and when it was Washington's headquarters. *Robert Furman Collection.*

During the occupation, the British maintained the fort as it was until July 3, 1781, when they cut the top off the hill to improve protection and provide proper fields of fire for Forts Brooklyn and Stirling. When the Revolutionary War line of defense was reconstructed and strengthened for the War of 1812, this work was rebuilt and dubbed Fort Swift in honor of General Joseph G. Swift, its construction engineer. When Court Street replaced Red Hook Lane in the street grid and was broken through, Cobble Hill was leveled.

FORT STIRLING

Besides the Cobble Hill unit, three other defenses were constructed in the area, which presaged its urban development. Only two had been completed by the day of the battle. These works brought large numbers of men to the area, and during the British occupation, their soldiers were stationed here for

years, becoming a city in waiting. The first in Kings County was Fort Stirling (figure 1), named for William Alexander, "Lord Stirling" (he was a pretender to this title never granted him by the House of Lords), the American general who commanded the Marylanders at the Old Stone House and the rest of the American right. This fort guarded the Bay and East River and was located near today's Clark Street entrance to the Brooklyn Heights Promenade. It is commemorated by a plaque there (figure 7) that reads:

> *This tablet marks the site of Fort Stirling. On this bluff in the spring of 1776 it formed one of a chain of redoubts built in Brooklyn opposite New York. This work fell into the hands of the British during the Battle of Long Island and was thereafter garrisoned by the Hessian troops until victory by the American army led to the evacuation of New York, November 25th, 1783. Erected by the Fort Greene Chapter Daughters of the American Revolution, 1924.*

It was also known as "Fort Half Moon" because it was reportedly of that shape with an open back. Three of the maps represent it as a closed five- or six-pointed star. However, Sproule notes on his map that it "has also been closed to the rere [*sic*] by the same [the King's troops]," suggesting that none

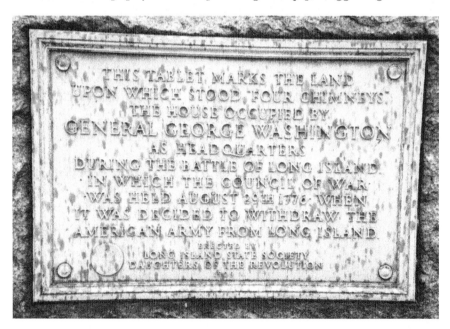

Figure 6. The Four Chimneys plaque at the Montague Street Promenade entrance. *Robert Furman photograph.*

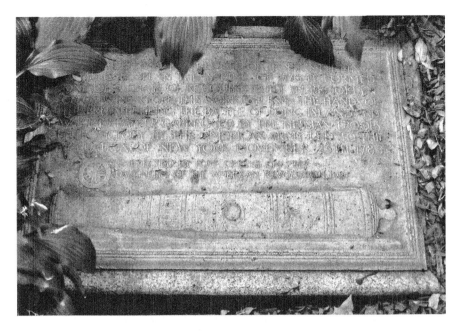

Figure 7. The Fort Stirling plaque at the Clark Street entrance to the Brooklyn Heights Promenade. *Robert Furman photograph.*

of them accurately shows its original configuration. He indicates that it was quite large, at 250 by 350 feet. On a nineteenth-century map, it is shown as a crescent, but this is not a very accurate plan and further suffers from not being contemporary to the fort's existence.

It was begun on March 1, 1776, in anticipation of invasion by 519 soldiers under Colonel Artemus (?) Ward. Local citizens were asked to help build it and to contribute wood and other materials. A May 22 report quoted in Robert B. Roberts's *New York's Forts in the Revolution* indicates that it mounted four thirty-two-pound cannons and two eighteen-pounders and was manned by a garrison of a lieutenant and twelve men.

Upon the American evacuation during the night of August 29–30, 1776, Fort Stirling's guns were spiked, but the British managed to get them working and fired at the escaping Continental forces. The fort was retained and reinforced by the British during the occupation to ward off Patriot attacks and was initially manned by Hessians and later by Grenadier Guards. The Skinner map of 1781 may represent its configuration under the British, but this map contains many inaccuracies. The more correct Wheeler map of 1778 also shows a different layout than Sproule, indicating the occupiers may have already altered it within two years.

THE CONGRESS FORTIFICATION AND CLOVER HILL

The incomplete American Congress Fortification was placed at the area's highest point, Clover Hill, a name for both the hill and the entire area, which is still known in the neighborhood. The hill, at eighty-four feet above sea level at Monroe Place and Pierrepont Street, is still the Heights' highest point. George Sproule notes on his map that "the Rebels braced and began a Hexagon Fort with Bastions but never got it in a state of Defence."

THE CORNELL MANSION

For the Battle of Brooklyn (designated the Battle of Long Island by the U.S. Army), General Washington chose to set up his headquarters at the Cornell Mansion (figure 5), later known as "Four Chimneys." Because of the house's location on top of the bluff within sight of Manhattan, a "telegraph" (a platform for sending signals by flags or lanterns) was set up on its roof. It is not clear whether George Washington actually slept there or whether he returned to Manhattan during the run up to August 27, 1776, and until the evacuation overnight on August 29–30. We do know that he rode out on horseback to observe first his defenses at the Cobble Hill Fort, then Fort Putnam in today's Fort Greene Park and later at Valley Grove Pass in Prospect Park.

Henry Stiles (figure 8) states in his *A History of the City of Brooklyn*, a book that is in print in facsimile, that the house was built by John Cornell, who may have been a brother of Whitehead Cornell, a major property owner in the mid- to late eighteenth century and the father of Peter C. Cornell. Whitehead Cornell was a Loyalist, and his sons migrated to England and Nova Scotia after

Figure 8. Henry Reed Stiles (1832–1909) was a physician and Brooklyn's historian during its great period. From *The Eagle and Brooklyn*, 1898, pp. 768.

the war but later returned. John Cornell's mill had been owned by Patriot Cornelius Seabring, but it was burned by the British. When the Seabrings returned during the occupation, they were impoverished and had to sell to the Cornells. After 1786, the house was owned by George Powers. (Third Avenue was originally Powers Street.)

General Israel Putnam, the field commander for the battle, stayed at Francis van Dyke's house on Fulton Street, near the ferry, according to Gabriel Furman's notes. The house had earlier been used by the colonial legislature and in 1822 was a mustard factory. At the time, there were fifty-six buildings at the ferry landing, which was Brooklyn village. According to Gabriel Furman, John Rapalje was among the property owners there.

THE COUNCIL OF WAR

After the Continental army was defeated on August 27, 1776, it retreated behind its earthen battlements to regroup, lick its wounds and await further orders. A Council of War was held on August 29 at Philip Livingston's country house (figure 9), located near what would become Joralemon and Hicks Streets.

Generals Washington and Putnam, along with the other general officers and their staffs, decided that Long Island was indefensible and the army must be withdrawn to New York City.

No. 21 Proceedings of a Council of Gen'l Officers.
At a Council of war held at Long Island
August 29, 1776.
Present his Excellency General Washington

M. Generals Putnam	B. Generals Parsons
Spencer	Scott
B. Generals Mifflin	Wadsworth
McDougall	Fellows

It was submitted to the consideration of the Council that when
Then under all circumstances it would not be eligible to leave Long
Island and its dependencies and remove the Army to New York.
Unanimously agreed in the affirmative for the following reasons.

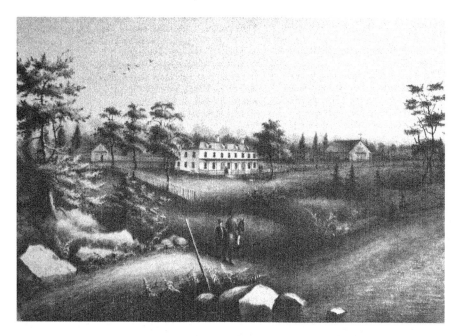

Figure 9. Van Brunt's "historic recapture" of the Livingston House. *Robert Furman Collection.*

At the time, Mr. Livingston (figure 10), who had signed the Declaration of Independence for New York a scant month and a half earlier, was still attending the Continental Congress in Philadelphia.

On September 6, 1776, Brigadier General John Morin Scott—who attended the Council, signed its decision document and is shown on the pictorial representation of it—wrote a letter to John Jay, later governor of New York and chief justice of the United States, analyzing the discussions there. This letter is the principal piece of evidence about the deliberations. Scott states, "I was summoned to a Council of War at Mr. Philip Livingston's house on Thursday 29th ult. [last month] never having had reason to expect a proposition for a retreat until it was mentioned."

This letter is reproduced in Henry P. Johnston's *Campaign of 1776 Around New York and Brooklyn, 1878,* an early publication of the Long Island (now Brooklyn) Historical Society, and is highly persuasive on the location of the Council since it is contemporaneous with it.

In August 1824, during the Marquis de Lafayette's triumphant final American tour, the gallant French democrat was joined in Brooklyn by President John Quincy Adams. Hezekiah Pierrepont entertained Lafayette

at his home, the Cornell-Pierrepont Mansion. Colonel Nicholas Fish (1758–1833), who had been Scott's aide-de-camp during the battle, attended the dinner. His son, the first Hamilton Fish (named for his father's friend Alexander Hamilton), became a governor, senator and later secretary of state under Grant, and a later descendant was killed with Teddy Roosevelt's Rough Riders in the Battle of San Juan Hill in Cuba during the Spanish-American War. Another descendant was President Franklin Roosevelt's congressman in the Hudson Valley, whom Roosevelt famously tormented as a member of "Martin, Barton and Fish," Republican House leaders who opposed his New Deal. This Hamilton Fish, in his dotage, appeared in Warren Beatty's 1981 film *Reds* because he had known John Reed, an early Communist, at Harvard.

Fish said that he had attended the Council of War at which Washington decided to withdraw to Manhattan and said to Lafayette, "By the by, General, are you aware that this house has a great historical interest? This is the room in which the Council was held which decided upon the retreat from Long Island."

Nicholas Fish may (or may not) have been present at the Council of War, but he was sixty-six years old in 1824 and may be excused for forgetting its location of forty-eight years previous. This statement is the source of the error of location, repeated by Henry Stiles and immortalized by history and the plaque at the Montague Street entrance of the Brooklyn Heights Promenade (figure 6). It has even been repeated by modern writers such as Barnet Schecter in *The Battle for New York*.

PHILIP LIVINGSTON

Philip Livingston (figure 10) was a Manhattan lawyer, businessman and slave trader, and his house on the Heights was his "farm" or country house from 1765 until his exile and death. He had purchased the land in 1750 from the Remsens. Livingston headed the Low Church Party in America, and his Manhattan mansion was a Patriot headquarters. Our information about the house is derived from Gabriel Furman's+ (Furman Avenue) (no relation to the author) *Antiquities of Long Island (Monuments and Funeral Customs)* published in 1875. He lived in the area and, as the son of William Furman+ (Furman Street), one of the village of Brooklyn's founders and leaders, had been in the house. He described it as follows:

Another noted house in Brooklyn was the mansion-house of Philip I. Livingston, afterwards a member of the Continental Congress. This was a large frame building, actually forming two dwellings. The larger part, which was about forty feet square, Mr. Livingston erected for his son [Walter], who was a young man then travelling in Europe; who, upon his return, was to be married to a lady to whom he was engaged before he left home, and occupy that new house; but he was taken sick, and died abroad only a few months before his return home was expected.

This mansion, both the old and the new part, was finished throughout in the best and most costly style of that period, having much beautiful carved woodwork and ornamented ceilings, also Italian marble chimney-pieces sculptured in Italy. Most beautiful specimens they were; we have often admired them. This house, upon the death of its last owner and occupier, Judge (Teunis) Joralemon, in 1842, was about to be taken down, and these marble chimney-pieces were packed up for removal, when it took fire, and they, with the house, were destroyed. The gardens attached to the mansion, when the British took possession of it and converted it into a naval hospital in 1776, are said to have been among the most beautiful in America.

Livingston also owned a distillery on the shoreline at the River Road, later Joralemon Street, which is shown on the Ratzer map of 1767 (chapter 2, figure 3) and the property map prepared for his estate's sale (figure 11). It probably made gin, originally the Dutch genever, from juniper berries, and rum. Ships from the West Indies unloaded sugar cane, which was crushed by wind and tidal mills. Local forests provided fuel for distillation. As the King's Brewery during the occupation, the distillery produced spruce beer for British soldiers, of which they consumed twenty barrels a day. A ship known as a bethel was moored nearby and served as a place of worship for sailors from these ships and helped bring the Anglican, or Episcopal, Church to Brooklyn.

During the occupation, Livingston was forced to move to Kingston, which served as the Patriot state capital, where he died in 1778, two years later. His Brooklyn house was used thereafter by the British as a hospital principally for soldiers with scurvy. The British erected outbuildings to house additional sailors, and these occupied Ralph Patchen's neighboring property. Twelve to fifteen died there a day. Bodies interred on the property were regularly unearthed during development. William Furman reported seeing some whose teeth were removed for reuse. This hard use ran the

Figure 10. Philip Livingston, Esq. (1714–1778). *Library of Congress.*

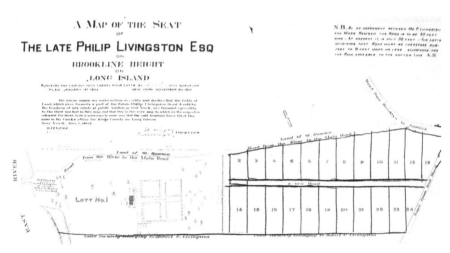

Figure 11. The 1802 plan of the Livingston "farm" prepared before its sale to Teunis Joralemon. State Street is below the property. What is simply called "a new road" would become Livingston Street, and the "Road from the River to the Main Road" is Joralemon Street, which was straightened by the City of Brooklyn in 1843. Sidney Place separates the lots at the east from the house and garden to the west. The house is to the left of the garden. Note that the area is called "Brookline Height" and that the distillery, at left, also belonged to Dr. Theodore Jones, Walter Livingston and William Denning. The land to the north is part of the Remsen farm, and that to the south is the former property of Robert G. Livingston. Kings County Clerk's Office in vol. 18, no. 2 of the *Copied Maps*, annotated with street names.

house and garden down. A site plan filed for the sale of the property freezes the exact moment in 1803 when country began to become city (figure 11). Garden Place is located where the garden+ was and is named for the Livingston/Joralemon retreat.

The Livingstons were patroons, huge colonial landowners, and became prominent in military and public life since they owned the tremendous upstate property known as Livingston Manor in Dutchess and Columbia Counties and also because they were among the few college-educated men in America. (The patroonships were abolished by New York State during the Jacksonian Revolution of the 1830s.) A cousin of Philip's, Robert G. Livingston, owned the adjacent plot of land and house south of what would become State Street (figure 11).

Other cousins included Robert R. Livingston, who became chancellor of New York State and as ambassador to France negotiated the Louisiana Purchase for President Thomas Jefferson. Philip's brother William served as governor of New Jersey (and has a town there named for him), and William's son Henry Brockholst (who was a trustee of Philip's estate) became a justice of the U.S. Supreme Court. During the Revolution, Henry Brockholst was a lieutenant colonel in the Continental army and was a son-in-law and personal secretary to John Jay. For the nation's centennial, the house was painted as a "historic recapture" (i.e., it is not from life) by James Ryder+ Van Brunt+, descendant of Dutch Brooklynites, from Henry Pierrepont's sketch from memory (figure 9).

Edward Livingston (1764–1836) served as mayor of New York City from 1801 to 1803 and represented the state in the House of Representatives. Following a scandal, he moved to Louisiana and was a Louisiana senator and representative, later Andrew Jackson's secretary of state from 1831 to 1833 and then ambassador to France. Livingstons remain prominent there, and one was not too long ago a leading Republican representative in Congress.

Edward may have moved also to allow him to keep his slaves. It needs to be noted that as the Deep South opened up in the 1810s, many other prominent Brooklynites, such as members of the Sands and Lott families, moved there because Brooklyn was losing its agricultural character, and there were economic opportunities in the South. New York State moved to abolish slavery in 1799, and they did not wish to surrender that privilege.

The Occupation

The British military occupation, as in the rest of the present New York metropolitan area, was marked by death and despoliation. The Heights and vicinity became a military base and staging area. Attempts to prevent looting by soldiers or signs of disloyalty were met with threats of death and sometimes execution. No one's property was safe from expropriation by troops who regarded the populace as of questionable loyalty (which was true). At the evacuation of the British on November 25, 1783 (Evacuation Day was a state holiday until the British-American detente of the late nineteenth century), the area was a wasteland. On Evacuation Day, George Washington visited Brooklyn.

The Old Stone House near the ferry, belonging to George Hicks, was used as a guardhouse and prison, and according to Gabriel Furman, there were approximately ten thousand troops in all of today's New York City, many of them Hessians. Two regiments of them were stationed in Brooklyn. Later, one thousand men were stationed there with thirty heavy guns.

In May 1780, the British began to erect a new fort on the site of the Congress Fortification as their local headquarters and to defend against an anticipated Patriot attack on the New York area, which was, in fact, considered by General Washington. French warships made forays into local waterways, and several were lost to British gunfire. Several thousand men, both soldiers and civilians, are said by Henry Stiles to have been engaged in the fort's construction. Local people were forced to help build the fort and to provide materials.

It was located on the block bounded by Pierrepont, Henry, Clark Streets and Monroe Place, roughly where the Appellate Division of the New York State Supreme Court is today. Called the Citadel, or Brooklyn Fort (figure 1), it was a 450-square-foot work, with walls 40 to 45 feet above a 20-foot-deep surrounding ditch. Four bastions (diamond-shaped armed points) with buttonwood or plane trees protected its corners. The size figure is consistent with the Sproule map, which indicates that it was about 650 feet along each side, including the protective ditch. In July 1781, it was manned by two hundred Brunswicker Hessians with eighteen cannons.

It contained four barracks structures, a powder magazine and a well, which are shown on the Skinner and Sproule maps. A large stone gate and drawbridge controlled access. A rarity in its day, a deep, stone-lined well provided water, and after 1783, this became a public well and was covered with a shed with a pump. Today's Love Lane was the fort's sally port (entrance

Figure 12. Love Lane is the sole physical remnant of the Battle of Brooklyn in the Heights. It was the British Brooklyn Fort's sally port (entrance and exit). The Appellate Division is in the background. *Robert Furman photograph.*

and exit) to the river and Fulton Street (figure 12). The remaining one-block length of the lane is the sole physical remnant of the Revolution in the area, and a hidden aspect of this is that 155, 157 and 159 Willow Street and 174, 176 and 178 Henry Street align to the former path of the lane from the time it ran to the river. It began as a branch of the Indian trail that is now Cadman Plaza West, leading to the bluff. Governor Cadwallader Golden used it as the approach to his house.

The British Headquarters Map of Manhattan of 1782–83, the primary source for Eric Sanderson's *Mannahatta: A Natural History of New York City*, also shows the Heights' and downtown's topographical features and British forts and is similar to the others used here. However, it was produced in 1782–83 and, as the last chart made during the occupation, also shows new defensive trenches zigzagging from the shoreline at Vinegar Hill and to the Cobble Hill Fort by way of the small redoubts. The trenches encircled the fort to its north, east and west and then threaded their way to the shoreline at the end of Joralemon Street. Their purpose was to provide communication routes among the forts in case of attack.

The Postwar: Teunis Joralemon, John Swertcope and the Debevoises

In 1803, Judge Teunis Joralemon+ bought the entire property and moved into the part west of Sidney Place containing the house and garden+ (Garden Place); the lane took his name. He sold produce in New York and used the garden as a vegetable patch. He allowed his waterfront property to be used by neighbors as the area's fishing grounds. He was opposed to development, wanted to keep the area rural and opposed opening streets on his property, which was done anyway by order of the village government (organized in 1816). In 1826, Charles Hoyt+, a developer, forced Henry Street through Joralemon's farm, and soon thereafter, Hezekiah Pierrepont+ opened Clinton+ Street through his own property to honor Governor DeWitt Clinton, whose Erie Canal was revolutionizing New York State and City by making it the nation's leading port. What would become Joralemon Street was known as the River Road and then as Remsen's and Livingston's Lane.

Among the new residents of Brooklyn Heights in its still sylvan days right after the Revolution was John Valentine Swertcope, a former Hessian soldier who stayed on after independence and worked as an armorer, physician and farmer of strawberries, which his slave Peggy hawked on Fulton Street along with hot corn and stewed pears covered with molasses (see chapter 7). Swertcope and the De Bevoises sold out to Pierrepont in 1816. Swertcope had an office on Clinton and Fulton Streets and owned property on Love Lane, which then traversed the Heights. The De Bevoise brothers also lived on Love Lane, which is reportedly named for Sarah De Bevoise, who lived there around 1800. She was so beautiful that the young men in the area cut love poems to her into the house's fence. Robert De Bevoise cultivated strawberries, which he sold in New York. He used the Milkman's Dock on Orange Street to moor boats that crossed the East River. The famous Manhattan restaurateur William Niblo kept a turtle crib off Cranberry Street.

Storage yards were maintained for cotton and naval stores, and there were salt plants along the shore. In addition, several astronomical observatories operated in the area because of its clear wind-blown skies, including one at 210 Columbia Heights run by Senator Stephen White.

At the same time, in the north Heights there was a small street known as Buckbee's Alley, which had served to divide the properties of the Hickses and Middaghs. Palmer Buckbee lived next to his grocery. He was a known criminal who was killed while burglarizing a neighbor's house.

Chapter 4

THE COMING OF URBANIZATION

1784–1883

The development of Brooklyn Heights almost got off to a fast start in 1789 when the first U.S. Congress under the Constitution, which met in Federal Hall, the former New York City Hall (the building on the site is the U.S. Sub-Treasury of 1834), considered the Heights for the national capital. Part of the reason for this was the suffering endured by the New York area during the extended British military occupation. However, in order to paper over sectional issues (i.e., slavery), it was decided to locate it on the banks of the Potomac River by taking some territory from two slave states, the southern commonwealth of Virginia and Maryland, a border state. The Virginia lands were ceded back in the early nineteenth century and are now Arlington County, a federal area that includes the Pentagon.

Urban development began in the early 1800s because of the Heights' proximity to Manhattan, even before the 1815 advent of steam ferry service. This resulted in significant growth and also in part of the town of Brooklyn in 1816 becoming a legal village with some powers of self-government (figure 3). Development proceeded southward from Brooklyn Ferry (now Fulton Ferry Landing), which is why the oldest houses in the area are in its far northern section, but also westward from the Joralemon Street downtown core near Red Hook Lane. This history is traced here.

But it was the conversion of Fulton Ferry into a scheduled steam service that made Brooklyn and Brooklyn Heights. It became easy to get to jobs and to do business in burgeoning New York and to ship goods in

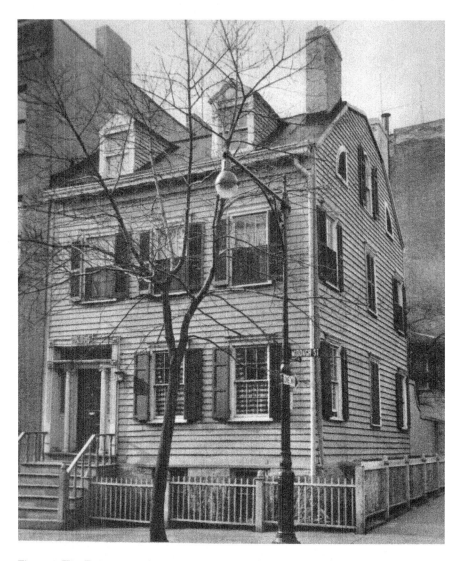

Figure 1. The Federal-style Eugene Boisselet house at 24 Middagh Street is shown here in 1960. It may be the oldest in the Heights. Part dates from around 1820, but another section is clearly older. According to Otis Pearsall, the owner told Clay Lancaster during his 1960 survey that part is from the eighteenth century. The carriage house at 27 Willow Street is slightly visible at right. From Clay Lancaster's *Brooklyn Heights: New York's First Suburb*.

and out. Factories, especially ropewalks to make the rope needed by ships and shippers, proliferated.

The rural character of the area at the beginning of urbanization (figure 2) is indicated by the fact that a rowboat was kept on the shore

Figure 2. The Brooklyn shore in 1820 gives a good sense of what the Heights was like before it was built up. From *The Eagle and Brooklyn*, 1898.

for commutation by Hezekiah Pierrepont and that George Gibbs grew Isabella grapes for winemaking in his garden at Cranberry and Willow Streets.

Some of the British Citadel survived until 1816 (figure 3). It was used for target practice until the village put a stop to this since it endangered passersby on Fulton Street. After independence, the men on whose land it had been imposed—Lodewyk Bamper, Cadwallader Golden and the Debevoises—began to disassemble it. Governor George Clinton ordered them to stop because the land was state property, but they did not and kept the remnants of it.

The Hicks family hired the surveyor Jeremiah Lott to develop a street plan for the north Heights, which they implemented starting in 1806 with two-hundred-foot-long blocks and forty-foot-wide streets. Middagh Street was cut through in the early 1800s at a much lower angle than it had been previously. According to Gabriel Furman+, Brooklyn's first historian, in 1821 it held eighteen dwellings, three private schoolhouses, a carpenter's shop, a firehouse at the corner of the Ferry Road (now Cadman Plaza West) and the house of a Mr. St. Clair, who introduced knitting machines to America. Many of the oldest houses in the area are simple wood-frame structures, some of which survive.

The street was named either by or for the Middagh family, probably by the Hicks+ brothers who were their descendants. The western block was

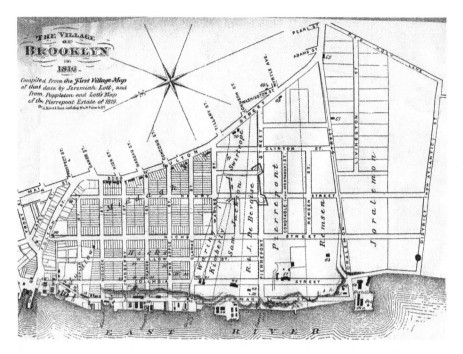

Figure 3. Brooklyn Heights on the 1816 Lott Map, at the founding of the village, showed the remnants of the British Citadel, lots in its northern section and a few buildings (mostly on Fulton Street) as darkened squares. Note the distillery at the end of Joralemon Street. Only the streets in the north Heights where lots are shown actually existed. Others were legally mapped but often had not been broken through. For example, Columbia Street at Four Chimneys was constructed differently than Columbia Heights, Montague Terrace and Pierrepont Place to accommodate the ramp to the Wall Street Ferry and Waring (between Pierrepont and Clark, which was never opened). Moser Street, another never-opened way, is shown between Clinton, Pierepont, Fulton and Joralemon Streets. Also indicated are slips where early boats docked, such as "Clarke's Slip." This map was drawn from the first village map of 1816 and the Poppleton and Lott map of the Pierrepont property of 1819. *Brian Merlis Collection.*

razed for the Brooklyn-Queens Expressway, but modern low-rise co-ops were added later (see chapter 11). A notable structure is the original P.S. 8, which survives as co-ops (see chapter 6, figure 19).

On the corner of Willow Street, 24 Middagh Street (figure 1) may be the oldest house in the Heights. According to Councilmember Genevieve Beavers Earle, speaking on a radio broadcast in the 1930s, it was built in 1790. But since no streets were opened in the area until after 1800, part of the house was probably moved from nearby Brooklyn Ferry to align it with the new street corner, according to Otis Pratt Pearsall. The doorway features a paneled door with fluted Ionic columns, and there are leaded

sidelights and a leaded transom. On the Willow Street side, the principal attic window is arched and surrounded by quarter-round ones.

Willow Street was opened by the Hickses between Middagh and Clark Street around 1810, but the village trustees in 1818 asked that it continue to State Street. Hezekiah Pierrepont (figure 9) wanted the north–south streets to end in the central Heights, so Willow terminates at Pierrepont Street, at the edge of the Pierrepont Estate. Gabriel Furman stated in 1821 that there were eleven houses and four stables on Willow, of which only number 84 survives. Numbers 43, 45, 57, 155, 157 and 159 are only slightly newer.

Hicks Street was one of the first streets in the north Heights to be built up. In 1821, Furman said that there were thirty-one houses, two groceries, a school and two stables on Hicks. The blocks north of Cranberry have been commercial since the street was opened but were run down from the 1920s until around 1960, when Clay Lancaster reported the opening of small galleries and art shops.

Henry Street began life in 1816 as John Street, as shown on the village map. The present name honors an early physician and predates 1822. Clay Lancaster believed that part of 39 Henry Street may have been the oldest house in the neighborhood because it is the only one shown on the 1816 village map that still exists, although the front wall was later replaced. It was razed for the Cadman Plaza housing development.

Orange Street originally had many wood-frame houses, of which only two, numbers 54 and 69, survive. The western part of the block is dominated by modern structures built by the Jehovah's Witnesses (see chapter 13).

Cranberry Street dates from 1806 when the "fruit streets" were opened. According to Meredith Langstaff's classic 1937 history, *Brooklyn Heights: Yesterday, Today, Tomorrow*, the name probably derives from the efforts of the Hicks brothers to promote their fancy produce business. The first building on the site of the Brooklyn Fort went up on Henry Street in 1823 as development proceeded south from Fulton Ferry.

Columbia Heights may take its name from Hezekiah Pierrepont's Cornell-Pierrepont House estate, which he called Columbia, an obsolete descriptive for the United States (viz *Columbia the Gem of the Ocean*). The street was laid out in 1819 by the village trustees and was projected to end at Joralemon Street. Later, the jog for the ferry ramp was added, causing the street to end at Pierrepont Street (chapter 8, figure 3). It bears the names Pierrepont Place between Montague and Pierrepont Streets, Montague Terrace between Montague Street and Remsen Street, Columbia Place between State and Joralemon Streets and Columbia Street south of Atlantic Avenue.

In 1861, Walt Whitman reported in the *Brooklyn Standard* that the housing being built in the Heights was showing the way to "architectural greatness." He continued that the city of Brooklyn possessed "hundreds and thousands of superb private dwellings, for the comfort and luxury of the great body of middle-class people—a type of architecture unknown until comparatively late times, and no where known to such an extent as in Brooklyn."

There has always been a hint of eccentricity associated with the Heights, perhaps a trait of old-stock British Americans, best still seen in the film *Arsenic and Old Lace*, which portrays a weird family in the area (although in the film the area rather resembles Gravesend, but the Brooklyn Bridge is prominently shown). Two sisters murder boarders, a brother thinks he's Teddy Roosevelt and a cousin is a homicidal maniac. An amusing parallel is an apparently apocryphal story carried in the famous *WPA New York City Guide* of 1939.

A Mrs. Middagh in the 1850s resented the names of other local aristocracy appearing on north Heights streets when a street name was changed from John to Henry. She is alleged to have torn down the street signs bearing these detested names and repeated this act of vandalism after they were replaced. Of course, she liked her name appearing on the signs.

The August 1, 1895 *Brooklyn Eagle* carried a letter on the derivation of the name of Henry Street, which is another version of the tale above. It was written by "G.H.H." at the request of the granddaughter of John Middagh, and the lady in question was the grandmother. Apparently, she took an action by the village government personally:

> *Henry street, which ran through the Middagh farm, was originally called John street, after John Middagh, whose widow had signs to that effect nailed on the trees along the road. These signs were removed surreptitiously and other signs were put up bearing the name, Henry.*
>
> *This naturally incensed Mrs. Middagh, and from time to time as she drove along the road she would order her coachmen to stop and take down the Henry signs. Afterward she had signs put up bearing the original name, John. The mysterious Henry, however, constantly reappeared, despite Mrs. Middagh's efforts to suppress them, until, finally, wearying of the task, she relinquished it and allowed the substituted signs to remain. She never knew positively who the culprit was, but always suspected that it was that Yankee doctor* [at the time, "Yankee" meant New Englander] *who lived on Washington street. This may sound like an improbable story, but as my informant says: "it must be remembered that Brooklyn was merely*

*a village at the time," and as she heard it from her grandmother's own lips
it would appear to be about as well authenticated as could be any incident
of so long ago.*

It is difficult to imagine what living in a half-developed neighborhood
must have felt like, although most of us have seen such things in our lifetimes.
Of course, today's suburbs lack the sense of permanency we associate with
Heights townhouses.

The following is from *The Boroughs of Brooklyn and Queens, the Counties of
Nassau and Suffolk, Long Island, N.Y., 1609–1924*, Volume 3, by Henry I.
Hazelton, published in 1925:

> *Men were living in Brooklyn in 1888 who could remember when the block
> bounded by Court Street, Livingston, Sidney Place and Joralemon was an
> empty lot, and R.P. Buck kept his cow in a shed just opposite where St.
> Ann's church now stands. Sunday school children used to use the lot for a
> parade ground every spring just as they have come to use the streets for their
> May procession.*

In midcentury, George Hall, the city of Brooklyn's first mayor, recalled
what it was like in 1823 (the ferries were at Fulton and Dock Street):

> *The population of the city at that time consisted of about 20,000 persons;
> residing for the most part within the distance of about three quarters of a
> mile from Fulton Ferry. Beyond this limit no streets of any consequence
> were laid out, and the ground was chiefly occupied for agricultural
> purposes. The shores, throughout nearly their whole extent, were in their
> natural condition, washed by the East River and the bay. There were two
> ferries, by which communication was had with the city of New York,
> ceasing at twelve o'clock at night...Of commerce and manufactures it can
> scarcely be said to have had any, its business consisting chiefly of that
> which was required for supplying the wants of its inhabitants. Sixteen
> of its streets were lighted with public lamps, of which thirteen had been
> supplied within the previous year.*

Around 1830, an Englishman described the Heights as follows:

> *The houses in the principal streets have a particularly neat and elegant
> appearance. They are chiefly built of wood, and painted white, with green*

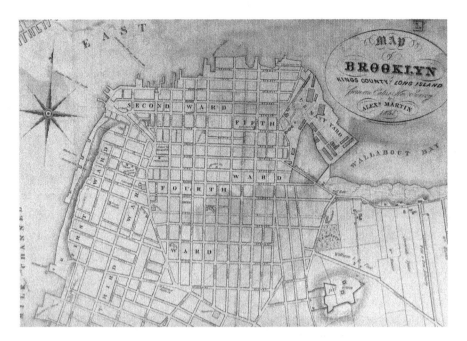

Figure 4. The Heights section of Martin's Map of the City of Brooklyn of 1834, the year it was founded, shows what little existed there, including the Female Academy (Packer), the First Presbyterian Church on Cranberry Street, the Apprentices' Library, the Second Old School Presbyterian Church on Clinton Street near Fulton (see chapter 7), the glass works near the river and Washington Garden on Fulton between Pineapple and Orange Streets. Note that city hall and Atlantic Avenue are missing, that George Street takes the place of Court Street, that Montague is called Constable, that Love Lane traverses the neighborhood, that there are several "watering places" on the river and that numerous streets that were never opened are shown, such as Moser, Waring, Evelyn, Manhattan and Monroe Street (not Place) in the south Heights. St. Ann's Episcopal Church is on Washington Street between Sands and Prospect, a Methodist church is on Sands between Fulton and Washington Streets (see chapter 6) and St. Ann's Church cemetery is on Fulton Street opposite Clark Street. *Robert Furman Collection.*

latticed blinds on the outside…For the entire length of some of the streets, weeping willows are planted on each side, each, independent of being very ornamental, offered a delightful shade to the fronts of the houses, and protect the foot paths even from the noon-day sun.

The Remsens sold land to the City of Brooklyn for city hall, which dates from 1848, and its then small park. Manhattan Street, which became part of Remsen Street, was mapped on the property, as was George Street, now part of Court Street (figure 4).

Residential Development in the Southwest Heights

In 1824, all that remained unsold of the Remsen estate lay between Court and Clinton Streets. The Remsen farmhouse, originally on Hicks Street, was owned by ropewalk operator Fanning C. Tucker. Leather merchant Jonathan Trotter, who had just been elected Brooklyn's second mayor, purchased it in 1835. He laid the cornerstone of city hall and opened Myrtle Avenue. He was also the first president of the Atlantic Bank at Fulton Ferry. When the Packer Row was built on its site in 1847, the house was moved to the bay end of Joralemon Street. This house was entered via a swinging gate at Hicks Street.

When Charles Dickens visited America on his first tour in 1842, Trotter was reported to have held a reception for him in his home, which was known long thereafter as the Boy (or Boz) Reception ("Boz" was a nickname for Dickens) for the author's youth. The sources are in conflict on this point. Relying on old memories, those who were around then held opposing opinions, but the reception does not appear to have occurred.

What we now call Willowtown and the southwest Heights was developed fairly early on with rows of luxury townhouses. A group of four three-story brick houses—numbers 84, 86, 88 and 90—was built between 1846 and 1855 by Albert Wells on the south side of Joralemon Street, just east of Hicks Street, extending to Garden Place. Among their owners were Lathrop P. Safford, a New York merchant; A.D. Wheelock, a booter who was also a member of the Brooklyn Board of Education; Edward H. Arnold, a commission merchant on Beaver Street in Manhattan; and Agnes McClune of Thomas Freres, New York merchants.

A similar row of Greek Revival Type B houses (see chapter 5) was built on the block to the east, at numbers 120, 122, 124 and 126 Joralemon Street and 2 Sidney Place, up to Henry Street (figure 4) by Daniel and M. Chauncey in 1842, when wooden buildings were being replaced by brick ones under the influence of Hezekiah Pierrepont. Among their occupants were William J. Vanderhoef, Brooklyn watchmaker and jeweler, and developer Daniel Chauncey, whose son and namesake built a mansion on Joralemon Street. Daniel Chauncey Jr. lived at 2 Sidney Place before he moved to 129 Joralemon Street.

Four two-story wooden houses with piazzas, separated by a summer house and gardens, were built on the south side of Joralemon Street in 1829, across Henry Street, beginning just past the corner toward Sidney Place. Testifying to the early port's importance, their owners included merchant ship captains

Figure 5. The Chauncey Row of 1842—126, 124, 122 and 120 Joralemon Street, with 2 Sidney Place at left. *Robert Furman photograph.*

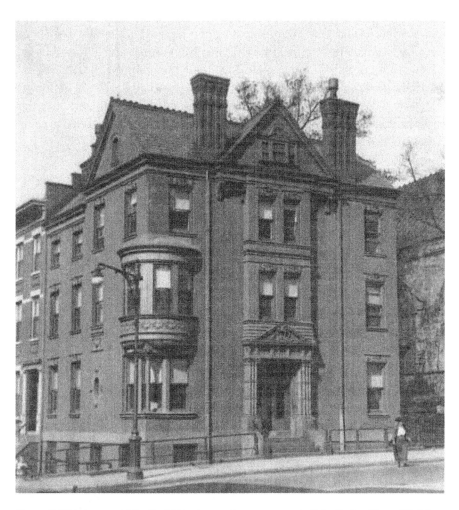

Figure 7. This house, originally 56 Joralemon Street, was part of the Packer Row of brick homes of 1847 and resembled the others. It is now 260 Hicks Street and is shown here in a 1922 *Eagle* photo. It had been made into a villa and enlarged and modernized in 1887 in Queen Anne and Romanesque Revival style. *Brian Merlis Collection.*

Opposite, bottom: Figure 6. The Packer Row of nineteen Greek Revivals with Type F steps at 37–75 Joralemon Street built by William and Harriet Packer in 1844. At right is 260 Hicks Street, which originally matched the others. *Robert Furman photograph.*

John Rathbone and John Waterman; Captain James Renshaw, United States Navy, who was later commandant of the Navy Yard; and Philip Flagler, a New York commission merchant. Rathbone commanded the *Nashville* of the Red Star Line and later the *Oxford*, which was built for him. He died at sea along with three mates. Waterman captained the *Natchez* and later the *Invincible*. Like many other wooden houses, they are gone, in part because of Hezekiah Pierrepont's success in promoting stone and brick dwellings, but mostly because wood is less durable.

William S. and Harriet Packer built a row of twenty-one houses on the north side of Joralemon Street west of Hicks Street in 1847, originally numbered 14 through 56 Joralemon, and now 37 through 75 (figure 6), plus 260 Hicks. They were brick houses with green blinds. Besides the Samuel McLean house (figures 7 and 8) at 260 Hicks (56 Joralemon in 1845), owners included Warren L. Russell, proprietor of the Pierrepont House Hotel (see chapter 6), who also ran a restaurant in Manhattan; Samuel Sloan, president of the Hudson River

Figure 8. Believe it or not, this is 260 Hicks Street today, barely recognizable from what it was. The third floor was stripped of details and the fourth floor enlarged (the brick is lighter). This occurred when it may have been converted into a rooming house in the early twentieth century. *Robert Furman photograph.*

Railroad; John N. Pirnie of Schenck, Rutherford & Co., distillers on Furman Street; and James H. Leggett, secretary of the Eagle Insurance Co. Others included businessman and abolitionist W. Lord, whose son married a daughter of Lucretia Mott; John S. Hyde, a jeweler on Manhattan's Maiden Lane; Moses Whitcomb, who worked for J.H. Prentice & Co., successor to Packer, Prentice & Co., beaver hat manufacturers (see below); William Hinned, owner of flour mills at Broome and Lewis Streets in New York; and R.W. Adams, lumber dealer and owner of the Lockett Street Railroad.

On the south side of Joralemon Street at Hicks were three high-stooped houses. One was owned by William P. Libbey of the Citizens' Gas Light Company, ancestor of the Brooklyn Union Gas Company; a second by C.N. Bovee, a Wall Street lawyer; and the third by Howard C. Cady, a law partner of J.M. Van Cott.

THE GREAT MEN [AND A FEW WOMEN] AND THEIR HOUSES

This section describes the people most responsible for making the Heights what it was in the nineteenth century and, to a great extent, still is in terms of their lives, careers and homes. They were responsible for founding and endowing the institutions, mostly voluntarily, that created the public life of Brooklyn, everything from the water department to hospitals, schools and cemeteries.

The Pierreponts

Hezekiah Beers Pierrepont (the name is French for "stone bridge") (figure 9), the principal developer of the Heights, was born in New Haven, Connecticut, and moved to New York City in 1790. He learned business at the U.S. Customs House and was of French Huguenot (Protestant) extraction. At some point, he Anglicized his family name to Pierpoint, but it later reverted to the earlier spelling. (Most Franco-Americans were Huguenot Protestant refugees.) In 1802, he married Anna Maria Constable, daughter of William Constable, who, as the partner of Alexander Macomb, purchased 1 million acres in far upstate New York, thereby becoming a patroon. Pierrepont's almost 500,000 acres were in Franklin, Lewis, Jefferson, St. Lawrence and Oswego Counties in the Adirondacks. Hezekiah's eldest son, William Constable Pierrepont, managed the upstate property. Hezekiah was the

prime mover in the development of the area as a real estate man, village founder and trustee and as the principal owner of Robert Fulton's steam ferry service from Brooklyn Ferry, now Fulton Ferry Landing.

Hezekiah went into the import-export business as Effingwell and Pierrepont in 1793 but left it when the fallout from the French Revolution and the Napoleonic Wars made European commerce impossible.

He moved to Brooklyn in 1803 when he purchased the Benson farm, including Four Chimneys, and moved into the house. To improve ventilation in the summer, he added a wing with a

Figure 9. Hezekiah Beers Pierrepont (1768–1838). From *The Eagle and Brooklyn*, 1898.

southern exposure to take advantage of the prevailing southwesterly winds (figure 10). The property included a ditch down to the water, which he spanned with a footbridge.

What the area of the Cornell-Pierrepont Mansion was like in 1816 may be judged from the extract below from the 1898 *Brooklyn Eagle* history, *The Eagle and Brooklyn*:

> *The Pierrepont mansion, which stood near the present Pierrepont place, was a landmark of especial interest. On the Heights its gardens and orchards were the pride and wonder of the place. There the choicest fruits and the rarest flowers were grown and there too the best society in the state were entertained. When the village was incorporated, the big house had few neighbors. The favorite walk, of a summer evening during the twenties, for the young people of the village, was up Fulton street to Love lane, and down that romantic path to the Heights, where, turning to the left, they came to the grove of cypresses near the Pierrepont mansion, where there was for those who desired it a degree of seclusion, which could be still further enhanced by a descent along the winding path that led from there to the beach below* [consequently known as "Hymen's Grove"].

In the 1820s, the period referenced above, "the Heights" meant the bluff, not the entire neighborhood.

Figure 10. The Cornell-Pierrepont Mansion was enlarged by Hezekiah Pierrepont and is shown here circa 1816. From Henry Stiles's *A History of Kings County*, 1884.

Pierrepont rebuilt Livingston's Distillery and added a windmill. The manufactory became famous as the Anchor Gin Distillery, but he closed it in 1819. It is shown on the 1816 village map (figure 3) and on a print indicating its still rural flavor in 1823. It was reopened by Schenck and Birdwell. Pierrepont made a fortune distilling gin, which he reinvested in ferry service and real estate. Alcoholism was a major problem at the time, and Brooklyn's first mayor, George Hall, was a Prohibitionist. The city directory for 1822–23 shows that Pierrepont had an office at 133 Front Street in Manhattan.

He began buying as much property in the central Heights as he could and owned most of the area between Joralemon Street (Remsen farm) and Love Lane (Debevoise property). The Remsen+ farm ran from Fulton Street to the river between Montague and Joralemon Streets. It became the core of the Heights. As originally planned, the area contained Waring Street (figures 3 and 4) running north–south between Pierrepont and Clark. Waring was legally mapped by Pierrepont to frustrate the designs of brothers Peter and Abraham Schermerhorn+, who wished to establish a larger rope factory (ropewalk) on the site of Borough Hall; Pierrepont believed that this would be bad for the area. This was the beginning of zoning regulations. The Schermerhorns opened a street named for them in 1838.

The De Bevoise brothers, who moved to the area in 1760, opposed urbanization and sought to defeat Pierrepont by asking a price for their property that they considered ridiculous—but he paid it. Among the properties Pierrepont bought was the former Robert B. Livingston estate

and undeveloped land south of his late brother Philip's property (see chapters 2 and 3).

Montague Street was originally dubbed Constable Street. The name Montague is derived from Lady Mary Wortley Montagu, a blue-stocking, belletrist and mentor to Alexander Pope and Henry Fielding, by way of Hezekiah's daughter Mary Montague Pierrepont, who died young and unmarried in 1859.

In the early nineteenth century, developers (rather than the government) could define what sort of houses could be built on their property and how wide streets would be, as they were responsible for opening them. Pierrepont retained the British surveyor Thomas Poppleton to develop a plan for the Heights from Fulton Street south to Joralemon, which was largely followed over the years. He laid out the north and central Heights, attaining control of the area by inducing friends to buy and follow his rules.

Pierrepont insisted on stone or brick houses on Hicks Street, which he widened at his own expense to fifty feet in 1819, and also on Henry Street, on sixty-foot-wide Pierrepont (opened 1820) and on Montague (Constable) in 1821, the latter two of which he opened and named for his family and children. He also widened Fulton Street at his own expense. His plan was so successful that the old-time Hicks family moved to a new mansion at 130 Hicks Street near Clark, after pooh-poohing his vision. His activities resulted in an escalation of land prices in 1833 to the then unheard of level of $1,000 an acre!

Reverend Evan Johnson, rector of St. John's Episcopal Church, then on Washington and Johnson Streets, and a friend of Hezekiah's, criticized his plans in a story cited in the *Brooklyn Eagle* on November 21, 1886. Johnson said, "Mr. Pierrepont, why don't you sell your lots without conditions, as other gentlemen do? See how briskly the Hickses are selling their lots on Hicks and Willow and Columbia, and the Middaghs upon John Street [afterward Henry]?"

Pierrepont replied, "Johnson, don't you see that every good building which goes up on my lots increases the value of the remainder, whereas every small building that goes up on a lot has the opposite tendency?"

In 1825, Pierrepont, using his position as a trustee of the village government and chair of its streets committee (which laid them out and regulated their width), offered the village government land for a promenade but withdrew the offer when a local property owner, Judge Peter W. Radcliffe, who lived in a house on the site of the current 118 Willow Street (then number 100) in 1835, objected, since he did not wish to alienate this neighbor. A later nineteenth-century proposal also failed.

To entice buyers, in 1823, Pierrepont began placing ads in New York City newspapers titled "Lots on Brooklyn Heights," emphasizing the area's suburban charm:

> *Situated directly opposite the s-e part of the city, and being the nearest country retreat, and easiest of access from the centre of business that now remains unoccupied; the distance not exceeding an average fifteen to twenty-five minutes walk, including the passage of the river; the ground elevated and perfectly healthy at all seasons; views of water and landscape both extensive and beautiful; as a place of residence all the advantages of the country with most of the conveniences of the city. Families who may desire to associate in forming a select neighborhood and circle of society, for a summer's residence, or a whole year, cannot anywhere obtain more desirable situations; and by securing to themselves an entire square, or portion of a street may always remain detached, even when the whole space between the river and Fulton street shall be occupied, which, from the rapid increase of respectable buildings in this quarter, it is evident will be the case in a very few years.*
>
> *Gentlemen whose business or profession require their daily attendance in the city, cannot better or with less expense, secure the health and comfort of the families, by uniting in such an association. Lots are 25 feet by 100—some fronting on the city, others on spacious streets 60 feet wide. They will be sold in squares, or blocks of four or more lots, or separately, as may be desired.*

Figure 11. Henry Evelyn Pierrepont (1808–1888). From *The Eagle and Brooklyn*, 1898.

Pierrepont's son Henry Evelyn (1808–1888) (figure 11) inherited his father's ferry interests and turned them into a profitable near-monopoly via the Union Ferry Company. In 1844, as an adult, he lived initially at 166 Columbia Heights (122 in the old system) after moving out of Four Chimneys. His mother, Anna Maria Pierrepont, lived at Four Chimneys until it was demolished in 1846. In 1857, he built himself a four-story Venetian palazzo designed by Richard Upjohn (figure 12) up the block from his father's old house on Pierrepont Place (see below). The house had a dining/living room that, with the furniture removed, served as a ballroom. He owned

Figure 12. This 1930s view of the Henry Pierrepont Mansion is one of the best. It shows the sunken garden to the right of the house and the south garden. *Brian Merlis Collection.*

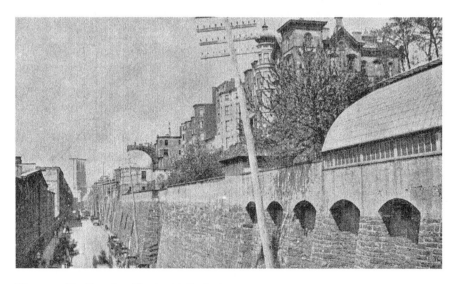

Figure 13. The Brooklyn Heights bluff with its retaining wall in 1897, before the BQE was built. Furman Street, named for village founder William Furman (no relation to the author), is at left. To its left are piers and warehouses. The A.A. Low greenhouse is at right, and 222 Columbia Heights is to the greenhouse's left. From *The Eagle and Brooklyn*, 1898.

an original portrait of George Washington by Gilbert Stuart. After his death, Henry Evelyn's family continued to occupy the house until the 1940s, when it was abandoned and demolished in 1946 for Pierrepont Playground. It is considered by some to be the finest home ever built in New York City.

Henry Evelyn also put up other houses, including one on Pierrepont and Henry Streets, whose first occupant was Arthur Tappan (see chapter 7). Henry was a founder of the Brooklyn Historical Society and the Brooklyn Hospital (there is a plaque to him in its lobby) and a president and founder of Green-Wood Cemetery, the Brooklyn Academy of Music and the Church Charity Foundation of Long Island, operator of St. John's Episcopal Hospital, now Interfaith Medical Center.

Always interested in city planning, Henry also sat on the commission that laid out the city of Brooklyn's streets in the late 1830s and is considered a pioneer city planner. He also led the effort to open Furman Street and build a 775-foot-long retaining wall above it to support the buildings atop the bluff (figure 13). The opening of the Brooklyn Bridge in 1883 was the death knell for his ferries, which all closed by the 1920s.

Stories of buried treasure are a feature of seaside life, and Brooklyn has a trove of these. Henry Pierrepont reported that filled holes dating to the 1830s and '40s on the bluff below his house indicated digging. He had hired two men to shore up the bottom of the bluff who reportedly found $3,000 (a fortune in those days) and absconded with the loot.

The Great Houses

The first houses on the Heights were vacation-oriented ones like the Livingston house, built in the eighteenth century, or wooden mansions such as the Cornell-Pierrepont. None survive, if only because they occupied large lots. Great detached stone houses (as opposed to townhouses) rose on the brow of the Heights and elsewhere in the early nineteenth century, such as the Seney (figure 14) and Prentice (figure 23) houses. None survive for the reasons cited above. In the 1850s came the more urban mansions, such as the Low and White mansions. Some survive because they are contextual in an urban landscape.

George Ingraham Seney (1826–1909) was the principal endower of Park Slope's New York Methodist Hospital (originally Seney Hospital). He made a fortune in banking (the Atlantic Bank, among others), railroads, real estate

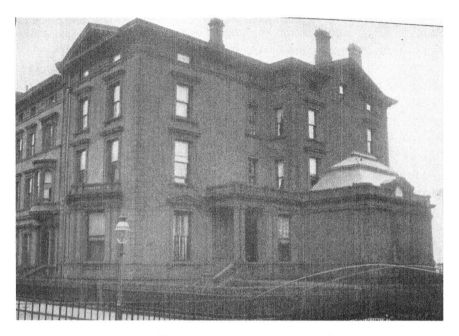

Above: Figure 14. The George I. Seney House was an 1850s mansion built by the endower of Park Slope's Methodist Hospital. Located at 2 Montague Terrace, south of the A.A. Low House, it abutted the ramp down to the ferry and the Penny Bridge, shown in the foreground. *Brian Merlis Collection.*

Opposite, top: Figure 15. The extant A.A. Low and Alexander White Houses are on the left here in 1922. They are located just north of the Montague Street Promenade entrance. The demolished Penny Bridge and Henry Pierrepont mansion are also shown, respectively, in the foreground and at right. *Brian Merlis Collection.*

Opposite, bottom: Figure 16. The David Leavitt/Henry C. Bowen Mansion on Clark and Hicks Streets was a nineteenth-century Georgian residence that survived until 1904. Note the large amount of land on which it sat since it was in the country when it was built. *Brian Merlis Collection.*

and the stock market. He also supported the Brooklyn Historical Society, Brooklyn Eye and Ear Hospital and the Brooklyn Library and was a major art collector. He had previously lived on Pierrepont Street and at 123 (now 87) Remsen Street.

The Seney House (figure 14) was later purchased by Edward H. Litchfield, son of Edwin, the former owner of some of what became Prospect Park and a major developer of Park Slope. In 1920, it was the clubhouse of National City Bank, now Citibank, which began in Brooklyn. It was soon demolished and replaced by the current high-rise apartment building at Two Montague Terrace (chapter 9, figure 22).

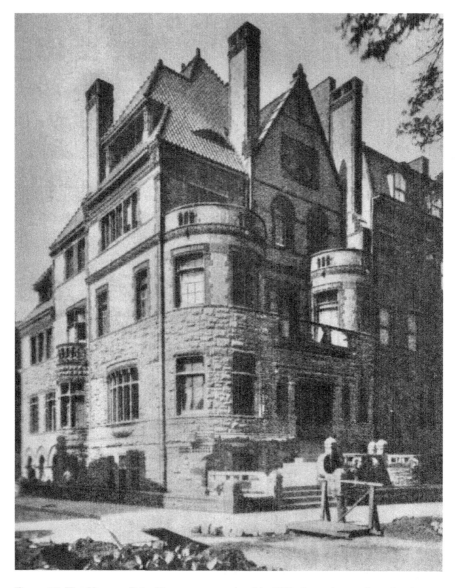

Figure 17. The Herman Behr House was completed in 1891. It was later enlarged to its current size when it became the Palm Hotel. *Brian Merlis Collection.*

In 1890 came the extant Romanesque Revival Herman Behr House on Pierrepont and Henry Streets (figure 17) by Frank Freeman, the style's great practitioner, later enlarged into the Palm Hotel (chapter 6, figure 49). In 1962, it became staff housing for St. Francis College and is now apartments.

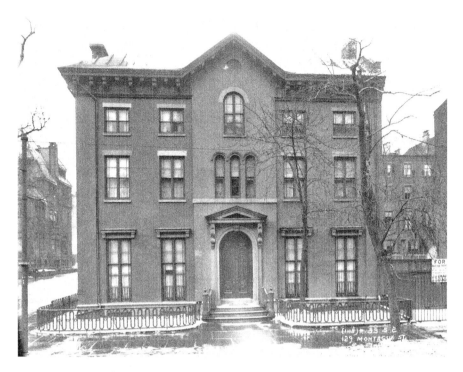

Figure 18. The Dr. Howard Rushmore House at 129 Montague Street occupied the northeast corner of Henry Street. In 1915, this lovely Gothic Revival house was a remnant of a rural past and was for sale. It was torn down in 1926 and replaced by the current two-story commercial building. *Brian Merlis Collection.*

The Low and White mansions at 3 and 2 Pierrepont Place (figure 15) by Frederick A. Peterson are the two largest surviving Italianate mansions in the entire city. The A.A. Low House is perhaps the Heights' finest existing home, a brownstone mansion north of the Montague Street Promenade entrance, built for China tea and silk importer Abiel Abbot Low (figure 26). (See below for the family history of the Lows.) It formerly included a greenhouse below the bluff, which was demolished when abandoned and deteriorated for BQE-Promenade construction. The two houses work together as an aesthetic unit.

There were other early great mansions in the Heights. We show as many as possible. One of the first was the John Jackson house of 1822 on the east side of Hicks Street just south of Clark Street (chapter 6, figure 14). His property originally extended from Columbia Heights to Henry Street. The Jackson house was quite lovely. It faced the bay and was approached from Willow Street by a lane bounded by Lombardy poplars. It had several

gardens, which were its owner's pride and joy. Jackson is remembered today as the man who sold the U.S. government the land for the New York Naval Shipyard (Brooklyn Navy Yard). He later went bankrupt, and his estate was liquidated.

Another early great house was on the west side of Clinton Street between Remsen and Montague Streets, which later served as the Long Island (later Brooklyn) Club (chapter 6, figure 54).

There was a mansion on the southeast corner of Pierrepont and Clinton Streets (chapter 6, figure 18) until around 1863 and a grand wooden house just south of the Hotel Margaret on Columbia Heights (chapter 6, figure 48).

Montague Street, only begun to be developed in the 1840s, originally was mostly residential and sported many mansions between Clinton Street and Montague Terrace. The razed Dr. Howard Rushmore House (figure 18) on the northeast corner of Henry and Montague was one of these. The unobtrusive Colonel Sanger House at 10 Montague Terrace (figure 19) is another.

Figure 19. Built in the latter nineteenth century, 10 Montague Terrace, shown here in 1922, is the Italianate Colonel Sanger House at the corner of Remsen Street. *Brian Merlis Collection.*

Others on the last block between Hicks Street and Pierrepont Place included the extant Hastings House (chapter 5, figure 16) by Richard Upjohn at 36 Pierrepont Street and the razed Martin House down the street toward Pierrepont Place, which was torn down in the early twentieth century (the only clear photo we have is of its yard and rear). The western end of the block was occupied by the Misses Whites' Garden, a private park (figure 40).

The Misses Whites' Garden and the huge Montague Street backyard of the Martin House were largely responsible for the semi-rural ambience that persisted at the western end of the central Heights until the construction of the Heights Casino and Casino Apartments in 1903. There was still a farmhouse at the northwest corner of Montague and Hicks Streets in 1900!

The Packers and Prentices

William Satterlee Packer (1800–1850) and John H. Prentice (1803–1881) (figure 20) were partners in an Albany, New York fur business called Packer, Prentice & Company, founded in the late 1820s, which had a branch in Manhattan. They made beaver hats, which were all the rage and led to the near extinction of the animals. Packer and Prentice moved to Brooklyn in 1840 when Packer decided to retire due to ill health (he probably had a heart condition) and expanded the Trotter house at 2 Grace Court (figure 21). It was later moved toward the end of the bluff between Grace Court and Joralemon Street by Harriet Putnam Packer (1820–1892) (chapter 6) and expanded.

Figure 20. John H. Prentice (1803–1881), circa 1840. From *The Eagle and Brooklyn*, 1898.

While the house was under construction, the Packers lived at 82 Remsen Street (figure 22) (extant) from 1844 until 1850, the year Mr. Packer died. It was purchased by the Hookers in 1912 and passed down through their family, including the family of Alice Davidson Outwater, who wrote *Coming of Age in Brooklyn Heights* about growing up there. Packer and Prentice endowed

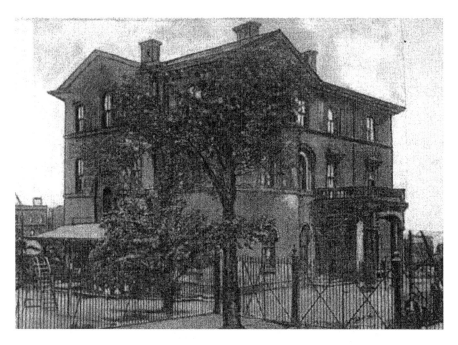

Above: Figure 21. The Packer House at 2 Grace Court. *Brian Merlis Collection.*

Below: Figure 22. Nos. 80–82 Remsen Street today. No. 82 was the home of William and Harriet Packer before they moved into their shoreline mansion. *Robert Furman photograph.*

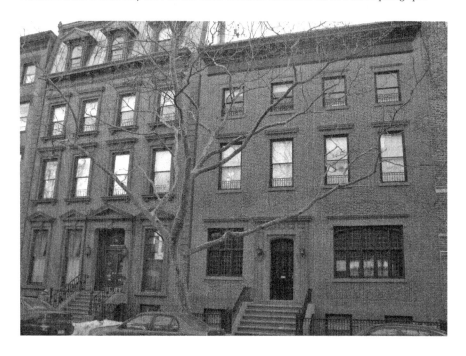

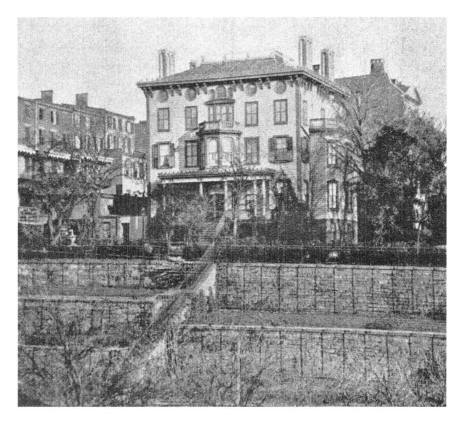

Figure 23. This is the only published close-up photograph of the Prentice House at 1 Grace Court, circa 1900. It was built by Charles Hoyt around 1835, enlarged by John Prentice and moved to the edge of the bluff, as shown here, when local streets were opened. *One Grace Court.*

what became Packer Institute. Harriet further supported the school after her husband's death (see chapter 6). She was a Barnard College graduate and invited the alumni association to meet in her house, which it continued to do after her death. She built a row of Queen Anne–style houses at 262–68 Hicks Street in 1887 (chapter 5, figure 36). The Packer house was demolished in 1916 and replaced by the apartment house at the same address. Prentice, who continued the business, purchased the Hoyt estate, which had been part of the Remsen farm. His part was bounded by Remsen, Joralemon and Hicks Streets and the bluff.

The Prentice house was built by Charles Hoyt circa 1835. He expanded the house in several stages but had to move it to the edge of the bluff to accommodate development on new neighboring streets such as Willow

Place. It became 1 Grace Court (figure 23). Both houses were replaced by apartment buildings. Prentice was an incorporator of the New York and Brooklyn Bridge Corporation, presided at the bridge's on-site opening ceremony and served on its board. He also supported Polytechnic Institute, was a director of Green-Wood Cemetery and served on the board of the Brooklyn Savings Bank. He was the president of the board of directors of the Nassau Water Works and supported the effort to develop a now closed reservoir in Ridgewood that served as a major part of the city's water supply. The company was donated to the City of Brooklyn. He was subsequently city sewer commissioner in 1857, a commissioner of Prospect Park in 1865 and a trustee of the Brooklyn Academy of Music in 1869–70.

A fascinating 1837 engraving by William James Bennett from a painting by John William Hill is entitled *New York from Brooklyn Heights* (figure 24). While the focus is on the big city, our interest is on this side of the East River. A wealthy family surveys the channel and city from the roof of their house on the bluff (which is not visible) in the early stages of the area's development. A park-like area is to their right on Columbia Street, and below and ahead of them are the warehouses and ships of early Furman Street.

Figure 24. *New York from Brooklyn Heights* is a celebrated image of the city. *Brian Merlis Collection.*

This print may be seen at the New York Public Library and the Museum of the City of New York, and it identifies numerous structures in New York, but not the vantage point from which it was made. Since there is vacant land north of the house, we may guess that it was taken from the Hoyt House, later the Prentice House, given that there were no other large houses on the bluff at this time.

The Lows

The Low family fortune was begun by Seth Low the elder (figure 25), A.A.'s father, who was born in 1782 in West Gloucester, Massachusetts. After the death of his father, who had served in the Revolution, the family moved to Haverhill, where Seth prepared to enter Harvard College under the Unitarian minister Abiel Abbot. He left Harvard due to illness, and in 1828, as a young married man (to the former Mary Porter, a descendant of General Israel Putnam and a relative of Nathaniel Hawthorne), moved to Manhattan from Salem, Massachusetts, since the city was growing due to the Erie Canal. This Seth was in the drug business and became an importer/exporter of opium and drugs from Latin America to India and China.

In 1829, the entire family moved to Nassau Street in Brooklyn and later to 40 Concord Street. What became downtown Brooklyn was then a fashionable residential area. Low was a developer and built two blocks of houses on Concord and Washington Streets and added Eames and Putnam's English and Classical School behind them (see chapter 6). He was president of the board of trustees of the village of Brooklyn, among the incorporators of the city of Brooklyn in 1834 and served as an alderman (the equivalent of a city councilmember). He was the first president of the city board of education and a supporter and board member of the Brooklyn Institute, Packer Collegiate Institute and other organizations. In 1843, he founded the Brooklyn Association for Improving the Condition of the Poor, which sought moral uplift and teaching the value of

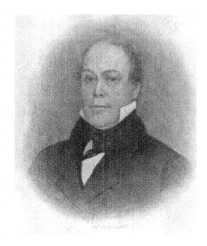

Figure 25. Seth Low the elder (1782–1853) founded the family business. From Henry Stiles's *A History of Kings County*, 1884.

Figure 26. Abiel Abbot Low (1811–1893). From *The Eagle and Brooklyn*, 1898.

thrift, sobriety and hard work. He was also among the founders, in 1844, of the First Unitarian Church of the Saviour on Monroe Place and Pierrepont Street, beginning a long tradition of Low and White family involvement there. He died in 1853.

Seth the elder's son Abiel Abbot (A.A.) Low (figure 26) was born in Salem in 1811 and clerked for Joseph Howard and Company, an importer/exporter from South America. In 1833, he started working in Canton, China, for an importing company called Russell and Company, which his uncle William Henry Low headed. It was the largest opium importer into China.

He had a side business with Wu Bingjian, also known as Houqua, the wealthiest merchant in Canton. During the Panic of 1837, this business enabled A.A. to bail out his father's firm; he thereby became a partner in Russell and Company. In 1839, the Chinese began a crackdown on the opium trade, so the company surrendered its opium stocks and ceased involvement in that business. It continued to buy and sell Japanese silk and Chinese fabrics, spices and tea. In 1840, after becoming a partner at Russell, A.A. returned to his family in Brooklyn, where he founded A.A. Low and Brother with Josiah Orne Low and was managing partner of Low, Griswold and Aspinwall.

A.A.'s first home of his own was at 165 Washington Street, where his son Seth was born in 1850 to his wife, the former Ellen Dow Almira (they had three other children, one of whom, Abbot Augustus, is well known as an Adirondack businessman and inventor of the paper shredder). A.A.'s wife died that same year, so he married his late brother William H. Low's widow, Anne Bedell Davison, and had several children with her. Thereby the sea captain Mott Bedell became Seth the younger's step-grandfather. Mott Bedell's house survives at 11 Cranberry Street (figure 27) and is marked by a plaque. He had previously lived at the extant house at 51 Hicks Street (then number 47) in 1833.

Around 1845, A.A. Low built the first streamlined or "clipper" ship, the *Houqua*, named for his Chinese partner and captained by his brother

Figure 27. Nos. 11–19 Cranberry Street (No. 11 is the Mott Bedell House; it is Greek Revival). No. 19, a great Federal house with a later Mansard third floor, on the corner, is the *Moonstruck* house, where Cher and her family lived in the 1987 film. *Robert Furman photograph.*

Charles Porter Low. They were the fast transports of the time, especially in the faraway China trade. He let competitors buy the more expensive first pickings of Chinese tea and got the cheaper leavings but was able to beat the others to market because of the speed of his ships.

Instead of going west around Africa, they braved Cape Horn at the tip of South America, which enabled them to also transport passengers and goods to San Francisco for the gold rush of 1848. The clippers set numerous speed records. Their still-famous *Flying Cloud* set a New York to San Francisco speed record and sailed over 433 miles in one day. To give an idea of the standards of the time, another clipper, the *Oriental*, made the run from Canton to London in a record ninety-seven days in 1850.

A.A.'s clippers sailed from the docks off South Street in Manhattan. At first sharing office space with his father on Fletcher Street in Manhattan, in 1850 he built 167–71 John Street in Manhattan (figure 28) between Front and South Streets as the office of his company. It survives in the South Street Seaport Museum. It is said he sited his house on the bluff of the Heights so he could see his ships across the East River.

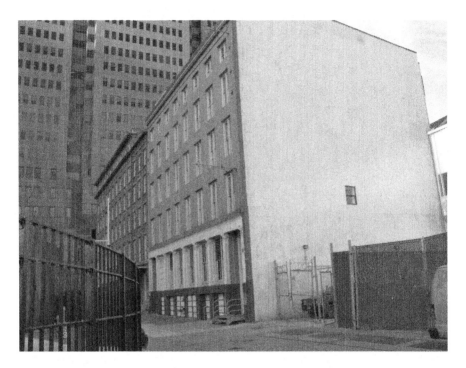

Figure 28. 167–71 John Street in Manhattan was the offices of A.A. Low and Brother. It is preserved in the South Street Seaport Museum. *Robert Furman photograph.*

A.A. was also involved in local civic affairs as a founder of the Mercantile Library, president of Packer and an incorporator of the Long Island Historical Society (see chapter 6) and Brooklyn Hospital. As a member of the board of Packer Institute, he gave anonymous scholarships to students and bonuses to teachers.

He played a major role in stabilizing the nation's economy at the outset of the Civil War. As a director of the New York Bank of Commerce, he helped support the federal government by floating loans and selling bonds. As president of the New York State Chamber of Commerce in 1863, he organized mercantile opposition to possible British and French support of the Confederacy. He was treasurer of the New York Union Defence (a persisting British spelling) Committee and raised funds to outfit soldiers through the War Fund Committee of Brooklyn. He was also president of the General Committee of Citizens in Brooklyn, in support of the Sanitary Fair and Commission (see chapter 7). He even lost two of his own ships, the *Contest* and the *Jacob Bell*, to Rebel raiders. After the war, he was a major investor in the Nickel Plate Railroad, the Atlantic Cable with Collis P. Huntington,

the Chesapeake and Ohio Railroad and in iron foundries in Virginia. He helped develop Newport News, Virginia, and Huntington, West Virginia. He also supported federal subsidies for the U.S. Merchant Marine.

Seth Low the younger (1850–1916) (figure 29) prepped at Brooklyn Poly, attended Columbia College and, breaking with the family tradition of Unitarianism, became a member of Grace Episcopal Church in 1872 because he disliked the former's factionalism. As junior partner in his father's firm, he worked on tea imports. He married Anne Curtis, daughter of U.S. Supreme Court justice Benjamin Curtis of Boston, indicating a continuing New England family connection. In 1887, he built 186 Remsen Street (chapters 9 and 11) as an investment and liquidated his father's firm in 1888 as steamships replaced clippers. He thus became a wealthy man to the tune of $3 million, then an incredible amount. His real interests, however, lay in civic reform and politics.

Figure 29. Seth Low the younger of the Heights was mayor of Brooklyn from 1881 to 1885, (shown here as) president of Columbia University from 1890 to 1901 and mayor of Greater New York in 1902 and 1903. *Brian Merlis Collection.*

As a young man, he was a Brooklyn Volunteer Visitor to the poor at the Kings County Commission of Charities, where his job was to determine who needed help. He and Alfred T. White (see chapter 6) found that the commission was a sinkhole of corruption because of the dominance of the county's government by Boss Hugh McLaughlin's Tammany Hall Democratic Party machine. A police judge's parents on home relief (an early version of welfare) were housed at the Flatbush Almshouse when he could help them, which was required. But most seriously, they found that a third of excise license funds were being diverted to contractors before reaching the city treasury, an open invitation to corruption. A board of aldermen investigation led not to reform but to cutting off home relief in January 1876. This led to the formation of the Brooklyn Bureau of Charities to coordinate assistance and make it efficient. This experience set Seth on a lifetime's course as a Republican reformer. He achieved reform of the commission as its president.

Seth was mayor of Brooklyn from 1881 to 1885. He appointed competent professionals to head city departments, was active in school reform, gave textbooks to all students (not just those who took a pauper's oath), hired teachers via civil service exams rather than on a political basis, abolished racially segregated schools and reformed the tax system to collect arrearages. Large property owners had either relied on lax Tammany administration by McLaughlin's minions to under-assess their property or else paid off the Tax Department to do so. Low established fair assessments, shifting the tax burden off the middle class and onto the wealthy.

Unlike the more political Theodore Roosevelt, Low was a mugwump (his "mug" faced the Republicans and his "wump" the Democrats); he did not support the corrupt Republican James G. Blaine in 1884 for president against the more honest Democratic New York governor Grover Cleveland and was consequently not renominated as mayor because he had alienated party chieftains. Blaine lost the presidency because he did not carry New York State since he did not carry Brooklyn strongly enough (yes, Brooklyn was once a Republican stronghold, and the Republicans were once the advocates of progressivism and honest government).

Of course, the Republican pols did not consider the fact that Cleveland was from Buffalo, New York—then a major city—had been governor of the state and so was well known and liked by New York voters. Blaine was from Maine. As an adult, Low lived in two houses in the Heights: 201 (figure 30) and 222 Columbia Heights (the former Peter C. Cornell House), on opposite sides of Columbia Heights (figure 13).

Seth Low was president of Columbia University from 1890 until 1901. He made Columbia College into Columbia University by professionalizing and expanding it. He founded the medical and law schools and brought Teachers College and Barnard College into the university, following the then predominant German model for universities. He moved Columbia from Fiftieth Street east of Madison Avenue to Morningside Heights, where it purchased seventeen acres from the Bloomingdale Insane Asylum. (Founded during the colonial era as King's College, Columbia was originally located west of today's city hall.) He retained Charles Follen McKim of McKim, Mead and White to design a new campus, of which the university library is the centerpiece. Low personally endowed the library to the tune of $1 million, one-third of his personal fortune, and named it the Low Memorial Library for his late father. While president of Columbia, he supported the creation of Greater New York (today's five boroughs) as chair of the Charter Revision Commission and ran for mayor as a Republican and Citizens

Union (then a political party) candidate in the first consolidation election in 1897. He lost to corrupt Tammany hack Robert Van Wyck (as in the expressway in Queens).

In 1901, he ran with the support of the Republican Party, Citizens Union and independent Democrats and won. He served one two-year term. He was the first successful "fusion" candidate for mayor, running as a Republican, Independent and with some Democratic support, a pattern for liberal Republicans that would be repeated by Fiorello H. LaGuardia, John V. Lindsay, the conservative Rudolph Giuliani and Michael R. Bloomberg.

He supported subways entering Brooklyn and assisted the effort to build the Pennsylvania Railroad tunnels under the Hudson River (until then one had to take a ferry across) and the electrification of the New York Central Railroad, which allowed the open tracks north of Forty-second Street to be covered and the land created by air rights to be sold at a huge profit after Grand Central Terminal was constructed.

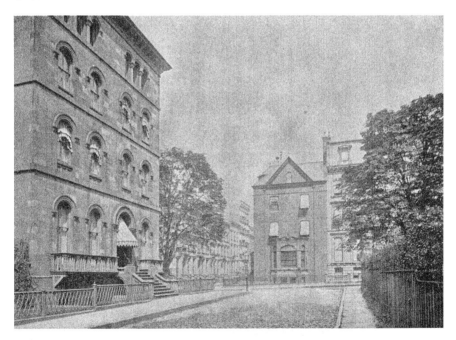

Figure 30. Here we look north along Pierrepont Place to Pierrepont Street, in the right background, in 1898. The Pierrepont House is at left; 201 Columbia Heights, the first Seth Low House, is at center; and the Morgan House, 7 Pierrepont Street, partially concealed by trees, is at right. The Misses Whites' Garden, a private park a la Gramercy Park, also known as "Pierrepont Park," is at right between Montague and Pierrepont Streets. All of these are gone. This scene epitomizes the nineteenth century excluding elegance of the Heights. From *The Eagle and Brooklyn*, 1898.

As New York mayor, Low repeated his record in Brooklyn of honesty and reform but lost public support because of his inflexible application of the law at a time when elected officials usually played it fast and loose. For example, he denied an injured employee Workmen's Compensation because the man had not held his job long enough but gave him the $1,000 indemnification out of his own pocket.

What became a serious political problem for him was that he strictly enforced blue laws that limited liquor sales and bar hours, alienating his German-American supporters whose beer gardens were community social centers. (Irish-American New Yorkers were Tammany men since they controlled it. Women couldn't vote until 1920 when the Nineteenth Amendment to the Constitution took effect.) Because of this and his elitist attitudes, he failed to be reelected. Surprisingly, for that era, he opposed any form of racial and religious discrimination, an incredibly advanced position.

Figure 31. The scene in Figure 30 today. To the left is Pierrepont Playground, to the right, 57 Montague Street, and in the right background is 1 Pierrepont Street. The only element remaining from the 1898 photo is the townhouses on Columbia Heights in the left background. *Robert Furman photograph.*

Low was succeeded as president of Columbia by the reactionary Nicholas Murray Butler, who instituted maximum Jewish quotas, a policy soon imitated by the entire Ivy League. While mayor of New York, Low wrote Butler an open letter opposing the quotas.

Low later was president of the historically black Tuskegee Institute (today Tuskegee University) in Alabama, where he worked closely with Booker T. Washington. He also headed the Regional Plan Association and supported the right of labor to organize. In retirement, he bought a farm in then-rural Bedford Hills, New York, and sought to advance cooperative farming.

Figures 30 and 31 show Pierrepont Place in 1898 and today. While the 1898 scene is aesthetically superior, the spot today is more democratic, with Pierrepont Playground and apartment buildings, and testifies to Robert Moses's more populist vision.

FERRIES, STREETCARS AND RAILROADS

The opening of steam ferry service from Brooklyn Ferry, now Fulton Ferry Landing, in 1814 by Robert Fulton, Hezekiah Pierrepont and William Cutting created reliable public transportation between Brooklyn and Manhattan; boats would no longer be dependent on tide, wind and weather. The immediate result was the legal beginning of the Village of Brooklyn in 1816, the development of Fulton Ferry as a downtown and the acceleration of the building up of Brooklyn Heights into a fine residential area.

While Brooklyn Ferry left from the end of Fulton Street, the first ferry to actually land in the Heights was based on Joralemon Street (then the River Road) in 1693. It was called the St. George's Ferry at a time when Brooklyn was deemed part of "Nassau Island" (the derivation of the name of 1898 Nassau County, which had previously been part of Queens County). This ferry was operated by Philip Livingston (chapter 3, figure 10) in the later 1700s but was discontinued when he went into exile in 1776 at Kingston, the Patriot state capital, during the British military occupation.

Streetcars

Local public transportation from the ferries was provided first by omnibuses (horse-drawn stagecoaches), which bounced their passengers around

Figure 32. This postcard shows the razed ramp, stairs and houses south of Montague Street (the Seney House is in right foreground), along with the extant A.A. Low house in left foreground (and its demolished greenhouse), a cable car and the extant apartment house at 62 Montague Street. *Robert Furman Collection.*

unmercifully. Later, these coaches ran on rails to cut down on shaking and were later replaced by cable (figures 32 and 33) and trolley cars powered by electricity.

These cars were operated by a maze of companies that were often licensees of one another. The first was the Brooklyn City Rail Road Company (BCRR), founded in 1853 with a line down Fulton Street and Myrtle Avenue from Fulton Ferry. Its headquarters were on Montague Street (chapter 9, figure 8). It also operated cars down Court Street and Furman Street from the ferry. The Furman Street trolley was gradually discontinued as bridges and subways replaced ferries.

The Montague Street line was operated by the Brooklyn Heights Rail Road Company, which was acquired in 1891 by a holding company, the Long Island Traction Company, which became its operating arm when it also acquired the BCRR. The traction company failed in 1895 and was reorganized the next year as the Brooklyn Rapid Transit Company (BRT), which soon acquired most of the streetcar and elevated lines in Brooklyn.

In 1895, the Knights of Labor, a national labor organization and ancestor of the American Federation of Labor, called a five-week strike against all of the trolley lines in Brooklyn over issues of salary and working conditions. The companies responded to the Great Brooklyn Trolley Strike with police

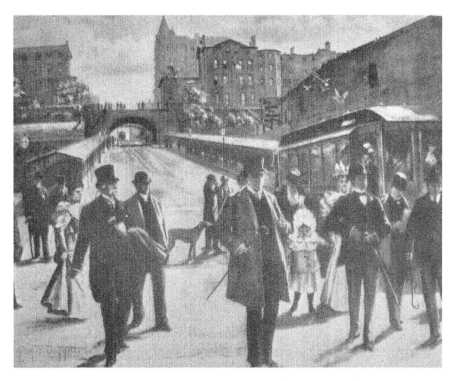

Figure 33. This scene epitomizes the exclusivity of the Wall Street Ferry: not a poor or middle-class person in sight, only wealthy businessmen on their way to work, circa 1890. A cable car is prominent in the right foreground. *Brian Merlis Collection.*

violence and by calling in the National Guard to protect replacement workers, called "scabs" by the unions. Two people were killed, and the strikers lost.

In 1919, following the disastrous Malbone Street elevated railroad accident that killed ninety-three people, the BRT went into receivership. The surface lines reverted to an independent BCRR, but in 1923, the BRT was reorganized as the Brooklyn-Manhattan Transit Corporation (BMT), which operated a group of subway lines until 1940, now designated J through R. New Yorkers of a certain age will recognize BMT as one of the three old divisions of the subway system. The BCRR remained independent until 1929, when the BMT formed the Brooklyn and Queens Transit Corporation. It continued to operate the streetcar lines through its subsidiaries until 1940, when the city took over the two private companies. Their fate was sealed when the city refused to allow any increases in the nickel fare until 1948 because of public pressure.

Another early mover and shaker in the Heights was David Leavitt (or Leavett), president of the American Exchange Bank in Manhattan. In

1832, he lived in a house on the site of the present 122 Willow Street (then number 105). In 1833, he bought control of Fulton Ferry by purchasing forty-four of the sixty shares of the Fulton Corporation. This had the effect of returning the ferry lease to Brooklyn, although it was licensed by New York City. Raising the ferry's fares was a contentious political issue, and the controversy prevented Leavitt from raising them. He could not make a go of it and in 1836 sold out to a group led by Henry Pierrepont.

In 1843, Leavitt built himself a splendid Neoclassical mansion at 102 Willow Street (figure 16) (later owned by Henry Bowen; see chapter 7) at Clark, which occupied half of its block. He had a brother (?) named Sheldon who lived at 101 Willow Street (then number 81) in 1839. They may have been the first Jews in Brooklyn Heights.

The Wall Street Ferry

Henry Howland purchased the Four Chimneys property in 1846 and demolished it with an eye toward operating ferry service from the foot of Montague Street to Wall Street so that wealthy businessmen would not

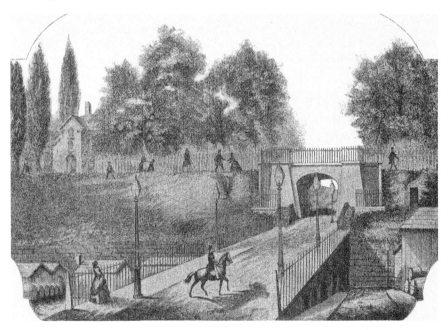

Figure 34. The top of the Montague Street ramp circa 1848 before any large houses were constructed. From *The Eagle and Brooklyn*, 1898.

Figure 35. The original Wall Street Ferry house at the end of Montague Street, in an 1870s print. From *The Eagle and Brooklyn*, 1898.

have to traipse up to Fulton Ferry or down to Atlantic Avenue and mix with the hoi polloi (figure 33). Incredibly, when the house was torn down, no one seemed to care that the Cornell Mansion had been Washington's headquarters during the Battle of Brooklyn. It was routine to move houses at the time, but this one was instead razed.

Howland commissioned Minard Lafever to design a ramp down to the river from the top of the bluff, a masonry bridge (figures 32, 33 and 34) and the cast-iron Penny Bridge (figures 14 and 15; chapter 11, figure 8), which carried pedestrians over the part of the ramp depressed below street level. There was a viewing area around the edge of the ramp. The Penny Bridge is so fondly remembered in the neighborhood that its name is used by a variety store on Clark and Henry Streets.

A franchise to operate the ferry was finally granted in 1853, and service began. Cable cars ran down Montague Street to the ferry until 1914 (figures 32 and 33), when they were converted to electricity.

Traffic was so scant that Henry Pierrepont very quickly took over the line. It was never profitable and was subsidized by the Union Ferry Company's other routes. A chain was stretched across the ramp to the ferry once a year to maintain legal title to the land, as is sometimes done today with buildings set back from the street.

The South Ferry and the Long Island Railroad

Besides the Fulton and Wall (Montague) Street ferries, a third route, the South Ferry (figure 36), served the Heights and Cobble Hill from Atlantic Avenue, which stimulated the development of that area. Ferry and train service were begun in 1836 by the Brooklyn and Jamaica Railroad from

Figure 36. The South (Atlantic Avenue) Ferry connected passengers to the Long Island Railroad. This is its ferry house, shown in 1877. From *The Eagle and Brooklyn*, 1898.

South Ferry to Jamaica, Queens. One transferred there to the Long Island Railroad. The companies merged in 1837, but this is why you still "change at Jamaica."

From 1842 until 1859, the trains ran in a tunnel (figure 37) between South Ferry and a point between Boerum Place and Smith Street. However, as the area grew into a fashionable shopping street, people began to object to filthy, smoke-belching steam engines emitting smoke into the street, so the company was forced by law to move its depot to rural Atlantic Terminal, then called "Hunter's Point," where a new station was erected and where the terminus remains, ending service to the shore and causing the tunnel to be closed.

Railroad buff and entrepreneur Bob Diamond explored the tunnel and led periodic tours of it from the 1980s until December 2010, when the fire department raised safety concerns because the only access was via a manhole. This led the transportation department to ban his outings. He had hoped to establish streetcar service on Atlantic Avenue. An archaeological expedition failed to locate period engines believed to have been left in the tunnel.

Environmental activist Raymond Howell reported that the western end of the tunnel was filled in and cannot be inspected, but remote archaeological sensing located a large metal object in the former tunnel. At the time of this writing, businessman John Quagliano is working with Diamond to establish light rail service in the tunnel to Red Hook, which lacks adequate public transportation and is becoming increasingly residential and commercial.

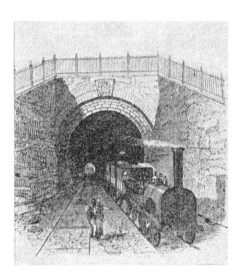

Figure 37. An early steam locomotive emerging from the Brooklyn and Jamaica Railroad tunnel at South Ferry (Atlantic Avenue). From *The Eagle and Brooklyn*, 1898.

The South Ferry Company failed in 1839, so Pierrepont's New York and Brooklyn Ferry Company took over the lease the next year and reduced the fares from four to three cents in 1842 and from three cents to two in 1844, making ferries cheap public transportation. Pierrepont did, however, raise the fare on the Fulton Ferry from one cent to two. He had hoped to reduce the fare back to one cent but

claimed that an increased lease price in 1859 prevented this. From 1860 to 1863, however, Pierrepont's Union Company built ten first-class boats and remodeled the ferry houses into luxury accommodations, which some have criticized as foolish given that the Brooklyn Bridge project was then pending and that Pierrepont was a director of the Bridge Corporation. But perhaps he thought that improved facilities would help him compete. Ferry service at Atlantic Avenue ended in 1914.

DISASTERS

Fires were a constant danger in an age of candles and kerosene gaslight, and sometimes house fires spread to entire neighborhoods. The Great Brooklyn Fire of September 9, 1848, laid waste to seven blocks of the north Heights and downtown from Henry, Pineapple and Sands Streets to Washington Street. Firefighting was so primitive that a water supply was often not accessible, and sometimes the only weapon available was to blow up buildings to create firebreaks, as is still often done today in combating forest and brush fires.

Figure 38. Monroe Place during the Blizzard of March 1888. From *The Eagle and Brooklyn*, 1898.

At 3:00 a.m. on September 10, a house at Liberty and Concord Streets was exploded, bringing the fire under control.

In addition, plagues were common, including cholera, which is caused by dumping germ-carrying feces into the water supply, common practice before the general acceptance of the germ theory of disease. The last such outbreak occurred in 1832. Yellow fever, a mosquito-borne disease, was also common. It was one of the reasons the proposal to drain the Gowanus marshes and create a canal was popular in the 1840s. A major yellow fever outbreak occurred in 1822–23 with many deaths in the Heights. Many children were consequently left orphans, leading to the founding in 1833 of the Brooklyn Orphan Asylum (see chapter 6).

A still famous disaster is the Blizzard of (March) '88 (figure 38), which buried the city under twenty inches of snow at a time when snowstorms were especially dangerous.

EARLY PARKS

As the Heights was built up in the 1840s, the harbor view began to be closed off to the public. Less wealthy citizens petitioned the state legislature (parks were then controlled by the state via a Parks Commission, whose first chair was James S.T. Stranahan, creator of Prospect Park) to purchase land at the end of Clark, Pineapple and Middagh Streets for small parks. Alden Spooner's *Long Island Star*, Brooklyn's first newspaper, supported the program, but Walt Whitman, editor of the *Brooklyn Eagle* at the time, opposed it because these would allegedly not readily be accessible to working people.

Fort Stirling Park, at the west end of Clark Street, was the product of this effort. The land for it was acquired by the City of Brooklyn in 1867, designated as Brooklyn Heights Park and later renamed Fort Stirling Park by New York City. Part of it was closed after subway construction in 1904. An Italianate mansion at 152 Columbia Heights (chapter 9, figure 20) was razed for Seventh Avenue subway line construction, and afterward, its site became part of the park (see chapter 9). It was later one of Robert Moses's "vest pocket parks" (figure 39) of 1935 but was closed after 1971. The area, the location of the Fort Stirling plaque, is now undeveloped property inaccessible to the public.

The (World War I) Remembrance Pier opened as a recreation area at the end of State Street in 1928 after ten years of effort by the Riverside

Figure 39. Fort Stirling Park in the 1940s, when it was the only public space in the Heights facing the East River and Manhattan. The parkland is now unutilized and overgrown. A sign explains its history. *Brian Merlis Collection*.

Figure 41. The block between Remsen Street and Grace Court west of Hicks Street is too narrow for houses on the north side of Grace Court, so those on Remsen have extraordinarily deep backyards, permitting a public view of their backs and backyards. This is a modern view. *Robert Furman photograph.*

Opposite, bottom: Figure 40. This 1914 shot is the best we have seen of the Misses Whites' Garden, the private park at the western end of the block bounded by Montague, Pierrepont and Hicks Streets and Pierrepont Terrace. A gazebo is in the background. The houses in the background and at center are on the south side of Pierrepont Street. The side of the Heights Casino is at right. The railing in the foreground is around the ramp to the ferry and shore. *Brian Merlis Collection.*

Association, despite the efforts of the dying ferry companies to forestall it. It lasted until the BQE was constructed.

In 1935, the Parks Department planned a series of small parks at the end of several streets in the north Heights. Designated "rest areas" or "vest pocket parks," they were a Robert Moses innovation and were added at the ends of Pineapple, Cranberry and Middagh Streets. They later became accesses for the Promenade.

There was, however, an early larger park near the harbor, a private one called the Misses Whites' Garden, or Pierrepont Park (figures 30 and 40),

which occupied the western end of the block between Montague, Pierrepont and Hicks Streets and Pierrepont Place. It dates from at least 1867, since it is shown on the Dripps map of that year (chapter 8, figure 3). Founded by Alfred T. White's sisters, Frances and Harriet, it was open only to local residents. One had to apply to Harriet (died 1947) or Frances (1847–1937) and show that one's children were well behaved. Mothers had to wear white gloves when they visited. These rules effectively excluded the poor. In 1948, the property was sold by Harriet's estate for the two present high-rise apartment buildings at 57 Montague Street and 2 Pierrepont Street. Her house at 2 Pierrepont Place was sold to Darwin Rush James III and Gladys Rush James.

Chapter 5

ARCHITECTURAL STYLES

1820–1940

The Heights possesses the greatest variety of nineteenth-century townhouses in the city, mostly built between 1815 and the early 1900s. We include here examples of every major style of house and larger building used in the area, both extant and razed.

One unusual thing we do here is to show major changes to extant houses where we have period images and to indicate demolished houses, mostly from photos made in the 1910s and '20s, and sometimes earlier, when many apartment buildings were raised in the Heights. To eliminate confusion, we have divided these into groups within styles: extant houses that are preserved or only have minor alteration, buildings with major changes and demolished houses. We give the addresses of the replacements when these are discernable. One will note how many wooden houses were torn down in this process, since they are more vulnerable because they deteriorate more quickly than stone buildings. Another notable phenomenon is the destruction of mansions, likely to be lost because they occupy large lots otherwise more profitably utilized by developers. We picture as many as possible, both in this section and elsewhere herein.

This is a general history of the Heights, not an architectural history; the latter has been provided by Clay Lancaster and Francis Morrone. We have chosen to illustrate the more attractive or interesting extant houses, as well as most of the razed ones of which pictures are available.

This exposition illustrates just how much demolition took place in the Heights over the years. So much occurred that one wonders if the whole neighborhood would have been designated a historic district today. If you walk around the

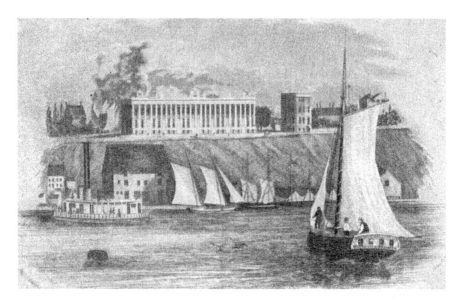

Figure 1. General Underhill's colonnade row was built on Columbia Heights and Middagh Street in 1835 and burned down in 1853. The Gowanus Building is shown on fire. From *The Eagle and Brooklyn*, 1898.

area, you will notice swaths of apartment houses and must assume that these buildings, constructed in the 1880s through the 1960s, replaced townhouses. Here we show some of the former structures that have been replaced. Of course, in most cases, especially from the 1920s on, they were aesthetically superior to what replaced them.

It may be that there is nothing new under the sun, but this was certainly the case in the nineteenth century when architecture mostly dealt in updating older styles, whether derived from ancient Greece, Egypt, medieval Europe or the Italian Renaissance. The last decade of the nineteenth century into the twentieth century, for better or worse, saw genuinely new genres come into use, beginning with Art Nouveau, continuing with Art Deco and proceeding to Art Moderne and International Modernism, before exhausting itself when designers embraced "retro" styles in the 1980s.

LANCASTER'S STYLE SURVEY

Clay Lancaster's classic *Old Brooklyn Heights, New York's First Suburb*, published in 1961, indicates that in 1960, half of the buildings in the neighborhood were from 1860 or before, his preservation threshold, and 90 percent were

pre-1900 (including apartment buildings). There were 60 Federal houses, 405 Greek Revivals (by far the predominant style), 47 Gothic Revivals, 201 Italianates, 216 Eclectic buildings and 61 carriage houses.

Of course, in 1960, the 1860 date made some sense as a definition of the antique. But in 2015, fifty-five years later, we perceive the glaring omission of anything built from 1861 until 1905. This gap is being repaired by Francis Morrone.

According to Lancaster, the following styles of architecture were used in the Heights:

1. The Federal style (1820–35)
2. The Greek Revival style (1834–60)
3. The Gothic Revival style (1844–65)
4. The Romanesque Revival style (1844–1900)
5. The Italianate style (late 1840s–1860)
6. The Renaissance Revival style (1850–1900)
7. The Ruskinian or Venetian Gothic style (1867–69)
8. The Queen Anne style (1880–1900)
9. The Colonial Revival style (1890–1940)
10. The Neoclassic or Palladian style (1892–1940)
11. The Modern period (1890 onward)

THE COLONNADE ROW

One of the earliest popular architectural styles was the colonnade row, related to both the Federal and Greek Revival styles. These were set back, separate houses connected at their rooflines by square wooden columns. Three rows were constructed in the Heights by General Underhill+ in the 1830s and '40s. The one at 43–49 Willow Place (chapter 13, figure 3) survives, along with one house at number 46 from the former four across the street, but the row on Columbia Heights and Willow Street burned down in 1853 (figure 1).

Figure 2. No. 135 Joralemon Street is a rare Federal wooden house surviving in the south Heights. It shows an added cast-iron porch and railings, which are late nineteenth century, in this 1922 photo. The Type C railings have been replaced with plain ones. *Brian Merlis Collection.*

THE FEDERAL STYLE

Preserved Houses

The Federal style is divided into two types. Classic Revival is very formal and includes tall columns and impressive porticoes. The best-known examples are Thomas Jefferson's University of Virginia colonnades, the U.S. Capitol by Dr. William Thornton and the White House by James Hoban. In the Heights, we see the second type: the columns are slender and the porticoes less grand (figures 2–7).

Figure 3. Nos. 155, 157 and 159 Willow Street are 1820s Federal-style houses, with dormers on 155 and 157. Francis Morrone considers them "the best examples of Federal-period design on the Heights." *Robert Furman photograph.*

Opposite, bottom: Figure 5. Nos. 128 and 126 Willow Street, Federal houses, in 1922. No. 126 shows lovely ironwork and a transom window above the door. Note its huge side yard. No. 126 is the Fisher house, and No. 128 was the Peabody house. No. 126 still exists and is a Federal house with Type C steps, lintels over the window and Ionic colonnettes. To the right are 124, 122, etc. Nos. 128, 132 and 134 were replaced by an apartment house at 128 Willow Street in the 1920s. *Brian Merlis Collection.*

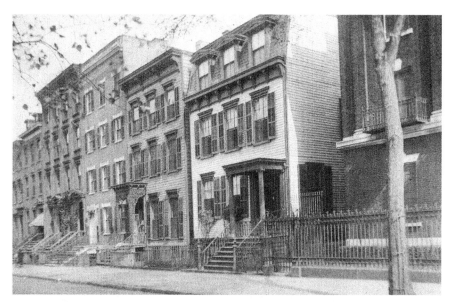

Figure 4. *From left*, 107, 109, 111, 113 and 115 Willow Street in 1922. This view gives a good sense of place. According to Francis Morrone, the second house is unusual: it is an example of how homeowners sometimes added fashionable elements to their older houses over the years. The doorway is classic Federal style, but the entablature overhanging it, with its carved brackets, had to have been added later. The house is likely 1810–20, but the add-ons are from the 1850s or later. The cast-iron railings are of Italianate-era vintage. There are a lot of hybrids (none exactly like this one) on the Heights, usually Federal buildings given Greek Revival flourishes or, later, Federal or Greek Revival buildings given Mansard roofs. No. 115, *at right*, has been razed. *Brian Merlis Collection.*

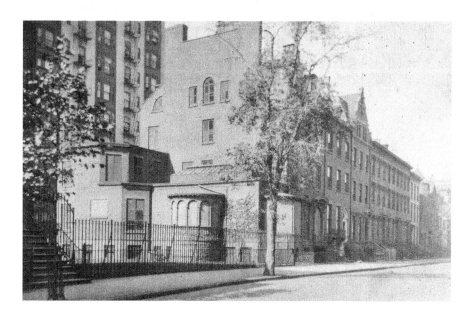

Demolished Houses

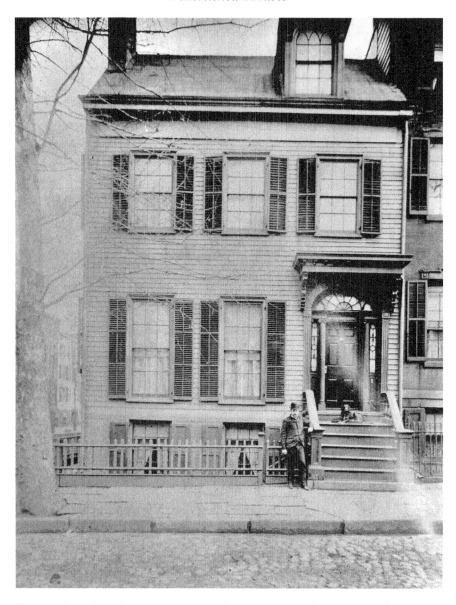

Figure 6. No. 61 Hicks Street was a Federal-style wooden house. Note the pattern in the transom and the attractive attic window. It is shown here in 1890 when it belonged to a member of the Schenck family, one of Brooklyn's oldest Dutch families. *Brian Merlis Collection.*

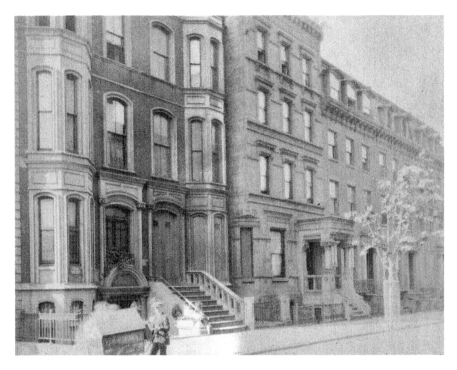

Figure 7. *From right*, 142, 144, 146, 148 and 150 Columbia Heights, between Clark and Pineapple Streets, in 1922. They still exist and are Greek Revival houses with Corinthian pilasters and Type E stairs. No. 146, the house with the portico, has had a large picture window added on the first floor. The door on 148, plain here, has had an era-appropriate one substituted. *Brian Merlis Collection.*

GREEK REVIVAL

The Greek Revival style uses mostly classical elements and is heavier-looking than the Federal style. The best-known examples of it are the Washington Monument by Robert Mills, the U.S. Customs House in lower Manhattan, the Litchfield Villa in Prospect Park by Alexander J. Davis, Brooklyn Borough Hall by Gamaliel King and 70 Willow Street, the Van Sinderen House (chapter 7, figure 2). Davis published many house model designs used in the area. They are built of wood or brick with brownstone or white marble trim, and their façades are in low relief—i.e., the sills and lintels barely break the plane of the brick front. The doorway enframements protrude, and the ironwork of the railings and fences is delicate with Greek motifs. The front door is single, but double doors were often substituted later.

Stairs, railings and ironwork were classified by Lancaster according to the following types:

A. The stoop is in front of the doorway with the stairs to one side (84 Willow Street).

B. Stairs are perpendicular to door with railings making a horizontal spiral to a post (no surviving examples in area).

C. Stairs are in front of doorway with complex ironwork and pagoda tops (155, 157, 159 Willow Street).

D. Stairs are in front of doorway with stone bases for the railing with iron basket urns above (135 Willow, razed; 13 Cranberry Street, urns missing).

Figure 8. No. 42 Willow Street is a Greek Revival house with a Type E stoop and great ironwork. From Lancaster's *Old Brooklyn Heights: New York's First Suburb.*

Figure 9. The stairs and railings on the Greek Revival house at 46 Monroe Place are the only complete specimen of Type D steps. *Robert Furman photograph.*

Three additional stoop types display on Greek Revival houses:

E. There are frontal steps, end blocks next to first few steps with vertical volute ironwork above (42, 44, 46, 69, 71 Willow Street).

F. There are frontal steps, blocks around lower steps have rounded front ends with horizontal volutes ironwork (39–52, 61–67 Joralemon Street).

G. There are frontal steps, railing volutes turn over short columns (121 State Street).

Figure 10. No. 103 Willow Street in 1915. It is a Greek Revival house with Type B steps and "Greek Ears" (the decorations above the doors and windows), and it dates from around 1848. The "Greek Ears" above the windows on the first and second floors and the ornaments on top of the fenceposts have been removed. A full fourth floor has replaced the attic dormers. *Brian Merlis Collection.*

Opposite, top: Figure 11. The scrolled ironwork on 79, 81, 83 and 85 Remsen Street makes them special. These Greek Revivals date from around 1841 and are shown in a modern photograph. *Robert Furman photograph.*

Houses with Major Alterations

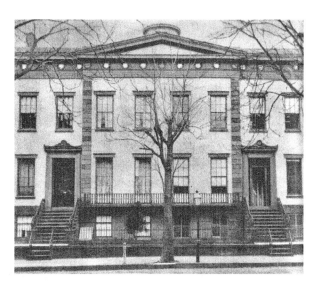

Figure 12. Nos. 108, 110, 112 and 114 Pierrepont Street were constructed circa 1840 in the Greek Revival mode, and in an unusual variation at that, apparently with later Ruskinian elements. No. 108 is the first Peter C. Cornell House, and 114 belonged to his brother George. The stairs and railings were Type E. From Lancaster's *Old Brooklyn Heights: New York's First Suburb.*

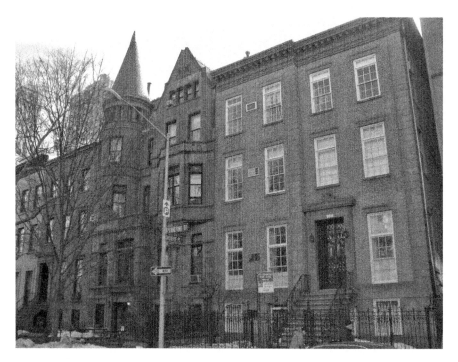

Figure 13. This is 108, 114 and 116 on the south side of Pierrepont Street at Monroe Place today. No. 108, the original condition house, is at right. No. 114, at left, was rebuilt in 1887 in Romanesque Revival. The American Institute of Architects (AIA) guide to New York's buildings states: "A simple brick building became a Wagnerian stage set." It became the Brooklyn Women's Club in 1912 (see chapter 6), was further altered and today has rock-faced brownstone covering the basement and parlor floors. Two floors were added and the stoop removed. The rooflines were modernized on the (relatively) original-condition houses, and the polychrome blocks were removed. *Robert Furman photograph.*

Demolished Houses

Opposite, top: Figure 14. This is Berenice Abbott's 1930s photo of the Greek Revivals at 131, 133 and 137 Willow Street. The cornice on 133 is extremely unusual. They have been replaced by a circa 1960 apartment house designated No. 135. *Brian Merlis Collection.*

Opposite, bottom: Figure 15. Nos. 79 and 85 Willow Street at Cranberry were wood-frame houses dating to around 1830. No. 85 was owned by Hans von (H.V.) Kaltenborn, a *Brooklyn Eagle* reporter who went on to become a conservative radio commentator. They are shown here in 1922. No. 79 at left was Greek Revival, and No. 85, to the right, was Federal. They were torn down for the Leverich Towers Hotel. *Brian Merlis Collection.*

132

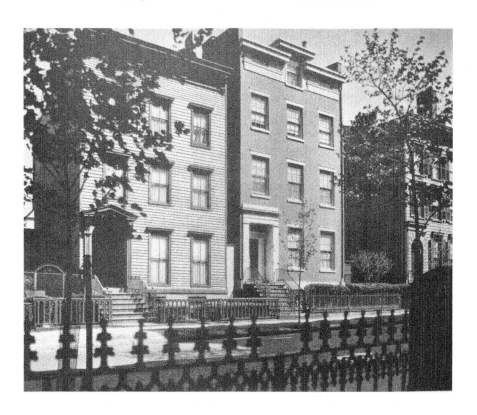

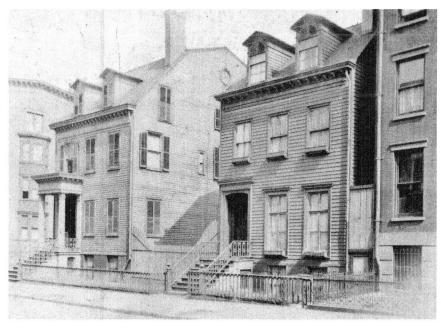

GOTHIC REVIVAL

The Gothic Revival style came to America principally for churches but was also very popular for homes, which feature carved spandrels, slender colonettes between interior rooms and medieval-style windows, ceiling plasterwork and railings. One would think that churchlike elements in a house would be anachronistic at best, but they work surprisingly well.

Francis Morrone writes, "The style was very popular in the Heights, especially for churches, since the style is associated with the great period of Medieval European ecclesiastical construction, with its apses and flying buttresses. Its principal exponent was the architect Minard Lafever whose work in this genre includes Packer Collegiate Institute, the Church of the Holy Trinity, the (former) Unitarian Church of the Saviour and the late Church of the Resurrection/Redeemer on Monroe Place. Richard Upjohn gave us Grace Episcopal Church. Despite its anachronistic qualities, it is my personal favorite." I agree.

Figure 16. No. 36 Pierrepont Street, the George Hastings House, is a great Gothic Revival house by Richard Upjohn that dates from 1846. It is one of the grand corner houses and the finest surviving Gothic Revival house in the area. Note the peaked arch entranceway. Besides his own house in Cobble Hill, this is Upjohn's only extant residential design in Brooklyn, and a great one. *Robert Furman photograph.*

Figure 17. Nos. 131 and 135 Hicks are the least modified Gothic Revival houses in the Heights and show medieval-style pointed arches. Henry Chandler Bowen built No. 131. Lewis Mumford and his wife, Sophia, moved to a small basement apartment in 135 Hicks in 1925, and he wrote about the house, that time and the area in 1982. He said: "Our new neighborhood was as genial an example of both urbanity and community as Boston's Mt. Vernon area…Hicks Street, then so humane and serene with its nearby assortment of restaurants, markets and shops, at hand but not under one's nose, met our need for esthetic comeliness and social variety. Small wonder many of our younger New York friends had begun to move over to the Heights." From Lancaster's *Old Brooklyn Heights: New York's First Suburb.*

Numbers 118, 120 and 122 Willow Street are a lovely Gothic Revival row. Number 118 (originally number 100) was owned by Judge Peter W. Radcliffe and dates from 1835. Number 120 is listed as number 102 in the 1829 city directory as the David Leavitt House. Number 122 (number 104) was owned by Joseph Sands, but the three date in present form from 1850. Number 124 was originally Gothic Revival and dates from 1831, with Romanesque stone posts flanking the entrance steps. It was modernized in the late nineteenth century with a Dutch gambrel roof.

Houses with Major Alterations

Figure 18. Nos. 80, 82 and 84 Willow Street today. Changes to no. 80 include the addition of a bay window and the removal of the balcony on the left side, the removal of the Type A stairs and the bay windows above, the substitution of a ground-level entrance and inappropriate balconies above on the right side and the reopening of the windows that had been closed up in 1897. Both were two stories when new. No. 82 (originally no. 86) dates from 1826 and was built for shipmaster Silas S. Webb. No. 84 (no. 70 in 1825) is from 1822 and shows some later remodeling. *Robert Furman photograph.*

Figure 19. This is the Philo P. Hotchkiss House at 80 Willow Street (originally 66 Willow) at the corner of Pineapple Street. It was constructed circa 1849 by George Chapman. Hotchkiss, a banker, rebuilt it in 1887 (note the bricked-up windows). Its Gothic Revival features probably date to that renovation and added a church organ. Brooklyn city directories suggest that he had moved to Carroll Gardens and that the house was occupied by his son. It was a Gothic Revival house with Type A stairs. From *The Eagle and Brooklyn*, 1898.

ROMANESQUE REVIVAL

The Romanesque Revival style was never as popular as Gothic Revival because its heaviness mostly limited its use to public buildings. The first building constructed in this manner in the United States was the former Church of the Pilgrims by Richard Upjohn (chapter 7, figure 18). Another fine local example is the former General Post Office (now the U.S. Bankruptcy Court and a local post office) on Cadman Plaza East and Johnson Street.

The style's great practitioner was Frank Freeman, whose local work in this style includes the former Fire Department Headquarters on Jay Street in Metrotech, the former General Post Office and the Herman Behr House at Henry and Pierrepont Streets (chapter 4, figure 17).

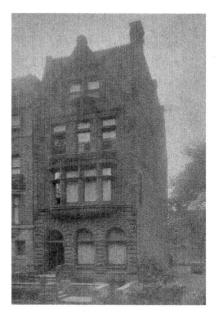

Figure 20. No. 6 Pierrepont Street (extant) is Romanesque Revival. It was built for Seth Low the Younger, but it does not appear that he ever lived there. The Misses Whites' Garden is at right in this 1922 photo. *Brian Merlis Collection.*

THE ITALIANATE STYLE

Italianate-style buildings feature elements from the Etruscan and Roman periods, namely plain walls (often stuccoed), clean-cut windows and low-pitched roofs with deep overhanging eaves on brackets and double entrance doors. Houses were often asymmetrical. These houses were often limestones and brownstones and show high relief on their façades, in contrast to the comparatively flat-faced Greek Revivals. The post–Civil War examples display a grandeur symbolic of the triumphalism of the industrial North and are the types of houses we often call "brownstones" (regardless of what they are actually made of), which proliferate in Park Slope, Fort Greene and Bedford-Stuyvesant. The best-known examples include Plymouth Church (chapter 7, figure 7) in a plain version of this mode. Other Italianate buildings were constructed nearby on Orange Street at numbers 22–30.

Extant Houses

Figure 21. Nos. 34, 36 and 38 Grace Court are lovely Italianate houses. Note the gorgeous bay window at left. *Robert Furman photograph.*

Figure 22. Nos. 253, 255 and 257 Henry Street are Italianate. They were 153, 155 and 157 in the old numbering system and are circa 1849. No. 253 has Renaissance Revival details and was once owned by Francis Vinton, the rector of Grace Church. No. 257 has late nineteenth-century details and fences. *Robert Furman photograph.*

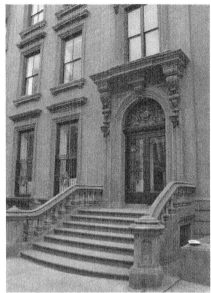

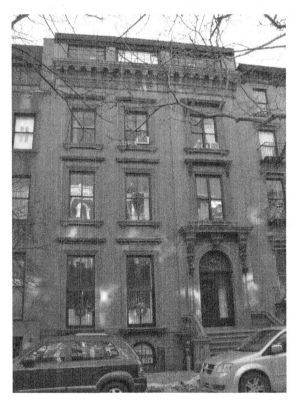

Above, left: Figure 23. The stained-glass bay window in the oriel in 40 Grace Court. *Robert Furman photograph.*

Above, right: Figure 24. The later nineteenth-century Italianate house at 124 Remsen Street had a fourth floor with picture window added but is otherwise well preserved. *Robert Furman photograph.*

Left: Figure 25. No. 124 Remsen Street has a grand entryway. *Robert Furman photograph.*

Demolished Houses

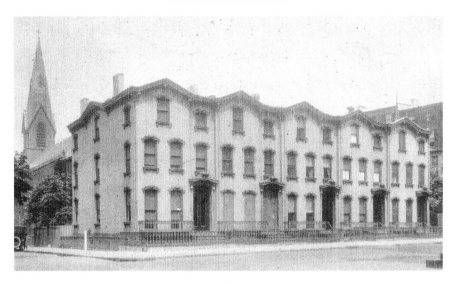

Above: Figure 26. Nos. 136, 138, 140, 142 and 144 Clinton Street at Aitken Place were built in 1845 and are shown here in 1922 when the row was still intact. The two on the right were demolished for 130 Joralemon Street, and the one on the left corner was torn down for a small office building, leaving 140 and 142 extant. This picture tells us what a loss those three houses were. They are a country vernacular version of Italianate, rather than that derived from palazzi. *Brian Merlis Collection.*

Right: Figure 27. No. 102 Remsen Street was a mansion in the Renaissance Revival Italianate style, shown here in 1921. It has been replaced by an apartment house at 100 Remsen Street. *Brian Merlis Collection.*

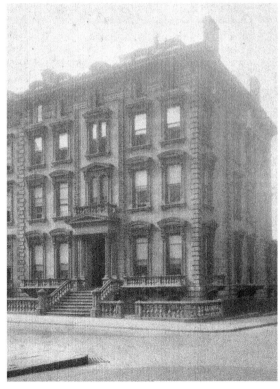

RENAISSANCE REVIVAL

The Renaissance Revival style is much richer in appearance than Italianate or Romanesque and was usually used in larger houses with higher ceilings. They also display great ornamentation such as capitals, friezes and acanthus leaves. Another significant aspect of this style is that brownstone was often utilized, which, like marble, quickly deteriorates, leading to the use of cast iron for architecural details, which were covered with paint and thus is often not distinguishable from stone. The style also utilizes the mansard roof (which disguises a full story) and was popularized during the French Second Empire, although it was invented there a century earlier.

The best-known buildings in this style are the A.A. Low, Alfred White and Henry Pierrepont Houses at 1, 2 and 3 Pierrepont Place (chapter 4, figures 12, 15 and 30).

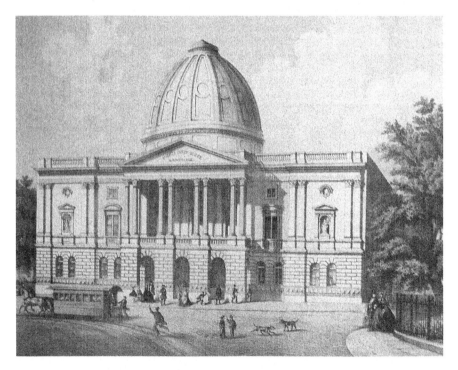

Figure 28. The late County Courthouse (1861–1960), on what was then known as Court Square, was opposite Borough Hall, where Brooklyn Law School now stands. It was a great example of Renaissance Revival work. Note how much more opulent it was as opposed to the austere Borough Hall, although they were both by the same architect, Gamaliel King. *Brian Merlis Collection.*

Figure 29. Nos. 168 and 170 State Street are red brick Renaissance Revivals with arched windows on the first and fifth floors; bays on the second, third and fourth floors; and a bas-relief pediment. *Robert Furman photograph.*

Figure 30. No. 149 Clinton Street on the northeast corner of Schermerhorn Street is a modernized Renaissance Revival with a fourth story added later. Note the two bay windows and the unusual bracketed cornice. The houses to the left—141, 143, 145 and 147 Clinton (originally 83, 85, 89 and 89)—are Greek Revivals from circa 1853. *Robert Furman photograph.*

Another example is the circa 1855 mansion at 123 Remsen Street occupied by the Brooklyn Bar Association (chapter 6, figure 61). A house at 220 Columbia Heights is another, including a mansard roof.

Demolished Houses

Opposite, top: Figure 31. This Renaissance Revival mansion graced the northeast corner of Remsen and Clinton Streets when the *Eagle* photographed it in 1922. *Brooklyn Public Library.*

Opposite, bottom left: Figure 32. Razed mansion at 138–40 Hicks Street in 1922. *Brooklyn Public Library.*

Opposite, bottom right: Figure 33. The Renaissance Revival 1874 Horace Claflin House at 55 Pierrepont Street in 1922. It was fifty-five feet wide and contained twenty thousand square feet. It would soon be razed for the current Hotel Pierrepont. *Brian Merlis Collection.*

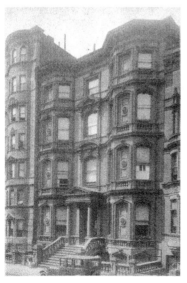

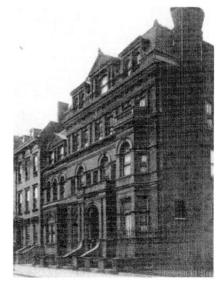

Venetian-Gothic Style

The Ruskinian or Venetian-Gothic style is named for the British critic John Ruskin, who believed in richness of ornament. This style features the pointed windows of the Gothic Revival but has alternating blocks of white and brown polychromatic stones in the arch and elsewhere. The principal examples in the area are the former St. Ann's Episcopal Church (chapter 6, figures 16 and 27), the demolished Mercantile Library (chapter 6, figure 6) and the Mechanics Bank Building of 1905 (chapter 9, figure 11). This style had little effect on domestic architecture.

Figure 34. Nos. 210 and 212 Columbia Heights, the center and left houses, still exist. They are Italianate and Renaissance Revival. No. 210 dates from 1852 but shows a Ruskinian doorway. The polychrome stones have lost their color. No. 212, from 1860, has an elaborate cornice. Iron railings have been substituted for the balustrade on no. 212. No. 204, the tall building toward the right, has been modernized with large windows and a new façade. The photo is from the 1920s. The fence in the foreground was around the Misses Whites' Garden. *Brian Merlis Collection.*

Figure 35. No. 7 Pierrepont Street, the James Lancaster Morgan House, of 1870, was the epitome of luxury in its day. It was Ruskinian (note the polychrome work around the door) and was demolished for the apartment building at 1 Pierrepont Street. Originally a three-story house, a fourth was added later. The late 201 Columbia Heights is at left and was also replaced by 1 Pierrepont Street. *Brian Merlis Collection.*

QUEEN ANNE STYLE

The Queen Anne style, named for the last British Stuart monarch of the early eighteenth century, is a mixture of Medieval, Palladian and other styles. The name would seem to be misleading in that the style is proto-modern because it resembles Art Nouveau. Number 123 Remsen Street features a Queen Anne entrance.

Extant Houses

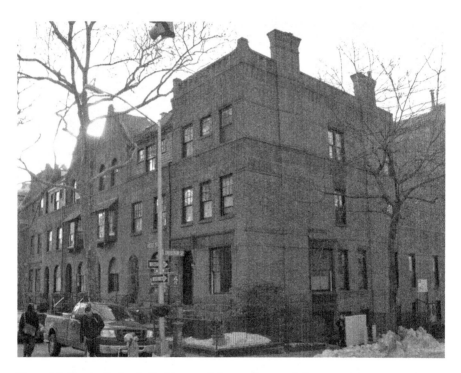

Figure 36. Harriet Packer built this row of Queen Anne–style houses at 262, 264, 266 and 268 Hicks Street in 1887. According to Francis Morrone, this is one of the preeminent rows of Queen Anne houses in Brooklyn. He adds in his essay on "Alfred White's Architects" in *The Social Vision of Alfred T. White*: "We note right away the essential elements defining the aesthetic concept: profuse gables, projecting bays, profuse doorway and window arches, and brickwork that is patterned so as to lend both line and texture to the wall surfaces. There is also a general sense of the spectator's being unable readily to tell where one house ends and another begins—as though too definite a delineation would violate a kind of 'organic' effect the architect is after." *Robert Furman photograph.*

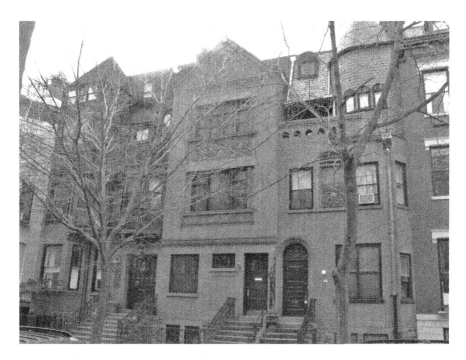

Figure 37. Nos. 108, 110 and 112 Willow Street are Queen Anne 1883 houses by W. Halsey Wood, of the sort common in Park Slope and Bedford-Stuyvesant. The *AIA Guide to New York City* calls them "New York's finest example" of the Queen Anne style. *Robert Furman photograph.*

Demolished House

Figure 38. No. 241 Henry Street is identified in this 1926 *Brooklyn Eagle* photo as the Packard House on Joralemon Street. Around 1950, it was razed for an apartment building at 245 Henry. Francis Morrone considers this "'châteauesque'—an adaptation of the 16th-century French château, which has a combination of Renaissance and Medieval forms. However, here it's twisted and pulled in a 'Queen Anne' direction. This is not uncommon for high Victorian buildings, where stylistic labels cease to be of much use. This is a 'Victorian mash-up.'" *Brooklyn Public Library Picture Collection.*

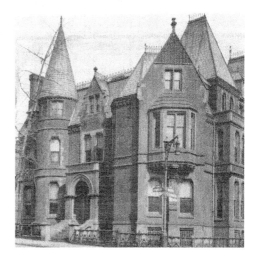

THE COLONIAL REVIVAL STYLE

The Colonial Revival style dates from the 1877 tour of New England Georgian-style houses by the members of the architectural firm of McKim, Mead, Bigelow and White. There are several local examples, and the best known is the Arbuckle Institute at Plymouth Church (chapter 7, figure 29).

Extant Houses

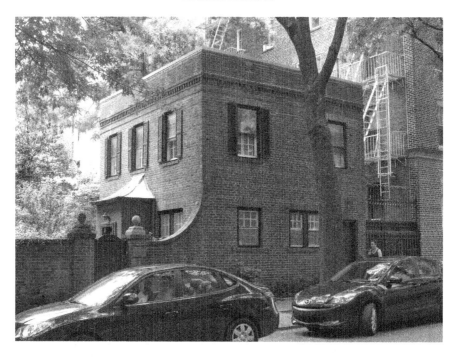

Figure 39. No. 14 Cranberry Street is a Neo-Colonial building. *Robert Furman photograph.*

THE BEAUX ARTS STYLE

The Neoclassic style, or Beaux Arts or City Beautiful styles, was derived from the White City at the World Columbian Exposition in Chicago of 1892–93. It utilized large-scale, particularly tall, thick columns and later gave birth to the City Beautiful movement for civic architecture (Manhattan Municipal Building). The local examples were the Brooklyn Savings Bank (chapter 8,

figure 10) on Pierrepont Street, the Brooklyn Trust Company (now a Chase branch) on Montague and Clinton Streets (chapter 8, figure 12), and the Hotel Bossert (chapter 6, figure 44).

Extant Houses

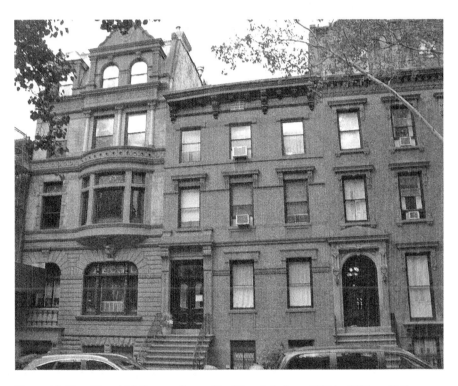

Figure 40. Nos. 87 and 89 Remsen Street. No. 87, at left, from 1889 by William H. Beers, is described by Francis Morrone as follows in his *An Architectural Guidebook to Brooklyn*: "The stoop has been removed from this beautiful house that is otherwise in pristine condition. A rock-faced brownstone basement yields to smooth rusticated sandstone at the first floor, which features a prominent segmental-arched window with rusticated voussoirs and a fine console bracket at the keystone. The mood changes at the second floor, which is faced in brick with stone trim. Twisted moldings surround a bowed oriel with stained-glass transoms. An open parapet tops the oriel and encloses a third-floor balcony, the windows behind which are divided by three polished granite columns with composite capitals. Crowning it all is an exuberant Flemish gable." No. 89, with 91 and 93, according to Clay Lancaster, is an 1843 Greek Revival with a console cornice and other stonework around the doors and windows. *Robert Furman photograph.*

Figure 41. Nos. 24, 26, 28, 30 and 32 Pierrepont Street are an attractive row of Beaux Arts or Georgian Revival houses that date from the late nineteenth century. *Robert Furman photograph.*

Figure 42. Engine Company 224 at 274 Hicks Street is a Beaux Arts building from 1903 with attic dormers. Note the carriage houses at left to its immediate south. *Robert Furman photograph.*

The Neo-Grec Style or Palladian Style

Neo-Grec style is a latter-day adaptation of classic principles. It is based on the work of Venetian architect Andrea Palladio (1508–1580), and later buildings in this style represent an evolution of his concepts, especially including symmetry of design. A hallmark of his work is Palladian windows featuring arches above.

This style is known in this country to a great extent because of the work of the great British architect Inigo Jones, such as the Banqueting Hall in London and the Queen's House in Greenwich. Thomas Jefferson's designs for both Monticello and the Rotunda at the University of Virginia are Palladian, featuring his trademark huge domes and columned façades reminiscent of the Pantheon in Rome.

Extant Houses

Figure 43. A very large house, 236 Henry Street, on the northwest corner of Joralemon Street, includes the small Neo-Georgian unit at right. *Robert Furman photograph.*

ECLECTIC HOUSES

The Modern period added many buildings—some of merit, others not. The Daniel Chauncey House (figure 44) is a good one since it draws from older sources. While Clay Lancaster disliked any later styles, many structures of the pre–International Modern era—including Beaux Arts, Art Deco, Art Moderne and their hybrids—are aesthetically pleasing. They were used for apartment houses, which are described in chapter 9. There are few small residential buildings in this style but many apartment buildings, many of which are strictly utilitarian, especially those built in the 1930s and later. The Beaux Arts style is transitional between Victorian and modern approaches and was used extensively for office buildings but for very few residential buildings. Art Nouveau and Art Deco were derived from Queen Anne and utilize organic forms, especially large

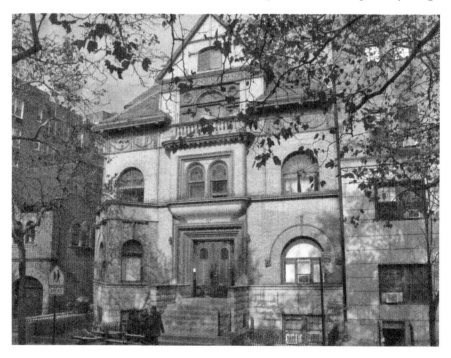

Figure 44. No. 129 Joralemon Street, at left, the extant Daniel Chauncey House, is a Chicago Romanesque Revival house by C.P.H. Gilbert, and has a bungalow feeling. It was built by the son of the developer of the row of houses portrayed in Part V, Figure 19. The house next door was federal with a cast iron porch and was replaced by an apartment building at No. 131. *Brian Merlis Collection.*

Figure 45. No. 222 Hicks Street at Remsen is a later nineteenth-century eclectic house. *Robert Furman photograph.*

curving shapes. Art Nouveau reached its apotheosis in Europe, especially in France, where the Paris Metro utilized it for its entries, but it was never that popular in the United States. The only building in the area using this style was the late Brooklyn Bank on Clinton Street south of Fulton Street (chapter 8, figure 11). Art Deco was only used for large-scale buildings. The best-known local examples are the Chamber of Commerce Building at 75 Livingston Street at (66) Court Street (chapter 9, figure 7) and the National Guarantee Trust Building at 185 Montague Street.

EDUCATION, CHURCHES, CULTURE, HOTELS AND CLUB LIFE

1778–Present

The Heights was the capital of Brooklyn when it was a separate city. Its location on a bluff above the East River and proximity to city hall and the courts worked together to create a unique area that was a downtown, fine residential area and cultural center all in one. Very quickly after its 1834 founding, the civic and political leaders of the city of Brooklyn determined to make it a cultural and educational oasis to compete with New York, the neighboring behemoth.

As it began to grow, Brooklyn attracted ambitious young men from New England, principally from nearby Connecticut and Massachusetts, who embraced the gospel of business and social improvement. They were merchants and lawyers, and many joined the churches that best expressed this: Plymouth and the First Unitarian. They became the leadership class of the city, supplanting the older Dutch and, to an extent, British population.

The democratic spirit of the new nation motivated wealthy people to be civic-minded and to engage in uplift activities to benefit the entire community and especially the poor. To this end, numerous educational and cultural institutions were founded. These projects were the product of a religious sense of obligation among evangelical Protestants out of both their sense of superiority as moral and wealthy people and their need to assist their lessers to become better citizens—to work, not drink too much and to become religious. This is an approach with which we both sympathize and disagree.

One of the earliest religious and educational institutions in the Heights area was the Brooklyn Union Sabbath School, organized in the early

Figure 1. The Apprentices' Library, built in 1825, was the first institution in Brooklyn to serve the public. From Chester A. Allen's *Our Brooklyn*, 1954.

1820s by devout Methodists Robert "Poppy" Snow and Andrew Mercein. They drew on all of the Protestant churches to engage in moral uplift and educational activities for the poor. Its first permanent location was in a frame building on Adams Street between High and Sands Streets, and it included a collection of three hundred books.

THE APPRENTICES' LIBRARY

The Apprentices' Library, organized by Snow and Alden Spooner, started out in 1823 in a room on Fulton Street. Its purpose was to provide some of the educational support kicked away by the free labor system that had eliminated apprenticeships and to keep young men out of grogshops. The trustees decided to obtain a proper building for the library and raised funds to build it on the southwest corner of Henry and Cranberry Streets (figure 1). It was dedicated in a July 4, 1825 ceremony attended by the Marquis de Lafayette, who then was on his triumphant final United States tour.

The library was modeled on the extant General Society of Mechanics and Tradesmen's Library in Manhattan (which still exists) at a time when

similar institutions were being established throughout the country. Alden Spooner, founder and editor of Brooklyn's first newspaper, the *Long Island Star*, said its purpose was to provide "lectures upon Mechanics and Sciences, and for the deposit of lecturing apparatus, useful machinery, models of improvements, with specimens of the arts and natural production."

Walt Whitman (figure 2) attended the opening as a child and, after 1885, described the scene:

> *Lafayette came over at Fulton Ferry (then called the old ferry) in a large canary-colored open barouche, drawn by four magnificent white horses, and passed through these lines of little children (of which the present writer was one), and a number of blacks freed from slavery by the then recent New York emancipation acts. These diversified the assemblage which was composed of the principal persons and officers of Brooklyn, of course, with Joshua Sands+, President of the Board of Trustees* [Sands sponsored Olympia; the trustees governed the village of Brooklyn], *who had gathered at the landing place. The Revolutionary veterans, if I remember right, being entertained in the meantime at Coe S. Downing's Inn, then a well-known public house on the east side of the street* [Fulton] *between Front Street and the ferry. I think there was a band of music.*
>
> *Lafayette, with his hat off, rode slowly through the lines of children and the crowd that was gathered on the walks, and that looked at him and cheered him from the houses, all the way up. I remember that the fine horses and their impatient action under the curb attracted my attention fully as much as the great visitor himself. The whole thing was curiously magnetic and quiet. Lafayette was evidently deeply pleased and affected. Smiles and tears contended on his homely yet most winning features.*

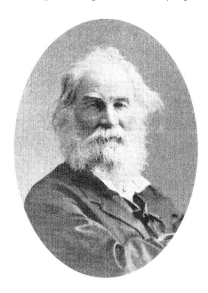

Figure 2. Walt Whitman was Brooklyn's greatest poet and a newspaperman, civic activist, historian and memoirist. Born in Huntington, Long Island, he lived on Front, Cranberry, Henry, Johnson and Tillary Streets both as a child and as an adult. From *The Eagle and Brooklyn*, 1898.

After he had gone ahead, to where Market Street now is, the carriage stopped, and the children, officers, citizens, etc., formed behind him in procession, and followed him up to the corner of Henry and Cranberry Streets, where the operation of laying the cornerstone was to be performed by Lafayette with his own hands—that is grasp the stone personally. Some half a mile from the ferry he stopped, got out of the barouche, and in the center of a group of veterans and some of the functionaries of Brooklyn, he awaited the arriving and getting in order of the children and the rest of the procession. The excavation, etc., for the foundation walls and basement for the proposed building was quite rough, and there were heaps of earth and stone around, as was to be expected in such cases.

As the children arrived there was a little delay in getting them into safe and eligible places—whereupon many of the citizens volunteered to lift the smaller fry down the banks of the cellar, and place them on safe positions, etc., so that they might have a fair share of the view and hearing of the exercises. As most of the group around Lafayette were assisting in this work, the old companion of Washington, while waiting the signal to begin, pleasantly took it into his head to aid the same work himself, as he was in a place where there were a number of lads and lassies waiting their turn to be lifted down. As good luck would have it, the writer was one of those whom Lafayette lifted down to be provided with a standing place. I remember I was taken up by Lafayette in his arms and held a moment—I remember that he pressed my cheek with a kiss as he set me down—the childish wonder and nonchalance during the whole affair at the time—contrasting with the indescribable preciousness of the incident since.

I remember quite well Lafayette's looks, tall brown, not handsome in the face, but of fine figure and the patterns of good nature, healthy manliness and human attraction. A life size full length oil painting exhibited years ago in Philadelphia, in 1877, I think, seems to me an admirable likeness as I recollect him at the time. [The portrait is in the Governor's Room in New York City Hall.]

The beautiful sunshiny day, over sixty years ago, the spontaneous effusion of all stages of humanity, and the occasion, made a picture, which time has continued to set deeper and deeper in my recollection.

Graham Hodges reports in *David Ruggles: A Radical Black Abolitionist and the Underground Railroad in New York City* (see chapter 7) that Lafayette, who was antislavery, met with newly freed blacks in Brooklyn and greeted their children warmly.

The library immediately became Brooklyn's center. The trustees of the Village of Brooklyn, who functioned as a town council and who had previously gathered in the back room of a grocery store, began meeting there, so it became a de facto village hall. The local post office and Brooklyn's second bank, the Brooklyn Savings Bank, founded in 1827 by Augustus Graham and other Apprentices' Library associates, with Adrian Van Sinderen as president, also moved into the first floor. In 1840, the Apprentices' Library

Figure 3. The Brooklyn Institute was housed in this building on Washington and Concord Streets until it was damaged by a major fire in 1890. From Henry Stiles's *A History of Kings County*, 1884.

Figure 4. Augustus Graham, industrialist, brewer, distiller and philanthropist. From Henry Stiles's *A History of Kings County*, 1884.

was reorganized at its Henry Street site by John B. Nichols and distillers Augustus Graham (figure 4) and John Bell, who changed his name to Graham.

The Apprentices' Library building was sold to the City of Brooklyn in 1836 and served as city hall until the current one was completed in 1848. It also was used as a police court and the county courthouse after the old one in Flatbush burned down. In 1849, the Thirteenth and Fourteenth army regiments used it as an armory, a role it continued to play during the Civil War, when regiments marched south from there. It was torn down during the war to build a new armory (chapter 7, figure 13).

THE BROOKLYN INSTITUTE AND AUGUSTUS GRAHAM

Augustus Graham (1776–1851) was an English emigrant whose original name was Richard King. He arrived in Maryland in 1806 and in Brooklyn in 1815. He owned a distillery near the Navy Yard that burned down in 1816 and was rebuilt on Fisher Street near Fulton Ferry. Augustus and John Graham sold their upstate brewery in 1822, and Augustus helped start the white lead (paint) business in America via the Brooklyn White Lead Paint Company.

Augustus and John were not related; they actually seem to have been a couple although they described each other as brothers—Augustus left his wife and children in Maryland (although he continued to support them) to live with John at Dock and Front Streets. They were joined by their widowed "sister" Martha Graham Taylor, who lived with them until her death in 1829. John later moved to 11 Monroe Place and married his housekeeper, and the two later moved to separate residences on Sands Street.

The Brooklyn Lyceum evolved from a private school, Eames & Putnam's English and Classical Hall on the east side of Washington Street between Tillary and Concord Streets (the site is now across from Cadman Plaza Park), which received the Apprentices' Library's book collection when that building was sold. The Brooklyn Lyceum took over the building in 1833, but it expired in the financial panic year of 1837.

In 1841, the library moved into the former Lyceum building as the Youths' Free Library, and in 1843, via Mr. Nichols's generosity, it received a charter as the Brooklyn Institute (figure 3). In 1848, Augustus Graham built a new building for the institute across Washington Street, and when he died in 1851, he left it a magnificent endowment of $27,000. Graham was also a founder of the Brooklyn Hospital with a $30,500 donation and was an active member of the First Unitarian Church. He is shown on the 1820 Francis Guy painting of Brooklyn Ferry.

The institute was a reading room with art studios that also offered night-school classes in grammar, bookkeeping and drawing and sessions in architecture, as well as mechanical, landscape and figure representation. It remained on Washington Street until the building was severely damaged by fire in 1890. Thereafter, it shared space with other area institutions. In 1892, the damaged building was sold to the New York Brooklyn Bridge Company for bridge improvements and razed. The organization changed its name to the Brooklyn Institute of Arts and Sciences and, in 1895, began construction of its Brooklyn Museum. It later gave birth to the Brooklyn Botanic Garden and Brooklyn Children's Museum. The institute was later housed in the new Academy of Music on Lafayette Avenue, which had joined its family of institutions. Today the institute is housed in the Brooklyn Museum.

THE BROOKLYN ATHENAEUM AND THE MERCANTILE LIBRARY

The Brooklyn Athenaeum, a four-story structure on the northeast corner of Atlantic Avenue and Clinton Street (figure 5), began in 1852 as a meeting and concert hall. It was not a success, and new supporters turned the building into the Brooklyn Mercantile Library in 1857, which occupied part of the building until 1869, when the library built its own structure on Montague Street, designed by Peter B. Wight (figure 6). This was the beginning of the Brooklyn Public Library system. The name was changed to the Brooklyn

Figure 5. The Brooklyn Athenaeum was on the northeast corner of Atlantic Avenue and Clinton Street. It was an early library and educational institution. This is the building in 1922, after the Athenaeum was long gone. *Brian Merlis Collection.*

Library in 1878 and then the Brooklyn Public Library, reflecting a decision that it should be free to the public. The Brooklyn Public Library began separately in 1890 with neighborhood branches, but the two later merged. In the late 1890s, it was suggested that a larger central library was needed, and Reverend Richard Storrs of the Congregational Church of the Pilgrims (see chapter 7) suggested a site on Grand Army Plaza. The Mercantile served as the central branch of the Brooklyn Public Library until the central library on Grand Army Plaza opened in 1940, but it also housed commercial tenants, such as *Brooklyn Life Magazine* (see chapter 8).

In 1931, the Montague Street branch was condemned by the fire department, so the library proposed an office building on its site with the lower floors serving as the library and the upper ones as income-producing space (figure 7).

The collapse of the commercial real estate market in the Heights during the Great Depression scotched this idea. The Mercantile branch was rehabbed and served as the local library until its demolition in 1960. The Mercantile was replaced by the Brooklyn Heights Business Library of 1961

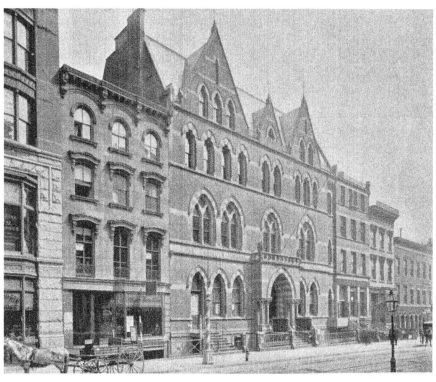

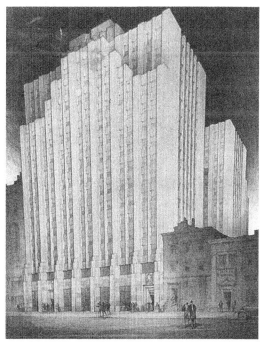

Above: Figure 6. The Mercantile Library was the main branch of the Brooklyn Public Library until the Grand Army Plaza building was completed in 1940. It was razed in 1960. From Henry Stiles's *A History of Kings County*, 1884.

Right: Figure 7. Proposed 1931 mixed-use building to replace the Mercantile Library. *Robert Furman Collection.*

on Cadman Plaza West (chapter 11, figure 6), which thus traces its heritage back to at least 1857.

In an eerie echo of the past, in 2013 the Brooklyn Public Library proposed a scheme similar to its 1931 formulation that would take advantage of an inflated real estate market and sell the site of the Business Library to a developer who would construct a high-rise residential structure that would house the local branch on its lower floors. This would provide funds for a modern branch with new central air conditioning, a chronic problem for the current building. The Business Library would relocate to the Central Branch at Grand Army Plaza, a plan that engendered much opposition from those who felt it should be near downtown.

THE BROOKLYN HISTORICAL SOCIETY

The Long Island Historical Society was begun in 1863 by the many civic activists we have met before, including Henry Stiles, Henry Pierrepont, Henry Cruse Murphy (an early Brooklyn mayor and major political leader) (figure 9) and Alden Spooner II. A meeting was called by Murphy and Spooner for February 4, 1863, to establish a repository for books, documents and manuscripts relating to the history of all of Long Island. It opened in the Hamilton Building on the west side of Court Street at Joralemon Street in June 1863, with Stiles as librarian, but he resigned after two years to devote his free time to writing (he was a physician).

Stiles and Murphy were also historians. Stiles and Spooner had already published Silas Woods's *Sketch of the First Settlement of the Several Islands, with Their Political Condition, to the End of the American Revolution* and Gabriel Furman's *Notes Geographical and Historical Relating to the Town of Brooklyn in Kings County on Long Island*, the first history of Brooklyn, which Spooner encouraged Furman to write in the course of his relationship with a publisher. Stiles, besides his renowned histories of Brooklyn and Kings County, also authored an account of the prison ship martyrs and histories of the Stranahan (see chapter 7 on James S.T. Stranahan) and Josselyn families.

Although a politician, Murphy, who was a founder of the Democratic Party organ the *Brooklyn Eagle*, did historical research during his tenure as ambassador to Holland from 1853 to 1860. He turned up the journal written by two agents for the Labadist religious sect who visited Brooklyn in 1679 to seek a friendlier clime for their Quaker-like group, since America was a

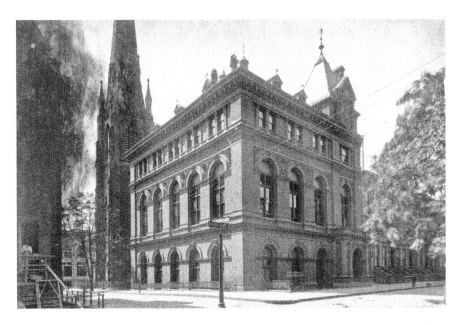

Figure 8. The Long Island Historical Society in 1897. This scene is largely unchanged. *Brian Merlis Collection.*

Figure 9. Henry Cruse Murphy, shown here in 1877, was the major leader of the Democratic Party in Brooklyn, a founder of many of the major local institutions, such as the *Brooklyn Eagle*, and president of the Brooklyn and Manhattan Bridge Company, builder of the Brooklyn Bridge. From Henry Stiles's *A History of Kings County*, 1884.

sanctuary for religious dissenters. This work is still an important reference for the history of both the early Dutch settlers and the local Native Americans. The historical society's early publications include Henry P. Johnston's *The Campaign of 1776 Around New York and Brooklyn*, 1878; Thomas W. Field's *Historical and Antiquarian Scenes in Brooklyn and Its Vicinity*, 1868; *Memoirs of the Long Island Historical Society, Vol. 2, The Battle of Long Island with Preceding and Subsequent Events*, 1869; and *Recollection of Incidents of the Revolution of the Colonies Occurring in Brooklyn, Collected from the Manuscript of Jeremiah Johnson, Descriptive of Which He Personally Witnessed, Journal of Long Island History*. These are still used by historians, and Johnston is cited herein.

The process of building a permanent home for the historical society began with the acquisition of its present site in 1868 (chapter 8, figure 3) when the area still contained many vacant lots, but funds for construction were lacking. A fire in the Hamilton Building in 1874, which damaged some of the collection, gave impetus to acquiring a new home, and Reverend Richard Salter Storrs led the effort, which raised $100,000. Storrs was president of the society from 1873 until his death in 1900.

The historical society completed its splendid palazzo on Pierrepont and Clinton Streets in 1881 (figure 8) using a design by George B. Post, and it was the first building in today's New York City to use extensive terracotta ornamentation. It features eight busts on the exterior spandrels by Olin Levi Warner. Benjamin Franklin and Christopher Columbus are portrayed on the Clinton Street side, with Johannes Gutenberg, William Shakespeare, Michelangelo and Ludwig van Beethoven on Pierrepont Street. There are also busts at the entrance of a Viking and an Indian, representing early Americans.

The most significant space in the building is the renamed Othmer Library, which is a New York City interior landmark, designated in 1982. The library includes 155,000 volumes, which, besides papers and books on Brooklyn history, includes extensive genealogical holdings, an original copy of the 1863 Emancipation Proclamation, the Henry Ward Beecher papers and a recently discovered original of the Ratzer map (see chapter 2). In the 1890s, and at least through 1910, there was a concert hall on the ground floor called Historical Hall. The library retains its original furnishings, stained-glass windows, columns and interior railings carved of black ash. In 1985, the organization changed its name to the Brooklyn Historical Society, reflecting its modern focus.

Among the distinguished librarians of the society was Emma Toedteberg, who took over the job in 1900 and compiled most of the family histories there.

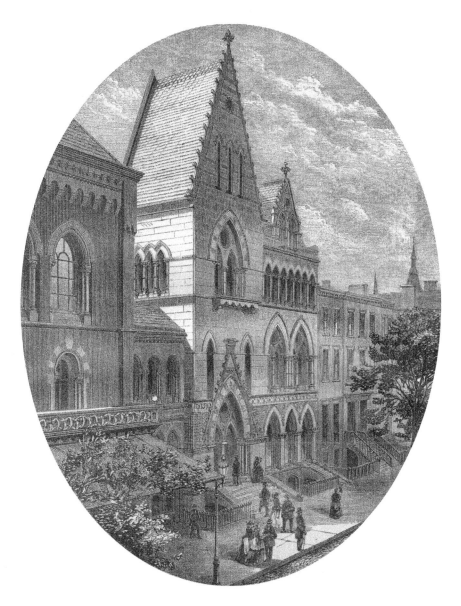

Figure 10. The Brooklyn Art Association is beautifully portrayed in this 1877 engraving. The Brooklyn Academy of Music is at left. From Henry Stiles's *A History of Kings County*, 1884.

At her death in 1935, she left the society $5,000, along with six thousand bookplates, a collection begun by her father, Augustus, an illustrator and artist. Later, Emma Huntington, who took over after Toedteberg, created a list of past and present monuments in Brooklyn, mostly related to the Revolution, which many (including this author) have found extremely useful.

The society has gone through many presidents in the last ten years. It received $16 million from the Othmer bequest in 1998, which led it, like the other recipients of the bequest, to engage in too-grand expansion plans, resulting in serious financial problems. The building closed for renovations in 1999 while the institution maintained offices in Metrotech. It reopened in 2003. Some of the plans, such as a gift shop and café, were abandoned. The current president, Deborah Schwartz, has stabilized its finances.

In December 2010, the society announced its new computer system, called EMMA, in honor of Emma Toedteberg. Available as of 2012, it is a comprehensive listing of the society's holdings. While it is not available online, it is an invaluable resource to historians and other researchers.

THE BROOKLYN ART ASSOCIATION

The Brooklyn Art Association began in 1861 and constructed a lovely building by Josiah Cleveland Cady next to the Brooklyn Academy of Music (see below) in the late 1860s (figure 10). Its function was to promote art by selling members' work at an annual reception. The building later was a social venue. The association became part of the Brooklyn Museum, and its home was later converted for commercial use.

THE BROOKLYN ACADEMY OF MUSIC

In 1861, the original Brooklyn Academy of Music (figure 11) opened in a rather chunky-looking Gothic pile by Leopold Eidlitz on the south side of Montague Street at number 178–94, between Court and Clinton Streets. It had been organized at the request of the Brooklyn Philharmonia, which was founded in 1857 by, among others, A.A. Low, Alexander White and Henry Pierrepont, because the orchestra needed a first-rate performance venue. It immediately became *the* gathering place in Brooklyn. The opening

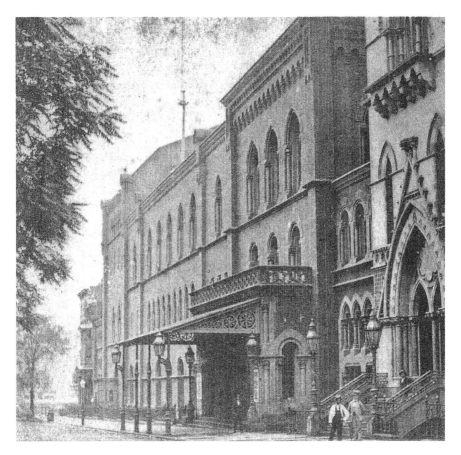

Figure 11. The original Academy of Music on the south side of Montague Street between Court and Clinton Streets in 1895. The Brooklyn Art Association, to its right, replaced Knickerbocker Hall (see chapter 7). From *The Eagle and Brooklyn*, 1898.

concert on January 19, 1861, was attended by soon-to-be first lady Mary Todd Lincoln and her sons Robert and Tad.

Before the opening of the academy, concerts were given in summer gardens, churches, the Athenaeum and the Brooklyn Polytechnic Institute, then located on Livingston Street between Court Street and Boerum Place. Among those performing at Poly was the Jewish Louisiana composer Louis Moreau Gottschalk, who is buried in Green-Wood Cemetery. The second floor sported an auditorium where plays were presented; this was the venue where the great Shakespearean actor Edwin Booth made his final appearance as Hamlet in 1891. His presidential assassin brother, John Wilkes, also performed there in 1863 as Richard II in the Shakespeare play.

The opening ceremonies for the Brooklyn Bridge took place at the academy in 1883, presided over by bridge company president and former Brooklyn mayor Henry Cruse Murphy (figure 9), who had lived on an estate at what became Owl's Head Park in Bay Ridge and later at 133 Remsen Street (now razed), and Reverend Richard Salter Storrs. There were also speeches by Governor Grover Cleveland, who would succeed President Chester Alan Arthur, also a New Yorker who had been head of the New York Customs House, a major source of federal revenue and local patronage.

A memorable concert took place in the academy when "Waltz King" Johann Strauss, while conducting the orchestra, grabbed a violin from a musician and played "The Blue Danube."

The academy's assembly rooms were used for social events such as the Ihpetonga Ball (figure 52). In 1903, the academy burned down without loss of life, and its replacement was raised on Lafayette Avenue.

An early "Brooklyn Museum" was located at Fulton and Orange Streets with pictures, stuffed animals and birds.

COURTS

In the nineteenth century, there were two courthouses in the Heights and, of course, others downtown, most notably the county courthouse on Joralemon Street (see chapter 5, figure 28). One was a Children's Court (today the Family Court) in the Berrean Building on Court and State Streets. The federal courthouse for the Eastern District of New York, covering all of Long Island, was on the southeast corner of Montague and Clinton Streets (figure 12). Its building was put up in the 1870s and enlarged around 1890 for the Brooklyn City Rail Road Company (chapter 9, figure 8).

The U.S. Bankruptcy Court for the Eastern District sat in an office building at the eastern end of the block bounded by Montague, Court, Remsen and

Opposite, top: Figure 12. The federal courthouse for the Eastern District of New York was first on the southeast corner of Montague and Clinton Streets from the 1870s until around 1890. The Art Institute is at left in this 1875 photo. *Brian Merlis Collection.*

Opposite, bottom: Figure 13. The Appellate Division of the New York State Supreme Court, the second level of state appeals court, stands on the northwest corner of Monroe Place and Pierrepont Streets. It replaced the Second Reformed Church in 1935. *Robert Furman photograph.*

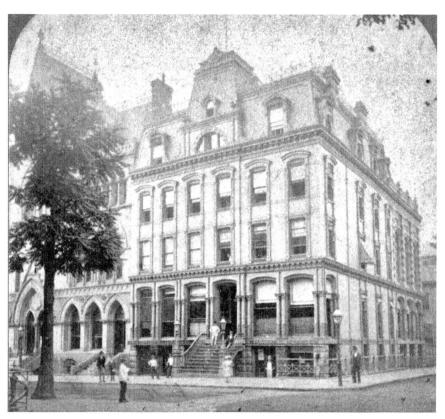

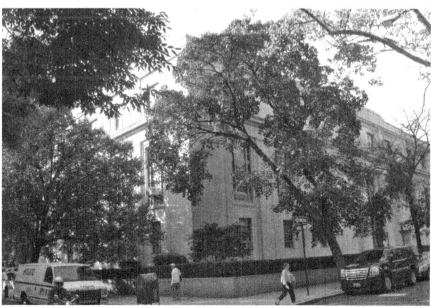

Clinton Streets until 2009, when it moved into the former General Post Office on Cadman Plaza East (which began life as a federal building), and its old home was replaced by an apartment building.

Today, the only courthouse in the Heights is the Appellate Division of the New York State Supreme Court on Monroe Place and Pierrepont Street (figure 13).

PRIVATE SCHOOLS

Early private schools included the Brooklyn School, founded by John Doughty+ in 1802, in the north Heights, which was succeeded by another of the same name run by George Hamilton. Joshua Sands+ was involved with the Brooklyn Select Academy, and in 1813, society ladies began a school for poor children called the Loisian Seminary, which lasted as long as volunteer teachers staffed it. It thereafter became a public school.

Packer Collegiate Institute

Packer Collegiate Institute is the area's oldest non-religious institution surviving in its original form. It was founded as the Brooklyn Collegiate Institution for Young Ladies or Female Academy in 1839 on Henry Street just south of Clark Street in the former John Jackson House of 1822 (figure 14), which later was the Brooklyn Orphan Asylum and the Mansion House Hotel. This site is shown on the Martin map of the Heights section of the city of Brooklyn (chapter 4, figure 4).

The school was reorganized on Joralemon Street between Court and Clinton, where it is shown on the 1849 Colton map of the city of Brooklyn. This structure burned down in 1853, but its reconstruction in 1854 in a Tudor Gothic design (figure 15) by Minard Lafever was endowed by Harriet Putnam Packer, widow of William Satterlee Packer (chapter 4), to the tune of $65,000 (equivalent to over $1 million today).

Harriet Packer was the most prominent woman in Brooklyn Heights during its great period. She attached a major condition to her gift: that a parallel school for boys be established, which was founded on Livingston Street and Boerum Place under the name the Brooklyn Collegiate and Polytechnic Institute. This prep school moved to Bay Ridge in the early

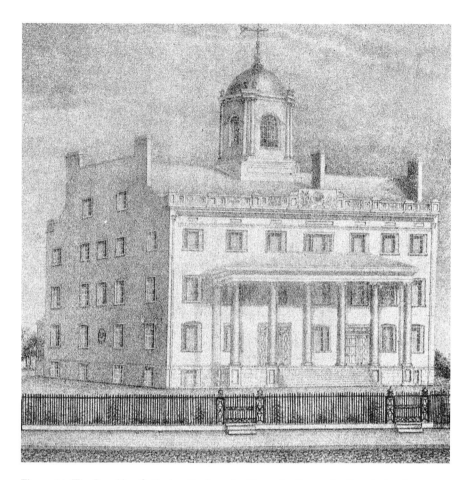

Figure 14. The Brooklyn Collegiate Institute for Young Ladies, or the Female Academy (later Packer Collegiate Institute), was founded on Hicks Street south of Clark Street. This building had previously been the John Jackson mansion and the Brooklyn Orphan Asylum. Packer moved to Joralemon Street, and this building became part of the Mansion House Hotel. From *The Eagle and Brooklyn*, 1898.

1920s, and its main campus on Livingston Street and Boerum Place became a college: today NYU–Polytechnic University on Jay Street.

The original school building on Joralemon Street survives as Founders Hall. It sported a 112-foot tower with a revolving astronomical observatory in a dome, which was removed in the early 1900s.

To the west is the chapel by the Napoleon LeBrun Sons firm. The east wing of 1886–88 is the science area, and the west wing includes Alumnae Hall of 1907 and the 1957 Katherine Sloan Pratt House.

Figure 15. The main building of Packer Institute, Founders Hall, shown here in 1897, is the same today. From *The Eagle and Brooklyn*, 1898.

Packer ran a junior college on the campus from 1919 until 1972, when the school went co-ed. In the well-remembered 1960s TV sitcom *The Patty Duke Show*, she attended "Brooklyn Heights High School"—Packer before boys were admitted.

In 1969, after the merger of the Episcopal Church of the Holy Trinity on Montague Street with St. Ann's Episcopal Church, Packer acquired the neighboring St. Ann's church building (figure 16). The school now serves 998 students.

It is significant that the first private school in the Heights was for young women at a time when that was practically unheard of and female equality was but a distant dream.

St. Ann's School

St. Ann's School was founded in 1965 by St. Ann's Episcopal Church in its basement in response to increased demand from the new brownstoner population (see chapter 13) for high-quality education. In 1966, it took over

Figure 16. The back of the former St. Ann's Episcopal Church as seen from Joralemon Street. This view is immediately to the west of the one on the following page (the former St. Ann's building is now part of Packer). *Robert Furman photograph.*

the former Century Club at Clinton and Pierrepont Street (figure 17) and became independent of the church in 1982. Its first headmaster was the late Stanley Bosworth.

The school has expanded over the years. According to its website, the preschool is located in the Alfred T. White Community Center at 26 Willow Place (chapter 13, figure 6), the kindergarten is in the First Presbyterian Church at 124 Henry Street (figure 32), the Lower School is located in the Farber Building at 153 Pierrepont Street and the middle school and high school are in the former Century Club, now the Bosworth Building, at 129 Pierrepont Street. The computer center and several middle and high school classrooms are housed in 1 Pierrepont Plaza; the office of admission, the development office and the art studios are in the Rubin Building at 124 Pierrepont Street, and several classrooms and offices occupy 122 Pierrepont Street.

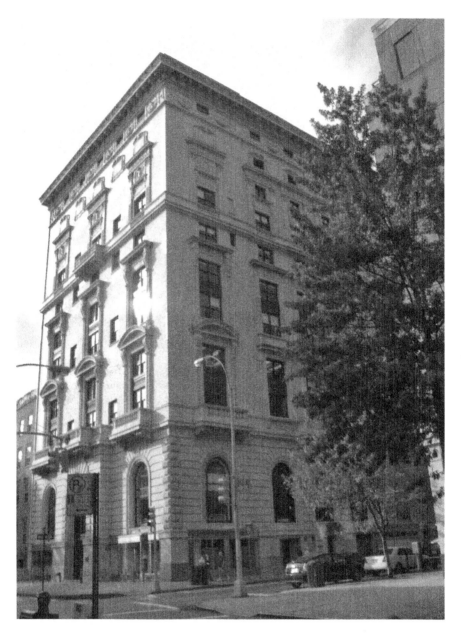

Figure 17. St. Ann's School today occupies the former Century or Crescent Club building on the northwest corner of Pierrepont and Clinton Streets, in addition to many other buildings. *Brian Merlis Collection*.

Private Schools of the Past

The Brooklyn Heights Seminary, a private school, operated at 138 and 140 Montague Street from 1860 until 1903 (chapter 9, figure 16). In 1904, as Montague Street commercialized, the school moved to 18 Pierrepont Street, the former Crittenden Mansion, a three-story brownstone building at the beginning of Willow Street. It survived into the 1930s, was a high school for girls and had lower grades for boys and girls.

Another school was Greenleaf's Institute for Young Ladies, established in 1837 by Alfred Greenleaf at 79 Willow Street. It later moved to a converted mansion on the southeast corner of Pierrepont and Clinton Streets (figure 18). The back of the Brooklyn Trust Company building now occupies the site. Greenleaf's closed during the Civil War, and the Brooklyn Club rose on its site (see below).

Other educational institutions included Professor N. Cleveland's School for Girls, which existed from 1840 to 1850 on Pierrepont Street, and Browne's Business College on Fulton Street south of the Ovington Building (chapter 8, figure 23) between Clark and Pierrepont Streets. In the early twentieth century, the Brooklyn Latin School held classes at 40–42 Monroe Place, and Miss Gilbert's School was at 128 Montague Street. In 1929, the

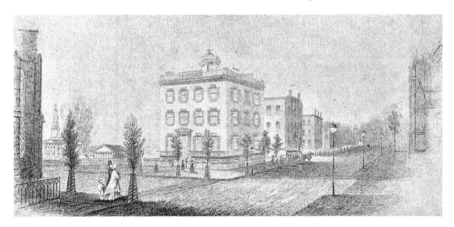

Figure 18. Greenleaf's Institute was another private girls' school in a converted mansion, shown circa 1850. The image notes that the building was later part of the Brooklyn Club's structure. We are looking south from north of the corner of Clinton and Pierrepont Streets, where the school was located. From *The Eagle and Brooklyn*, 1898.

coeducational Brooklyn Academy on the Heights relocated from Crown Heights to 182 Henry Street at the corner of Montague Street. Its night division was called the New York Preparatory School.

PUBLIC EDUCATION

Public education began in Brooklyn Heights before the Revolution, with a small schoolhouse for nineteen students on the property of Andrew Horsfield (chapter 2) that closed during the occupation. P.S. 8 was the area's first city-sponsored public school, and its original 1846 building survives at 65 Middagh Street, having been converted into housing in the 1970s (figure 19). The current building is at 37 Hicks Street between Middagh and Poplar Streets (figure 20). Its history during the brownstoner era is explored in chapter 11. It was expanded on the Poplar Street side in 2011. A middle school satellite to P.S. 8 is planned for the George Westinghouse High School

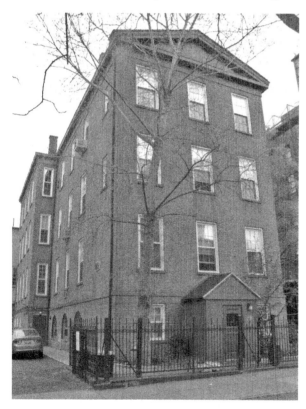

Figure 19. The original P.S. 8 on Cranberry Street is now housing. *Robert Furman photograph.*

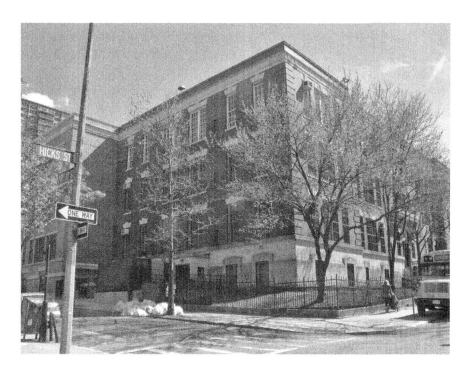

Figure 20. P.S. 8 stands on Hicks Street between Middagh and Poplar Streets. Its new addition is at left. *Robert Furman photograph.*

building on Tillary Street. Public schools tended to be built at the fringes of the neighborhood since wealthy people sent their children to private schools.

The first local public secondary school in the Heights was the 1880s Strivers' Academy in the Berrean Building on the west side of Court Street between State and Schermerhorn Streets. Later, the building housed Central High School and the Brooklyn Children's Court. This school later gave birth to Boys High School, Girls High and Manual Training High School, later the former John Jay High School in Park Slope.

ALFRED T. WHITE AND UPLIFT

During the Victorian era, before organized government relief efforts, wealthy people felt a religious obligation to aid the poor through private uplift projects. Alfred Tredway White (1846–1921) (figure 21) was the Heights' greatest philanthropist and community activist. In 1880, he

181

Figure 21. Alfred Tredway White (1846–1921). From Olive Hoogenboom's *The First Unitarian Church of Brooklyn: One Hundred Fifty Years*, 1987.

moved out of the home of his father, Alexander Moss White (1815–1906), at 2 Pierrepont Place (extant) and, with his wife, moved into 40 Remsen Street (figure 22) (also extant), where he lived for the rest of his life.

Alexander Moss White grew up in Danbury, Connecticut; the family retained an estate there. He was descended from early settlers in Weymouth, Massachusetts, and moved to Troy, New York, in 1830 and to Brooklyn in 1837. He married Elizabeth Hart Tredway of Dutchess County in 1842. Alexander's other children included Harriet Hart White (18??–1947) and Frances Elizabeth White (1847–1937), who never married, and William Augustus White II. Alexander was in the fur business with his brother William Augustus as W.A. & A.M. White.

Alfred T. White learned business working in his father's firm (see chapter 4), prepped at Brooklyn Poly and trained as an engineer at Rensselaer Polytechnic Institute, which gave him the pragmatic sense that all problems could be solved via the application of rational intelligence and that one could make a profit at solving them.

In 1878, Alfred married Annie Jean Lyman, a teacher at the Willow Place Chapel and a granddaughter of Seth Low the elder, strengthening the relationship between the two families. They had two daughters, Annie Jean (van Sinderen) (died 1919) and Katharine Lyman, who supported the Brooklyn Botanic Garden and Brooklyn Hospital.

In 1865, young members of the First Unitarian Church asked their pastor, Alfred P. Putnam, to open a Sunday school for poor immigrant children living on industrial Furman Street. White began teaching there in 1867 and, in 1869, became its superintendent. He and his sisters were major financial supporters. The Furman Street Mission, later the Mission School, initially utilized the attic of the Wall Street Ferry house as a religious school and opened a library, a day school for children too sick to attend regular classes, a

Figure 22. No. 40 Remsen Street, a Gothic Revival house, in a modern photo, was the home of Alfred T. White from 1880, when it was new, until his death in 1921. The top floor is an ugly twentieth-century addition. *Robert Furman photograph.*

sewing school for girls, evening classes for working boys and a daycare center, thus becoming the model for early settlement houses such as Jane Addams's Hull House in Chicago. The school moved into the Willow Place Chapel in 1876 (see chapter 13) and added a large two-story building to house most of the settlement at 25–27 Columbia Place in 1906 called Chapel House, whose name was changed to Columbia House in 1916. The new buildings were endowed by Alfred T. White and his sisters, Frances and Harriet, to the tune of $20,000. They also taught in the settlement. Chapel House had a basement for manual training, club rooms, a hallway for religious services, a kindergarten room, a gym, a locker room with a shower, a kitchen, billiards, pool and bowling facilities and a lounge.

It was closed from 1883 until 1886 for lack of funds but then reopened because of the generosity of the Brooklyn Women's Club (see below) and began to serve the children of Riverside, a model for clustering services around housing for the poor, now a common practice. The First Unitarian began a Boys Club in 1889, an ancestor of the Boys Clubs of America. First Church minister Hiram Price Collier stated that they treated the boys "just as men are treated in the Hamilton Club. They are as good as the rich and are entitled to and deserving of pleasures." They also provided summer vacations in the country and did outdoor camping with the boys to teach the "strenuous life."

To counter the effects of the Panic of 1893, the worst until the Great Depression of 1929 to 1939, the settlement hired sixty-one women to make clothes for the Industrial School and the Home for Destitute Children. With the growth of public early childhood education, the kindergarten was taken over by the New York City Board of Education in 1923. White greatly influenced Jacob Riis, the Danish immigrant journalist who chronicled the plight of the working poor in his classic photo essay *How the Other Half Lives*.

World War I, combined with a very cold winter in 1917–18, was a difficult period for the settlement because many of its workers got involved in war relief. The war was followed by the Spanish flu pandemic of 1919, which took many lives, including that of Alfred T. White's daughter Katharine.

The settlement closed in 1927 in the face of the general decline of the wealthy part of the Heights, the death of White, the country's more conservative postwar mood and greater wealth, the institution's failure to adapt to changing needs and the First Unitarian Church's financial problems. It is now the A.T. White Community Center (see chapter 13).

White and Housing

White was asked by a teacher to visit the home of one of the students and was appalled by the conditions he found there. The boy's sister was very ill, and a doctor who examined her found that this was due to the house's unsanitary conditions. This led White to connect the questions of housing and health.

After the deaths of three babies in the same family, settlement worker Bernard Newman visited a tenement on Furman Street and found the plumbing "so defective and broken that the house had made a cesspool" in the cellar, from which fourteen loads of ash-laden waste had to be removed. A survey indicating a death rate between 25 and 30 percent among children in tenement districts determined him to build healthful housing for the working poor. He said, "Well it is to build hospitals for the cure of disease, but better to build homes which will prevent it." (This at a time when people mostly went to hospitals to die.)

He went to London to study similar efforts there, since London had butted up against similar problems twenty years before the United States. He studied the plans of future Lord Mayor of London Sydney H. Waterlow's model tenements and borrowed his slogan "philanthropy plus 5 percent."

This also led to White's involvement in the Brooklyn branch of the Children's Aid Society. In 1876, he endowed and planned the society's Seaside Home for Neglected Children in Coney Island.

In 1889–90, he built Riverside (chapter 13, figure 4), model housing for the working class at Columbia Place (the continuation of Columbia Street) and Joralemon Street on the site of the Livingston-Pierrepont distillery (see chapter 3). His Industrial Dwellings Company expressed his businessman's hope (he was an investment banker) that private developers, not the government, would build adequate and healthful low-income housing. He had earlier completed the Tower and Home Buildings in Cobble Hill.

Riverside originally housed 280 families in nine buildings surrounding a courtyard, on the plan of his Tower and Home Buildings in Cobble Hill, which is considered the first model housing for the poor in the United States. In *How the Other Half Lives*, Jacob Riis called Riverside "the beau ideal of the model tenement." Stylistically, it is Queen Anne, especially in that all nine buildings looked like one. While White credited its design to William Field & Son, his scrapbook lists the great Queen Anne practitioner William Tubby as a project architect.

Each apartment was well lit and ventilated and had its own toilet and recessed balcony, which was unusual for tenements of the period. The home also had cross-ventilation, sunlit rooms, bedrooms off a hallway and storage bins for wood and coal. Bathing, however, was communal and in the basement. His buildings had fireproof stairways (an inspiration for modern fire codes). To teach the virtues of thrift and business, White offered a 10 percent discount to tenants who paid their rent four weeks in advance—20 percent of them took advantage of the deal.

Tom LaFarge, author of one of the essays in *The Social Vision of Alfred T. White*, believes that the New England heritage of so many of the Heights visionaries was embodied in Riverside. Like many small towns in Massachusetts, Riverside surrounded a green or town square with a fountain, playground, music pavilion and garden.

In order to provide open space, none of his developments occupied more than 52 percent of their lots. In so doing, he helped dispel the common myth that buildings were slums because of the filthy habits of the poor. While some builders adopted his standards, many continued to foist substandard housing on greedy or unwary investors at annual profits of 18 to 40 percent. Riverside earned a profit of around 5 percent per year, validating White's vision. Of course, operating these buildings was not how he earned his living.

Riverside's western four buildings were demolished for the Brooklyn-Queens Expressway in 1943. The courtyard is now a shallow backyard for the remaining buildings. Since the 1980s, successive owners have unsuccessfully sought to convert the property into luxury housing and to add underground parking.

White was involved in many activities promoting the welfare of the working poor. He advised father and son Charles and Frederic Pratt, who built the Astral Apartments in 1886 for their workers at Astral Oil on Newtown Creek. The company was later merged into John D. Rockefeller's Standard Oil Company. He and Commodore Cornelius Vanderbilt sat on the board of the City and Suburban Homes Company, the responsible developer of the time. That company built the First Avenue Estate on East Sixty-fourth Street in Manhattan: tenements on large lots. White also owned property in that area and in southern Park Slope. The Homes Company also constructed suburban houses in Bensonhurst, following the principle that smaller homes can be built in outlying areas.

White was also active as a public realm advocate for government action to promote healthful living conditions in housing and elsewhere. In 1879, he called for the creation of a state Board of Health to complement the

city organization and to require property owners to conform to minimum housing standards. At the time, many apartments for the poor did not routinely include toilets, so tenants used outdoor privies or hidden corners in cold or inclement weather. In 1895, he helped pass the first tenement reform law in New York City. In 1900, he was appointed to the New York State Tenement House Commission by Governor Theodore Roosevelt, and the two toured Brooklyn's slums and White's buildings as Roosevelt sought White's ideas on improving conditions. In 1913, White made a call for "strong tenement house laws" to lower the death rate. He was also a charter member of Survey Associates, whose Pittsburgh survey was a model for sociological investigation, and a leader of the National Red Cross in its 1918 fund drive.

White and Seth Low the younger founded the Brooklyn Bureau of Charities, whose building survives on Schermerhorn Street on the Downtown Brooklyn side of Court Street. White was commissioner of city (public) works from 1893 until 1896. He supervised the reconstruction of the Wallabout Market in the Brooklyn Navy Yard to a Dutch-inspired design by William B. Tubby featuring a clock tower that White personally paid for. By 1929, it was the world's largest public market. During World War II, the market was demolished for Navy Yard expansion and moved to Canarsie. As commissioner, he paved many streets and brought water to the city through water tunnels, as had John Prentice (see chapter 4). Like his cousin Seth, he was a trustee of black colleges Tuskegee Institute and Hampton Institute and of the Regional Plan Association. As a director of the Russell Sage Foundation Homes Company, he was involved in planning the "garden city" community of Forest Hills Gardens designed by Frederick Law "Rick" Olmsted II. In 1910, White was a founder of the Brooklyn Botanic Garden (also designed by Olmsted II), and he planned and endowed its Japanese garden and, in 1921, its Conservatory Plaza and lily pond. Along with Frederick B. Pratt, he purchased 150 acres of land that, along with another 500 acres donated by the Whitneys, became Marine Park, located near the eponymous bridge to the Rockaway peninsula. He also sat on the boards of the Society for the Prevention of Cruelty to Children and the National Red Cross and endowed the chair in Social Ethics at Harvard for his lifelong friend Unitarian minister Francis G. Peabody of the old Massachusetts aristocracy. He created this new area of study by linking philosophy with economics. Due to his efforts, the City of New York established a City Planning Commission in 1916.

It is not generally known that White was a Wall Street businessman. He organized W.A. & A.M. White at 14 Wall Street with partner W. Averell

Harriman (1891–1986), the son of railroad magnate Ned Harriman. Averell Harriman was later an active Democrat who served as ambassador to the Soviet Union during World War II (and to Britain afterward) and as governor of New York from 1955 until 1958. After White's death, Harriman worked at the investment bank Brown Brothers Harriman.

In 1921, White drowned while ice skating on a pond near the Harriman property, later Harriman State Park. A memorial service was held at the Brooklyn Academy of Music. He left an estate of $15 million to his surviving daughter, Annie Jean Lyman van Sinderen. There is a monument to him in the Brooklyn Botanic Garden.

OTHER PRIVATE UPLIFT EFFORTS

In 1833, following a yellow fever epidemic, the Brooklyn Orphans Asylum (see chapter 4) was founded by Judge and Mrs. Peter W. Radcliffe, Dr. Cutler of St. Ann's Church, Adrian Van Sinderen and Judge Lefferts, among others, in the former John Jackson mansion on Hicks Street (chapter 6, figure 14). The chair of the organization for many years was Mrs. James L. Morgan Sr., of 7 Pierrepont Street (razed) (chapter 5, figure 34). In 1839, the asylum moved to a much larger building on Cumberland Street in Fort Greene. That building had previously been a home for old ladies founded by Anna Maria Constable Pierrepont (see chapter 4). In order to liquidate the debt from the move, a special event was held (the source does not say where), at which Reverend Samuel Hanson Cox (see chapter 7) lectured, Fanny Kemble acted and Jennie Lind sang. In 1870, the asylum moved to Atlantic and Kingston Avenues.

As an aside, Frances Anne "Fanny" Kemble (1809–1893) was one of the most prominent actresses of her time. She was the daughter of a prominent English stage couple and became popular following her 1829 London debut. The family immigrated to America in 1832 to capitalize on Fanny's popularity. In 1832, she married Pierce Butler of Georgia, a prominent plantation and slave owner, who may have been the model for the unmarried Rhett Butler in Margaret Mitchell's *Gone with the Wind*. The couple resided in Philadelphia. In 1837, Fanny attended the coronation of Queen Victoria alone, a sort of trial separation, but in 1838, the couple stayed at his plantation. Seeing slavery firsthand contributed to her separating from her husband, divorcing him in 1849 and becoming an abolitionist, perhaps

the first celebrity activist for human justice. Her diary of her visit to the plantation, *Journal of a Residence on a Georgia Plantation in 1838–1839*, was a bestseller in America and England during the Civil War. The late great British actor Sir John Gielgud was a relative.

The Upanin Club was a recreation and education center for troubled youths. It began at 174 High Street and in 1913 moved to 1 Middagh Street, a former General Horatio C. King house. General King was a civic activist who assisted in the creation of the Prison Ship Martyrs Monument in Fort Greene Park. He later lived at 44 Willow Street. The Oneida Community, a nineteenth-century utopian socialist community, occupied 43 Willow Place, one of the colonnade row buildings (chapter 13, figure 3), as the home of its printing press.

Another local philanthropic organization was the Newsboys Home at 61 Poplar Street of the Brooklyn Children's Aid Society, which began in 1866 in a small building and later moved to a larger one in 1884 (chapter 11, figure 31), which is now housing. It was an industrial training school that taught troubled youths vocational skills and good work habits. It provided homeless boys with beds, meals, schooling and a library and gymnasium. Many of these services were available to non-residents. In 1888, the home organized a cooking school and sewing machine class for girls and a playground and outdoor kindergarten in 1899. It also held drawing and music classes and ran a reading club. In 1911, the building became studio apartments and was later a factory before it fell into disuse. It was renovated into luxury apartments in 1987.

A more modern addition to philanthropic institutions in the Heights is Catholic Charities, which supports many church-affiliated social service organizations and shares its building at 191 Joralemon Street on the St. Francis College campus with the Diocese of Brooklyn (chapter 11, figure 21).

Alcoholics Anonymous got its start in the Heights, or at least its principal founder did. The home of Dr. Clark Burnham was at 180 Clinton Street in the 1920s. In the 1930s, his daughter, Lois Burnham Wilson, lived there along with her husband, William Griffiths Wilson, the famous "Bill W." He was a raging alcoholic who managed to get himself under control. He met AA's other co-founder on a business trip to Akron, Ohio, in 1935, and as they say, the rest is history.

While there is no YMCA (or YWCA) in the Heights today (they are in Boerum Hill), for much of the twentieth century, the International Institute of the YMCA operated at 94 Joralemon Street at Garden Place, the 1850 John P. Atkinson–Wilhelmus Mynderse House (extant).

Afterward, the Brooklyn Central YMCA maintained offices at 153 Remsen Street. This 1897 scene is largely unaltered. There was a YMCA in the Washington Building on the east side of Court Street at Joralemon in the mid-nineteenth century.

The Heights and Hill Community Council (now Heights and Hills) was founded by local clergy in 1971 to provide services to senior citizens. Headquartered at 57 Willoughby Street, it provides case management and caregiver services to connect older adults in the Heights, Boerum and Cobble Hill, Carroll Gardens and Concord Village with in-home services. It also provides "meals on wheels" and transportation shuttle services to senior centers and other locales.

HOUSES OF WORSHIP

The Reformed Church and the German Lutheran Church

If Manhattan was sin city, Brooklyn was a pious place. Debby Applegate describes it as follows in her biography of Henry Ward Beecher, *The Most Famous Man in America*:

> *On weekdays women gossiped at the corner pumps, boys loitered about the stables that lined the side alleys, and children played in the surf of the bay below. On sunny Saturday mornings, ladies took their weekly jaunt down Fulton Street to Journeay & Burnham's Emporium* [later at 124–28 Atlantic Avenue and then on Flatbush Avenue], *while men lounged outside on barrels and bales, chatting, whittling, and chewing tobacco. But Sunday was the big day, when the entire town promenaded to church. The churches were so central to social life that Manhattanites returning from a visit to Brooklyn were sure to hear the hackneyed joke: "Oh, did you go to prayer meeting?"*

Life in Brooklyn Heights revolved around the churches and was conceived of as a religious matter. Social and political life was also based on religion.

The Reformed Church is the oldest in Brooklyn since it is the Dutch national church. The original one in the town and city of Brooklyn was on Fulton and Hoyt Streets downtown and moved to what is now the Municipal Building's site in the 1830s and to Park Slope in 1889 as the Old First Reformed Church.

Figure 23. The Zion Lutheran Church on Henry Street between Pierrepont and Clark Streets occupies the former Second Reformed Church building. *Robert Furman photograph*.

Figure 24. The second building of the Reformed "Church on the Heights" was on Pierrepont Street just west of Monroe Place. *Brian Merlis Collection.*

Figure 25. Minard Lafever (1798–1854) was one of Brooklyn's great architects. From Olive Hoogenboom's *The First Unitarian Church of Brooklyn: One Hundred Fifty Years*, 1987.

The Second Reformed Church was constructed on Henry Street between Pierrepont and Clark Streets in 1836 but relocated after the roof collapsed. In 1850, the Second Reformed, known as "the Church on the Heights," built a new High Renaissance structure (figure 24) designed by Minard Lafever (figure 25), which Henry Stiles celebrated in his definitive history of Brooklyn. The institution declined and was demolished in 1934 for the current Appellate Division of the Second Department (figure 13). Thus did the last remnant of Dutch colonial life depart Brooklyn Heights.

The original Second Reformed building is now the Zion German Lutheran Church (figure 23), which added a new façade in 1887. At the time, the city had a large German American population. Its pastor is the Reverend Josef Henning.

The Danish Seamen's Church

The least-known extant church in the area is the Lutheran Danish Seamen's Church at 102 Willow Street (figure 26). When it was a major port, Brooklyn had a large Scandinavian population since many of these men were sailors. The church built its first house in 1886 at Third Avenue and Ninth Street in Gowanus. Founded in 1878, when South Brooklyn was a Scandinavian neighborhood, this building is now

Figure 26. The Danish Seamen's Church occupies an unobtrusive townhouse at 102 Willow Street. *Robert Furman photograph.*

the Joseph Rawley American Legion Post. In 1957, the Danish church purchased 102 Willow Street and converted what still appears to be a normal townhouse into a house of worship, complete with capacious interior and classic pipe organ. At this time, the church caters to Danish seamen who put into the Port of New York. According to its website, it is the only church in the Western Hemisphere that conducts services in Dano-Norwegian.

The Episcopal Church–St. Ann's

The Episcopal Church is the American version of the Church of England or Anglican Church. It was brought to America by English settlers and may have started here as early as 1766 but definitely began by 1778, during the British military occupation, when British soldiers and Tories held services at Fulton Ferry. Outdoor services were later held at this location.

The church occupied Garrett Rapelye's barn at 40 Fulton Street at Front Street in 1784 and then John Middagh's barn at Henry and Fulton Streets (which later served as a soapstone factory). As Brooklyn grew, the church set down local roots. The local Episcopal church was chartered in 1787 and took the name St. Ann's in 1795. It later occupied an abandoned Congregational church. St. Ann's (also named for Mrs. Joshua [Ann] Sands, a philanthropist who endowed it) was built on Washington Street and Sands Street, just south of Prospect Street in 1805, as shown on the 1816 Village map (chapter 1, figure 4). It moved to Clark and Fulton Streets in 1825.

At that time, the church operated a cemetery between Fulton and Washington Streets south of Clark. The graves were removed to Green-Wood Cemetery in 1859 when the city of Brooklyn banned in-town burials.

St. Ann's moved to Clinton and Livingston Streets in 1869 (figure 27). Its former home was expanded and became the Pierrepont Street Baptist Church. The 1869 building is a major work of the architect James Renwick Jr. in Venetian Gothic/Ruskinian style and is considered one of the most important High Victorian Gothic church buildings in the nation. It is probably the most architecturally outstanding institutional building in the area. The eye is drawn to its polychrome (alternating color) stonework.

Figure 27. This modern winter view of the former St. Ann's Episcopal Church highlights the chapel on the building's north side. *Robert Furman photograph.*

It was the home church of the still-remembered Reverend Abram N. Littlejohn, bishop of Long Island. In the late nineteenth century, it operated a parochial school on site. In the late 1960s, with the 1966 merger of St. Ann's and Holy Trinity, the St. Ann's building was sold to Packer Institute.

The Church of the Holy Trinity

The (Episcopal) Church of the Holy Trinity (figure 28) (now St. Ann and the Holy Trinity Episcopal Church), designed by Minard Lafever (figure 25), a Gothic Revival structure, rose at Montague and Clinton Streets in 1846. It was the first major one on Montague Street. Jacob Landy, the authority on the architect, has called it the "outstanding, certainly the most splendid, achievement, of Lafever's career." The parish was founded in 1837 because of increased immigration from New England. The stained-glass windows by William Bolton are the crowning glory of the church and are the first major group of such windows manufactured in the United States. The interior is spectacular and belongs in one of the great European Gothic cathedrals.

Construction was funded by paper manufacturer John Bartow, who wanted to build a church to rival Trinity in Manhattan. Lafever planned a spire, but it was not until 1866 that one designed by Patrick C. Keely (who mostly did Catholic churches) was raised. It was removed in 1905 when subway construction of the Broadway Line under Montague Street undermined the building.

Figure 28. Holy Trinity in 1915 with its spire removed, as it looks today. The Historical Society and a bit of the Brooklyn Trust Company are at right. *Brian Merlis Collection.*

This has always been a troubled institution, mostly due to a tendency toward factionalism. Rev. John Howard Melish (1874–1969) was pastor from 1904 to 1949. His son, William Howard Melish (1910–1986), was associate pastor from 1938 until the church was closed in 1957, and was pro-Soviet at the height of the Cold War. When the church reopened in 1966, Rev. William Howard Melish returned as a member. According to Seth Faison, this occurred in part because Dr. Melish's son, whom he wished to succeed him, had joined a Soviet-American friendship organization during World War II. His son was made assistant minister and then senior minister, but he lacked the people skills to make a go of it. Things got so bad that the building was defaced by vandals with what appeared to be masking tape. Membership dropped, and the almost-abandoned church deteriorated. The Episcopal bishop closed the church in 1957. It remained shuttered until 1962, when it became the headquarters of a lay evangelical organization called the Church Army, which gave it up in 1967. Holy Trinity merged with St. Ann's in 1966, and Reverend Melish was invited back and presided until his death in 1986. The current priests are the Reverend John Denaro and the Reverend Nell Archer. In 1980, the church enlisted the support of the New York Landmarks Conservancy and an architectural firm and began restoring the building. It received a state grant for restoration in 1997, but more work needs to be done: deteriorated brownstone is obvious on the exterior.

Arts at St. Ann's began in the 1980s, partly as a restoration fundraiser. The St. Ann Center for Restoration and the Arts of 1983 institutionalized this work and raised over $4 million. The center sponsored the Stained Glass Workshop under David Fraser and restored the windows. The arts center became an important cultural force by sponsoring concerts by musicians such as Elvis Costello, Lou Reed and Deborah Harry of Blondie. However, conflict developed over control of the arts center, with the church demanding greater representation on the arts center's board. In 2001, a demand for a greater share of a $250,000 state grant led to the arts center moving to DUMBO, where it remains. These conflicts continue today with some church members insisting the central Episcopal Church authorities wish to sell the building.

Grace Episcopal

Grace Church began in 1842 as Emanuel Episcopal at Sidney Place and Livingston Street. Some Brooklyn Episcopalians were affiliated with Grace

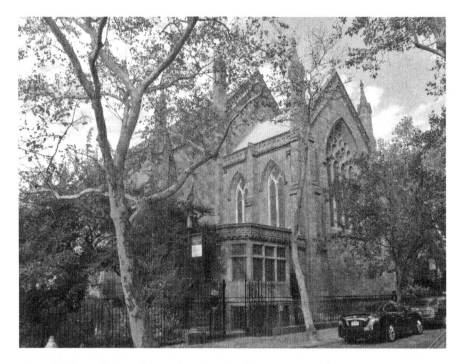

Figure 29. Grace Episcopal Church today. *Robert Furman photograph.*

Episcopal in lower Manhattan, and on Sunday mornings, they would call a boat to the Brooklyn shore by blowing a horn. When the church moved to Broadway and Tenth Street from lower Manhattan, parishioners found the trip too difficult, so they joined Emanuel. The merged congregation required a larger building, so the church appointed a building committee led by Henry Pierrepont, Colonel Tunis Craven and Rector Reverend Francis Vinton. In 1849, Vinton lived nearby at 253 Henry Street (then number 153) (chapter 5, figure 22). In 1855, he resided at 27 Grace Court (in 1856 number 3) and in 1857 in no. 5, which was built for him by the church.

In 1848, the church completed its current building (figure 29) at Hicks Street and Grace Court, designed by Richard Upjohn in the Ecclesiological style, which suggests an English country parish. It is notable for its vertical features including finials, pinnacles, gables and parapets. The sanctuary features an alabaster altar, stained-glass windows, mosaic tile floors and stone columns. Three of the stained-glass windows in the nave and aisle are by Louis Comfort Tiffany.

The rector (chief minister) is Reverend Stephen Muncie, and the rector emeritus is F. Goldthwaite Sherrill. The church has offered a

non-sectarian early childhood program since 1928. The church offers a free Thanksgiving dinner and participates in numerous charities such as Christian Help in Park Slope (CHIPS), which operates a food pantry; Episcopal Relief and Development; the Brooklyn Heights Interfaith Shelter; East Brooklyn Congregations; tutoring at Bushwick High School; Habitat for Humanity; and a worldwide development organization called Heifer International. It also hosts meetings of Alcoholics Anonymous and Narcotics Anonymous.

St. Charles Borromeo and Assumption Roman Catholic Churches

Grace Episcopal sold its Sidney Place property to the Catholic Diocese of Brooklyn, which used the old building until it burned down in 1869. The diocese then constructed the current St. Charles Borromeo Church (figure 31), designed by Patrick C. Keely, around 1870. There is a statue of St. Charles in the tower. The pastor is Reverend Edward P. Moran, PhD. The church operated a parochial school across Livingston Street at 21 Garden Place until 2007, when it was damaged by fire.

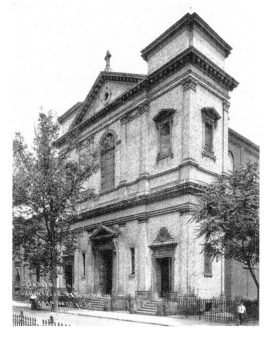

In 2013, the rectory and school were converted into a Quaker school for teenagers with learning disabilities. The rectory moved to a former nuns' residence at 31 Sidney Place.

The other Roman Catholic church in the Heights is Assumption (figure 30) on Cranberry Street. It was actually the first in the area, having been founded in 1842, and was enlarged after a fire in 1878. A parochial school opened in 1909, and it

Figure 30. Assumption Roman Catholic Church in 1928. *Brian Merlis Collection.*

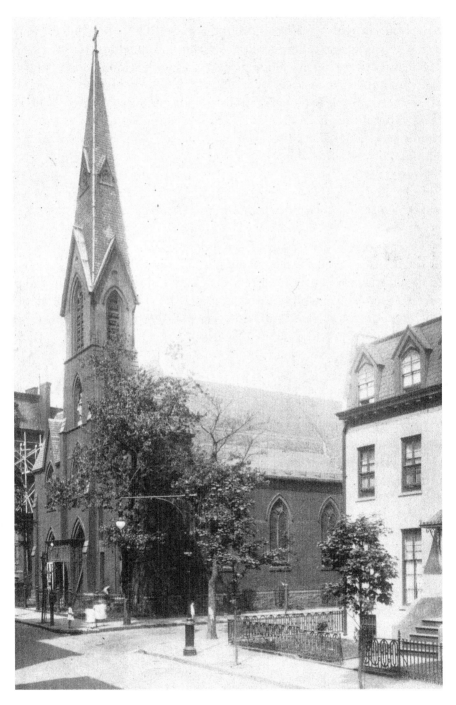

Figure 31. St. Charles Borromeo Roman Catholic Church. *Brian Merlis Collection.*

built its rectory across the street in 1913. There is also a neighboring nuns' residence (priory). The growth of the Catholic church is a product of a nineteenth- and early twentieth-century influx of working-class immigrants as the old-stock population fled.

The First Presbyterian Church

The Presbyterian Church is the state church of Scotland and developed quite early on in Brooklyn. Its first home was constructed on the west side of Clinton Street just below Fulton on a site later used as a church cemetery and occupied by the Old School Church (see chapter 7). It moved to Cranberry Street between Hicks and Willow Streets in 1823. The building survives in altered condition as part of Plymouth Church.

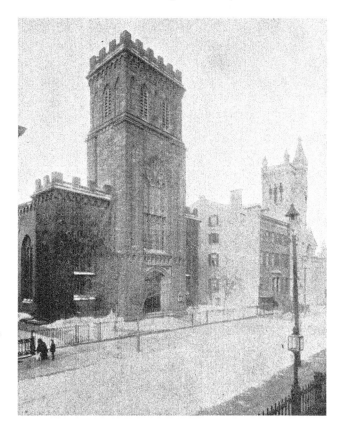

Figure 32. The First Presbyterian Church on the west side of Henry Street between Pierrepont and Clark Streets, circa 1915. The late Sands Street Methodist Church is at right. *Brian Merlis Collection.*

The congregation moved to a new First Presbyterian (figure 32) at 124 Henry Street in 1846, a Gothic Revival building, which it still occupies. It also had other branches, which have closed. Its minister as of 2011 was Dr. Flora Wilson Bridges. See chapter 7 on Reverend Samuel Hanson Cox, its longtime abolitionist pastor.

The Methodist Church

The Methodist Church was begun locally by Palatine Germans who immigrated to Ireland when their homeland was despoiled by France during its expansionist wars. In 1759, many came to New York and, in 1766, resumed practicing their faith. Their first churches were on the west side of Washington Street just north of Tillary Street and on Sands Street between Fulton and Washington Streets near St. Ann's (see above). Segregation at worship services at Sands Street led to the founding of Brooklyn's first black church, the Bridge Street African Methodist Episcopal. In 1898, the Sands

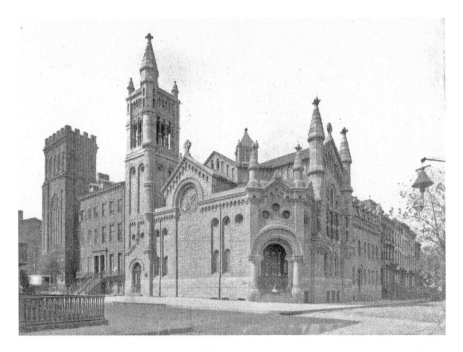

Figure 33. The Sands Street Memorial Methodist, shown here in 1897, was later the First Methodist Episcopal Church. It was one of the most beautiful church buildings in the Heights. *Brian Merlis Collection.*

Street church moved to the Heights, to the southwest corner of Henry and Clark Streets, when its former quarters were demolished for the Brooklyn Bridge el station, and built a splendid tabernacle that continued to be called the Sands Street Methodist Church but was later the First Methodist Episcopal Church (figure 33). As membership dwindled, the building was sold, torn down in 1947 and replaced by an apartment building.

The Baptist Church and the Church of the Restoration

The Baptist Church came to Brooklyn during a yellow fever epidemic in 1822. Two Baptists fled to Brooklyn and, finding five others, began a prayer meeting. After using private homes and community institutions, they built

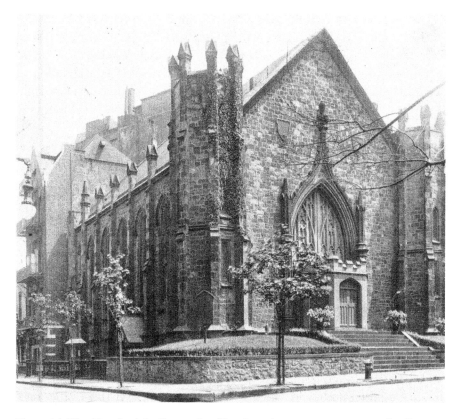

Figure 34. The Church of the Restoration, New Jerusalem, etc. was very attractive. From *The Eagle and Brooklyn*, 1898.

their first church on Pearl Street. In 1835, they started a new house on Nassau Street, which was destroyed by the great fire of 1848. They borrowed space from Plymouth and then Packer before moving to a new building on Nassau and Liberty Streets in 1850 (that site is now in Cadman Plaza Park).

Because of a factional dispute, some members started a new church on the southeast corner of Clark Street and Monroe Place, constructed in 1844 in the Gothic style by Minard Lafever, which was known as the Pierrepont Street Baptist Church.

When the Nassau Street building burned down in 1873, the two congregations united in a new structure, the First Baptist, on the northeast corner of Pierrepont and Clinton Streets. In 1892, they sold this site, and the church was replaced by the Brooklyn Savings Bank by Frank Freeman (chapter 8, figure 10), which was razed by the urban renewal. Thereafter, there was no Baptist church in the Heights.

The former Pierrepont Street Baptist Church became the Church of the Restoration in 1874 (figure 34). It later was the Church of the New Jerusalem, a Swedenborgian group, and in the 1940s, it became the Church of the Good Neighbor. Church attendance declined, and it was abandoned in the 1950s and demolished for the Cadman Plaza apartment development, in spite of efforts to reuse it as a home for Congregation Mt. Sinai (see chapter 11).

Society of Friends (Quakers)

The Quaker meetinghouse on Boerum Place and Schermerhorn Street that gave birth to the Brooklyn Friends School on Pearl Street (both in Downtown Brooklyn) has a Heights history. In 1834, the Hicksite Friends began meeting in a room on Henry and Cranberry Streets and erected a frame building on the northwest corner of Henry and Clark Streets. The present meetinghouse from 1859 is a descendant of this sect. The Brooklyn Orthodox Friends began meeting in a Packer lecture room and built their own meetinghouse at Lafayette and Washington Avenues in 1868. The two groups later merged. The Hicksites had silent meetings and impromptu preaching by members, but the Orthodox modernized with a more traditional scheme, including a full-time minister and hymn singing. The groups split over these issues and over community involvement, most notably with the Underground Railroad.

The First Unitarian Church

The First Unitarian Church of Brooklyn, formerly the Church of the Saviour (figure 35) (today the only Unitarian house in the borough), was founded in 1833 by a group led by Seth Low the elder and the merchant Josiah Dow, who were tired of journeying to Manhattan for services or listening to local preachers who offended their reason. They initially met in Eames and Putnam's English and Classical Hall, a private school on Washington

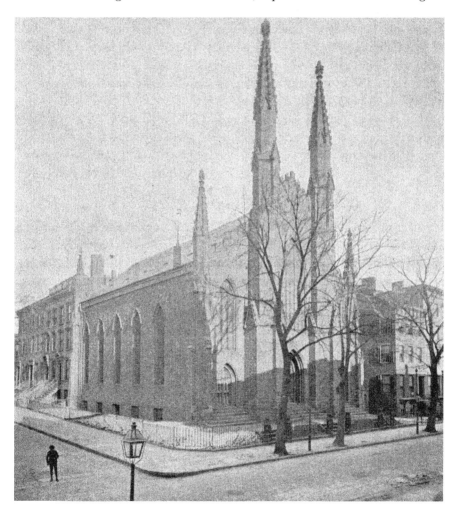

Figure 35. The First Unitarian Church (formerly) of the Saviour on Pierrepont Street and Monroe Place, shown in 1897, sits on the footings of the British Citadel. It was designed by Minard Lafever. *Brian Merlis Collection.*

205

Street founded in 1831 by Low. Their first church building was the former Second Presbyterian Church on Adams Street, later an armory and Gothic hall. Augustus Graham was an early minister. The church's 1846 building was designed by Minard Lafever and was constructed on the footings of the Brooklyn Fort, which, according to former pastor Fred Wooden, still exist in its basement.

Episcopalian Richard Upjohn demanded a $1,000 fee to submit preliminary plans because many Unitarians did not worship Jesus as the equal of God (they rejected the Trinity). They were hated by many traditional Christians, including the otherwise liberal Samuel Hanson Cox (see chapter 7). The building committee was headed by A.A. Low and Joseph L. Lord. In fact, there was a spectrum of views among Unitarians, from those who were rationalist but supported traditional Christianity to others who did not raise it above the other faiths of the world.

The church is modeled on King's College Chapel of Cambridge University and is considered one of Lafever's masterpieces. It was the home church of the Low family (except Mayor Seth because he could not tolerate the constant doctrinal bickering) and the White family and has been a center for liberal religion and activism ever since.

It built its Willow Place Chapel in 1865 (see chapter 13, figure 6), which served as a satellite church until 1928. The Pierrepont Street Chapel was added east of the church in 1866, as was a parsonage (minister's residence) at 98 Pierrepont Street in 1890. It retained this property until 1952, when it sold that building and purchased an apartment in 2 Montague Terrace (chapter 9, figure 22), which has also been sold. In 1937, it added 50 Monroe Place as its parish house, the site of which was acquired in 1917. In 1962, it purchased 48 Monroe Place as its offices. Tiffany windows were installed from 1894 through 1909, but one in a doorway was sold in 2014.

Tiffany glass is the principal American expression of Art Nouveau and is made by adding chemicals to molten glass, fusing the layers together and working it when semi-molten to create Tiffany's signature opalescent effect that both reflects and refracts light. His glass uses lead between the layers to express the decorative line, making it perhaps more aesthetically pleasing than traditional European stained glass.

In 1851, fifty families seceded from the First Church because they were more rationalist and liberal and organized the Second Unitarian Church of Brooklyn under Samuel Longfellow, brother of the poet, and began meeting at the Brooklyn Athenaeum. This schism was long-lasting and produced a church at Clinton and Congress Streets known as "the Little Church on

the Corner" that would last until 1924, when the two merged at the First Church (the Second Church site today is Cobble Hill Park). Its minister, John White Chadwick, in 1870 ordained the first female Unitarian minister, Celia C. Burr Burleigh. A third church was organized in Clinton Hill and a fourth church in Flatbush. With demographic changes (Cobble Hill was becoming Italian-American, and Clinton Hill was becoming black) and the financial problems of the various institutions of the 1920s, the Third Church closed in 1925, and in 1928, the congregation of the Willow Street Chapel returned to the First Church. Even with consolidation, the First Church had only 110 attendees at its opening service in September 1925. The Fourth Church of Flatbush lasted until the 1990s, when it, too, succumbed.

In 1867, the church founded the Brooklyn Liberal Christian Union, later the Union for Christian Work, a social work and adult education organization. In 1886, its Labor Bureau obtained jobs for 2,800 men and women, and its nine-thousand-volume library circulated 77,218 times. In 1887, it moved into a surviving building on Schermerhorn Street east of Court that it built and shared with the Brooklyn Bureau of Charities.

Samuel Atkins Eliot, brother of the president of Harvard University, was minister of the church from 1893 until 1897. He opposed the Great Trolley Strike of 1895 since he looked at the world from a conservative and individualistic point of view. He did his most important work afterward as head (secretary) of the American Unitarian Association, where he stabilized its finances by investing them wisely. He was an advocate of prison reform and Indian rights and was appointed to the U.S. Board of Indian Commissioners by President William Howard Taft (himself a Unitarian). He served as the board's chairman from 1927 until 1933.

During the Great Depression, the First Church struggled to aid members from Willowtown and became an employment and housing agency. It coordinated boarders with those seeking them. The Osborne Fund provided interest-free higher education loans to people associated with the church.

During the Second World War, the church served as an auxiliary United Service Organization (USO) post, hosting soldiers and sailors on their way to and from Europe. Afterward, minister John Howland Lathrop and his wife journeyed to the former German-occupied Czechoslovakia and founded a model orphanage near Prague. (Unitariansm was founded by the Czech martyr Jan Hus.) They put screens on the building's windows, a hitherto unknown innovation, to prevent flies from getting to the children. The United Service Organization brought over fourteen doctors to update local practitioners on modern medical methods and became an official

agency of the UN's World Health Organization. This relationship was based on the fact that the sect was founded there and the Lathrops knew the country's founder, Tomas Masaryk. Lathrop was also active in community affairs and served as president of the Brooklyn Urban League.

The well-known Pastor Emeritus Dr. Donald McKinney (figure 36) was assistant minister from 1952 until 1957 and presided from then until 1992. The spirit of the 1960s pervaded the church. Fort Greene resident and poet Marianne Moore lectured at the church in 1960, as did New Left activist and Jane Fonda spouse Tom Hayden in 1968. The Bill Evans Trio performed, and the church held a

Figure 36. Donald W. McKinney, circa 1985. From Olive Hoogenboom's *The First Unitarian Church of Brooklyn: One Hundred Fifty Years*, 1987.

Festival of the Winter Solstice in addition to Christmas services in 1965.

McKinney made a major effort to respond to its black caucus movement of the 1960s. After a 1961 sermon on race relations, Malcolm X requested an interview with him, and Louis Farrakhan spoke at the church in 1969. At an emergency denominational conference on urban riots in 1967 and as part of the Black Power and community control dynamic, thirty black attendees formed a separate caucus called the Black Affairs Council. They refused to meet with the other members and demanded that the national Unitarian Universalist Association give them $1 million over four years for social projects. The First Church supported the demand, though the funding was later reduced. In 1972, the church made up cuts to programs in Fort Greene with $150,000 from its endowment and reduced its contribution to the central Unitarian organization while insisting the organization restore the reductions. But separatism was contrary to the values of many, so Black and White Action was formed to support integration. Both groups had adherents in Brooklyn, and McKinney went so far as to call for a black caucus in the church although one had not developed on its own.

In 1966, the church opened the Fulton Street Fellowship at 739 Fulton Street in Fort Greene under black assistant minister Duke T. Gray as

a modern-day version of the Furman Street settlement. They got two domestic Peace Corps (VISTA) workers to organize block associations and work on problems such as police-community relations. The community organized the Central Brooklyn Citizens Unions (CBCU) to work with the fellowship on these problems. LeRoy Cole of CBCU was hired in the spring of 1966 as a lay minister to lead the organization. He built it up to several hundred members who chipped in twenty-five cents a week to support its programs. Although deemed effective (he organized a summer day camp for 195 children and became a community ombudsman), the integrated group irritated the local War on Poverty agency and church members who supported black power. These church members resigned from the church's Social Reinvestment Committee with a request they be replaced by blacks. Cole resigned in 1970, and the project collapsed. This culminated in a shoving match at a congregation meeting in 1971 between a supporter of the black power group and an integrationist. The polarization of the congregation led to a decline in membership and usual church activities.

In 1964, the Low Memorial Day Care Center was begun in the church, and in 1971, programs were added for severely handicapped children. The daycare center later moved to Boerum Hill. The church also contributed almost $10,000 to a Fort Greene daycare center.

McKinney and the church began to oppose the Vietnam War in 1963 and counseled draft evaders and sheltered draft resisters in 1967. In 1965, they gave the use of a chapel to Vietnamese exile and peace activist Vo Tranh Minh for a peace fast. He later returned home, was arrested, sentenced to death, paroled and killed in an American bombing raid on his home village. The church was changed by the women's movement and the church's Women's Alliance, which was founded in 1838 and became a feminist organization in 1973. The alliance's records are on EMMA, the Brooklyn Historical Society's records program. McKinney became involved in the effort to allow people to die with dignity and not be kept alive by heroic means. In 1965, he chaired the Euthanasia Society of America, later Concern for Dying, an educational organization that conceived the "living will" that allows a patient to defeat the presumption that hospitals will use all available means to keep him or her alive even if recovery is impossible, a major element in out-of-control healthcare costs. He was a member of Governor Mario Cuomo's 1984 Task Force on Life and the Law.

A major exterior restoration was performed in 1995. The church offers regular folk-type concerts and has become a haven for Christian-Jewish intermarriages. It removed the Church of the Saviour from its name in

2010, indicating that it is no longer Christian. The church has been selling some major assets, including an apartment at 2 Montague Terrace and a Tiffany window. Since McKinney's retirement in 1992, the church has had several ministers, and its senior minister as of 2012 is Ana Levy-Lyons.

SYNAGOGUES

Congregation Mt. Sinai

One of the effects of apartment construction and the brownstone movement was an influx of Jews into Brooklyn Heights, which had never before had a significant Jewish population. These new residents became a significant and influential element in the community.

Founded in 1868 as Cheva Mt. Sinai, a Conservative synagogue, the temple changed its name to Congregation Mt. Sinai in 1909 when it purchased 305

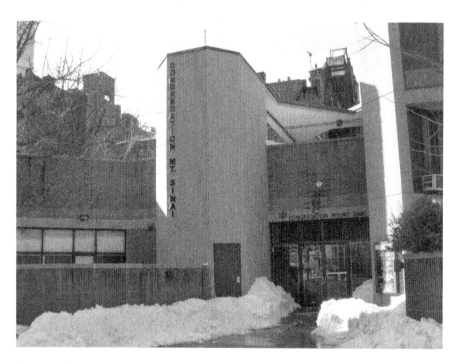

Figure 37. Congregation Mt. Sinai at Cadman Plaza West and Clinton Street was the first synagogue in the Heights. *Robert Furman photograph.*

State Street in Boerum Hill. This building had housed Congregation Beth Elohim before it moved to Park Slope that year. Conservative Jews may be a little less theologically liberal than Reformed Jews and use more Hebrew in their services.

According to the synagogue's website, the State Street building was destroyed by fire on January 4, 1948. Congregation Jacob Joseph on Atlantic Avenue offered its facilities, and Mt. Sinai conducted all of its services and activities there until October 1949, when it moved to 305 Schermerhorn Street. The synagogue remained there until October 1982, when that building was sold and facilities for a new synagogue at 250 Cadman Plaza West (figure 37) were acquired under a long-term lease. Its former principal rabbi, Joseph Potasnik, is a well-known community and Democratic Party activist who serves as the fire department's Jewish chaplain and has been a member of the Brooklyn branch of the Board of Elections.

The Brooklyn Heights Synagogue and Congregation B'nai Abraham

Figure 38. Congregation B'nai Abraham, at left, is a Modern Orthodox synagogue located at 117 Remsen Street between Clinton and Henry Streets. *Robert Furman photograph.*

A Reformed temple founded in 1960, the Brooklyn Heights Synagogue purchased the former Brooklyn Club building at 131 Remsen Street in 1994 (figure 39). It had previously been housed at Grace Episcopal Church. The chief rabbi is Serge Lippe. It has over three hundred members and operates a shelter for homeless women.

Congregation B'nai Abraham, a Modern Orthodox temple, is at 117 Remsen Street (figure 38). Modern Orthodox men wear very conservative suits. The women dress conservatively, shave their heads and wear wigs when married. Hasidic Jewish men dress as Polish nobles did in the sixteenth century and wear beards. Founded in 1992, the synagogue has been at its

Figure 39. The Brooklyn Heights Synagogue at 131 Remsen Street. *Robert Furman photograph.*

current address since 2000. It won the legal right to place an *eruv*, a wire creating a symbolic protected zone, to allow Orthodox Jews to engage in some otherwise banned activity on the Sabbath.

Masjid Dawood

There has been a mosque in the Heights since 1939: Masjid Dawood at 143 State Street (figure 40), part of the Islamic Mission of America. It has occupied the entire building since 1956. It is used by Muslims who joined the Near Eastern Christian immigration that created Our Lady of Lebanon Maronite Catholic Cathedral (see chapter 13).

Figure 40. Masjid Dawood, the only mosque in the Heights, occupies 143 State Street, at left. To the right are 145, 147 and 149 State. No. 143 (originally no. 79) dates from circa 1841. No. 145 dates from 1860 and has a newer Mansard roof. Nos. 147 and 149 are Greek Revivals with Type B stairs and date from 1856. *Robert Furman photograph.*

HOTELS

The Heights' first hotel was actually a tavern opened by John Cornell in 1774 on Tower Hill on Cranberry Street between Willow Street and Columbia Heights, which advertised its proximity to the new ferry. Another early hotel was Montague Hall (figure 41), which opened on

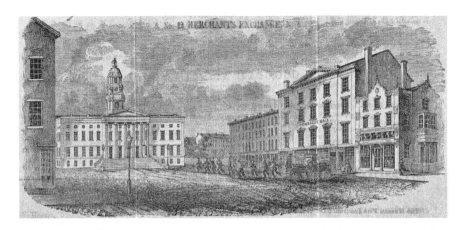

Figure 41. Montague Hall, at center right in this image, was an early Heights hotel that later became the offices of the Phoenix Insurance Company. This is a circa 1850 print. *Brian Merlis Collection.*

Court Street between Montague and Remsen Streets soon after city hall was completed in 1848. It later became the offices of the Ph(o)enix Insurance Co. (see chapter 8).

Opened in 1852, Montague Hall featured a chophouse, a type of restaurant derived from our British roots. Like other nearby restaurants such as J.E. Bell's Refreshment Stand and later House of Refreshment and Van Wart's, Montague Hall offered 1840s meat-and-potatoes meals, including roast beef, lamb, pork, veal, goose, duck, chicken, turkey, meat soups, clam or meat pies, pork and beans and, for dessert, apple dumplings and eleven different kinds of pies and puddings. Side vegetables included lettuce, cabbage, peas, parsnips, beets and turnips.

The Mansion House

The Heights' first luxury hotel was the Mansion House (figure 42) on the east side of Hicks Street, just south of Clark Street. Its building was converted around 1845 from the Female Academy that would become Packer Collegiate Institute. It was originally the John Jackson House. Part of it was reportedly brought to the Heights from Flatbush by soldiers preparing for the Battle of Brooklyn. The hotel hosted the farewell dinner for Democratic leader Henry C. Murphy, later chair of the New York and Brooklyn Bridge Company, when he was appointed ambassador to

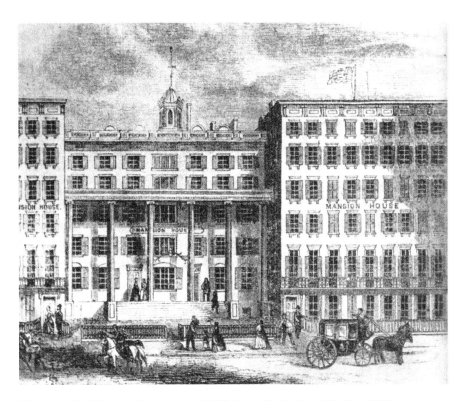

Figure 42. The Mansion House around 1860. From *The Eagle and Brooklyn*, 1898.

Holland by President Franklin Pierce in 1853. It was enlarged in 1875, and by 1910, it included a large garden and the Nieuw Amsterdam Grill Room when owned by J.C. van Cleaf. The Mansion House was replaced by an apartment house of the same name in 1931. A group of the hotel's stables, believed to date from 1875, survives on College Place.

The most notable later local hotels were the St. George (begun 1885) (figure 43), the Bossert (1909) (figure 44) and the Leverich Towers (1928) (figure 46). Their buildings still exist and were first-rate during the first half of the twentieth century.

The St. George Hotel

The St. George, named after the local Loyalist-owned St. George Tavern and England's patron saint, was located first at the Joralemon Street (St. George) Ferry in 1774 and on the future hotel site from 1776 until

Figure 43. The St. George today. *Robert Furman photograph.*

1783. It was founded by Captain William Tumbridge, a Civil War navy veteran, in 1885, with additional buildings added in the next two years.

Parts of the hotel designed by Montrose Morris were added in the 1890s, and the tower building dates from 1929–30. When that was completed, the hotel had 2,632 rooms, making it the largest in New York. The pool and ballroom were in the tower building. The hotel bragged of having the world's largest saltwater swimming pool and ballroom, which was popular with locals through the 1950s and into the '60s. Part of the pool still exists in the Eastern Athletic Club's branch in the St. George. It was both residential and transient, and in 1905, Theodore Ovington of the china store and his family lived here, including his daughter Mary White Ovington (see chapters 7 and 8).

Like the Bossert and Towers, the St. George also featured a rooftop restaurant in its halcyon days, and its bar and a hallway live on in the film *The Godfather* as the location where Don Corleone's enforcer Luca Brasi is killed. The etched-glass image of a fish seen as he enters is particularly poignant since he later "slept with the fishes." It also had the largest ballroom in the city, called the Colorama Ballroom because pastel lights created varying moods; it was advertised as "electricity's newest wonder." It had fine acoustics and hosted recording sessions by the New York Philharmonic Orchestra and its music director, Leonard Bernstein, in 1957, when it cut an LP of the Tchaikovsky "Romeo and Juliet" fantasy overture, and in 1959 with sessions for George Gershwin's "Rhapsody in Blue" and "An American in Paris." The great film actor Spencer Tracy did many of his drinking binges in the St. George because he was not known there.

By the 1980s, it had become a disreputable single-room occupancy hotel. Part of it on Clark Street burned in 1995 and was rebuilt as it had been. The entire group has been converted to residential uses, including apartments and student housing run by a company called Educational Housing Services. The ballroom has been converted into racquetball and squash courts.

The Hotel Bossert

The Beaux Arts Bossert (figure 44) of 1909–13 was founded by Louis Bossert, a German immigrant, who in 1869 started Bossert Brothers, a huge Williamsburg factory that made the wooden household fixtures so beloved by brownstoners. Called the "Waldorf-Astoria of Brooklyn" by the *Brooklyn Eagle*, the hotel hosted many of the Brooklyn Dodgers' annual dinners (see chapter 13).

Right: Figure 44. The Hotel Bossert on the southeast corner of Montague and Hicks Streets was returned to its former physical glory by the Jehovah's Witnesses. *Robert Furman photograph.*

Below: Figure 45. The Marine Roof in its heyday. *Robert Furman Collection.*

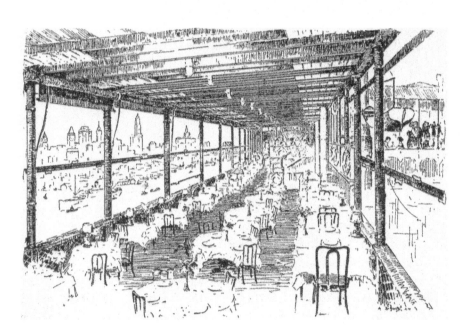

Its top was an outdoor nightclub and restaurant called the Marine Roof (or Grill) (figure 45), which was open from 1916 until 1949, with an interruption in 1943–45 because its lights violated the wartime blackout. It featured spectacular views of Manhattan, and its doings were broadcast on radio in the 1930s and '40s. The Little Italy Neighborhood Association held its dances here in the 1920s and '30s. Jimmy Walker, 1920s New York mayor, and Governor Alfred E. Smith, the first Catholic presidential candidate (1928), were among its patrons. It also sported the Palm Room and a restaurant.

Its roof had collapsed by the time the Jehovah's Witnesses took over in 1983. They took title to the hotel and restored it in 1988, and in 2010, it became a 224-room hotel. A few pre-Witness tenants remain. The Witnesses offered low-cost or free accommodations to members from around the country who wished to visit New York, as a reward for loyal service to the organization.

In 2012, it was sold for redevelopment as a normal 302-room short-stay boutique hotel. A rooftop terrace will be included. The lobby will be restored to its original configuration, with a coffered ceiling and oversized columns with elaborate capitals. The owners have requested a variance from the Board of Standards and Appeals to allow commercial use and are dealing with proposed conditions and restrictions.

The Leverich Towers Hotel

The massive Leverich Towers Hotel of 1928 on Cranberry and Willow Streets (figure 46) replaced some 1830s townhouses in the 1920s. When new, its four towers were illuminated by spotlights. It was a regular short-stay hotel until the 1930s, when it became residential. It was used as a visiting-team dormitory by the Dodgers and is now housing for the Jehovah's Witnesses and, like their other properties, is for sale.

In April 1934, in observance of the centennial of the city of Brooklyn, Mayor Fiorello LaGuardia lived in the Towers Hotel and worked at Borough Hall. In 1951, a man named Harry Gross was indicted for running a $20 million bookmaking operation with offices in every borough and several towns in New Jersey. His office was on the top floor of the Towers Hotel. What made this more than the usual gambling bust was that his operation could not have grown to the size it did without protection from police and politicians, purchased with huge bribes, reportedly distributed biweekly by two agents. When Brooklyn district

Figure 46. The former Leverich Towers Hotel at Hicks and Cranberry Streets is little known but is one of the most attractive buildings in the Heights in this contemporary photo. It may be so large as to be invisible. *Robert Furman photograph.*

attorney Miles McDonald finally unraveled this ball of worms, 150 cops went to jail, the police commissioner and several hundred more officers resigned and an inspector committed suicide.

Most significantly, Mayor William O'Dwyer, who had previously been Brooklyn district attorney, resigned and was appointed U.S. ambassador to Mexico. It was considered proper in the bad old days of urban Democratic machine corruption to kick disgraced politicians upstairs rather than send them to jail, so President Harry Truman obliged. Truman had come up via the Kansas City machine of Tom Pendergast, so he knew about such things. Like Governor Al Smith in New York, the losing 1928 Democratic presidential candidate, Truman was the honest window dressing of a larcenous organization. O'Dwyer was one of the elected officials who, as DA, had received Gross's bribes. O'Dwyer's brother Paul, who had been a leftist, was city council president in the 1970s.

The Pierrepont Hotels

The original 1853 Pierrepont Hotel on the southeast corner of Montague and Hicks Streets was quite grand it its day, hosting such luminaries as Tom Thumb and his wife, who were married in P.T. Barnum's lower Manhattan museum in a major public spectacle. The structure on Montague was replaced by today's Bossert.

The 1925 Pierrepont Hotel at 55 Pierrepont (figure 47) between Henry and Hicks replaced the old building on Montague Street but later deteriorated into a particularly nasty single-room occupancy hotel (see chapter 13). The Brooklyn Heights Association got it converted into senior citizen housing in 1974. Catholic Charities now operates it as senior housing, including the on-site St. Charles Jubilee Senior Center. In the last stages of its respectability,

Figure 47. In 1925, the Pierrepont Hotel at 55 Pierrepont Street replaced a mansion at the same address. *Robert Furman photograph.*

around 1960, Truman Capote was observed having drinks in its bar with Judy Garland. Her connection to the neighborhood is not clear, but she clearly visited and was a resident of the city since her daughter Liza Minnelli attended the High School of Performing Arts.

The Margaret

Figure 48. The Hotel Margaret in 1908. *Brian Merlis Collection.*

Another hostelry famous in its day was the Hotel Margaret at 97 Columbia Heights (figure 48), built by coffee magnate John Arbuckle and named for his daughter, on the southeast corner of Orange Street. It was long the highest and most prominent structure in the area and was designed by Frank Freeman in his signature Richardsonian Romanesque Revival style. It hosted many social events, such as the Brooklyn Friends School Mothers Club luncheon in 1931. In 1980, it burned down during apartment conversion by developer Ian Bruce Eichner, possibly due to arson, and was replaced by a Jehovah's Witnesses building in 1988 (chapter 13, figure 1). Ironically, it had replaced the colonnade row that also was destroyed by fire (chapter 5, figure 1).

The Palm Hotel

The former Behr Mansion at 82 Pierrepont Street (chapter 4, figure 17) was enlarged into the Palm Hotel in 1919 (figure 49). It later became a brothel but was purchased by the Franciscan Brothers Order in 1961 as a residence for teaching brothers at its new buildings for St. Francis College

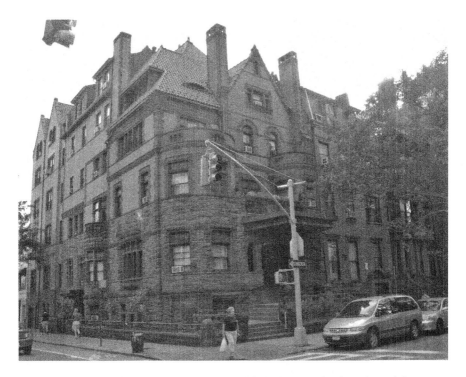

Figure 49. The Palm Hotel was an enlarged (and skillfully carried out) version of the Herman Behr House. It later became a brothel, was purchased by the Franciscan Brothers as staff housing for St. Francis College and is now co-ops. *Robert Furman photograph.*

on Remsen Street. It became apartments in 1977. The building was sold for $11 million in 2008.

The tale that Xaviera Hollander's establishment was in the Palm is an urban legend. According to her book *The Happy Hooker*, she operated the "Vertical Whorehouse" in a high-rise apartment building at Seventy-third Street and York Avenue in Manhattan from 1969 until 1971, at which time she was arrested and deported to Holland. St. Francis College was using the Palm Hotel building for staff housing at that time. The story is probably a conflation of Hollander's notoriety and the fact that the hotel had previously been a house of ill repute.

The Standish Arms Hotel was a residential hotel located at 167–71 Columbia Heights north of Pierrepont Street. It is now an apartment building designated 169 Columbia Heights. Other hotels that survived into the 1930s were the Franklin Arms at 66 Orange Street and the Montague, an apartment hotel at number 101 (figure 50).

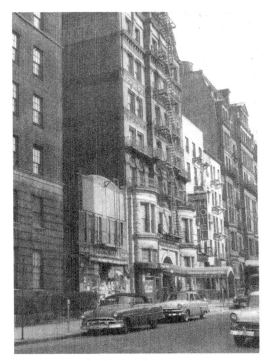

Left: Figure 50. The former Hotel Montague is now apartments. It survives across from the Bossert. Note the old name painted near the roofline on the left side in this 1957 view in which it is called the "Brookmont." *Brian Merlis Collection.*

Below: Figure 51. The entry of the former hotel at 70 Remsen Street is Moorish. The objects above the entry are mostly animal heads and gargoyles, but one is the head of the building's architect. *Robert Furman photograph.*

The 1886 Robinson's Atlas map shows a "Grand Hotel" on the east side of Clinton Street between Pierrepont and Clark Streets. It was succeeded by the Touraine, a luxury apartment hotel (chapter 11, figure 28). Others were the Clinton House in 1886, later the Globe and Eagle Hotel, in 1893 between the former Ovington Building on Fulton Street between Clark and Pierrepont Streets and Hardenbergh Carpets. It was a "commercial hotel" catering to salesman—i.e., not luxurious. The Star Hotel was at 56 Hicks Street. These were all demolished.

These hotels closed because they had become obsolete. Like hospitals, hotel standards rise so quickly that the luxury accommodations of one period quickly become outdated: witness the conversion of Manhattan's world-famous Plaza Hotel into flats. Today there is only one hotel in the Heights because the historic district prohibits new high-rise construction, but several new ones have been built over the last twenty years in nearby Downtown Brooklyn.

Hotels in the far north Heights catered to sailors and, when that trade fell off, became flophouses. They included the Peoples Hotel next to the Plymouth Bethel on Poplar Street and the Annex Hotel on Furman Street.

A present-day edifice that started out as a hotel is the Moorish apartment building at 70 Remsen Street (figure 51), which was a men's hotel in the late 1920s. Its architect, J.I. Feldman, who also designed the Hotel Pierrepont, added his own face to a group of reliefs above the entrance. He is the sixth from the left.

Social and Club Life

Dances were a way for young people to meet and included outdoor events in gardens and taverns—when held in private homes, there were called "germans" or cotillions. Organized dances called Junior Assemblies, Cinderella Balls and Bachelors' Balls also took place. The Junior Assemblies replaced Friday Evening Dances in 1905. Clubs often sponsored these events, and Dr. Charles Shephard's Turkish Bath (chapter 8), America's first, on Cranberry and Columbia Heights from 1863 until 1913, may have served this purpose also. Second fortnightly dances were held at the Assembly Building on Pierrepont Street, as were dances to benefit the Master School of Music.

Starting in 1857, a series of receptions organized by Mr. and Mrs. George Geran took place in a brick building owned by John Prentice

Figure 52. The Assembly Rooms at the Academy decorated for an Ihpetonga Ball, 1898. From *The Eagle and Brooklyn*, 1898.

(see chapter 4) at Furman and Montague Streets. The Gerans lived next door and also owned a country place in Jamaica, Queens. George Geran was a sailmaker in Manhattan who retired when steam replaced sails. There was also a monthly "hop" on Governors Island, and these events were the core of the social season in the 1850s and '60s. The Ihpetonga Ball, begun in 1886, was notorious for being exclusive—it excluded those not deemed sufficiently wealthy or socially prominent. Held in the Brooklyn Academy of Music's Assembly Rooms (figure 52), it was the neighborhood's premier social event.

Another feature of wealthy nineteenth-century neighborhoods was club life. It was de rigueur for men to join at least one club as a home away from home. These clubs were private spaces where members could eat, hang out, network and stay overnight. Most are now gone. The only one surviving in the Heights, the Heights Casino, still functions because it is a sports club. The only surviving old-fashioned club in brownstone Brooklyn is the Montauk Club in Park Slope.

The Brooklyn Club

The first club in the area was the Long Island Club, later the Brooklyn Club, founded in 1865, which originally occupied a mansion on the west side of Clinton at Remsen Streets (figure 53), later demolished for the Hamilton Club. From Remsen and Clinton, it moved to the southeast corner of Pierrepont and Clinton Streets (figure 54). In 1915, its building was demolished for the Brooklyn Trust Company, so it relocated to 131 Remsen Street (figure 39), which had been the home of James H. Post, president of the National Sugar Refining Company. Presidents Grover Cleveland and Franklin Roosevelt (both New York State Democrats) spoke there. From its WASP roots, it evolved into a predominantly Irish-American club—witness that Walter O'Malley was an officer. The club had over six hundred members in the 1970s. With changing styles resulting in declining membership and debt, and after unsuccessfully seeking new members, the club sold its building to the Brooklyn Heights Synagogue in 1994, but members continued to meet at Foffe's Restaurant on Montague

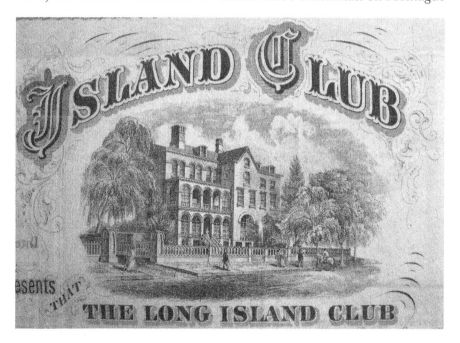

Figure 53. The Brooklyn Club began as the Long Island Club in a converted Italianate mansion on the west side of Clinton Street at Remsen that was demolished for the Hamilton Club. *Brian Merlis Collection.*

Figure 54. These exceptional buildings housed the Brooklyn Club in 1898. A sliver of the Historical Society is at right. From *The Eagle and Brooklyn*, 1898.

Street and then at Gage & Tollner's on Fulton Street. The club passed out of existence in 1998. Its proudest possession was an original Francis Guy painting of the Brooklyn Ferry area from around 1810, which was sold to the Brooklyn Museum when the club terminated.

The Hamilton Club

The Hamilton Club, an offshoot of the Apprentices' Library and the Lyceum, began as the Hamilton Literary Society and, in 1830, became the Hamilton Library Association. It was also a debating society and owned a library. It was renamed the Hamilton Club in 1882 when it was incorporated and built a clubhouse on the southwest corner of Clinton and Remsen Streets in 1884 (figure 55), on the site of the former Long Island Club mansion. The first president (1882) was Samuel McLean (see chapter 4), and incorporators

Figure 55. The Hamilton Club. This ponderous pile was on the southwest corner of Clinton and Remsen Streets. From Moses King's *King's Views of Brooklyn*, 1909.

included Charles Storrs and General Woodford. A.A. Low and Seth Low the younger (see chapter 4) were members, along with Reverend Richard Storrs (see chapter 7) and James S.T. Stranahan (see chapter 7).

In 1892, the club added a statue of its namesake to the front yard, which was removed to Hamilton Grange, his former home in Hamilton Heights in Harlem, when the club terminated in 1936 and merged with the Century Club. The clubhouse was replaced by an apartment building.

In its heyday, it was perhaps the glitziest club in the neighborhood and the Brooklyn equivalent of Fraunces Tavern, which is owned by the Sons of the

Revolution, a descendants' organization. Future president Herbert Hoover was a visitor in 1920, and Columbia University president Nicholas Murray Butler made a speech here in 1913. William J. Burns, who went on from Union military security service to found his own security firm, was also honored, as was New York City mayor George B. McClellan, son of the Civil War general, who served as mayor in 1904–05. The actor George Arliss visited to see the club's portrait of Martha Washington. Admiral Robert Peary, who may have been the first to reach the North Pole in 1909, was fêted here also.

The Washington and Hamilton birthday celebrations were major events, and the club was done up royally for the Hamilton observances. The grill was decorated as a forest, with birch bark covering the walls. Menus were printed on wood, with animal skins and heads and stuffed birds. The club featured souvenirs of Hamilton, including a lock of his hair and two letters he wrote. There was also a copy of the ballad "The Drum" sung by Hamilton and Aaron Burr at a dinner on July 8, 1804, of the Society of the Cincinnati, a group of officers who had known Washington during the Revolution, of which Hamilton was president. This duet occurred a week before their fatal duel (Hamilton had been Washington's aide-de-camp during the war and fought in the Battle of Brooklyn). Surprisingly, Hamilton and Burr had been friends and were witnessed leaving the old county courthouse in Flatbush together arm-in-arm.

Starting in 1830, members often adjourned to Johnny Joe's, an oyster bar on Prospect Street at Fulton Ferry, where they also held their reunions. The owner, John Josephs, was born a slave in Martinique around 1800 but as a boy was taken to New York by his master and freed. He worked as a waiter in private homes and then as an army servant under General Winfield Scott during the War of 1812. Scott would later become a hero of the Mexican War. In 1825, Josephs married Louisa Britton, a former American slave who became the cook in his restaurant, which became a recognized gathering place for judges, lawyers and newspapermen. It attracted what the *Eagle* called "the best company, the best wine, the best oysters and the best cookery." It was demolished for Brooklyn Bridge construction.

At club gatherings at Johnny's, members would sing an anthem whose lyrics were:

> *Our trysting place at Johnny Joe's*
> *Our glorious John Joe's*
> *Where we all ate the oyster fries,*
> *Down there at Johnny Joe's.*

Referring to the Brooklyn Bridge and Henry Cruse Murphy, Josephs's *Eagle* obituary stated, "This vestibule of the great structure should properly be christened as Johnny Joe's monument, for who of all mortals more enjoyed his wine and oysters (and was more royally treated by him) than the immediate President of the Bridge Company, who is a distinguished Hamiltonian and whose portrait hangs in his ancient hall."

The Crescent or Century Club

The Century Club was founded in 1883 as the Crescent Football Club by Harvard and Yale football players who played in Prospect Park and later at the Brooklyn Athletic Club at Ninth Street and Prospect Park West in Park Slope. It was reorganized as the Crescent Athletic Club in 1886, with Walter Camp, one of the founders of American football, as president. That year, the club members won the championship of Brooklyn at the Brooklyn Athletic Club grounds at Seventh Street and Fifth Avenue. In 1887, they were the champions of the new American Foot Ball Union. They were locally dominant, losing only to powerhouse teams such as Harvard and Yale, at a

Figure 56. The Crescent Athletic Club with the Hotel Touraine to the left. *Brian Merlis Collection.*

time when football was principally a collegiate sport. They then ventured into other sports, such as lawn tennis on ice and track and field. They were so successful that in 1889 they merged with the Nereid Rowing Club and acquired a boathouse and property in Bay Ridge between First and Second Avenues and Eighty-third and Eighty-fifth Streets. They also competed in baseball, rugby, cricket, golf, hockey, shooting, basketball and other pursuits. They expanded and used the old Van Brunt house there as a clubhouse and added an eighteen-hole golf course. They became an amateur power in baseball, defeating teams from Englewood, New Jersey, and Columbus, Ohio. But by 1919, development pressures led the Van Brunt estate to sell off some of the property that the club utilized, so the athletic fields moved to still-rural Huntington, Long Island, in 1929. This branch still exists. Most of the Bay Ridge property was sold in 1936, and in 1940, the last of these grounds became the athletic fields of Fort Hamilton High School.

The Crescent Athletic Club absorbed the Heights Tennis Club whose courts were at Hicks and Joralemon Streets. They occupied a building in the Saracenic style on the east side of Clinton Street between Pierrepont and Fulton Streets (figure 56). The Brooklyn Women's Athletic Club utilized this building in the 1920s, but it was demolished in 1960 by the urban renewal.

In 1906, the club built a splendid home on Pierrepont and Clinton Streets (figure 17) designed by Frank Freeman, which for many years was the epitome of luxury club life, with 2,650 members by 1912. It had a bowling alley, squash courts, a pool, a double-height dining room, a top-floor gymnasium, a library and a rifle range. It branched out into non-athletic activities, such as a mandolin and banjo club. During World War I, in support of national defense, it opened its rifle range to non-members who wanted to improve their shooting skills. Overexpansion and the Great Depression led to a reorganization in bankruptcy in 1939. The club closed in 1956. After being used for commercial purposes, including as a bowling alley, its former building became St. Ann's School in 1966.

The Brooklyn Women's Club and Other Women's Organizations

The Brooklyn Women's Club was organized in 1870 as the Social Science Club of the City of Brooklyn with Unitarian minister Celia C. Burr Burleigh as president and Elizabeth Tilton as recording secretary and immediately thereafter changed its name. It was an early supporter of the kindergarten at the Willow Place Chapel. In 1912, it purchased 114 Pierrepont Street

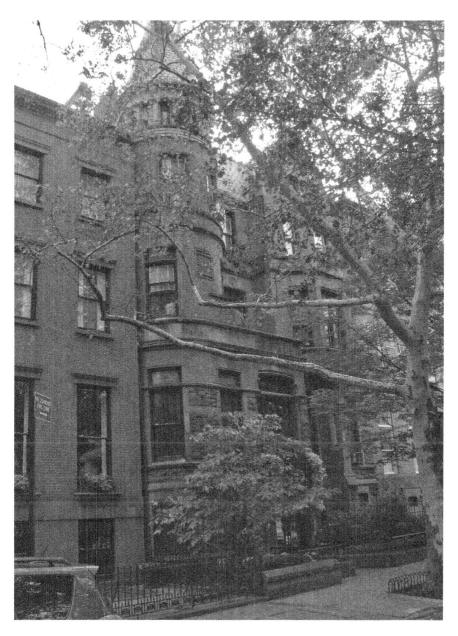

Figure 57. No. 114 Pierrepont Street was the home of the Brooklyn Women's Club from 1912 until 1978. *Robert Furman photograph.*

(figure 57) and met there. The club became the home base for most of the borough's women's organizations, including the Colonial Daughters of the Seventeenth Century, which held its thirty-fifth annual meeting there in 1931, and the Brooklyn Colony of New England Women, which held its meetings and smaller social events there. The club's building had a ballroom that was used for dances and other gatherings. Proms were held there too, including one for Brooklyn Friends School in 1931 (then located adjacent to the meetinghouse on Livingston Street and Boerum Place). Miss Hepburn's Dancing School, remembered by older Heights residents as their first highly proper social experience, held its sessions here in the 1920s and '30s. Paying off the building's mortgage in 1932 was celebrated at the club. It also sponsored serious discussions of civic issues, such as Brooklyn Bridge modernization.

For a paper focused on local affairs, the *Brooklyn Eagle*'s early coverage was surprisingly dismissive of the efforts of these wealthy women. On April 12, 1871, under the headline "The Brooklyn Women's Club and Its New Departure," the paper opened with, "After holding irresponsible and irrelevant discussions upon all matters of no moment for many months, the Brooklyn Women's Club have yielded to the weakness of the sex they signify." It went on to report that the club was getting incorporated. At that time, agitation was beginning on women's suffrage (see chapter 7). Later coverage was more respectful, but it did repeat allegations that involvement outside the home would cause women to neglect their families.

In 1894, the club published a book of women's writings in celebration of the club's silver jubilee (twenty-five years), which included two pieces by Celia Burleigh and a history of Lady Deborah Moody, the founder of the town of Gravesend, by Brooklyn historian Gertrude Lefferts Vanderbilt. A major event under the club's aegis was the annual Readers' and Writers' Luncheon, held from 1941 until 1968, co-sponsored by the Walt Whitman Foundation, which was based at Brooklyn College. In December 1953, actress Rosalind Russell (remembered today for her starring roles in the films *Wonderful Town* and *Auntie Mame*) appeared at the club in support of the Arthritis and Rheumatism Campaign. Other well-known speakers included Eleanor Roosevelt, poet and Lincoln scholar Carl Sandburg, choreographer Agnes DeMille (*Oklahoma!*) and playwright Thornton Wilder (*Our Town*). The club also engaged in a continuing effort to help women handle their finances, and many speakers addressed this issue.

The *Brooklyn Heights Press* reported in April 1978 that the club's building was sold for condos. The paper said that membership had been declining

since the late 1950s, that Christian Scientists had been renting space there for twenty years and that lodgers related to the organization had been living there.

Another women's organization in the 1900s was the Civitas Club, which met at 132 Remsen Street and later at the Women's Club. There is also a chapter of the Junior League. In the 1920s, it operated a bookshop and circulating library at 183 Joralemon Street.

The Daughters of the American Revolution (DAR) is composed of female descendants of participants in the Revolution. The Fort Greene Chapter was once a major organization that operated the Lefferts Homestead in Prospect Park and placed plaques noting Battle of Brooklyn sites (see chapter 1). It drew its members from most of brownstone Brooklyn and often met in the Heights. This chapter still exists. There was also a Women of '76 Chapter and a Nathanael Greene Chapter of the Children of the American Revolution, which held tea dances at the Women's Club in the 1920s. There was also a chapter of the Daughters of Colonial Wars in the State of New York, which met in members' homes and heard history lectures by such local luminaries as Charles Ditmas, head of the Kings County Historical Society, an activist organization that owned a house in Flatbush and closed in the 1930s. In 2005, the Battle of Brooklyn Chapter of the DAR was organized for all of Brooklyn and has forty members. Laura H. Congleton of the Heights is the chapter regent (chair).

The Heights Casino

The Heights Casino, at 75 Montague Street (figure 58), is a squash and tennis club and hosts numerous tournaments. The principal founder was Alexander M. White Jr. (1870–1929), grandson of his namesake via William Augustus White. He lived at 52 Remsen Street. White organized the Wall Street firm of Moffat & White in 1895 and partnered with Francis Weld in 1905, and the families intermarried. The partners joined the old Boston Weld firm in 1910 and moved it to New York as White Weld, which merged into Merrill Lynch in 1978.

Designed by Boring and Tilton, who also modeled Ellis Island's immigration buildings, the club's building dates to 1905 and features a Dutch-style stepped gable at its top and intricate brick and ironwork, including iron tie rods in the shape of squash rackets. Four skylights were reinstalled in the last few years that had previously been removed. The casino sports a

Figure 58. The Heights Casino. This Dutch-style structure houses the last remaining operating club in the Heights. Note the restored skylights. *Robert Furman photograph.*

restaurant, bar, governors room, lounge and fitness center, along with six singles squash courts, one doubles squash court and two tennis courts (figure 59). The squash courts did not originally conform to required specifications and were upgraded in the 1960s. A bowling alley was converted into doubles squash in the 1930s. Creating it required the removal of a huge boulder from the building's basement. The lower tennis court converts into a ballroom for four hundred people. Tennis had previously been played on various local outdoor sites, including 200 Hicks Street, 100 Remsen Street, 245 Henry Street and 145 Hicks Street. But as the area was built up, the indoor courts at the Casino became the only local places to play.

Socialite Craig Whitney—of the business (*New York Herald Tribune*), sports (Saratoga Racetrack and New York Mets) and philanthropy (Whitney Museum) family—commented in 1904: "Ihpetonga meant 'on the Heights' in Native American, but nowadays the word practically means 'Brooklyn's Aristocracy.' Ihpetonga members came from many of the same families that built the Casino."

Figure 59. Tennis court in the Heights Casino. *Courtesy of the Heights Casino.*

Well-known members in the 1920s from Wall Street included William McChesney Martin, chairman of the Federal Reserve in the 1950s; James V. Forrestal, secretary of the navy during World War II and the first secretary of defense (1947–49); and John J. McCloy, U.S. high commissioner for Germany after World War II. McCloy was a national tennis champion in 1927 and narrowly lost a tournament to world champion Bill Tilden in 1924.

"Little Men and Women of '76" dances, pre-debutante balls, were held at the Casino when it was new. There was a separate Cinderella Ball for prep school teenagers at the Hotel Bossert. The Casino closed during U.S. involvement in World War I (April 1917 until November 1918). The Yuletide Ball functioned from 1920 until 1969 as the Brooklyn Debutante Ball to benefit the Brooklyn Kindergarten Society for preschool education for poor children. It had previously been the Ihpetonga Ball at the old Academy and at the Casino from the time that institution opened. It was suspended during World War I. The first one was the All-American Costume Ball on April 16, 1920, with Frederic Pratt, son of Standard Oil partner Charles

Pratt, appearing as Alexander Hamilton. The next one on December 27, 1921, was the first Yuletide Ball. In 1923, a Thanksgiving Debutante Ball was begun to avoid the expense of families holding private parties, with the actual presentation of the debutantes taking place at the Yuletide Ball. In the 1920s and '30s, the balls alternated among the Casino, the St. George and the Towers Hotels. Tea dances substituted for the balls in 1942 and 1944, with no events in 1943. In 1945, a Victory Ball was held at the Towers Hotel, presided over by Gladys Darwin James. In 1945, a separate Yuletide Debutante Ball was reactivated at the Hotel St. George. Thereafter, the events took place at the hotels or the Casino. By 1970, the Yuletide had ceased being a debutante event because such things seemed frivolous amid the dislocation caused by the drafting of local young men for service in the Vietnam War and their consequent alienation from society.

Unlike many of the other clubs, it managed to survive the Great Depression, but by the early 1950s, it ran into increasing annual deficits due to declining membership, leading to higher dues, which further depressed membership—this in spite of free loans from Darwin Rush James III and Gladys Darwin James (see chapter 11).

On April 21, 1955, the Board of Governors tentatively decided to close the club, but two rival groups presented plans to save it. The first proposed that thirty members pay $1,000 each per year, but by the time the board had to decide the issue, this group had only seventeen volunteers. Seth S. Faison (born 1924) (figure 62), club president from 1958 to 1960, proposed cutting membership dues in half, as well as other cost-cutting measures, and eliminating racial or religious restrictions that prohibited blacks, East Asians or Jews. An exception had been made in the 1940s for Heights resident Robert Blum and his family, who was the grandson of Abraham & Straus founder Abraham Abraham (chapter 8, figure 20). This was a "gentlemen's agreement," not a rule, so change required only a consensus. Anti-Semitism was apparently endemic to wealthy Brooklyn and was socially acceptable (figure 60).

Faison is best known for bringing former dancer Harvey Lichtenstein to the Brooklyn Academy of Music (BAM) as its artistic director in 1968 when he was board chair there. Lichtenstein made BAM the most exciting avant-garde arts center in the city. Before he took over, it was dowdy and in danger of collapse because it could not compete head-to-head with Lincoln Center and Carnegie Hall in Manhattan.

This plan to save the Casino was adopted by one vote and led some of the old-line members to resign. Board member Gladys Darwin James offered to

BUSINESS BEFORE EVERYTHING.

Figure 60. This anti-Semitic cartoon ran in *Brooklyn Life* magazine, the organ of wealthy Brooklyn, on April 5, 1890. It depicts a Jew attempting to sell another man a new suit after they have been blown up. The caption reads "Business Before Everything." This is probably a reaction to Jews taking over the dry goods business via department stores because of lower prices and sophisticated marketing. The reputation of Jews for cheapness is probably a result of this rather than personal parsimony. *Robert Furman Collection.*

(and did) subsidize the operations of the restaurant. Membership went from 289 families in 1956 to 360 in 1959 and 422 in 1964. The Casino became significantly more representative of the community and was more solvent, in spite of some resignations. In the 1970s, the admission rules were streamlined following the rejection of municipal union chief Victor Gotbaum in 1976

(he and his wife, Betsy, the city public advocate from 2006 until 2009, then lived on Joralemon Street). According to club president Faison, this rejection occurred because the Membership Committee felt the Gotbaums' attitude toward the club was rather cavalier; they dressed too casually and acted entitled to join. Today, the main hurdle to membership is an ability to pay the dues. However, the club continues to possess an unwarranted reputation for exclusivity and discrimination, perhaps because of its history and luxury.

The apartment building next door, the Casino Mansions at 200 Hicks Street of 1911, is in a Classical style with similar brickwork and features huge apartments. The backyard is shared with the great Gothic Revival house at 36 Pierrepont Street and features a garden by Alice Recknaygel Ireys, who also created the Fragrance Garden in the Brooklyn Botanic Garden.

Other Clubs

The building at 293 Henry Street was the home of the Teachers' Club in the early twentieth century. The Columbian Club met at Clinton and Joralemon Streets in 1890. There was also a Brooklyn Chess Club at 146 Montague in the early 1900s, along with a Democratic Party club at 201 Montague. The Brooklyn Excelsiors baseball team's home at 133 Clinton Street evolved into the Excelsior Club by 1874 (chapter 12, figure 5), a social club. There was also a Neighborhood Club at 104–08 Clark Street that hosted local social events and presentations by the Brooklyn Neighborhood Players in the 1920s and '30s.

The Rembrandt Club for men and Mrs. Fields' Literary Club for women still function, although they have never had permanent homes.

Figure 61. No. 123 Remsen Street has a lovely Corinthian-columned entryway and balustrades. This building was erected circa 1856 for Charles Condon and was no. 87 at that time. It is now the Brooklyn Bar Association. *Robert Furman photograph.*

Both are limited to one hundred members, hold formal dinners and sponsor cultural events. The Irish poet William Butler Yeats's first American speech was at Mrs. Fields'.

The Brooklyn Bar Association makes its home at 123 (number 87 in the old system) Remsen Street, the Charles Condon House (figure 61). The building is also home to the Brooklyn Women's Bar Association.

Figure 62. Seth S. Faison at home in 2012. *Robert Furman photograph.*

Chapter 7

SLAVERY, ABOLITIONISM, THE UNDERGROUND RAILROAD, THE CIVIL WAR AND ITS AFTERMATH

1640–1887

SLAVERY IN BROOKLYN

The Heights was farms until the early nineteenth century (see chapter 2, figure 3), and the Dutch and British owners used slave labor there, as they did throughout Kings County. This is indicated by the fact that of the county's population of 4,500 in the first U.S. census of 1790, one-third, or 1,500, were slaves. Bondage ended in Brooklyn in 1825, two years ahead of the date prescribed by New York State's Gradual Abolition Law of 1799, as amended. Very quickly, Brooklyn Heights and the surrounding area, which was then residential and would later become downtown, exploded as a hotbed of abolition.

Slavery in Kings County was especially peculiar as the Dutch managed it. It was recognized that it was a money-based institution, but because there were only relatively small farms in the area rather than plantations, there were some humane features to this brutal practice. Bondsmen were allowed days off, could have their own side businesses and could seek new masters if they disliked their owners, as is recognized by the black historian Craig Wilder (see below).

The British were more callous in their attitudes toward bondsmen. They would not allow slaves to gamble or have more than twelve people at a funeral (probably for fear that such meetings could be used to organize revolts). If found away from home at night, slaves were to be taken to jail and whipped. As abolitionist feelings rose after the 1783

Figure 1. A slave kitchen on a Kings County farm. Date of photograph unknown. From *The Eagle and Brooklyn*, 1898.

British evacuation of New York, public auction sales were ended in Kings County in 1790.

We know there were slaves in the Heights since Peggy, the bondswoman of former Hessian soldier John Valentine Swertcope, sold hot corn and pears with molasses on Fulton Street around 1800. In addition, the list below shows that Cornell and Hicks family members freed slaves, and these names are not known outside the Heights.

EMANCIPATION IN NEW YORK STATE

The New York Manumission Society, led by Alexander Hamilton (who had seen bondage in its worst form in the sugar cane fields of Nevis in the Caribbean where he grew up) and future Supreme Court chief justice John Jay, encouraged owners to free slaves and lobbied for abolition. In 1799, the

state passed a law for its gradual abolition, which specifically authorized manumission (the freeing of slaves "by hand") and required that the institution end by 1827, when young people born in 1799 would complete the term of service the law prescribed they owed their owners (twenty-seven years for men and twenty-five for women).

The 1864 *Manual for the City of Brooklyn* lists manumissions (freed slaves) in all of Kings County after 1800. The first, however, was Caesar Foster, released in 1797 under a 1788 law that allowed but did not require manumission. During 1820, Anna Vanderbilt+ freed Margaret, aged sixteen years. Agnes Rappelyea+ let thirty-year-old Anthony go in 1821, as did Leffert Lefferts+ with Henry, aged thirty-three. Adriance Van Brunt+ freed Sude, a thirty-five-year-old woman, and Jack, forty-four. Jeremiah Remsen+ let go thirty-one-year-old Nancy in 1820, and Selah Woodhull+ freed Fanny, aged twenty-eight, that year. Similarly, families with the names Polhemus+, Hicks+, Berry+, Duffield+, Cornell, Freeke, Cowenhoven+ (often Anglicized as Conover+), Strong+, Luqueer+, Johnson+, Bergen+ and Birdsall also freed their slaves. While there were Remsens+ all over Kings County (there is a Remsen Avenue in Canarsie), the woman named Nancy freed by Jeremiah Remsen may have lived on the Heights.

However, all was not positive in manumission. It is clear that people who were legally free were being held in bondage and that slaves were being purchased for the specific purpose of selling them in the South for a profit. Craig Wilder, now professor of history at Massachusetts Institute of Technology, reported in *A Covenant with Color*, the only book about slavery and black history in Brooklyn:

> *In 1800 the New York Manumission Society charged that Captain Gilford of Flatbush was holding a free black woman from Nova Scotia in bondage. Peter Van Roden of Brooklyn bought Peggy Hull and sold her out of state before she could become free. Justice William Livingston of Kings County asked the Manumission Society to intervene on behalf of Harry, a servant who had been promised his freedom and fifty dollars in his owner's will. John Lott, whose family bound twenty-six Africans on their Flatlands farms in 1790, seized Harry and his purse. The executors of the estate of Eleanor Simmons listed Margaret Ansley as a runaway, although Peter Courtelyou of Brooklyn witnessed her emancipation. (In 1790 the Courtelyous of Brooklyn and New Utrecht claimed thirty-two Africans.) A 24-year-old black woman was "sold for life" at auction in the Old Ferry Market. Administrator William Arnold did not display the bondswoman*

at the market, but made her available for private inspection in the preceding days, because public auctions were considered distasteful. Jacobus Van Nyun of New Utrecht illegally removed Lydia Hill to New Jersey where she remained enslaved. A store on the Williamsburg [Bushwick] border sold a 15-year-old black boy, "strong and in good health." A 10-year-old black girl from Brooklyn was bound out until she was 25, a 15-year term of service offered even though slavery was to end in eight years. By 1820, when bondage was in marked decline almost everywhere else in the state, half of the African Americans in Kings County remained enslaved.

As early as 1800 the Standing Committee of the New York Manumission Society was decrying the "very general" practice of cheating the manumission law by transporting "Negroes from this to the Southern states…from whence they are reshipped to the West Indies." The city also kept an open door for slave smugglers. "Any day of the week, slaves could be discovered stowed in the holds on board ships docked in New York harbor. They were brought from Africa, the West Indies, South America, and the American South, bound for reshipment to Southern plantations," notes Anthony Gronowicz in his history of pre–Civil War Manhattan politics.

In 1819, a year after the founding of Brooklyn's first independent black church, fugitive Africans seemed to be overtaking the county. Sam Johnson, an enslaved 10-year-old mulatto, liberated himself to the dismay of Cornelius Van Cotts of Bushwick, and a bondsman named Charles loosened himself from the Wallabout estate of Jacobus Lott. Lott forbade all from "harboring or employing said runaway under penalty of the law." Johannes Stoothoff of Flatlands was particularly cross when his bilingual servant Dan, age 22, absconded. What most bothered Stoothoff was that Dan had permission to take leave for one day to look for a new master. Dan did exactly that when he decided to own himself but the arrangement was not to Stoothoff's liking. Similarly, 38-year-old Yaff abandoned the Flatbush farm of Levi Hart on which he was enslaved. John Hegeman+ of Flatbush suffered the loss of two bondspeople, "a negro wench, named BET, and her boy, named Sam, about nine years old." The 28-year-old mother took with her "a considerable quantity of clothing, and other articles." Abraham Selover of Bedford was so vexed when his 25-year-old bondsman Peet escaped that he asked that hunters return him "or confine him in some jail." Garrit Vanderveer of Flatbush had his Bet, 28, flee (he warned his neighbors not to trust her), while 17-year-old Millane fled Brooklyn's Losee Van Nostrand+.

The New York State Gradual Abolition law provided that the counties should help maintain former slaves who were unable to earn a living. This was done via almshouses whose administrators were called overseers of the poor. David Ruggles, an early black abolitionist, reported in 1838 that Brooklyn overseer Lance Van Nostrand had illegally incarcerated a freeborn woman and her two children with the intention of selling them into southern slavery.

AIDING FREEDOM SEEKERS

One will notice the prominence of wealthy businessmen in the abolitionist movement. This was the product of their belief in "free labor," a founding principle of the Republican Party, which held that business needed workers with the flexibility to move from job to job and place to place as economic conditions required. While slavery was inconsistent with this concept, "free labor" would later have anti-union implications.

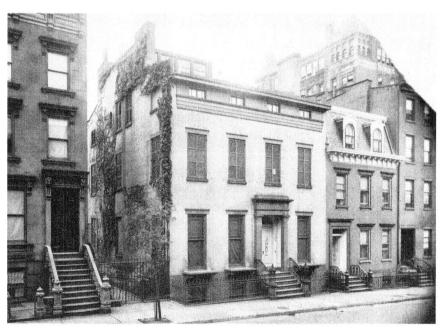

Figure 2. Although better known as the 1950s home of Truman Capote, 70 Willow Street is the Adrian Van Sinderen House. The house dates from 1839. *Brian Merlis Collection.*

A suggested solution to slavery was the colonization of Africa by American blacks. This scheme, although developed by whites who could not imagine a successful multiracial society, engendered significant support over the years, most notably in the 1920s and '30s "Back to Africa" movement of Marcus Garvey, who is seen as a prophet by Jamaican Rastafarians. Liberia, with its capital at Monrovia, named for President James Monroe of Virginia, the founder of the American Colonization Society (ACS), which led the movement, is the product of this effort.

Adrian Van Sinderen was the first president of the Brooklyn Savings Bank. He moved from 58 Willow Street to number 70 (figure 2), his new house, around 1839. He died before 1850. He helped found a Brooklyn branch of the ACS in 1830 and gave freedom-seeker Reverend James W.C. Pennington

Figure 3. Frederick Douglass, himself a runaway, was the most prominent black man in America during and after the Civil War. *Library of Congress Picture Collection.*

(1807–1870), a runaway originally from Maryland by way of Pennsylvania, a job as a coachman, probably in 1829. Pennington is probably best known for performing the wedding of Frederick Douglass (figure 3) to Anna Murray at the home of David Ruggles. Clearly, Van Sinderen opposed slavery but could not imagine a multiracial society. In fact, while the ACS was opposed to slavery, its purpose was to exile free blacks to Africa.

Here is Craig Wilder on Pennington:

> *The most prominent African to escape to Brooklyn was James W.C. Pennington, born James Pembroke in 1807. In 1829, he ran away from the eastern shore of Maryland. A long and dangerous flight brought Pennington to the North where he "went to New York, and in a short time found employment on Long Island in Brooklyn, where slavery was so recently abolished; and finding much to do for their elevation, I resolved to give my strength in that direction." In 1830 the Brooklyn Temperance Association was organized to reduce drunkenness and disorder. Benjamin*

Croger was president, Pennington was secretary, and George Hogarth, a minister and a teacher at the area African school, was a manager. A year later Pennington helped construct the public statement of a convention of Kings County's black residents in opposition to the local ACS's schemes to relocate free colored people to Africa and Haiti. The parents of black children on Long Island felt Pennington's presence through his constant proselytizing to get them to send their youngsters to school. He served as instructor at a new school for Africans in Newtown, Long Island [Queens]. The fugitive turned teacher attended classes at Yale Divinity School, although its officials would not formally allow him to enroll, and in 1837 was licensed as a preacher in Brooklyn. In the following years Pennington received the degree doctor of divinity from the University of Heidelberg, became a major antislavery spokesman in the United States and Europe, and was installed as pastor of an African church in Manhattan. In 1852, in the concluding remarks to her Uncle Tom's Cabin, *Harriet Beecher Stowe added Pennington to a list of "individuals [who] have thus bravely succeeded in conquering for themselves comparative wealth and social position, in the face of every disadvantage and discouragement."*

Beginning in 1831, J.W.C. Pennington represented Brooklyn at the first conventions in Philadelphia and New York. "A public meeting was held on the 27th of March [1832], when Mr. James Pennington was duly elected the delegate to the Convention from this village," announced "A Colored Freeman" from Brooklyn.

The Second Great Awakening: William Lloyd Garrison, Arthur and Lewis Tappan, Lydia Maria Child and David Ruggles

Today, religious reformers are conservatives, but in the nineteenth century, they were liberals. (The major exception to this within living memory is the civil rights movement of the 1950s and '60s.) It is not generally known that the reform movements of the nineteenth century were the product of intense religious feelings. It is therefore not an accident that Reverend Henry Ward Beecher (figure 9) is the best-known New York City abolitionist.

The intensity of the abolition movement was, to a great extent, a product of the Second Great Awakening of the 1820s through the '40s, which generally revived religious feeling in the United States and thereby ended

the Age of Enlightenment. Both white and black foes of slavery were deeply religious or religious leaders. Indeed, the only major leader who was not was William Lloyd Garrison (figure 4).

Besides abolitionism, the Awakening also led to the women's suffrage movement, strengthened the temperance movement, eventually led to prohibition and caused the founding of the Church of Jesus Christ of Latter Day Saints (Mormons). All of this took place in western New York State, near the Erie Canal, which was rapidly modernizing life there and generating a religious reaction. The area was therefore called the "burnt-over district." The Civil War may be considered a religious crusade, as indicated by the lyrics to the "Battle Hymn of the Republic," whose composer, Julia Ward Howe, was also an early feminist. The fifth verse is transcribed below:

Figure 4. William Lloyd Garrison was a Boston-based secular abolitionist who also aided the cause in New York and Brooklyn. *Library of Congress Picture Collection.*

> *In the beauty of the lilies Christ was born across the sea.*
> *With a glory in His bosom that transfigures you and me.*
> *As He died to make men holy let us die to make them free.*
> *While God is marching on.*

The Anti-Abolitionist Riots of 1834 were a major factor in the growth of the abolition movement in the new City of Brooklyn. Arthur and Lewis Tappan (figure 5)—religious philanthropists, dry goods merchants and political activists—although raised as Unitarians, began attending the more pious liberal Congregational evangelical church where they grew up in Connecticut. Arthur moved his New York base to the Heights as rumors of impending anti-abolitionist riots spread through Manhattan in 1834. He owned a home in Bridgeport, Connecticut.

Lydia Maria Child (figure 6), an activist and writer, reported from Brooklyn that assassins were actively pursuing Arthur. This was not an idle threat: in 1836, he received a black person's ear in the mail. The city of

Figure 5. Lewis Tappan (1786–1865). *Robert Furman Collection.*

Figure 6. Lydia Maria Child was the most famous children's book author in America before and during the Civil War. She was also an active abolitionist. *Library of Congress Picture Collection.*

Brooklyn's first mayor, George Hall, ordered Arthur Tappan protected by city police and persuaded the commandant of the Brooklyn Navy Yard to assign a marine unit to guard him (the U.S. Marine Corps was and is part of the navy). The guards were posted along the route from the navy yard to Tappan's residence. A positive effect of this terrorism was that numerous evangelicals, especially from Connecticut, began to move to Brooklyn because of its more sympathetic attitude toward abolition.

Child was the most famous children's book author in the country at the time. But in 1833, she published *An Appeal in Favor of That Class of Americans Called Africans*, the first published abolitionist treatise. The title was significant in that black people were often not considered Americans but were referred to as Africans, a treatment with which she obviously disagreed. She knowingly paid the price of her activism by losing her position as a best-selling author, as her other works were boycotted by the large segment of America that viewed abolitionism as either evil or extremist. She was an early example of the prominence of women in all of the humanitarian and moral reform issues of the day, from abolition to prohibition and from the fair treatment of workers and the support of proper living conditions to women's suffrage.

But remnants of slavery remained in Brooklyn. Southerners transshipped cotton and rice to New York for export to Europe and elsewhere and owned property here, and their businesses were often financed by Wall Street. They often kept slaves in New York State, where it was only legal to keep them in bondage for nine months, and as the deadline approached, they would remove them from the state, often to New Jersey, return them to the city and re-register them for another nine months. This was an evasion of the law (after the nine months they were supposed to be freed). In addition, often with the contrivance of proslavery or bribed judges, free black people were held and sent south in chains. Black abolitionist David Ruggles reported in his newspaper that he had freed fourteen people from slavery in Brooklyn between 1836 and 1838 and that there were so many slave owners in Brooklyn that it should be called "the Savannah of New York"! As tensions between the North and South grew, these southerners mostly removed to their homeland.

Ruggles, a black Manhattan abolitionist, sought to expose slave owners in the city. Among these was David Stanford, a member of a Methodist Episcopal church who Ruggles suggested should be ostracized or expelled by his congregation (unlikely since that sect was not activist). Stanford, identified only as a "gentleman" (implying that he was an heir who did not work) in the 1848 Spooner city directory of Brooklyn, lived at 108 Henry Street near Joralemon Street in the Heights.

Fergus M. Bordewich in his *Bound for Canaan* tells the story of Ruggles freeing three bondsmen—Jesse, Jim and Charity Walker of South Carolina—who had been retained in Cobble Hill beyond the limit allowed by New York State. The issue came to a head when their owner, a Mrs. Dodge, informed Charity in the spring of 1838 that she intended to take them back to South Carolina in part to avoid having to free them under the New York law. Charity went to see Ruggles, who visited the house:

In June 1838 Ruggles reported in detail how he had entered the house of D[avid]. K. Dodge, a slaveholder from South Carolina who maintained a home on Henry Street, in Brooklyn Heights [actually 12 Strong Place in Cobble Hill near Henry Street], *where he kept three slaves, one of them for four years, far longer than the nine months permitted to out-of-state slave owners by New York law. At least one of the slaves, a maid-servant named Charity, had made contact with the Vigilance Committee and asked for help. Once admitted to the Dodge house, Ruggles simply refused to leave. Dodge's wife maintained that they had brought the slaves north specifically to set them free.*

"Haven't I told you that you are free?" she asked Charity.

"You told me to say so if anybody ask me," Charity replied, emboldened by Ruggles' presence, *"but you beat me here as much as ever missee."*

"Why, if Mrs. Dodge brought you here to be free, she would not treat you ill; but on the contrary, she would be kind to you and pay you wages," said Ruggles.

"Wages!" exclaimed Charity.

"Oh, no," said Dodge. *"But I take good care of you."*

At this point a neighbor, a Dr. McClennan, *"a little fellow with a pair of stiff whiskers,"* suddenly appeared, apparently intending to evict Ruggles, whom he charged with being an intruder. Ruggles retorted that it was the doctor who was the true intruder, with no right to interfere *"against liberty and the laws of the state."*

"I am here to remove a disorderly person," McClennan declared.

"Find such a person here, and I will aid you in his removal," replied Ruggles. *"I was invited here to relieve humanity."*

"I wish you would leave, sir," McClennan repeated.

"I wish you would leave, sir," said Ruggles.

"You aggravate me," said the doctor.

"You don't aggravate me," replied Ruggles.

The doctor, looking over and under his spectacles, as though getting ready to use his rattan cane, visibly came to the conclusion, Ruggles supposed, that since the abolitionist was some inches taller and heavier, he did not attempt it. After further irritable debate over the consequences of bringing slaves into New York, the doctor at last begged Ruggles to leave until the man of the house returned before attempting to *"carry off one of the slaves."*

"They are perfectly free to do as they please," said Ruggles blandly. *"If I choose to remain, they can; I employ no force to remove them; if they go with me, I will protect them."*

"I is free as a rat, and am going," Charity proclaimed. *"If I was to stop; I should find myself dead tomorrow morning. I know you, missee."* Concluded Ruggles, *"As I was then ready to leave, Charity took a bundle of rags, which were an apology for clothes, and with the editor, left her kind and affectionate mistress to take care of herself, and is now doing well."*

The D.K. Dodge described here is David K. Dodge, a merchant who lived in Cobble Hill from the 1830s through the '50s, by 1859 living at 120 Congress Street. His two daughters probably attended Packer in 1861 (see below).

A legal case about liberating slaves in free states in which Brooklynites participated was the Darg case in 1838. John P. Darg brought his slave Thomas Hughes to New York in spite of the fact that the right to retain ownership in a free state was under negotiation between the governors of Virginia and New York. Hughes absconded with $7,000 or $8,000 of his master's money and asked for help from abolitionist Isaac T. Hopper. The matter evolved into a lawsuit in which Barney Corse and David Ruggles were arrested for complicity in grand larceny in spite of a proposed agreement to return as much of the money as Hughes still possessed. This occurred because Darg was unsatisfied with the amount to be returned. Ruggles spent three days in jail until Arthur Tappan and J.W.E. Higgins posted $3,000 bail, an outrageous amount. During the trial, Tappan and Moses Y. Beach (see below), as editor of the *New York Sun*, testified. The case became moot when Hughes decided to return south, having been tricked into being resold.

A more conservative way of freeing slaves was to buy them out of bondage, which was pursued by many churches in the 1830s and '40s, including the First Baptist Church on Nassau and Fulton Streets and also by Plymouth Church. A fundraiser for this purpose took place at the First Baptist in 1848 (located in what is now Cadman Plaza Park), featuring Reverend Beecher and Reverend Samuel Hanson Cox of the First Presbyterian Church (see below). Up Nassau Street from the Baptist church was African Hall, about which little is known except that it was a fraternal meeting place owned by members of the black community who had gathered in that area. This community was served by three churches: Siloam Presbyterian, Concord Baptist and the Bridge Street African Wesleyan Methodist Episcopal (AWME). The latter's former building, a city landmark, survives in Metrotech as Wunsch Hall of NYU–Polytechnic University.

Henry C. Thompson was a wealthy black man who owned a "blocking factory" at 43 Hicks Street in 1840 when the north Heights was a light industrial area. He sold James Weeks the land that would become Weeksville, and he was the second president of the Brooklyn African Woolman's Benevolent Society (which had nothing to do with the wool business—it was a communal benevolent association) and a deacon (in 1832) of the High Street AWME Church that became the Bridge Street AWME when it moved. William J. Wilson, also known as "Ethiop," was a teacher and Brooklyn's correspondent to the black and abolitionist press, often writing under his pseudonym. He was also a contributor to the *National Anti-Slavery Standard* in 1853. He lived at Atlantic Avenue and Hicks Street.

The Heights was a wealthy neighborhood, so few blacks lived there. An exception in 1804 was James Ash of 41 Hicks Street, who was the first black homeowner in Brooklyn. The distinction between the Heights and downtown is a product of twentieth-century commercial development and urban renewal and disguises the fact that, in the mid-nineteenth century, they were little different and that black and white people worked together in the abolitionist movement.

Moreover, there were some mixed-race people in the area. For example, wealthy businessman Thomas Truesdale (or Truesdell)—who lived with his wife, Harriet, at 227 Duffield Street in what is now downtown Brooklyn—seems to have been a mulatto, according to William Lloyd Garrison, who stayed at their home during a New York visit. Both Thomas and William were longtime abolitionists who contributed financially to Underground Railroad organizations. Elizabeth Harris, a seventeen-year-old black girl from North Carolina, lived with them from 1853 until sometime before the 1860 U.S. census. It is most likely that she was a runaway.

PLYMOUTH CHURCH AND HENRY WARD BEECHER

The most famous church in the Heights is Plymouth Church on Orange Street (figure 7). The Cranberry Street side of the site was (and still is) occupied by the former 1823 First Presbyterian Church. It was sold to Plymouth when it was organized in 1846 as an offshoot of the "mother" Church of the Pilgrims, which some members felt was too conservative. Plymouth was founded by a group of practical-minded yet pious businessmen who gathered around Arthur and Lewis Tappan and John Tasker Howard (figure 8) of 150 Hicks Street (razed). Tasker and his father began scheduled sailings to California around Cape Horn during the gold rush of 1848 and consequently proposed a Panama Canal to cut the travel time. They earned a fortune building steamships to transport prospectors.

Other Plymouth founders included David Hale, merchant Seth Hunt (who lived at the corner of Remsen and Clinton Streets) and Henry Chandler Bowen (at that time of 119 Hicks Street, now demolished). Hunt put up the $50,000 purchase price for the Plymouth site by himself, and Bowen and Hale bought one-third interests each and went off to find a minister for a militant organization. They found one in Indiana: Henry Ward Beecher (figure 9).

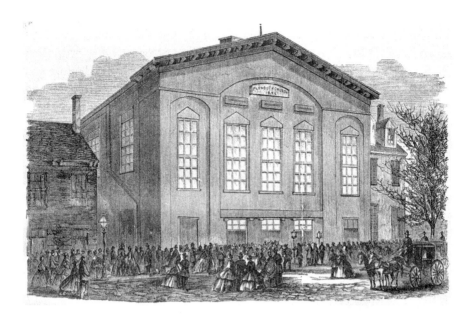

Above: Figure 7. Plymouth as completed, shown in 1877. There is no vestibule structure. From *The Eagle and Brooklyn*, 1898.

Left: Figure 8. John Tasker Howard, a major businessman who lived in the Heights, was a founder of Plymouth Church. From *The Eagle and Brooklyn*, 1898.

Opposite: Figure 9. Henry Ward Beecher with his sister, Harriet Beecher Stowe, author of *Uncle Tom's Cabin*, circa 1850. *Robert Furman Collection*.

Lewis and Arthur Tappan became wealthy in the dry goods business and were philanthropists in both Christian education and abolition. In 1830, Arthur Tappan and David Hale founded a newspaper called the *Journal of Commerce*, a predecessor of the *Wall Street Journal*, and also helped begin modern commercial credit.

Lewis's wealth exceeded his brother's by the 1850s. Per Bertram Wyatt-Brown in *Lewis Tappan and the Evangelical War Against Slavery*, Lewis moved to 68 Pierrepont Street (demolished) in the Heights in 1844 and began a local Liberty Party club to support the abolitionist presidential candidacy of James G. Birney. After the party disbanded, Tappan and others joined the Free Soil Party, which opposed the extension of slavery to the new states but was not antislavery where the institution existed. This was a predecessor of the Republican Party. Lewis not only subsidized abolitionism, but he also sheltered a fugitive slave, Anna Weems, in his house.

Among Henry Ward Beecher's new friends of 1853 were Moses Sperry Beach and his wife, Chloe, who lived at 66 Columbia Heights (razed). His father, Moses Yale Beach, invented the "penny press" (cheap newspapers that exploded in circulation and profits) when he founded the *New York Sun* (it was later the flagship of Joseph Pulitzer). Sperry took over the *Sun* in the late 1840s, backed by the Associated Press news service, but later sold it to Charles Dana. He also tested a pneumatic subway on Broadway near city hall. Yale's brother Alfred founded the *Scientific American* magazine. Debby Applegate believes Beecher may have been the father of Chloe's daughter Violet.

The old building on Cranberry Street was severely damaged by fire in 1849 and was replaced by the current one on Orange Street by English architect J.C. Wells, which is modeled on a New England meetinghouse with seats in the round for two thousand, no rostrum and a proscenium that thrusts well out into the congregation (figure 10). Nineteen memorial windows by Frederick S. Lamb represent "The History of Puritanism and Its Influence Upon the Institutions and People of the Republic." The church is Congregational (i.e., it is controlled by its members), a descendant of the Puritan church and the Pilgrims of 1620. The former Presbyterian church building was restored and today serves as a meetinghouse with some exterior features removed.

Henry Ward Beecher was the "Most Famous Man in America" according to the 2006 biography by that name by Debby Applegate. Instead of appealing to the intellect with tales of hell and damnation, he put on a show of oratory that reached the emotions. The *Brooklyn Eagle* described him as

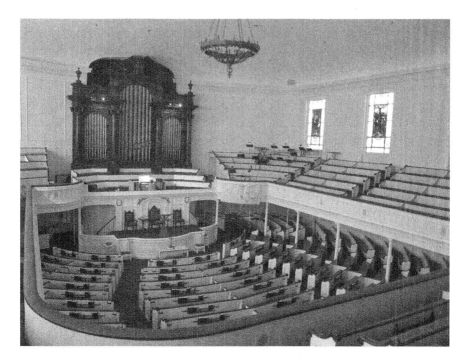

Figure 10. Plymouth's interior showing the in-the-round seating. *Courtesy Plymouth Church.*

the "Hercules of American Protestantism," and Mark Twain witnessed a sermon in 1853 and reported that "he went marching up and down the stage, sawing his arms in the air, howling sarcasms this way and that, discharging rockets of poetry, and exploding mines of eloquence, halting now and then to stamp his foot three times in succession to emphasize a point."

Beecher was funny, a quality appreciated by congregants more than colleagues and editorialists. Applegate says, "But one thing truly shocked: the Reverend Beecher was funny. He didn't tell jokes, exactly. He just put human foibles in such an ironic light that people couldn't help giggling. The effect was often so subtle, so dependent on a knowing tone of voice, a roll of the eyes, or a slight shrug of the shoulders, that it is hard to find the humor when reading the sermons on paper."

Walt Whitman was an early admirer of Beecher's and wrote after hearing him in 1849, "He hit me so hard, fascinated me to such a degree, that I was after-ward willing to go far out of my way to hear him talk." Whitman gave Beecher a copy of the 1855 first edition of *Leaves of Grass* and commented

that Beecher "stole terrifically from it…[or] that perhaps quite unconsciously he imbibed, accepted its spirit: molded many of its formulas into his own work. [Friends said] I heard Henry Ward Beecher last night (or the night before) and his whole sermon was you, you, you, from top to toe."

Beecher literally redefined American Protestantism by creating the "Gospel of Love," which we recognize today in the statement that "God is love." He was the brother of Harriet Beecher Stowe, author *of Uncle Tom's Cabin*, and an advocate of abolitionism (rifles sent to "Bleeding Kansas" were called "Beecher Bibles"), temperance, universal education and feminism in the 1850s through the '80s. He later sowed the seeds of the split between liberal and conservative religion by becoming a "Christian evolutionist." Brooklyn ferries were so crowded on Sundays with Manhattan devotees that they were dubbed "Beecher boats" and extra runs were scheduled.

Beecher made Plymouth a national center of abolitionism and the Underground Railroad in the 1840s through the '60s. In October 1848, he was instrumental in raising the funds to free the Edmonson sisters at a major fundraising rally at the Broadway Tabernacle in Manhattan. In April 1848, runaway slaves Emily and Mary Edmonson had sought to free others in the District of Columbia by joining their four brothers and seventy-one other escapees on the schooner *Pearl*. When the ship was captured and the six Edmonsons were returned to Washington, their father, Paul, a free man, started raising money to purchase the freedom of his children, especially his daughters, who were slated to be sold as "fancy women" (prostitutes) in New Orleans. The girls were shipped to New Orleans and then returned when a yellow fever epidemic threatened them. As time passed without success for Edmondson in Washington, the slave trader who owned the sisters became more insistent that he would sell them unless $2,250 was raised and delivered to him quickly.

At the suggestion of Washington abolitionists, Paul Edmonson took a train to New York City to try to raise money to purchase his daughters' freedom. They sent him to the offices of Lewis Tappan's American and Foreign Anti-Slavery Society (AFASS). Those in the office sent Edmonson to the Reverend James W.C. Pennington, one of the members of the American Missionary Association's Executive Committee. He was able to raise fifty dollars for the Edmonson sisters.

Beecher may be best remembered for his fake slave auctions, which were actually publicity stunts and fundraisers at which young women were supposedly put up for sale to raise money to buy other bondsmen out of slavery and to give them a good start in their new free lives. One was held

to benefit the Edmondson sisters, who were successfully bought out of bondage. A sale and its follow-up were reported as follows in *Historic Brooklyn*, a 1941 book commissioned by the Brooklyn Trust Company and written with the help of Edna Huntington of the Long Island Historical Society. This account, while moving, conflates several incidents:

A memorable slave auction occurred on Sunday, June 11, 1861. News of the event had been noised abroad, and the church and street outside were crowded. The service was begun by reading the story of the man cured of a withered hand: "Is it lawful," read Henry Ward Beecher, "to do good on the Sabbath day or to do evil, to save life or to kill?"

"About two weeks ago," he said. "I had a letter from Washington, informing me that a young woman had been sold by her own father to be sent South. She was bought by a Federal slave-dealer [a dealer in Washington, D.C.; they were not licensed or sanctioned by the U.S. government] *for $1,200, and he has offered to release her if the necessary funds are raised. She has given her word of honor to return to Richmond if the money be not raised, and slave though she may be called, she is a woman who will keep her word.*

"Now, Sarah, come up here, so that we can see you." The girl came slowly up the pulpit stairs and stood by Mr. Beecher's side. The pastor of Plymouth Church at once took on the voice and action of a slave auctioneer. His dramatic impersonation has been reported thus: "Look at this remarkable commodity—human flesh and blood like yourselves.

"You see the white blood of her father in her regular features and high, thoughtful brow. Who bids? You will have to pay extra for that white blood, because it is supposed to give intelligence. Stand up, Sarah! Now look at her trim figure and wavy hair! How much do you bid for them? She is sound in wind and limb I'll warrant her! Who bids? Her feet and hands—hold them out, Sarah—are small and finely formed. What do you bid for her? She is a Christian woman—I mean a praying nigger—and that makes her more valuable, because it insures [sic] *her docility and obedience to your wishes. 'Servants, obey your masters,' you know. Well, she believes that doctrine.*

"How much for her? Will you allow this praying woman to be sent back to Richmond to meet the fate for which her father sold her? If not, who bids?"

His audience was breathless. Women sobbed. "Come, now," continued Mr. Beecher, "we are selling this woman, you know, and a fine specimen

she is, too. Look at her! See for yourselves! Don't you want her? Now, then, pass the baskets and let us see!"

Bank-notes [sic] *were piled in those baskets, and jewels from women's hands. Those who were near the pulpit laid their gifts at Henry Ward Beecher's feet. "There, Sarah, you are free," said Mr. Beecher. More than a year before this event a young slave girl, valued by her master at $900, was sold in Plymouth Church. This occurred on a Sunday in February 1860. In the audience was a lady named Rose Terry, who put into the contribution-box one of her rings. Later the pastor placed this ring on the slave girl's finger, telling her it was her freedom ring, and that her name was Rose Ward, for the lady who gave the ring and himself.* [Rose Ward was later sent to Howard University by the Plymouth society.]

The Fugitive Slave Law of 1850 galvanized abolitionists. It was a response to a secession threat made over California's proposed entry into the Union as a free state without going through territorial status, since this would tip the balance of power in the Senate (and therefore the country) to the free states. Politicians attempted to keep the country together by giving the South equal power to the expanding industrial North. Senator Henry Clay proposed abolishing slavery in Washington, D.C., with compensation to owners and the permission of Maryland (which was highly unlikely since it was a slave state) and California's free-state admission. In addition, Texas ceded its claim to the New Mexico Territory, preventing the spread of slavery into the Southwest.

But southerners received reaffirmation that slaves were property that could be brought to free states without fear of liberation. The law was especially harsh: due process requirements for returning runaways were removed, and financial incentives stimulated federal marshals and others to shanghai free blacks into bondage. Alleged runaways could be detained on the say so of their alleged former owners, with no requirements for proof or jury trial. They were turned over to a special commissioner who received a $10 fee (quite a bit then) to transport them south. Northern marshals could be fined $1,000 for refusing to enforce the law, ordinary citizens could be forced to form posses to ferret out slaves and anyone assisting a runaway could be fined a similar amount for each person aided.

The Underground Railroad

Although it had existed previously, the local growth of the Underground Railroad, the effort to conduct runaways to freedom in New England or Canada, was spurred by the seizure of James Hamlet (James Hamilton Williams) in Williamsburgh, a separate city in Kings County until 1854. Hamlet was the first fugitive seized under the odious law. On the next Monday, October 7, Lewis Tappan, as corresponding secretary of the AFASS, published a thirty-six-page pamphlet he had prepared. In addition to setting forth the text of the Fugitive Slave Law as well as a synopsis of the bill, he included a description of the "way it was done," including the votes for and against and a discussion of its unconstitutionality. In the pamphlet, Tappan described the facts of Hamlet's case. He suggested that Hamlet had been captured and sent to Maryland under false pretenses. Hamlet, Tappan said, "insisted that his mother was a free woman, and that he was a free man, and denied he was a slave." But the law prohibited his testimony, and he was not heard. The *North Star*, Frederick Douglass's abolitionist newspaper, covered a meeting to demand Hamlet's freedom on October 24, 1850.

On October 1, 1850, according to the *North Star*, 1,500 people, almost all of them African American, two-thirds of them women, "with a slight and visible sprinkling of white Abolitionists," crowded into Zion Church on Church Street in New York City. Some of those who attended were from Weeksville. Junius C. Morel—a Weeksville teacher, journalist and community organizer, himself born to a mother in slavery and plantation-owner father in South Carolina—gave a speech and also reported the proceedings for the *North Star*. "It would be exceedingly difficult," he noted, "to take a fugitive publicly from this city, but unfortunately the work is done secretly and in the dark." The meeting collected $800, enough to buy Hamlet out of slavery, and James Hamlet eventually returned to his wife and children in Williamsburgh.

A division of labor was instituted between whites and blacks in the Underground Railroad. Blacks used such places as African Hall on Nassau Street, where a Manhattan Bridge approach is now located, and their churches, such as the Bridge Street African-Methodist Episcopal, as "depots," places where refugees were sheltered until they could be conducted to freedom (figure 11). Whites were fundraisers and political activists who occasionally sheltered runaways, but this service was mostly provided by blacks. A story of the Underground Railroad in Brooklyn that explicates its operations and may be taken as exemplary is the following, reported

Figure 11. One of the basement chambers believed to have sheltered runaways at Plymouth Church. *Courtesy Plymouth Church.*

in the *Brooklyn Eagle* on December 10, 1857 (an unsympathetic source as may be judged from the manner of coverage and the fact that the *Eagle* was a Democratic Party organ). Perhaps most significantly, the article in a proslavery newspaper proves that the existence of a secret channel for freedom-seekers was common knowledge.

> *Another Fugitive Slave Case in This City*
> *The Mulatto steward of the bark* Pawtucket *from which $10,000 was taken some time since, played a clever trick upon a colored man named Brown of this city. Mr. Brown is the proprietor of a Hack, and his stand is at the corner of Concord and Bridge streets, or somewhere near there. The steward, whose name is Pagen, we believe, escaped from the vessel with the booty and coming to Brooklyn, called at the house of Mr. Brown and representing that he was a fugitive slave, urged the hackman to conceal him until such time that he could make arrangements to board the underground railroad train, Mr. Brown's sympathies were enlisted at once and accommodating him at his house for the night accompanied him by railroad to Farmingdale, L.I., next day, where he placed him in charge of another colored friend and brother, and out of the reach as he supposed, of the Kidnappers. Mr. Brown came home satisfied of having done his duty thus far, as a Christian, until a day or two afterwards, he discovered in the*

papers that the bark Pawtucket *had been robbed, and the supposed robber was the steward of the vessel whose description tallied exactly with his friend the fugitive slave.*

This makes clear that upon arriving in a black neighborhood (Concord and Bridge Street near the Concord Baptist Church), a fugitive could ask any brother or sister on the street for aid and probably receive it. However, in some cases, the supplicants were decoys sent by slave-catchers and the persons petitioned might turn the refugee in for the reward. In this case, the false fugitive was sheltered for the night in Mr. Brown's house and taken the next day to Farmingdale at the eastern end of what is now Nassau County, for transport across Long Island Sound to New England.

On May 7, 1850, the national abolition reform organizations met in convention at the Broadway Tabernacle in Manhattan for the May Anniversaries. They heard William Lloyd Garrison of the AFASS and Henry Ward Beecher amid an incipient riot that the police refused to suppress. The next day, the militant abolitionist Wendell Philips was scheduled to speak, but the tabernacle's management ousted the convention, and no other New York venue would have them.

The national reform organizations attempted to rent the Brooklyn Institute, but that was also refused. Beecher got the church's trustees to allow them to use the sanctuary, so Philips spoke there on May 8—a triumph for both Beecher and Brooklyn.

The poem below appeared in the first (1855) edition of *Leaves of Grass*, which Whitman had locally printed (see chapter 11). Whitman lived in the Heights for a while but mostly dwelt downtown and in Fort Greene. It is not known whether the story he tells is true or not, but it indicates his sympathy with the slaves.

> *The runaway slave came to my house and stopt* [sic] *outside,*
> *I heard his motions crackling the twigs of the woodpile,*
> *Through the swung half-door of the kitchen I saw him limpsy and weak,*
> *And went where he sat on a log and led him in and assured him,*
> *And brought water and filled a tub for his sweated body and bruised feet,*
> *And gave him a room that entered from my own, and gave him some coarse*
> *clean clothes,*
> *And remember perfectly well his revolving eyes and his awkwardness,*
> *And remember putting plasters on the galls of his neck and ankles;*
> *He stayed with me a week before he was recuperated and passed north,*
> *I had him sit next to me at table, my firelock leaned in the corner.*

THE COMING OF CIVIL WAR

In 1854, Democrat Stephen Douglas of Illinois, who would defeat Lincoln for the U.S. Senate after their famous Lincoln-Douglas debates, proposed that Kansas and Nebraska be admitted as states under "popular sovereignty" procedures, meaning that the citizenry would decide whether the states would be slave or free. After adoption by Congress, this led to vote-packing and serious violence in Kansas, which became known as "Bleeding Kansas." Beecher thundered at the compromisers who were willing to do anything to save the Union, "That compromise was a ball of frozen rattlesnakes… We protested and abjured. You persisted in bringing them into the dwelling. You laid them down before the fire. Now where are they? They are crawling around. Their fangs are striking death into every precious interest of liberty! It is your work!"

The Beecher family's abolitionism played a major role in fomenting secession and the Civil War. Henry's sister's novel *Uncle Tom's Cabin* stirred up terrific national and international antislavery feeling. When Lincoln met her in 1862, he said to her, "So you're the little woman who wrote the book that made this great war."

This abolitionist group was also politically savvy. When Abraham Lincoln ran for president in 1860, he came to New York to drum up support. He was invited to speak at Plymouth but needed a larger venue, leading to his famous Cooper Union speech, which made him a leading Republican contender. Upon his arrival in New York City, he visited Henry Bowen at the office of his abolitionist newspaper the *Independent*, greeting him with the words, "I am Abraham Lincoln." Bowen said, "Will you come to church with me on Sunday?" which Lincoln did. The pew in Plymouth where they sat is marked (figure 12). Bowen invited him home to dinner, but Lincoln said that he needed to be alone to complete his speech and so returned to his hotel room. Later, President Ulysses S. Grant and Hungarian patriot Lajos (or Louis) Kossuth did partake with Mr. Bowen. General Grant visited Plymouth during his successful 1868 campaign for president, and abolitionists Wendell Phillips and William Lloyd Garrison, Massachusetts senator Charles Sumner and poet John Greenleaf Whittier also addressed the crowds.

Bowen's son Clarence wrote a letter to James H. Callender of 55 Pineapple Street, the author of the 1927 book *Yesterdays on Brooklyn Heights*, explaining what happened. Clarence relates Lincoln's attendance at Plymouth when he was a child. Lincoln sat in his father's pew and was going to join the

Figure 12. The Lincoln Pew (actually Henry Bowen's) in Plymouth. *Robert Furman photograph, courtesy Plymouth Church.*

Bowens for lunch. Bowen saw the great man at the gate. They were walking from church to the house and "going home got as far as the gate that stood between the sidewalk and steps leading up to the front door of our home, when Mr. Lincoln said, 'Mr. Bowen, I have an important speech to make at Cooper's Institute tomorrow night and must go back to the Astor House to work on that speech. You must allow me, therefore, to recall the acceptance of your invitation to lunch.'" Lincoln made his Cooper Union speech the next day.

The trustees of Plymouth had planned a new and larger church in 1860 and, at Beecher's insistence, actually went so far as to purchase lots for it on Montague Street near the ramp to the ferry, while other trustees wanted to utilize less expensive property. However, the economic dislocation caused by the secession crisis of January 1861 caused them to abandon these plans and sell the lots. The day Fort Sumter surrendered after Confederate bombardment in 1861, Henry Stiles said, "The Stars and Stripes were flung to the breeze upon all public places, from almost every store and from hundreds of private dwellings...indeed...the absence of the national flag in certain quarters invited a suspicion of disloyalty."

But not everyone in the Heights supported the war. Two Packer girls from South Carolina, probably the daughters of David K. Dodge, wore palmetto badges (the state symbol) that day while the Unionists wore red, white and blue cockades, leading the principal to order students to not wear any insignias.

While the Democratic Party had been anti-abolition and sympathetic to the South before the war, when hostilities began, most in New York State became "Unionist Democrats." They were less militant about secession and terms for settling the war, not to mention that they accepted the existence of slavery.

Secession created an economic crisis, and Bowen & McNamee approached bankruptcy in late 1861. Bowen decided to use his abolitionist newspaper,

the *Independent*, to leverage funds from the new Lincoln administration. Bowen associate Hiram Barney lent Salmon P. Chase, secretary of the treasury under Lincoln and U.S. chief justice, a substantial sum of money and was rewarded with the plum position of (tariff) collector of the Port of New York. Bowen also signed over ownership of his newspaper to his father-in-law, Lewis Tappan, preventing his creditors from attaching it, and forced out the more conservative editors Reverend Richard Salter Storrs, Joseph Thompson and Leonard Bacon. In January 1862, Tappan returned the

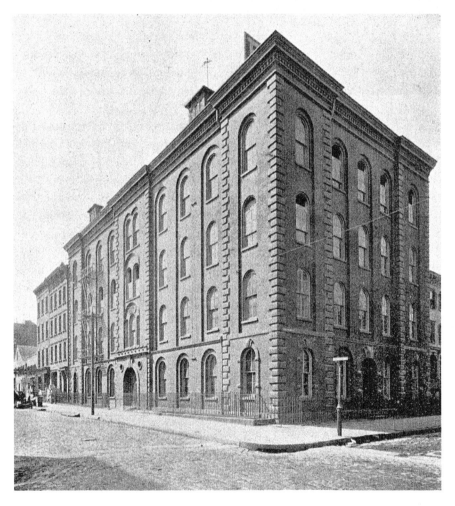

Figure 13. In 1857, this armory, shown in 1897, replaced the Apprentices' Library on the southwest corner of Henry and Cranberry Streets. From *The Eagle and Brooklyn*, 1898.

paper to Bowen and hired Beecher as editor in chief with Theodore Tilton as assistant editor. This move would lead to nothing but trouble.

The new Brooklyn City Armory on Cranberry and Henry Streets (figure 13) included the old cornerstone from the Apprentices' Library, which had been on the same site. It housed several Civil War units, including the Fourteenth New York Regiment, the famous Red-Legged Devils, who dressed in the manner of French-Algerian Zouaves, with red stockings. The name was derived from a shriek by Confederate general Thomas "Stonewall" Jackson, who reportedly called out during an attack by the Fourteenth, "Hold on! It's the red-stocking devils again (figure 14)!"

The Sixty-seventh New York Volunteers, or First Long Island Regiment, known as the Brooklyn Phalanx, was organized by Beecher himself, who also donated funds for equipment and supplies. They were also known as "Beecher's Pets." The regiment was commanded by Colonel Edward H. Fowler. Beecher's son Harry was elected second lieutenant of the unit. The Fourteenth captured Confederate president Jefferson Davis's Mississippi Brigade at Gettysburg on July 1, 1863. (Davis was not present.) The Fourteenth lost two officers and seventy-five enlisted men during the war. A monument to them was raised after the war on the Gettysburg battlefield.

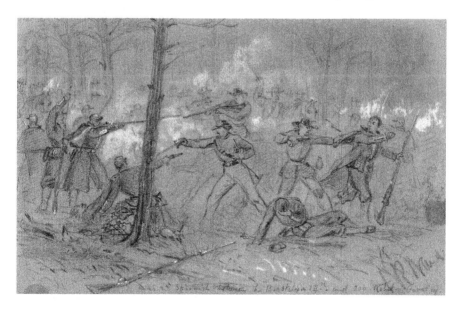

Figure 14. Skirmish between the Brooklyn Fourteenth and three hundred Rebel cavalry. Sketch by Alfred R. Waud. *Courtesy of the Library of Congress.*

During the Civil War, entire regiments marching south often stopped at Plymouth. The armory was sold off in 1862 during the Civil War and became a factory for the Eureka Fire Hose Company and later for printing machine manufacturers the Wesel Company (see chapter 8) until it was demolished in the 1930s for an Art Deco apartment building (chapter 9, figure 29).

Another Brooklyn unit that served in the war was the 23rd Regiment of the New York State National Guard under Colonel William Everdell, ancestor and namesake of the Heights historian. The 163rd Infantry Regiment went to Virginia in 1862 and lost sixty-three men killed, wounded and missing, mostly at Fredericksburg. The 164th Infantry, including several Brooklyn companies, went to Newport News, Virginia, under Colonel John McMahon and was later consolidated with other units and served there until the end of the war. The 173rd Infantry (also known as the 4th Metropolitan Guard) was organized by the police forces of Brooklyn and New York and served in the states around the Gulf of Mexico under Colonel Charles B. Morton. Colonel Mark Hoyt+ organized the 176th Infantry (known as Ironsides). The 47th Regiment under Colonel J.V. Meserole+ served in battle, as did the 28th under Colonel Michael Bennett and the 56th under Colonel John Quincy Adams II.

Henry Pierrepont's Union Ferry Company honored a requisition to supply five ferries for blockade duty. Wealthy people were able to purchase substitutes from among the poor to escape the 1863 draft or else joined volunteer regiments of the state militia, which were less likely to see combat.

The 1863 Draft Riots affected Brooklyn less than Manhattan. In fact, the Brooklyn Seventieth Regiment was deployed in suppressing the New York outbreak. Good police work and mayoral supervision prevented damage in Brooklyn except for a mob burning two grain elevators at the Atlantic Basin in Red Hook. In fact, Brooklyn became a place of refuge for victimized blacks during these events, less from feelings of brotherhood than from a dedication to civic peace.

THE SANITARY FAIR OF 1864

The Brooklyn and Long Island Sanitary Fair, which was like a world's fair, was the most important event ever held in Brooklyn Heights. It brought past and present together in one place for the amazed to gawk at. It was the

thirty-year-old city of Brooklyn's "first great act of self-assertion." The newest technologies and scenes from colonial America were combined in what we would now call a publicity event to raise money to improve the care of sick and wounded soldiers and to better their living conditions.

The Academy of Music hosted the fair (figure 15 and chapter 6, figure 11), which was sponsored by the War Fund Committee of Brooklyn and the County of Kings, 130 "prominent active citizens" whose president was A.A. Low; the Women's Relief Association of the City of Brooklyn, chaired by Marianne Fitch Stranahan, the wife of James S.T. Stranahan (figure 16); and the Ladies' General Committee. It was thus largely the work of women who were beginning to engage in helping

Figure 15. The interior of the old Academy, with a fancy dress ball in progress for the Brooklyn and Long Island Sanitary Fair. *Library of Congress Picture Collection.*

and nurturing outside the home. It ran for two weeks from Washington's birthday on February 22, 1864, until March 6 and was organized at the behest of the U.S. Sanitary Commission in 1862, a forerunner of the Red Cross. It opened at 3:00 p.m. on the twenty-second with a grand parade of the city's military force past the academy.

Stranahan also advocated for the construction of the Brooklyn Bridge and served as a trustee of the New York and Brooklyn Bridge Corporation and as its president in 1885 after its completion. Along with Henry Cruse Murphy, he presided over its dedication. Later, he advocated for the consolidation of Greater New York and served on its Charter Commission. He lived in Cobble Hill at 333 Henry Street in 1850 and in Carroll Gardens at 269 Union Street in 1898, when he died.

As an aside, James Samuel Thomas Stranahan is known principally as the president of the Brooklyn Park Board (a state office) that developed Prospect Park and retained Calvert Vaux and Frederick Law Olmsted to

design it. There is a statue of him at the park entrance. He was born in Peterboro, New York, in 1808 and was a schoolteacher, surveyor and wool merchant in Albany; a developer in Oneida County; and a railroad builder who served in the State Assembly. In Peterboro, he was involved with Gerrit Smith, a Livingston patroon and prominent abolitionist also involved in other social reform movements. Smith is best known for helping fund John Brown's raid at Harpers Ferry, (West) Virginia. At Smith's urging, Stranahan founded the town of Florence on Livingston land. He moved to Brooklyn in 1844, invested in ferry development and led the effort to create the first port for the Erie Canal, the Atlantic Basin, recently revived as a cruise ship port. In Brooklyn, he served as an alderman (council member) and congressman. His statue in Prospect Park by Frederick

Figure 16. James S.T. Stranahan, like other Republican reformers, was a businessman. He and his wife, Marianne Fitch Stranahan, played a major role in organizing the Sanitary Fair. From *The Eagle and Brooklyn*, 1898.

MacMonnies was dedicated during his lifetime on June 6, 1891.

Fairs had been held in Chicago, Cincinnati and Boston, and Brooklyn was to have been part of a larger New York City fair until that was postponed by the Manhattan groups. Henry Ward Beecher and others felt that Brooklyn should not wait for Manhattan, so they began to plan their own event. The fair was not just for the city of Brooklyn but for all of Long Island and involved the town of Flatbush and many areas of Queens and Suffolk Counties (Nassau County is the part of Queens that voted not to become part of Greater New York in 1895).

The Sanitary Commission was a civilian auxiliary of the Medical Bureau of the War Department, which found itself completely overwhelmed by the number of wounded soldiers it had to treat in what had been expected to be a short, sharp war that, in fact, ground on for four long years. The fair was organized and sponsored by most of the churches in Brooklyn, and Unitarians in particular were prominent in this effort. Henry W. Bellows, minister at Manhattan's First Unitarian Church, headed the national commission. In

Brooklyn, First Brooklyn Unitarian Church minister Frederick A. Farley was its secretary, Unitarian James H. Frothingham was its treasurer (he had proposed holding the fair) and his brother Abraham R. Frothingham was its grand marshal. As early as 1862, the Brooklyn organization turned over $60,000 worth of clothing and stores to the commission. In 1863, the Brooklyn Sanitary Fair Committee was appointed, including James S.T. Stranahan, Henry Pierrepont (chapter 4, figure 11) and A.A. Low (chapter 4, figure 26), who was elected president.

The floor of the academy's auditorium was boarded over so it could serve as the Great Central Bazaar, creating 20,300 square feet of selling floor when combined with the other venues. Booths were staffed both by volunteers and paid clerks, some from the Dime Savings Bank of Brooklyn, but others worked for the stores whose merchandise had been donated. The stage wall was covered by a huge painting of a Sanitary Commission field hospital, and on the left side was a replica of a hospital where photos of war scenes, battlefield souvenirs and curiosities made by wounded soldiers were sold. At the extreme left was an imitation skating pond created with mirrors, which was very popular (skating was then a new sport). It presented a "striking optical illusion…of ice…crowded with skaters in brilliant and picturesque costumes, all in rapid and graceful motion." The walls were covered with borrowed paintings, including a portrait of Washington by Gilbert Stuart owned by Henry Pierrepont (see chapter 4), and afghans and quilts.

Above the stage's arch was a sign reading "In Union Is Strength." A huge American eagle was suspended from the ceiling. Besides the fancy dress ball depicted in figure 15, a Calico Ball was held by the Brooklyn Female Employment Society to raise funds for soldiers' families, where the female attendees wore old-fashioned dresses that were afterward donated to soldiers' wives. There were two bands, and supper was served at Knickerbocker Hall. It raised $2,000.

Two hundred people purchased gifts for President Lincoln for $1 each, including a silk bedspread made by eighty-one-year-old Margaret Dodge, "emblazoned with the Stars and Stripes and the National Eagle." The second-floor lobby held a book and stationery store, and the Third Circle contained a scale on which one could weigh oneself, an innovation at the time. On display were a Steinway piano, laundry wringers, dressing gowns, autograph albums, a soda fountain and a large table decoration purchased for $225 by A.A. Low. These items were then rarely seen since department stores would not begin to open for another ten years.

Figure 17. The New England Kitchen at the Sanitary Fair was a restaurant that was a large-scale replica of a colonial-era home. From *The Eagle and Brooklyn*, 1898.

Knickerbocker Hall was a five-hundred-seat restaurant that made almost $24,000 in profits because the food was donated and the staff were volunteers. It was built next door to the academy on vacant land owned by A.A. Low. A building for the Hall of Manufactures, featuring industrial technology, was erected on a lot across the street owned by Henry Pierrepont. Another restaurant was the New England Kitchen (figure 17) on Harriet Packer's property. It served colonial-era meals and featured a replica of a colonial-era hearth with glowing logs and an actual chowder pot being kept hot in it, where customers ate with period two-tined steel forks. An Indian, "hideous in horns and paint," occasionally stalked solemnly through the crowd. The buildings were connected to the academy by a temporary pedestrian footbridge over Montague Street so visitors would not have to venture out in case of snow.

At 119 Montague Street on the corner of Clinton Street, the old Taylor Mansion, later the home of the Brooklyn Trust Company, served as the Museum of Arts, Relics & Curiosities and the offices of the *Drum-Beat*, the

fair's daily five-cent newspaper. The museum featured some of Robert Fulton's steamboat models and drawings, along with a working model of a pontoon train that was purchased by Polytechnic Institute. Also on display were letters written by George Washington and Britain's sixteenth-century Queen Elizabeth, along with 246 engravings, 87 of which belonged to Henry Ward Beecher. It was said that Beecher lent the event "his rare enthusiasm and electric force and spirit."

Opening-night tickets to all the departments were $2, and season tickets were $4. A.A. Low presented Lieutenant Colonel J. Harris Hooper with a sword, sash and belt (Hooper had escaped from a Rebel prison and was aided by slaves). A Calico Ball raised $2,000. The largest well-known individual donors were A.A. Low at $2,500, Peter C. Cornell and Henry Pierrepont at $1,000 and James S.T. Stranahan at $500.

Numerous events were held as part of the fair as fundraisers. The fair raised $400,000, a tremendous sum at the time, second nationwide only to New York's $1 million purse. It was crowded from beginning to end and was a huge success from every point of view. Afterward, everything left was auctioned off, down to the floor planking, further swelling the fair's coffers.

An organization founded in 1854 that still exists that did yeoman's work during the Civil War is the Brooklyn Women's Exchange, now at 55 Pierrepont Street in the former Hotel Pierrepont (chapter 6, figure 47). They made winter clothes for soldiers, and Reverend Beecher purchased "coarse garments" for the poor from them. After Lincoln's assassination, they handmade a commemorative flag that is now part of the Brooklyn Historical Society's collection.

The war brought great growth to Brooklyn, strengthening its position as a leading manufacturing and shipbuilding city. The *Brooklyn Eagle* wrote on February 16, 1868, "Twenty-five years ago corn grew on Montague Street...Today [the population of the city of Brooklyn] is nearly three hundred thousand. Long rows of brown stone [*sic*] and brick buildings have risen, seemingly, in the space of a single night. The past year has seen no diminution, and in fact, the new buildings of 1868 exceed in value those of any previous year."

Of course, many of the new millionaires who built homes on the Heights had gotten rich by manufacturing supplies for the U.S. Army, much of it "shoddy," like shoes that fell apart in a few weeks.

BEECHER IN EUROPE

On May 30, 1863, Beecher traveled to continental Europe and then England, where he sought to persuade the British not to support the Confederacy. This was difficult, however, since the South was the major source of cotton for the cloth mills of Manchester. Beecher was seen off from a nearby pier by a gala crowd of eight hundred, complete with a brass band.

This effort was dangerous. Many workers feared destitution since the flow of "king cotton" had been cut off by the Union naval blockade. He spoke before crowds in Manchester, Glasgow, Edinburgh, Liverpool and London and created tremendous sympathy for the Union. The trips were a personal triumph since Beecher was able to emphasize the identity between slaves and workers. For the British, who had never had domestic slavery, this transcended their interest in a steady, cheap supply of cotton.

Sidney V. Lowell, who lived at 164 Columbia Heights and had his office on Montague Street, was a politically prominent Democratic attorney and former elected official. In 1926, he sent James H. Callender a letter asserting that during the Civil War, he had seen the Great Emancipator alight from a carriage on Pierrepont Street near Columbia Heights, in front of the Cornell-Low house (chapter 4, figure 13). (Peter C. Cornell, its builder, was the son of Whitehead Cornell and probably a nephew of John Cornell who built Four Chimneys.)

Callender quotes Lowell's letter:

> One day in the Civil War period I walked down Pierrepont Street towards Columbia Heights. I held public office then and now think my errand was to the parks—so-called on the Heights. As I approached Columbia Heights, I observed a battered old phaeton—two horse, standing at the foot of the street near the curve and heading south. I watched it closely (and my eyes then were young) because it was noticeably shabby and yet in a high-class place. There was an elderly man, the sole passenger. He was hunched up as if not desirous of being seen and his hat over his face. While looking at him, the door of the house where he stopped opened. The owner, Peter C. Cornell, passed down the steps rapidly, and advanced toward the phaeton with both hands rapturously extended. "Why," I thought, "Mr. Cornell, that quiet Quaker, would not act as he does for any one less than the Governor of the State." The man in the carriage then arose—a tall rugged figure. At a glance I saw that he was Abraham Lincoln. He looked out over the Bay, across the Pierrepont gardens. He then said to Cornell in

my hearing, "There may be finer views in the world, but I don't believe it!"
I had seen him before in life—I was to see him as he lay in state of death.
I like to think of him drinking in our great view across the Pierrepont lawn
to the great city and the bay.

According to the obituary of Peter C. Cornell (1803–1885) in the *Brooklyn Daily Eagle* on May 6, 1885, he had built himself a house at 222 Columbia Heights "opposite the end of Pierrepont Street" (later owned by Brooklyn mayor Seth Low, demolished in 1954) around 1855, confirming a detail in Lowell's letter. Cornell had previously lived at 108 Pierrepont Street (1840), and his father, Whitehead Cornell, lived at 33 Monroe Place from around 1839 until his death in 1846. Another brother, George, lived at 114 Pierrepont Street.

Cornell was a prominent businessman who served on the boards of the Brooklyn Gas Light Company, the Union Ferry Company, Brooklyn Hospital and the Packer Institute. Given the weight of historical evidence recording Lincoln's every day in office, it is unlikely that he secretly journeyed to Brooklyn in 1862 or 1863. We must conclude that an old man misremembered Lincoln's 1860 visit, an incident from his youth.

The forts in the harbor of Charleston, South Carolina—except for the infamous Fort Wagner (the assault on it by the black Fifty-fourth Massachusetts Regiment is portrayed in the movie *Glory*)—fell to the Union in early 1865. This foretold the end of the war and allowed the American flag to be raised over Fort Sumter, where the conflict began. Brooklyn was represented at the flag raising by Reverends Henry Ward Beecher and Richard Salter Storrs, who brought boatloads of parishioners south with them. President Lincoln told his cabinet "that if the war was ever fought to a successful conclusion there would be but one man—Beecher—to raise the flag at Fort Sumter, for without Beecher in England there might have been no flag to raise."

On April 2, 1865, Beecher's sermon was interrupted when he was handed a telegram from Secretary of War Edwin Stanton announcing that General Grant had breached the Confederate lines at Petersburg, Virginia, near Richmond, their capital, signaling the coming end of the war. The congregation sang "My Country 'Tis of Thee" with tears streaming down their faces. A week later, Beecher set off for Fort Sumter with friends, family and congregants to preside over the flag raising on April 14 at the site of the beginning of the war, but by the time they returned, Lee had surrendered and Lincoln was dead. Beecher also invited well-known abolitionists and celebrities to speak at his church, including William Lloyd Garrison, Charles

Sumner, Wendell Phillips, the poet John Greenleaf Whittier, Clara Barton, Ralph Waldo Emerson, Horace Greeley, William Makepeace Thackeray, Mark Twain and Booker T. Washington. Charles Dickens was featured on his second U.S. visit of 1867.

A Heights couple, the Samuel McLeans of 47 Pierrepont Street (today 260 Hicks Street, chapter 4, figure 8), visited the Crystal Palace Exhibition in London in 1851. Mrs. McLean could not see the royals and celebrities because she was short and slight. An unknown Englishman picked her up to enable her to see, and she did not know who he was. At a meeting at Plymouth, Beecher entered with the guest of the evening, and she exclaimed, "That's my Englishman!" It was Thackeray.

THE CHURCH OF THE PILGRIMS AND THE REVEREND RICHARD SALTER STORRS

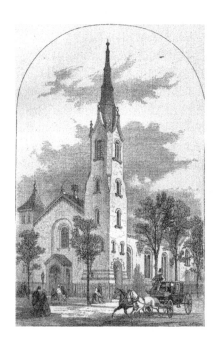

Figure 18. The Church of the Pilgrims, the original Congregational house of worship in the Heights. *Brian Merlis Collection.*

The Congregational Church of the Pilgrims (figure 18) and its founding pastor, Reverend Richard Salter Storrs (figure 19), are probably the most underappreciated place and person in the Heights because the church no longer exists (although its building does—see chapter 13 on Our Lady of Lebanon). As noted earlier, Plymouth was born out of Pilgrims, located at Remsen and Henry Streets, whose members had left the First Presbyterian. The men who founded Plymouth felt that Pilgrims was too conservative. Plymouth removed the Pilgrims name from its designation in 2011.

Pilgrims was designed by Richard Upjohn (who also modeled Grace Episcopal on Hicks Street and Grace Court in 1849 and Manhattan's Trinity Church). It is the first Early Romanesque Revival building in the

Figure 19. Reverend Richard Salter Storrs, DD. From *The Eagle and Brooklyn*, 1898.

United States and served as a model for other evangelical Protestant churches. It was expanded in 1869 with High Victorian additions by Storrs's former aide Leopold Eidlitz, one of the designers of the state Capitol. This resulted in the addition of 450 seats, a larger lecture room and other lecture rooms and meeting rooms. This is one of his few surviving buildings, although he was a major figure in American design. Its minister from its opening in 1846 until just before his death in 1900 was Richard Salter Storrs, in his time almost as famous as Beecher, indicated by the fact that he presided over the opening ceremonies for the Brooklyn Bridge, which was a Brooklyn-sponsored project (hence the name). He lived at 34 Livingston Street when the church began, then at 80 Pierrepont Street (extant) and later at 1 Pierrepont Street (a townhouse, demolished), where he died. The church owned a piece of Plymouth Rock, now displayed at Plymouth Church (figure 20).

Storrs was also an active abolitionist and gave a speech after the passage of the Fugitive Slave Law in 1850 that counseled the moral obligation of disobedience to the law—i.e., that Christians had an obligation to aid escapees but had to accept the consequences of punishment, while the fugitive had the right to resist kidnapping via his right to self-defense.

In a sermon entitled *The Obligation of Man to Obey the Civil Law: Its Ground and Its Extent. A Discourse Delivered December 12, 1850, on Occasion of the Public Thanksgiving in the Church of the Pilgrims, Brooklyn, N.Y. by Richard S. Storrs, Jr., Pastor of the Church*, he counseled all who heard that no one had an obligation to obey an unjust law, and in fact, all were morally obliged to disobey it and to actively aid fugitive slaves.

A small but significant extract follows that recommends civil disobedience, including bearing the legal consequences, and suggests that the fugitive has the right to resist kidnappers by force, although Storrs recommends flight instead. The sermon was so influential it was reprinted in book form.

Figure 20. A piece of Plymouth Rock from the Church of the Pilgrims now at Plymouth Church. *Robert Furman photograph, courtesy of Plymouth Church.*

Though its penalties were accumulated to tenfold greatness, they should not shut my doors against him [the fugitive slave]. *You will not resist the law by force and violence. I will even advise the Man to flee it if he can, and not resist it, although it hurls him back upon his right of Self-Defence. But I will not obey it, unless by bearing its penalties. The man who does otherwise is in peril of his Soul. For Eternity is grander than crime and its scenes!*

The participation of the Heights and downtown in the abolitionist movement was so total that word got around to fugitive slaves that they could knock on the door of any church there and discover succor. According to an April 23, 1889 speech by Storrs (perhaps significantly, given two years after Beecher's death) reported in the *Brooklyn Eagle*, such a man appeared in the early 1850s at the threshold of the Reformed Church on Joralemon Street, an institution whose minister, Dr. Maurice Dwight, was a Southerner and had previously said Storrs

was "going to the dogs" for his abolitionism. Their interaction had unexpected results:

> *Dr. Storrs related an incident about the Rev. Dr. Dwight, who early in the fifties was pastor of the First Reformed Church in Brooklyn, and was a warm friend of the speaker. He was of Southern birth. It happened that Dr. Storrs preached an earnest sermon denouncing the Fugitive Slave Law and declaring that he would never be bound by it nor would he obey it. Dr. Dwight expostulated with him as a friend and feared that Dr. Storrs had ruined his chance for usefulness in the community, but Dr. Storrs was flinty about it and did not repent. A week later, one stormy Saturday night, Dr. Dwight came to Dr. Storrs' door in the pouring rain, with a man as black as the night, and explained that the poor fellow was a runaway and he wanted Dr. Storrs to tell him where he could take the man for safety. Dr. Storrs wanted to go himself and relieve Dr. Dwight, but the latter would not hear of it, nor would he permit Dr. Storrs to bear a part of the expense, but insisted on doing the whole work himself. So Dr. Storrs told Dr. Dwight where to take the man over in Nassau street* [probably African Hall], *where there was a depot on the underground line.*
>
> *"As long as this more abstract question was concerned," said Dr. Storrs, "he thought I was going to the dogs, but when the reality was presented to him, he went to the dogs faster than I did."* [Applause.]

The quotation does, however, indicate that Reverend Storrs was not an active participant in the Underground Railroad until after the incident.

The process by which neutrals became abolitionists is fascinating in itself. It often involved fleeting contacts with the peculiar institution rather than the presence of kidnappers operating on Northern streets. The experience of Reverend Storrs is instructive. He spoke to the Congregational Club on how he became an abolitionist. His talk was covered by the *Brooklyn Eagle* on April 23, 1889. In it, he contrasts and compares the history of his own involvement with that of Oliver Johnson, an earlier abolitionist, Underground Railroad participant and editor of the *Anti-Slavery Standard*:

> *My point of view…was not antagonistic to him* [Oliver Johnson] *but was different. It began later with me. It was about 1845 when I began to be active in affairs, and Mr. Johnson had already been twelve or fourteen years at work in the field. My personal position was such that it had an effect in modifying my view on the question. I was never an apologist for*

slavery, but I was never under the control of the ideas put forward by the men who circled around Mr. [William Lloyd] Garrison and the immediate group of friends who followed his lead. Through Mr. Wendell Phillips, with whom I was brought in frequent contact, I knew very much about what went on within the inner circles of the Abolitionists as to what they were doing and as to the ideas which dominated them, and learned also to appreciate the worth and character and earnestness of Mr. Garrison and those about him. But although very familiar with what they were doing I was not of them. In 1849, however, I was suddenly converted to an intense hostility to slavery by an incident which I shall never forget, either in this life or in the immortalities. I was coming home from Richmond, after a trip of some weeks through Virginia. I had seen no evidence of cruelty. I had come down by rail to Aquia Creek, there to take the boat for Washington. When the boat came in people poured off to take the train to Richmond. Behind them, under charge of a couple of men, came about twenty or thirty colored children, ranging in age from 8 or 10 years, up to, perhaps 16 or 18 years, they were well fed, healthy looking children, comfortably clad and at first I said, "Why, here comes a colored Sunday School."

Behind the children came a colored woman, no darker of skin than many a brunette in the North, and great tears were rolling down her cheeks. A little child was clinging to her dress, in one hand she carried a bundle and with the other led along a sickly looking boy. Nearly every child had a little bundle. As the woman came off the boat she looked at me full in the face and I saw her grief and then it came to me like a flash what the scene meant. Those children had been picked up by the dealers around Washington and were being taken to Richmond, there to be scattered over the south from the auction marts in that city.

That woman was on her way to separation from her children. I was hastening home to the bedside of a sick child, and as I stood there I thought "Can anything make it right to sell wife and child? Could a whole book filled with reasons make it right?" And I thought that I would be burned alive before I would consent to such a thing in my own case, and then I will be burned alive before I will excuse or palliate the system which makes such a thing possible. [Applause]

I never felt after that that there was anything excessive in Wendell Phillips' declaration, "Your national banner clings to the flagstaff covered with blood."

Other local Underground Railroad activists, both black and white, included Croyden Sperry of 91 Willow Street and the black Reverend Samuel Cornish, who were involved with or officers of the American and Foreign Anti-Slavery Society. Others who lived in Downtown Brooklyn or Brooklyn Heights supported abolition and the Underground Railroad by contributing to the *National Anti-Slavery Standard* (circa 1848–59) or were officers or contributors to AFASS (circa 1840–55).

These included George W. Bergen, Daniel Carmichael, E.S. Dudley, R.G. Fairbanks, E.L. Green, the black Reverend Eli Hall, C.S. Halstead, Enoch Harrington, William Holmes, Robert W. Hume, Isaac Hunter, Henrietta Johnson, Iverson Knapp, Reverend Samuel Longfellow (brother of poet Henry Wadsworth), George and Martha Mott Lord (daughter of suffragist Lucretia Mott), Miss E. Martin, John Maxwell, John E. Morse, Thomas P. Nichols, Theodore Ovington (founder of Ovington China— see chapter 8), Amos P. Stanton and P.C. Wyeth. (Since the Heights was a wealthy neighborhood, few blacks lived there; they were centered on its fringes in downtown.)

Theodore Ovington (1829–1909) was typical of the liberal, evangelical Protestant businessmen who were the core of the abolitionist movement, the Republican Party and the Heights in 1860. His daughter, Mary White Ovington (1865–1951), became famous as an activist for racial equality (her grandmother was Mary H. White). She wrote a well-respected book on the treatment of blacks in America called *Half a Man* and in 1909 was a founder of the National Association for the Advancement of Colored People (NAACP). The family belonged to the Second Unitarian Church in Cobble Hill.

Mary White Ovington had to drop out of what would become Radcliffe College following reverses in her father's business in the Panic of 1893, and she returned to Brooklyn to work as registrar of Pratt Institute and then as head worker at the Greenpoint Settlement, which she helped found. She was also vice-president of the Brooklyn Consumers' League and assistant secretary of the Social Reform Club in New York. A speech there by Booker T. Washington informed her that racism existed at home also, which stimulated her to dedicate her life to achieving black equality. In 1904, she started a study of black living conditions and employment problems that was published in 1911. Demonstrating white southern fear of black sexual prowess, Ovington was attacked for sitting next to a black man at an interracial dinner. President Theodore Roosevelt was similarly vehemently criticized for having Washington to dinner in the White House because his

wife, Edith, sat next to the educator. White became chair of the NAACP in 1919 and in 1923 persuaded the organization to fight for equal federal aid to black schools, thus beginning the critique of "separate but equal." She was an active leader of the group until her death.

The family lived at 218 Livingston Street in Boerum Hill in 1879 (later called "North Gowanus"), at 69 Willow Street in 1884, at 58 Orange Street in 1897 (demolished around 1950 for the apartment building at 52–54), in the Hotel St. George in 1905 and afterward in 5 Monroe Place (extant), where Theodore died. Many of the family are buried in Green-Wood Cemetery.

THE CONSERVATIVE REACTION TO ABOLITIONISM

Like all progressive movements, abolition engendered opposition, called "political reaction." A new church was founded in the 1840s because some members of the First Presbyterian Church (chapter 6, figure 32) opposed the antislavery views of its pastor, Dr. Samuel Hanson Cox (figure 21), who had fled Manhattan and moved to Fort Greene during the anti-abolitionist riots of 1834. He later lived at 66 (formerly 79) Cranberry Street (demolished) when the church was located on the block. (The former church building has been part of Plymouth since the latter's founding.)

Figure 21. Samuel Hanson Cox in 1877, pastor of the First Presbyterian Church, was an abolitionist. *Library of Congress.*

The conservative breakaway organization was initially the Second Old School Presbyterian Church (figure 22) on Clinton Street south of Fulton Street. Its edifice was a dead-on match for the 1834–87 Reformed Church on Joralemon Street opposite Borough Hall, down to the small satellite chapel. When the area became commercial (see chapter 8),

it moved to Remsen Street to a new 1850 building and later became Spencer Memorial Church (figure 23). Some of the sources incorrectly report that the original building was moved stone by stone to Remsen Street. It was actually used by Hardenbergh Carpets—see chapter 8.

In 1960, it was the First Church of Brooklyn, New York Presbytery (Old School). By mid-decade, reflecting the spirit of rebellion of the 1960s, it was no longer a conventional house of worship, having been taken over by an avant-garde group that soon gave it up. In 1964, they replaced the church's old doors with new inappropriate ones in spite of the push for historic district status. (It is the only structure on Remsen Street between Court and Clinton Streets included in the Brooklyn Heights Historic District.) In the 1970s, the church was converted into Spencer Mews, a cooperative housing development, with the exterior not further altered since the historic district makes a jog onto that corner to include the building.

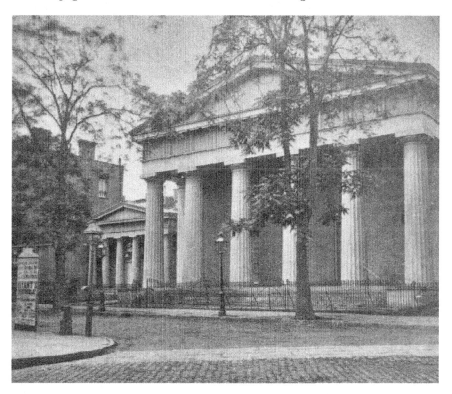

Figure 22. The Second Old School Presbyterian Church, as completed, circa 1845, on Clinton Street south of Fulton Street, circa 1877. *Brian Merlis Collection.*

Figure 23. The extant former Spencer Presbyterian Church on the southeast corner of Remsen and Clinton Streets. *Robert Furman photograph.*

Reverend Cox of the First Presbyterian seems to have ceased his participation in the Underground Railroad when he presided at Henry Street, but he did not alter his views; perhaps he had been intimidated into inaction by the anti-abolitionist riots of 1834. He remained both abolitionist and modernist (as opposed to fundamentalist). On several occasions, the fire of his antislavery oratory led to mob attacks from which he barely escaped. He was a delegate to a meeting of the British and Foreign Bible Society in London and heard a British preacher denounce America for the continuation of slavery. He replied:

> *Thirty days ago, I came down New York Bay in the steam-tug* Hercules *and was put on the good packet ship* Samson—*thus going on from strength to strength, from mythology to scripture—I do not yield to my British brother in righteous abhorrence of the institution of negro slavery; I abhor it all the more because it was our disastrous inheritance from our English forefathers and came down to us from the times when we were*

*colonies of Great Britain. And now, if my brother Hamilton will enact the
part of Shem, I will take the part of Japhet and we will walk backward,
and cover with the mantle of charity the shame of our common ancestry.*

Of course, Cox did not mention New Amsterdam's Dutch bondage.

Plymouth and Beecher After the War

Figure 24. Theodore Tilton was
Henry's protégé and colleague until
the reverend's affair with Mrs. Tilton
ruptured their relationship forever. *Brian
Merlis Collection.*

Reconstruction (1865–77) was a time
of reform—as were the 1830s, 1900s,
1930s and 1960s—and was a challenge
for Henry Ward Beecher. He tended
to support moderates when he could,
and this extended to the man who took
Abraham Lincoln's place in the White
House: Andrew Johnson, a Tennessee
Democrat, Unionist and notorious
drunkard and racist. Frederick Douglass
spoke at the Brooklyn Academy of
Music in 1866 and condemned the
pastor for advocating gradual abolition
through Christ in 1852 and supporting
Johnson, who was perfectly willing to
see a new form of slavery imposed
in the South through the notorious
"Black Codes." Congress, however, was
dominated by Radical Republicans,
who enacted three new constitutional amendments: the Thirteenth to
outlaw slavery; the Fourteenth to provide for due process of law in the states,
equal protection of the law and citizenship for black men; and the Fifteenth
to give them the right to vote, along with a civil rights law to guarantee
these rights. The struggle deteriorated into an attempt to remove Johnson
from office via impeachment. Conviction failed in the Senate by one vote.
Beecher was forced to appear on the same stage and seemingly repudiate his
former position.

Impeachment was advocated by Beecher's great friend and protégé
Theodore Tilton (figure 24), who lived at 124 Livingston Street in what is

now called Boerum Hill. Tilton called for impeachment via the *Independent* newspaper, of which he was editor, creating alienation between the two and climaxing in Tilton's adultery charges against the pastor for having an affair with his wife, Elizabeth (figure 27).

By 1867, Beecher was falling away from traditional Christianity, or at least the Puritan version of it. By 1870, Beecher wanted to drop the concept of hell from Plymouth's official beliefs. He noted, "Love, with its freedom, has taken the place of authority, and of obedience to it," beginning the trend toward modern religion.

A five-month luxury tour of the Holy Land was organized by Captain Charles Duncan, a friend of Beecher's and a Plymouth member, which was to feature Beecher and General William Tecumseh Sherman. Mark Twain, the famous skeptic and exposer of hypocrisy, thought it was a good story and convinced his California editor to pay his way aboard. But by the time the ship sailed, Sherman, Beecher and most of the Plymouth people had canceled, with the exception of Moses Sperry Beach, who was fleeing his home situation. Beach hosted a gala farewell party for the sojourners featuring Beecher. The voyagers on the Grand Holy Land Pleasure Excursion turned out to be sanctimonious and self-righteous, and Twain bitingly satirized them in his novel *The Innocents Abroad.*

Perhaps not surprisingly, Henry Ward Beecher and his associate Theodore Tilton were early and prominent feminists. Their principal goal after the Civil War was obtaining the vote for women, but some also advocated full legal equality and what would eventually become the feminist agenda of the 1970s. Susan B. Anthony and Elizabeth Cady Stanton formed the National Women's Suffrage Association in New York in 1869 with Theodore Tilton as president and with Henry's sisters Harriet Beecher Stowe and Isabella Beecher as editors of the group's organ, the *Revolution.*

The more conservative Boston group, led by Lucy Stone and later Julia Ward Howe, composer of the "Battle Hymn of the Republic," opposed taking on other women's issues, such as abortion, birth control, divorce reform, prostitution and financial independence, as the New Yorkers had. They felt these issues were a destructive distraction and formed the American Women's Suffrage Association with Henry Ward Beecher as president. Equality would be a long road. Later, the two organizations merged as the American National Women's Suffrage Association, led by two women—Susan B. Anthony and Elizabeth Cady Stanton—and dedicated only to votes for women.

After the war, Henry Bowen began work at the New York Customs House, the major source of federal revenue and corruption before the income tax, where he gave lucrative contracts to himself and his friends. Later, he was appointed (tariff) collector of the Port of New York, and a number of his appointees were accused of taking bribes. This post (legally) made future president Chester Alan Arthur and others millionaires. Bowen accepted a gift of $50,000 in bonds and $460,000 in stock from the Northern Pacific Railroad in exchange for promoting the company in the *Independent*. Henry Ward Beecher, Harriet Beecher Stowe and *New York Tribune* owner and editor Horace Greeley also accepted such dubious gifts but did not get in trouble for it as Bowen did. He supported Andrew Johnson during the impeachment struggle, which lessened his influence with the local Republican Party, leading to his losing his post as collector. The *Independent* was also losing subscribers to Beecher's new magazine, the *Christian Union*. Bowen's biography represents the descent of a man from idealism to corruption.

The *Union* was edited by Beecher associate General Horatio C. King (1837–1918) (see chapter 6), who had studied law under Lincoln's secretary of war Edwin M. Stanton (before the institution of law schools, aspiring attorneys apprenticed with practitioners). King was a Civil War hero who won the Congressional Medal of Honor. He lived at 1 Middagh Street and later at 44 Willow Street.

In order to regain his lost political influence, Bowen purchased the *Brooklyn Union* newspaper as a forum for himself and his ideas and decided that he needed a rapprochement with Beecher. In order to do this, Bowen threatened to make Beecher's affairs public and promised to keep them secret if the two became friends. It worked for a while.

In 1868, Bowen aligned himself with the pro-Grant Republicans, while a new "liberal" faction opposed Grant because of his tolerance of corruption. The *Brooklyn Union*'s editor, Theodore Tilton, refused to support Grant and called for the election of a liberal local House of Representatives candidate, who won.

Victoria Woodhull (figure 25) was a spiritualist, investor colleague and lover of Commodore Vanderbilt (figure 26) and feminist. She broke into suffragist politics by testifying before the U.S. House Judiciary Committee on a proposed women's suffrage constitutional amendment in 1871 but soon got into a fracas with the Beechers over Henry's womanizing. Woodhull advocated "free love" and charged that Henry was a hypocrite who practiced it but lied about it, while she publicly advocated it, even stating that she had been having an affair with Theodore Tilton. Her downfall came when she

Above: Figure 25. Victoria and Tennessee Woodhull testifying before the House Judiciary Committee in favor of women's suffrage in 1871. *Library of Congress Picture Collection.*

Left: Figure 26. "Commodore" Cornelius Vanderbilt. *Library of Congress Picture Collection.*

stated, in response to heckling at a public meeting, "Yes, I am a free lover. I have an inalienable, constitutional and natural right to change that love every day if I please." The press went wild. The Victorian era, like today, would not publicly accept what it characterized as "easy morals," and she had the poor judgment to announce it at a public meeting.

In 1872, the Liberal Republicans, now a party, nominated Horace Greeley, who opposed Radical Reconstruction, for the presidency against Grant, and the Democrats supported him, with Theodore Tilton as his campaign manager. (Greeley is best known for saying, "Go West, young man," although he himself stayed in New York.) He lost in a landslide. Beecher went with Grant in spite of massive corruption in his administration. To make matters worse, Woodhull ran for president although she had broken up with Vanderbilt and therefore lost his financial support. She called her effort the "People's Party" and printed Karl Marx's Communist Manifesto in her weekly magazine. Her campaign failed to ignite, she was evicted from her house and no one would rent to her because of her radical views. The "Liberal Republican" Party was liberal in the modern sense that it opposed corruption. But it was also elitist and believed in rule by the "best people," a concept left over from the pre-Jacksonian period.

On September 12, 1872, desperate for publicity, Woodhull addressed a crowd in Boston and publicly called Beecher the "king of free love" but a hypocrite and named Elizabeth Tilton as his mistress. Woodhull charged that he preached to a dozen of his lovers at Plymouth, which was inflammatory and an overstatement (but perhaps only by a bit). On October 28, just before Election Day, she published an edition of 150,000 copies of *Woodhull and Claflin's Weekly* in which she set out the sordid details of the Tilton affair. The publication sold out and went on the secondary market for as much as twenty dollars! However, Henry Bowen contacted Anthony Comstock, the notorious censor of the YMCA's Anti-Pornography Campaign, and mailed a copy of the weekly to him. Comstock had Woodhull arrested as a smut-peddler for publishing obscene materials and sending them through the mails, a federal crime.

There followed several investigations of the adultery charge by Plymouth Church and related Congregational bodies, which found Beecher innocent. Theodore sued for $100,000 on a civil complaint charging that Beecher had willfully alienated his wife's affections.

Elizabeth Tilton changed her story repeatedly, both before and after the trial, leaving no one sure what the truth was. The 1875 trial was a sensational scandal, but the jury came back deadlocked and Beecher was not re-tried

Right: Figure 27. Elizabeth "Lib" Tilton was probably Henry Ward Beecher's most notorious conquest. Their affair led to the reverend's civil trial. *Brian Merlis Collection.*

Below: Figure 28. This period print gives a sense of the excitement and scandal surrounding the Beecher trial. *Library of Congress Picture Collection.*

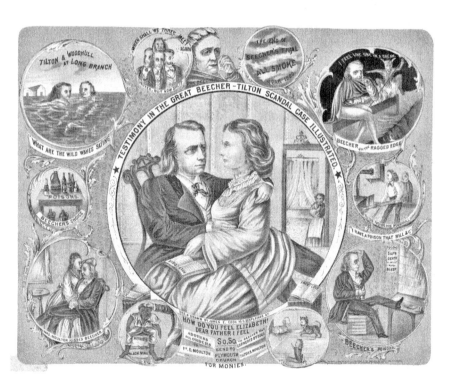

(figure 28). Those who had charged Beecher with wrongdoing were expelled from Plymouth, and he was embraced as the injured party!

Debby Applegate suggests that Beecher's disgrace was a factor in the decline of the neighborhood since he had occupied such an exalted position. The fact that he was imperfect was demoralizing.

Later, Beecher embraced Herbert Spencer's "Social Darwinism," the laissez-faire defense of robber barons known as the "survival of the fittest," and later the actual Darwinism of which it was a distortion (Darwin's term was "natural selection"). Beecher began to sympathize with labor in the strike-plagued hard economic times of the 1870s and '80s. This was an advanced point of view for a member of the Republican Party, which had mostly become the party of big business except for occasional bursts of reformism about civil service reform, conservation and other issues. Beecher suffered a stroke and died in 1887 and was buried in Green-Wood Cemetery.

Reverend Beecher lived in numerous houses in the Heights and Downtown Brooklyn. When he first arrived in Brooklyn, he lived at 66 Cranberry Street from 1847 to 1848 (demolished, formerly number 56 and the residence of Dr. Samuel Hanson Cox when the First Presbyterian was on Cranberry). He later moved to 22 Willow Street (extant) from 1848 until 1850 (then number 18) and 197 Washington Street (1850, now demolished). Later he lived at 176 Columbia Heights (then number 126) from 1851 to 1855 (extant), at number 124 (82 in the old system) Columbia Heights from 1856 to 1881 (razed for the BQE) and at 124 Hicks Street from 1881 to 1887 (demolished), when he died. His father, Reverend Lyman Beecher, lived at 73 Willow Street (razed), where he died in January 1863.

Beecher was succeeded by Lyman Abbott (1835–1922), who was also an attorney and an editor of *Harper's Magazine*, then the most prominent national publication, and of the *Illustrated Christian Weekly*. He also wrote twenty-one books, including a biography of Reverend Beecher. Abbott served from 1888 until 1898 and followed in Beecher's liberal footsteps.

A porch in the Tuscan style was added to Plymouth's entranceway in the mid-nineteenth century, and a church house, known as the Arbuckle Institute (figure 29), was endowed in 1913 by coffee merchant John Arbuckle, whose DUMBO warehouse is part of Brooklyn Bridge Park (see chapter 13). The institute, itself a city landmark, is a Beaux Arts design in the Georgian Palladian manner and covers the corner of Hicks and Orange Streets. It connects to the church via an enclosed walkway that serves as the Plymouth Gallery.

Figure 29. These statues are located in a park-like area outside the church gallery. A standing Beecher with freed slaves (reminiscent of the one in Columbus Park) is at center, and a relief of a seated Lincoln is at left. The gallery houses its collection of artifacts and art. The Arbuckle Institute is at left. *Robert Furman photograph.*

John Arbuckle (1838–1912) was a pioneer in food processing, inventing a machine for weighing, packaging and sealing bags of ground coffee. He used the mechanism for sugar, which brought him into conflict with the Havemeyer sugar monopoly, which was based in Williamsburg at what became the Domino Sugar factory. Arbuckle prevailed in spite of the wealthier Havemeyers competing in the coffee business. He was a member of Plymouth Church. A Yuban sign (his major coffee brand) was formerly visible on his DUMBO warehouse.

An outdoor memorial park features a 1914 Beecher statue with freed slaves (figure 29) by sculptor Gutzon Borglum, who is best known for his gigantic presidents' heads at Mount Rushmore. There is also a relief of Lincoln in a recessed panel.

Plymouth Bethel (a branch church or chapel) was founded at 15 Hicks Street in 1866 to reach out to the working class of the north Heights, which was then an industrial area. It later became a branch of the Brooklyn Tabernacle and was demolished for the Brooklyn-Queens Expressway in 1950.

As the old Protestant population continued to flee the Heights for Manhattan and the suburbs, Plymouth Church merged with the Church of the Pilgrims in 1935, and they combined at Plymouth on Orange Street. In February 1963, the Reverend Dr. Martin Luther King Jr. gave an early version of his famous "I Have a Dream" speech at Plymouth.

Plymouth's history is on display in its gallery, and its sanctuary and Underground Railroad chambers are also available for viewing. To view the church, contact church historian Lois Rosebrooks by e-mail at loisrosebrooks@plymouthchurch.org. Plymouth continues to be a major neighborhood institution, offering a daycare center, summer camp, children's choirs, weekday children's religion classes and a vacation Bible camp. Reverend David C. Fisher is senior minister. The institution's name reverted to Plymouth Church in 2011. The church opened a thrift shop in its basement the same year, selling both donated designer items and used garments. Proceeds will benefit worldwide antislavery efforts, extending the church's historic mission into the future.

Chapter 8

THE PORT AND OTHER BUSINESSES

1825–1965

The economic life of the Heights developed in response to its location on the East River just north of Upper New York Bay. Thus, it first became a port for freight and later passenger ships and then a warehousing, transshipment and manufacturing and processing center for the cargo the ships exported and imported. Imports included sugar, bananas and coffee.

Piers and warehouses were constructed all along the East River at Furman Street (figures 1–2), creating a working waterfront. The biggest impetus for the growth of the Brooklyn waterfront was that in the 1840s, Red Hook became the discharging end of the Erie Canal, first at the Atlantic Docks and then throughout the area, but the unique shallow draft narrow canalboats only tied up in Red Hook. Ships that docked in the Heights carried these cargoes to and from the rest of the world.

Ships tied up to finger piers, which were backed up by warehouses for cargoes called stores. This remained the predominant format for shipping until change was forced by the advent of containerization in the early 1960s.

The development of the streamlined sailing ship, or clipper, by A.A. Low was another major engine of growth. These ships revolutionized shipping in a world without a Panama Canal or steam power that nevertheless needed speed to prevent spoilage and to compete with rivals. Clippers from Brooklyn sailed around the southern end of South America (Cape Horn) to reach San Francisco, to pick up and deliver cargoes and to push on to China, which was becoming a major export-import market in the mid-nineteenth century. Cargoes included silks, tea and opium. The

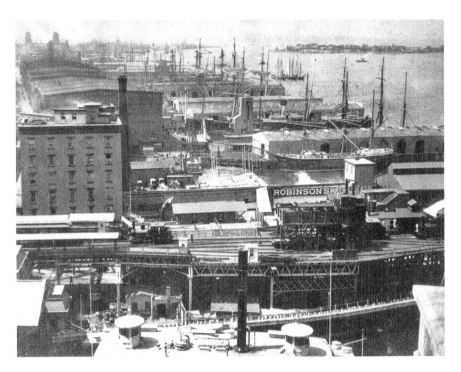

Figure 1. In 1877, there were docks, sailing ships and small warehouses along Furman Street. From *The Eagle and Brooklyn*, 1898.

Lows engaged in the opium trade until pressured out of it by their Chinese partner (see chapter 4).

Numerous clipper ship captains lived in the Heights to be near their ships. On Joralemon near Henry Street dwelt Captain John Rathbone of the *Nashville* of the Red Ball Line and the *Oxford* of the Black Ball Line. Captain Robert Waterman was the master of the *Natchez* and later the *Invincible*. Shipmaster George Coggeshall lived at 12 Monroe Place in 1849. The best known today of them is Low relative Mott Bedell (see chapter 4), whose house at 19 Cranberry Street (chapter 4, figure 27) bears a plaque.

A major shipping line owner also lived in the Heights: Danish immigrant Hans Isbrandtsen, who founded Maersk and the American Export Lines and whose passenger liners SS *Constitution* and *Independence* were famous in the 1940s and '50s. He lived at 87 Remsen Street.

In 1900, the New York Dock Company obtained a franchise from the City of New York to operate all of the piers and warehouses in Brooklyn from Erie Basin in Red Hook to Fulton Street. It shipped barges across the harbor to reach the railroads and, later, highways on the mainland. New

York Dock subleased the piers to other companies, including freight and passenger lines. The Booth Steamship Company, the North German Lloyd (passenger) Line, the New York and Cuba Mail Steam Ship Company and, later, Moore-McCormack Lines were tenants.

The Port of New York Authority (today the Port Authority of New York and New Jersey) was founded to build a rail tunnel across the bay to end this clumsy arrangement but never did.

In 1946, the warehouses on the east or Heights side of Furman Street were razed for BQE-Promenade construction, followed by those on the west side in 1958. In the 1960s, the advent of containerization (truck bodies transported on specially constructed ships) made these old break-bulk finger piers obsolete. Consequently, the New York waterfront moved to New Jersey, where adequate space, rail and highway connections were easily available. This was facilitated by a deal between the two states' governors (Nelson A. Rockefeller of New York) that swapped a new World Trade Center in Manhattan for the port moving to Elizabeth and Newark. After demolition and fires, the piers were replaced by new ones in the 1960s (figure 2), but this did not lure the ships back; they continued to prefer the space and access of the New Jersey facilities, in spite of the construction of the Red Hook Containerport along the Columbia Street waterfront.

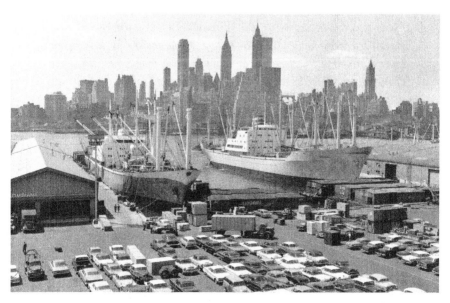

Figure 2. New piers replaced the old warehouse system in the 1960s after numerous fires and demolitions. They failed to reverse the decline of the waterfront. The prewar needle-spire downtown skyline is still intact. *Brian Merlis Collection.*

Businesses such as Strober Brothers used the piers as warehouses until Brooklyn Bridge Park was begun in the 1990s. The entire shoreline from Atlantic Avenue to Vinegar Hill is now being converted into the park.

By 1886, there was a Pennsylvania Railroad Ferry Annex at the foot of Fulton Street, with tracks and stores along Furman Street. Before the advent of trucks, most long-distance cargoes were carried by canals and later by railroads. There were stores running south from Fulton Street called Martin's, Watson's, Roberts', Pierrepont's, Prentice's, Mediteranean [sic], Woodruff's and Harblow's (figure 3). The warehouses were used by many companies, including Robinson's Stores in 1910 and the National Cold Storage Company in 1940.

The 1867 Dripps map (figure 3) shows Knickerbocker Ice, D.E. Forest's Stores, Luderons' Stores, Thompson's Storage, Harbeck's Stores, Roberts' Wall Street Stores, Pierrepont Stores, Prentice Stores and Schenck's Stores along the river.

In 1880, Knickerbocker Ice Co. and Martin's, Watson's, Harbeck's and Roberts' Stores could be found in the north Heights. South of these were McLean's and Pierrepont's Stores.

In *A House of the Heights*, Truman Capote described the Furman Street docks and ships in the late 1950s at the end of its prosperity:

> *Close by the hotel begins a road* [Furman Street], *warehouses with shuttered wooden windows, docks resting on the water like sea spiders. From May through September, la saison pour la plage, these docks are diving boards for husky ragamuffins—while perfumed apes, potentates of the waterfront but once dock-divers themselves, cruise by steering two-toned (banana-tomato) car concoctions.*
>
> *Crane-carried tractors and cotton bales and unhappy cattle sway above the holds of ships bound for Bahia, for Bremen, for ports spelling their names in Oriental calligraphy. Provided one has made waterfront friends, it is sometimes possible to board the freighters, carouse and sun yourself: you may even be asked to lunch—and I, for one, am always glad to accept, embarrassing so if the hosts are Scandinavian: they always set a superior table from larders brimming with smoked "taste thrills" and iced aquavit.*

But he was nearly mugged by a gang called the "Cobras."

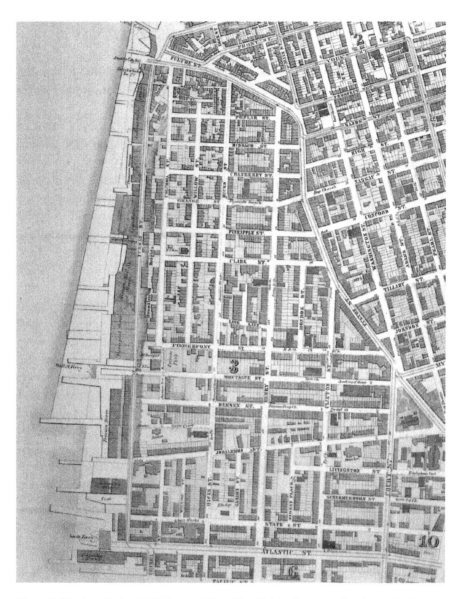

Figure 3. Matthew Dripps's 1867 map of Brooklyn Heights is extraordinarily detailed. It identities major structures and carries old-system house numbers on each corner. The companies along the shore are, *from top*, Knickerbocker Ice, D.E. Forest's Stores, Luderons' Stores, Thompson's Storage, Harbeck's Stores, Roberts Wall Street Stores, Pierrepont Stores, Prentice Stores and Schenck's Stores. The streets are the same as today except that some designations have changed (e.g., Atlantic Street instead of Avenue). Although the Historical Society building was not yet constructed, it owned the site. The glass works are shown at the end of their stay in Brooklyn. The western part of Montague Street is largely empty, and the Misses Whites' Garden is labeled "Private Park." From Matthew Dripps's *Map of Brooklyn Heights*, 1867.

FACTORIES AND OTHER LARGE BUSINESSES

In the early days, the proximity of Furman Street to the docks made locating factories and processing plants there cost effective, since they could receive imported raw materials and ship out finished goods.

One business on Furman Street in the late 1800s was the American Gas Machine Company, which built 334 Furman Street and other satellite buildings. This facility was originally four stories but was later expanded to cover the entire quadrangle and was expanded to its current fifteen floors probably during World War II. After manufacturing left Brooklyn, it was a marginal office building owned by Jehovah's Witnesses and has now been converted into co-ops with the address 1 Brooklyn Bridge Park. Another factory on Furman Street was Fred Fear & Company, a food processor. Near Fulton Ferry was the Knickerbocker Ice Company. Before the advent of refrigeration, you had to purchase ice for your icebox.

Businesses in the industrial north Heights in 1922 included National Cold Storage and Adam's Express along the west side of Furman Street, a soap factory, a foundry, a machine works and a coal yard. On the east side were piers used by the Booth Steamship Company and, along Fulton Street, the extant Eagle Warehouse and Storage Company building, now housing. Poplar Street was utilized by two machine shops, while E.R. Squibb and Sons, a major aspirin and drug manufacturer, lay between Doughty and Vine and Columbia Heights and McKenney Street.

It was common in the nineteenth century for businessmen prominent in real estate and other fields—such as William Prentice, Henry Pierrepont (see chapter 4) and James S.T. Stranahan (see chapter 7)—to also operate warehouses and piers.

Fred Fear & Company, founded in 1892, was at one time the largest wholesaler of maple syrup, clam juice and Easter egg colors and operated three plants. In 1954, it was acquired by the restructuring Childs Restaurant chain.

There were many factories on Furman Street and elsewhere in the north Heights. The Knickerbocker Ice Company was at 6 Furman Street near Fulton Ferry in the 1860s through 1880s, but the best known of these factories was E.R. Squibb & Sons, on the east side of the northern end of Columbia Heights. Squibb was an aspirin and drug manufacturer whose building (figure 4) was purchased by the Jehovah's Witnesses after Squibb left Brooklyn.

Major businesses in the north Heights included the Peoples Hotel (which catered to sailors) next to the Plymouth Bethel (a chapel), the

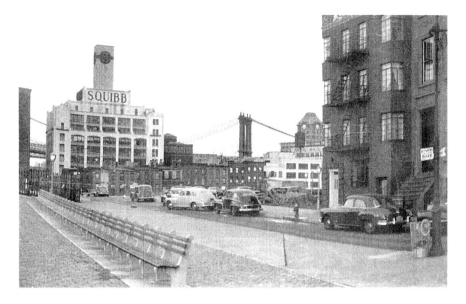

Figure 4. The E.R. Squibb & Sons factory is shown here in 1952 from the Fruit Streets Sitting Area. The building was taken over in 1969 by the Jehovah's Witnesses. Numerous houses were razed to accommodate the highway's turn to the east here, which allowed for the creation of the sitting area. *Brian Merlis Collection.*

Annex Hotel on Furman Street and the Fulton Ferry terminal. There were also residential buildings on many streets, such as Henry Street and Columbia Heights.

Edward Robinson Squibb (1819–1900) was a physician who became convinced of the importance of developing effective anesthesia. After the Mexican War, he was the assistant director of the U.S. Naval Laboratory at the Brooklyn Navy Yard, where he invented a new method for distilling ether with steam, obviating the dangerous use of an open flame. He gave the technology away rather than patent it. This is an example of the generous impulses of nineteenth-century businessmen before corporations came to dominate American economic life.

In 1857, Squibb left the service and set up his own company on Furman Street, which experienced several fires. He also bought a house on Middagh Street. During the Civil War, he supplied ether and chloroform to the U.S. Army and invented a new standard medication pack for field physicians. Obsessed by purity and uniformity of medications, he became a crusader for the creation of the U.S. Food and Drug Administration.

The Squibb building (figure 4) dates to the turn of the twentieth century. During World War II, the company produced penicillin, the first

Above: Figure 5. The F. Wesel Manufacturing Company occupied two large buildings on the east side of Cranberry and Henry Streets, in addition to the former Brooklyn Armory. All were demolished for the Cadman Plaza apartments. From *King's Views of Brooklyn*, 1909.

Left: Figure 6. In 1905, candy manufacturer Mason, Au & Magenheimer was new to 22 Henry Street, having moved from Fulton Street. From *The Eagle and Brooklyn*, 1898.

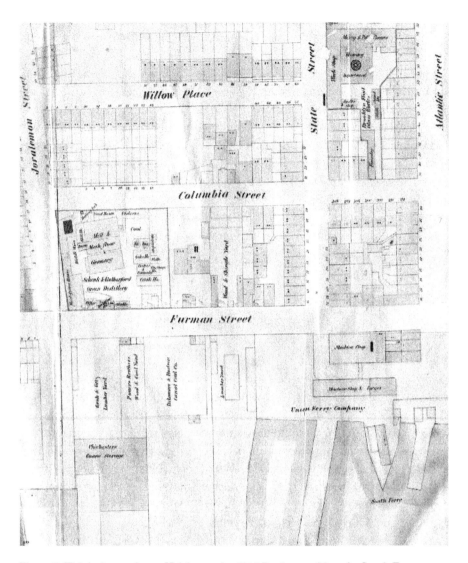

Figure 7. This is the southwest Heights on the 1855 Perris map. Note the South Ferry at lower left; industrial plants between Columbia, Joralemon, State and Furman Streets; and the Brooklyn Flint Glass Company on State Street between Hicks, Atlantic and Columbia Streets. Joralemon Street is at top. *Perris Map of Brooklyn*, 1855.

antibiotic. In 1989, the company merged with Bristol-Myers, becoming part of Bristol-Myers Squibb.

One of the largest employers in the Heights was printing and photographic equipment maker F. Wesel Manufacturing (figure 5). The business was begun in Manhattan in 1880 by German immigrant F. Wesel. Wesel purchased the old Armory building (chapter 7, figure 13) in 1892, two factories in 1897 and another at 96 or 98 Cranberry Street in 1899. He used his Manhattan property for sales and executive offices. The company moved to the Scranton/Wilkes-Barre, Pennsylvania area in the early to mid-twentieth century.

Another factory was Mason, Au & Magenheimer (figure 6), which survived as Mason-Peaks Candy at Henry and Middagh Streets into the 1960s. The building is now housing.

INDUSTRIAL WILLOWTOWN

The first large business in the Heights, founded in the 1700s, perhaps by Philip Livingston (chapter 3, figure 10), was the Livingston/Joralemon distillery (chapter 3, figure 11), which made gin. It was on the shore at Joralemon Street (the site today is the northern half of the block between Joralemon, Columbia, State and Furman Streets and includes the area to the west across Furman Street). It became the core of a business district in the southwest Heights, later called Willowtown. Small factories persisted there into the 1960s, when they were pushed out by gentrifying residents.

The 1855 Perris map of the area (figure 7) shows a lumberyard, a coal yard and machine shops west of Furman Street. There were also a flour mill, a wood and shingle yard and a distillery on the northern half of the former distillery block. In 1886, this area was the Livingston Sugar Refinery.

Around 1730, Lodewyk Bamper founded a glass works on what would become State Street. In 1823, it was owned by John L. Gilliland, as shown on the 1827 Hooker map (introduction, figure 3), the 1855 Perris map (figure 7) and the 1867 Dripps map (figure 3). At that time, it occupied the entire area between unopened District and Joralemon Streets west of Hicks Street. It made bowls, glasses and other hollowware. This company became the South Ferry Glass Works in 1840 (ferry service having begun in 1837), and in 1855, the site—by then the northern half of the block bounded by Atlantic Street (Avenue) and Hicks, Columbia and State Streets—housed Gilliland's

Brooklyn Flint Glass Works, mostly fronting on State, according to the Perris map, making first Irish-type crystal and later Venetian-style glass.

Elias Hungerford patented a process to make blinds out of colored translucent glass and contracted with the works to manufacture this popular new product. In 1864, Amory Houghton Sr. bought the company from Gilliland and in 1868 was persuaded by Hungerford and his investors to move to Corning, New York, thus giving birth to the Corning Glass Company. Fine examples of the Brooklyn company's work are preserved in the Corning Glass Museum and may be seen in its various publications. The 1886 map shows the site as vacant, indicating where the works were.

Another business founded in Willowtown was the Benjamin Moore Paint Company, begun in 1883 by brothers Benjamin and Robert at 55 Atlantic Avenue between Hicks Street and Columbia Place (this area is now the northbound entrance to the BQE). The building burned down the next year, and the company relocated to 231 Front Street and also Adams and Water Streets. Their first products were Calsom Finish for walls and later Muresco (*mur* is French for "wall") for ceilings in 1892. As they expanded, they moved around Brooklyn and later to Canada.

Insurance and Title Companies

The first insurance company in Brooklyn was the Brooklyn Fire Insurance Company of 1824. It suspended operations following losses from the Great Brooklyn Fire of 1848 but reorganized in 1849 and functioned until 1870, following another panic. The disastrous fires common in the nineteenth century led to the bankruptcy of many insurance companies. The Long Island Insurance Company was organized in 1833 and continued until 1890. These were based at Fulton Ferry and later downtown.

As Court Street near city hall became Downtown Brooklyn after 1850, insurance companies grew to become major businesses. One of the first was the Home Life Insurance Company, founded in Brooklyn in 1860. The Phoenix (or Phenix) Insurance Company began in 1851 as the American Temperance Life Insurance Company in Montague Hall (chapter 6, figure 41), a former hotel on the site of 16 Court Street. The company changed its name in 1860 to expand its market. It occupied the entire building, outgrew it, demolished it and put up its own headquarters at 12 Court Street in the

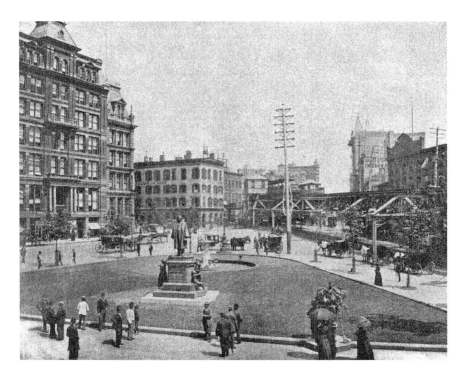

Figure 8. Court and Fulton Streets around City Hall Park in 1897. From the left, we see the Phenix and Continental Insurance Company buildings, with the original Mechanics Bank Building across Montague Street, the Fulton Street el and small buildings. Note the huge telephone pole at a time before utility lines were buried underground. The only survivor in this scene is the triangle in front of Borough Hall. From *The Eagle and Brooklyn*, 1898.

1880s (figure 8). The company later merged with Fidelity Insurance and had a New York office.

Next door, at 8 Court Street, on the corner of Montague Street, was the Continental Insurance Company building (figure 8). The company was founded on Wall Street in Manhattan by Henry C. Bowen and Hiram Barney in 1852 because of their problems buying fire insurance. They opened a Brooklyn office in 1868 and expanded into this building in the 1880s.

In 1897, 186 Remsen Street (chapter 11, figure 18) was known as the Long Island Bank Building but also housed the Franklin Trust Company. Built for A.A. Low & Company, later tenants included other banks, the NAACP and Little Flower Children's Services. Another insurance company in the Heights was the Nassau Fire Insurance Company at 30 Court Street in 1897 (founded 1852), the oldest of its kind at the time.

The Williamsburgh City Fire Insurance Company had offices at 156 Montague Street in 1905, and the Home Insurance Company and the Phoenix Assurance Company occupied quarters on Montague Street in 1920.

Related to insurance companies are title insurance companies that examine whether prospective buyers of property have title clear of any claims or liens and insure the buyer's title. They were centered on the easternmost blocks of Montague and Remsen Streets. Major ones at the turn of the century were the Title Guarantee and Trust Company on Remsen Street and at 196 Montague Street (chapter 9, figure 14) and the New York Title and Mortgage Company at 205 Montague Street.

Among the title companies in business in the last few years were Fidelis Abstracts in 26 Court Street, Personal Touch Title Examiners at 32 Court, Team Examiners at 193 Joralemon Street and at 189 Montague Street and Kingsland Examiners at 85 Livingston Street. On Remsen Street are Barretta Examiners and Reality Research at number 175 and the Home Abstract Corporation at number 147. These companies have recently been dispersing; witness that Heights Abstracts is now in Carroll Gardens. With the consolidation of the City of Brooklyn into New York City and the rise of Wall Street, most of the insurance companies and major banks moved their main offices there.

In 1929, just before the Great Depression began, numerous insurance companies were headquartered or had offices in the Montague-Court Street area, despite the loss of insurance headquarters buildings during that decade. These included agent David Solomon, the Mallory Construction Company, New York Title and Mortgage and the Brooklyn National Life Insurance Company at 205 Montague; the Brooklyn Fire Insurance Company at 92 Clinton Street; American Surety of New York at 189 Clinton Street; and the Fidelity and Deposit Company, the National Surety Company and the Automobile Insurance Company of Hartford, all at 16 Court Street. Also, there were the Commercial Casualty Insurance Company at 147 Remsen, the Burke Agency at 163 Remsen, William Bove and Company at 92 Clinton, Continental Insurance at 158 Montague, the Empire Fire Insurance Company at 32 Court, Fidelity-Phoenix Fire Insurance Co. and the Home Insurance Company at 60 Clinton.

Large companies with local agents included the Hartford Fire Insurance Company at 138 Montague, New York Life Insurance Company at 164 Montague and Northwestern Mutual Life at 26 Court and more recently at 161 Remsen Street, via the A.J. Johanssen Agency, where

their sign remains on a now residential building, Prudential Insurance Company of America at 16 Court. The following title companies were also in operation: Lawyers Title at 188 Montague, National Title at 174 Montague, NY Title and Mortgage Company at 205 Montague and the Title Guaranty and Trust Company at 175 Montague. Art Deco 130 Clinton Street was constructed in the 1920s as the Insurance Building but later became an ordinary office structure. Today it is housing.

THE BANKS

The first bank in Brooklyn was the Long Island Bank, founded in 1824 at Fulton Ferry and later located on Montague Street. In 1887, it moved into 186 Remsen Street (chapter 11, figure 18), along with the new Franklin Trust Company, which put up its own structure on the southwest corner of Montague and Clinton Streets in 1891 (figure 9). The Long Island Bank liquidated in 1900.

The Brooklyn Savings Bank was founded in 1827 and first operated in the Apprentices' Library building (chapter 6, figure 1). Its first president was Adrian Van Sinderen (see chapter 7). It put up the building in figure 10 on the northeast corner of Pierrepont and Clinton Streets in 1893, which was demolished by the Cadman Plaza urban renewal. This site remained vacant until the Morgan Stanley back office (1 Pierrepont Plaza) went up in the 1980s (chapter 11, figures 16 and 17). In the early 1960s, the Brooklyn Savings Bank moved to the extant bank building on the northwest corner of Montague Street and Cadman Plaza West (chapter 11, figure 17) but soon merged out of existence.

Another local bank building demolished in the urban renewal was the Brooklyn Bank (not the Brooklyn Savings Bank) on Clinton Street below Fulton (figure 11). This was one of the few Art Nouveau buildings in Brooklyn. A 1915 image shows the structure occupied by the New York State Employment Bureau and a dry cleaner, indicating that its life as a bank had ended. It would serve such extemporaneous purposes until its demolition.

Several banks that still exist in another form originated in the Heights. The Brooklyn Trust Company was chartered in 1866 and grew into Brooklyn's largest bank. Henry Pierrepont was an incorporator. The bank was originally housed in an enlarged version of the Taylor

Right: Figure 9. The Franklin Trust Company building on the southwest corner of Montague and Clinton Streets is now housing. From *The Eagle and Brooklyn*, 1898.

Below: Figure 10. One of the still-mourned victims of the Cadman Plaza urban renewal is the Brooklyn Savings Bank by Frank Freeman, which stood on the northeast corner of Pierrepont and Clinton Streets. The Crescent Club on Clinton Street is visible at left along with the Hotel Touraine and a few low buildings. The bank had a covered passageway entrance from Fulton Street. Note the houses at right in this 1905 view. *Brian Merlis Collection*.

Figure 11. In 1905, the Brooklyn Bank shared its headquarters with the Long Island Safe Deposit Company, whose original building at Fulton Ferry Landing is the anchor of that historic district. *Brian Merlis Collection.*

mansion on the northeast corner of Montague and Clinton Streets (see chapter 7, Sanitary Fair section). Its 1915 headquarters branch (figure 12) on the same site is a replica of the Villa Medici in Rome by way of the New York State Building at the World's Columbian Exposition and the Palazzo della Gran Guarda in Verona, Italy. Its Neoclassic interior is modeled on the Tepidarium of the Baths of Caracalla in Rome, possibly via the 1906 Penn Station. Walter O'Malley was its general counsel, and it was the Brooklyn Dodgers' bank (see material about Walter O'Malley and the Dodgers in chapter 12). It had one Manhattan branch and two other Brooklyn branches and held deposits of almost $340 million in 1924. The bank later became part of Manufacturers Trust Company, later Manufacturers Hanover Trust, which also began in Brooklyn and was itself absorbed by the Chase Manhattan Bank, which now operates this branch as JP Morgan Chase.

The Mechanics Bank began around 1855 on the northwest corner of Montague and Fulton Streets (figure 8; chapter 9, figure 3) and put up its iconic Venetian Gothic headquarters (chapter 9, figure 11—note the polychrome work) in two stages in 1905 and 1907. The upper two floors were Beaux Arts, and surprisingly, the combination worked well. In 1910, the bank had five branches around Brooklyn but later merged with the Brooklyn Trust Company. From 1938 until 1957, the offices of the Brooklyn Dodgers were located here. In 1959, it was demolished as part of the Cadman Plaza urban renewal because of the weakness of the local commercial real estate market, because it was of pre-modern design and to accommodate the widening of Cadman Plaza West.

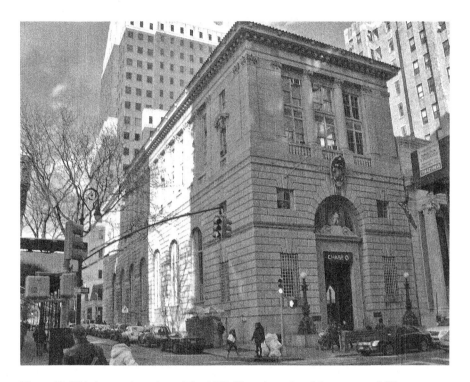

Figure 12. This is a modern shot of the 1915 Chase branch at Montague and Clinton Streets, originally the Brooklyn Trust Company, the Dodgers' bank. To its right is a classical Citibank branch, originally the People's Trust Company. *Robert Furman photograph.*

Banks in the area between 1900 and 1910 included the Union Bank of Brooklyn at 44 Court Street, the Long Island Loan and Trust on Montague Street between Fulton and Clinton Streets and the Long Island Safe Deposit Company in the Brooklyn Bank Building on upper Clinton Street.

Next door to the Brooklyn Trust is the beautiful People's Trust Company (figure 13), now a Citibank branch. People's began at 172 Montague Street in 1889 and built its splendid new quarters in 1905 at 205 Montague. In 1926, it had eight Brooklyn braches. Citi began in Downtown Brooklyn as National City Bank.

Another bank building is the National Title Guaranty building of 1930 (figure 14) at 185 Montague Street, called the "jazziest little Art Deco skyscraper in town" by Francis Morrone. It was later the Bank of the Manhattan Company, which became the "Manhattan" part of Chase Manhattan Bank. In 1948, the owners planned to cut the building down to three stories because of the depressed state of the Heights commercial real

PEOPLES TRUST CO.,
MONTAGUE ST.,
BROOKLYN, N. Y.

Above: Figure 13. The Neoclassic People's Trust Company is shown here in 1912 along with the original Brooklyn Trust Company building to the left, Holy Trinity Church and some neighboring razed small commercial buildings housing a tailor and two real estate agents. People's Neoclassic design and light color make it stand out among its Victorian neighbors. *Brian Merlis Collection.*

Left: Figure 14. The National Title Guaranty building at 185 Montague Street. *Robert Furman photograph.*

estate market. Fortunately, this did not occur to this particular building, but it was done throughout the Heights' commercial zones.

The high point for banking in the Heights was the 1920s. In 1929, the year of the great stock market crash, the Bank of the Manhattan Company; the First Bank of Brooklyn, founded in 1852; and the International Thrift Society were at 26 Court Street. Kingston Finance was at 50 Court Street; the Morris Plan operated at 198 Montague; the Nassau National Bank, founded in 1859, was at 16 Court Street and 175 Remsen Street; Bankers Trust Company was at 66 Court Street; the Title Guarantee and Trust Company was at 175 Remsen; the American Trust Company was at 209 Montague; the Stockbrokers Bank was on Court; and New York Title and Trust were at 205 Montague. The Brooklyn National Bank was at 32 Court Street (its board chairman was Congressman Emanuel Celler, first elected in 1922, who lived in Park Slope and was chairman of the House Judiciary Committee until his defeat by Elizabeth Holtzman in 1972). J.S. Bache was at 16 Court Street, the Brooklyn Commercial Company was at 215 Montague, the Chase National Bank is still at 191 Montague and the Lawyers Trust Company was at 44 Court Street.

Of these establishments, one deserves further explanation. Morris Plan banks were the first reputable lender to the poor and middle class, beginning in the 1910s. Eventually becoming a national chain, they replaced loan sharks who had previously been the lenders to the poor, rather than just to those in trouble or criminals. In 1931, there were 109 profit-making branches in 142 cities. The chain was founded on the principles of Virginia lawyer Arthur J. Morris, who perceived the lack of what we now call "micro-lending." The major banks started offering the same services, so Morris declined.

This makes it clear that Montague Street was the "Wall Street of Brooklyn" in the 1920s. At the time, the concentration of business in the Heights was felt to be negatively affecting its residential nature.

Today's smaller roster of banks includes HSBC, Dime Savings (of Williamsburgh) and Flushing FSN, all on Montague Street; Bank of America (166 Montague Street in 1929 and today); and TD, Chase, Santander and Citibank, all between Court Street/Cadman Plaza West and Clinton Street. New arrivals include a branch of Capital One Bank on Remsen Street just west of Court Street, Signature in 26 Court Street (chapter 9, figure 5), Esquire Bank (both catering to lawyers) at number 64 and the Latino-oriented Banco Popular at 66 Court Street (chapter 9, figure 7), which has recently been renamed Popular Community Bank to broaden its appeal.

The Dime Savings Bank of Brooklyn, begun in 1859, participated in the Brooklyn and Long Island Sanitary Fair of 1864 (see chapter 7). It was located in an Egyptian temple–style building on Remsen and Court Streets built in the 1880s (chapter 9, figure 6) and was demolished in 1918 when the bank sold off the site and moved to DeKalb Avenue in Downtown Brooklyn. It had considered erecting a high-rise on its site at 32 Court Street. The bank itself merged into Washington Mutual in 2002, which collapsed in 2010, and the building became an HSBC branch.

Newspapers and Magazines

The *Brooklyn Hall Gazette* of 1779, sometimes described as the first newspaper in Kings County, was actually a publicity sheet for the King's Head tavern operated by Charles Loosely and Thomas Elms at Brooklyn Ferry during the British occupation.

Thomas Kirk, a printer and bookseller at Front and Fulton Streets (then the Ferry Road), started the *Long Island Courier* in 1799. He began the *Long Island Star*, the first long-term survivor, in 1809, which was taken over in 1815 by Alden Spooner (figure 15), who also continued the book business. Spooner induced Gabriel Furman to write his *Notes Geographical and Historical Relating to the Town of Brooklyn in Kings County on Long Island*. The paper folded in 1863 under pressure from the *Eagle*. There were several other daily papers headquartered in the Borough Hall area.

The run of the *Star* is available on microfilm at the Brooklyn Historical Society and, although not online or indexed, is worth inspecting for its more objective reporting on the issues leading to the Civil War than the *Brooklyn Eagle*, which, as a Democratic Party sheet, was anti-abolitionist.

The more famous *Eagle* (because it lasted until 1955) was a relative latecomer of 1841. It was founded by Isaac Van Anden (figure 17) and Henry Cruse Murphy (chapter 6, figure 9) on Fulton Street at Fulton Ferry (figure 16) as a Democratic Party organ; Murphy was the local party leader. Walt Whitman (chapter 6, figure 2) was editor from 1846 until 1848, when he was fired after siding with the free-soil "Barnburner" wing of the Democratic Party and against Van Anden, who belonged to the conservative, or "Hunker," wing of the party. Whitman was a delegate to the 1848 founding convention of the Free Soil Party. The paper built a new headquarters on Washington and Johnson Streets in 1893 on the site of the burned Brooklyn

Theater, which is now in Columbus Park near the Beecher statue. In the 1920s, it became part of the Gannett newspaper chain. By 1939, however, it had moved to Johnson and Adams Streets. Other notable editors of the paper included Thomas Kinsella (figure 17), St. Clair McKelway, Cleveland Rogers and Franklin D. Schroth, who bought the paper in 1938. It absorbed other papers, such as the *Brooklyn Times Union.*

Figure 15. Alden Spooner I edited the *Long Island Star*, Brooklyn's first newspaper. From *The Eagle and Brooklyn*, 1898.

The "Barnburners" were the radical faction of the Democratic Party in New York State. Led by upstater and later president Martin Van Buren, they supported Andrew Jackson and opposed corporate power and internal improvements such as the Erie Canal. Later, they came to oppose the extension of slavery into the new territories and states (the issue that led to the Civil War), bolted from the Democratic Party in 1848 and supported the abolitionist Liberty and Free Soil Parties (see chapter 7). "Hunker" means that the conservatives would hunker down and dig in their heels in defense of old values.

The Democratic Party of the nineteenth century was very different from that of today. Cast in the image of Thomas Jefferson and Andrew Jackson, it was at first the party of the farmer and plantation owner and later, with the coming of significant Irish immigration, also of the urban masses. This latter cohort led to its modern incarnation. It embodied the anti–big government values of the Revolution. In the 1830s, universal white manhood suffrage was established in New York in the more democratic and anti-business spirit of President Andrew Jackson, who also opposed federal spending on "internal improvements" such as roads and the state-financed Erie Canal. He also abolished the Second Bank of the United States, a predecessor of the Federal Reserve, created to stabilize the currency and economy.

The *Brooklyn Eagle* was successful, outcompeting the *Star* and outgrowing its original home, and in 1893, it moved to a new, large building on Washington and Johnson Streets. It became the largest afternoon paper in

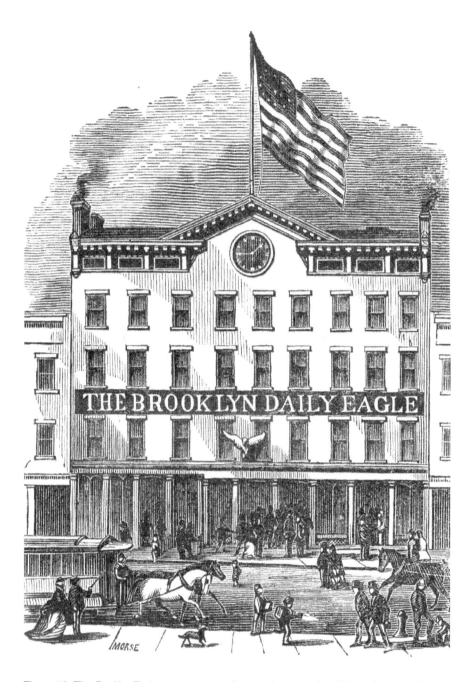

Figure 16. The *Brooklyn Eagle* newspaper was first headquartered on Fulton Street at Fulton Ferry, just east of Elizabeth Street. Parts of this original building are still visible within the current structure there. From *The Eagle and Brooklyn*, 1898.

the country, with a network of distribution offices throughout the enlarged city and the borough of Brooklyn and with correspondents in other American cities and in Paris, France, where it had an office for traveling Brooklynites to visit. It featured major columnists such as the conservative Hans Von Kaltenborn, who as a radio man was parodied by President Harry Truman after he incorrectly reported the president's defeat in 1948. Winston Burdett, another *Eagle* reporter, was a Russian spy in Helsinki during the Russo-Finnish War of 1938–39. He had become a Communist Party member in 1937 under the influence of party members in the *Eagle*'s Newspaper Guild local, the reporters' union. In 1940, he became a CBS (radio) correspondent working for Ed Murrow covering World War II. Strangely enough, he was not charged with espionage after he appeared before the Senate Internal Security Subcommittee in 1951 and confessed his sins. He later became the Vatican correspondent for CBS-TV. Quite a turnaround for a Communist!

Figure 17. In 1863, the senior staff of the *Brooklyn Eagle* included publisher Isaac Van Anden (seated, center, with full beard) and future editor Thomas Kinsella (seated at right). From *The Eagle and Brooklyn*, 1898.

The *Eagle* became the organ of the upper-class establishment and covered its doings in detail. But as the wealthy removed from Brooklyn, and with the rise of radio and television, the paper faded and died in 1955 after a newspaper strike, the same fate befalling several citywide papers in the 1960s. In 1996, a new *Brooklyn Eagle* was founded by current owner J. Dozier Hasty with the late Fred Halla as a downtown sheet specializing in covering legal and real estate news. Its offices were at 30 Henry Street but have moved to DUMBO with the demolition of its home base.

A significant magazine served the Heights and the other wealthy Protestant areas of Brooklyn. *Brooklyn Life* was initially published in 1890 in the Mercantile Library building at 199 Montague Street and later on Washington Street, Brooklyn's "Newspaper Alley," until 1931. It was an earlier version of local life magazines such as *New York*. It featured local news, marriages, social events, Rotary Club news and advertising from upscale merchants. It also shared news of who had bought cars. It later became *Brooklyn Life and Activities of Long Island Society* as its audience moved away. In a vain effort to save itself, it went from being a weekly to a bi-monthly in May 1931 and moved into the nearby *Eagle* building before expiring in September. Its run is available for inspection at the Brooklyn Collection in the Main Branch of the Brooklyn Public Library at Grand Army Plaza and in the library of the Brooklyn Historical Society.

A significant but short-lived magazine was the *Brooklynite*, published from 1926 until 1930, initially at 191 Joralemon Street and later at 1 DeKalb Avenue, with its production in Mineola, Long Island. It was modeled on the *New Yorker*, the *Smart Set* and *Vanity Fair*, with Art Deco cover graphics and featuring book reviews of modern literature such as the white Harlem Renaissance writer Carl van Vechten's *Nigger Heaven*, with reproductions of two of its drawings by Miguel Covarrubias. It also reviewed *The Blues*, a compendium of essays edited by W.C. Handy, as well as works by Sherwood Anderson, Thornton Wilder and Sinclair Lewis, and it had features on the critic and reporter H.L. Mencken and modern artists. It used the period term for dullard businessmen—"Babbit"—derived from Lewis's novel and sought a female audience by promoting the flapper, the modern young woman of the time who smoked and was sexually aggressive. It did also include traditional society pages and exhibited a conflicted attitude toward Jews. The decline of Brooklyn and the effects of the Great Depression were obvious in ads for apartment buildings in Manhattan and for local residential hotels like the Leverich Towers for readers who had to downsize.

There were numerous other newspapers in Brooklyn in the nineteenth and early twentieth centuries, and today there are community newspapers that issue local editions for the Heights. These include the *Brooklyn Paper* and the *Courier*, based in DUMBO after purchase by Rupert Murdoch's News Corporation.

Figure 18. The upper Fulton Street shopping district in 1886 from the *Robinson Atlas of Brooklyn*. Liebman(n)'s was north of the post office, which has expanded to cover the site. Across the street were Wechsler's, Loeser's and Hurd, Wait & Co. On the Heights side of Fulton were Hardenbergh's and Ovington's. Also shown are the Brooklyn Theater across Johnson Street from the post office, which burned with terrible loss of life in December 1876. At the upper left are a branch of the Brooklyn Savings Bank (chapter 11, figure 5) and John Wood Furniture. From *Robinson Atlas of Brooklyn*, 1886.

Figure 19. The Second Presbyterian Church, circa 1877 as first altered by Hardenbergh's with a storefront. *Brian Merlis Collection.*

RETAIL BUSINESSES

The area around the intersection of Clinton and Fulton Streets, south through Washington and Johnson Streets, was developed in the 1830s and '40s as a fine residential district. The major structures there were St. John's Episcopal Church on Washington Street and the Second Old School Presbyterian Church of 1834 on Clinton (chapter 7, figure 22) (see chapter 7 for its history), practically a dead-on match, down to the mini-chapel, for the Reformed Church on Joralemon Street between Court Street and Boerum Place of 1834 that served as the model for city hall (it was across from that structure).

The neighborhood became Brooklyn's department store district by the Civil War (figure 18). The conversion from residential to commercial was

gradual as Hardenbergh and King Carpets occupied the church site after it moved to Clinton and Remsen Streets. Figure 19 shows a small storefront added to the front of the former church. As the business expanded, a two-story and then a four-story building was constructed in front of the set-back church, which by the 1880s had obscured any remnant of it.

Numerous dry goods merchants operated in the Heights and across Fulton Street between Tillary and Johnson Streets. Jewish businessmen outcompeted old-stock Americans such as Hurd, Wait & Co. by offering better value and lower prices.

Of these, only one's descendant survives: S. Wechsler and Brother, operated by Samuel, Herman and Joseph Wechsler and Abraham Abraham (figure 20), who lived in Manhattan and later moved to 800 St. Marks Avenue in Brooklyn. The store was initially located at 192 Myrtle Avenue and was later at 257 and then 297 Fulton Streets between Johnson and Tillary Streets. Samuel and Herman lived nearby at 387 Bridge Street, and Joseph resided at 47 Smith Street. It evolved into Abraham & Straus (A&S) after it moved to lower Fulton Street in 1884 and is now a Macy's branch. A&S combined with other stores to form Federated Department Stores in 1929. Federated

Figure 20. Abraham Abraham, a founder and principal owner of Abraham & Straus. From *The Eagle and Brooklyn*, 1898.

principal Robert Blum, Abraham's grandson, lived in the Heights in the 1940s and '50s.

A well-known department store was Loeser's (pronounced Low-shers), begun in 1860 by German-Jewish emigrant Frederick Loeser (figure 21) and a partner at 277 Fulton Street, and in 1870 located at 289 Fulton Street at Tillary, as shown in the 1886 *Robinson Atlas of Brooklyn* (figure 18). Loeser's partners were Louis and Herman Liebmann as of 1872 and Gustav Loeser in 1875. Loeser's survived on lower Fulton Street until 1952. The Liebmanns opened their own store in partnership with John H. Owings (figure 22) nearby.

Another commercial establishment on the Heights side of Fulton Street was Ovington Brothers China and

Left: Figure 21. Frederick Loeser founded the department store that bore his name. It closed in 1952. From *The Eagle and Brooklyn*, 1898.

Below: Figure 22. This 1887 image of Liebmann Brothers and Owings indicates that it occupied the former quarters of Loeser's at Washington, Adams and Tillary Streets. The northern half of the federal building/post office now occupies the site. *Brian Merlis Collection*.

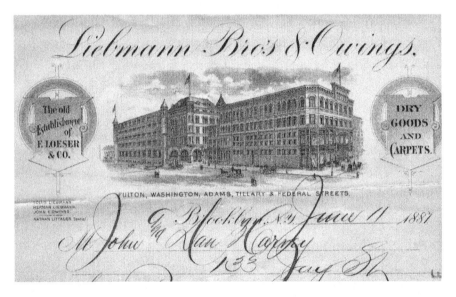

Glass, founded by Theodore (1829–1909) and Edward Ovington in 1843 on Fulton Street near the ferry. They moved to Fulton and Clark Streets in 1879, but this building burned down in 1884. The one in figure 23 was constructed for the company after the fire. After the department stores moved to lower Fulton Street, and following business reverses due to the Panic of 1893, the company relocated in 1895 to 58 Flatbush Avenue at Nevins Street and opened a branch in Manhattan at 314 Fifth Avenue. The company later closed the Brooklyn store. See chapter 7 for

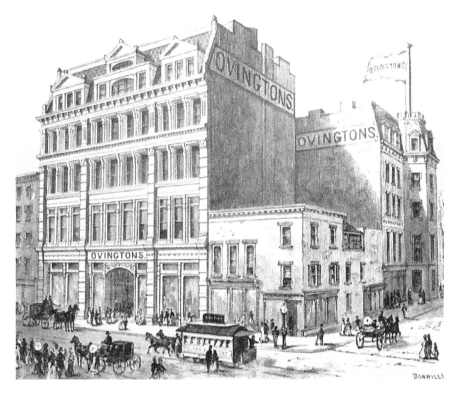

Figure 23. The Ovington Brothers China Company is shown here in its heyday circa 1890. It was on the southern corner of Fulton and Clark Streets. From *The Eagle and Brooklyn*, 1898.

the abolitionist and civil rights histories of Theodore and his daughter Mary White Ovington.

The Heights building later served many uses, especially as an artists' studio from the 1920s until it was demolished in 1964 by the Cadman Plaza urban renewal (see chapter 10). The Globe and Eagle Commercial Hotel was next door at the turn of the twentieth century. Many of these buildings became flophouse hotels and served other lower-end uses until condemned as part of the Cadman Plaza urban renewal. Much of the area is now Korean War Veterans Plaza, the park west of the post office/ federal building and east of the Brooklyn Heights Business Library.

The 1886 *Robinson Atlas of Brooklyn* shows that the Bell Telephone Company was headquartered on Fulton Street between Montague and Pierrepont Streets on a site that would later be the northern half of the Mechanics Bank Building.

An early enterprise was Dr. Charles H. Shepard's Turkish Baths on Cranberry Street at Columbia Heights, America's first, which flourished from 1867 until 1913.

Real estate companies are present in every area, especially in strong business zones, and the Heights has always had its share. Among these were Frank McCurdy Real Estate at 158 Remsen Street in 1931, which survived until fairly recently.

AMUSEMENTS AND THEATERS

One of the area's first amusement venues, the Colonnade Garden, opened on Columbia Heights opposite Middagh Street in 1840, when the area was still semi-rural. It was named for the neighboring colonnade row (see chapter 5, figure 1) and was an outdoor concert and dance hall, a popular type of venue at the time. There was a stage with footlights and curtains visible as one entered. The forum, which sloped halfway down to Furman Street, was enclosed. Fireworks, promenade concerts, cotillions and tightrope-walking exhibitions, along with vaudeville presentations, took place there.

Another early entertainment venue was Washington Garden on the west side of Fulton Street between Pineapple and Orange Streets, according to *Martin's Map of the City of Brooklyn, 1834* (chapter 4, figure 4). It burned down in the Great Brooklyn Fire of 1848.

Figure 13 in chapter 9 shows the south side of Remsen Street between Court and Clinton Streets in 1868, which was part of a theater district, mostly located across Fulton and Court Streets. One establishment there was Hooley's Opera House, built in 1863 on the southwest corner as a Negro minstrel theater. In 1876, Callender's Georgia Minstrels, the "Great Southern Slave Troupe," performed there (figure 24). Attitudes toward black people at that time, as indicated in the poster, make us wince today. What is shocking to me is that northerners could be nostalgic about slavery eleven years after fighting a war leading to its abolition.

The faux Tudor and German brauhaus Pierrepont Art Rooms housed the Mills-Platt Company, architects and interior designers in the 1890s, on the west side of Clinton Street at number 44, between Pierrepont and Fulton Streets. The whole block was demolished by the Cadman Plaza urban renewal. This building was replaced by an apartment house.

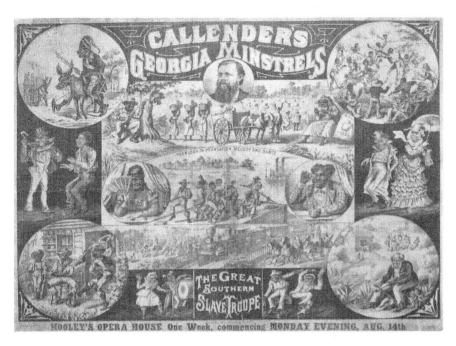

Figure 24. An incredibly racist advertising poster for Callender's Georgia Minstrels, the "Great Southern Slave Troupe," at Hooley's in 1876. This was, unfortunately, typical of its time. *Brian Merlis Collection.*

Hooley's became the Court Square Theatre in 1879. A rumor got around that a performance featured a naked woman, so all the Poly Prep boys went running there, only to find a chubby woman in a skintight costume. Later, the theater became Bunnell's Dime Museum before being demolished for the Dime Savings Bank (chapter 9, figure 6) in the 1880s. Other area entertainment venues were the Borough Hall Theater (1923) across Court Street, at number 21, and Herd's Concert Hall, later Herd's Lager Beer & Billiard Saloon, next to Hooley's. The Brooklyn Opera House was a theater on Fulton Street between Pineapple and Orange Streets when any joint could be called an opera house. There was a legitimate theater called the Heights Playhouse on Pineapple Street between Clinton and Fulton Streets that became a movie theater later in the 1920s and '30s.

RESTAURANTS

The pictures in this section show businesses from the eastern end of Pierrepont Street up through Fulton and Clark Streets. Among them were numerous restaurants and caterers. The predominant types were oyster bars and chophouses. Desor's was a hotel, restaurant and ice cream parlor on Cranberry Street in 1866. Dominick Colgan opened an oyster bar at 196 Fulton Street in 1841 and served pickled, stewed and fried oysters along with "spirits" (whisky), wine, beer and ale. J. Fussell's began in 1870 at 284 Fulton Street and was succeeded by Thomas Denham. The company was a caterer that sold pickled oysters and charlotte russes (a cream confection popular through the 1960s). It was the custom to visit friends on New Year's Day, and Denham advertised his pickled oysters as the thing to serve. By 1900, chophouses were on their way out as cuisine grew more varied and exotic.

Another chophouse was Thomas H. McDermott's at 139 Atlantic Avenue at Hicks Street, starting in 1863, which survived into the twentieth century. Unusual dishes served in chophouses included jellied lamb tongue and deviled crab. "Chophouse" today is an obsolescent term for any sort of lower-end restaurant.

Figure 25. The fondly remembered Joe's Restaurant was a shore dinner and steakhouse restaurant—a type now unknown, loved for its plethora of dishes. It occupied the southwest corner of Pierrepont and Fulton Streets and was demolished by the urban renewal. To the left is the Mechanics Bank Building, to the right a liquor store and behind it and partially obscured is the Real Estate Building, the only extant structure in this 1958 photo. *Brian Merlis Collection.*

Figure 26. The interior of Joe's is shown here in 1949. It was likely little changed from its early-century opening and was deemed hopelessly old-fashioned by a generation high on modernist design. Bentwood chairs, tile walls and tin ceilings remind us of modern re-creations of period restaurants. Apparently government officials thought little about closing down going businesses in the name of progress. There were other restaurants in Brooklyn called Joe's, including one on Nevins Street and Flatbush Avenue that was part of a chain. It was a business lost to the widening of Fulton Street. *Brian Merlis Collection.*

Joe's was a popular better chophouse still remembered today (figures 25 and 26). It was located in a two-story building on the southwest corner of Fulton and Pierrepont Streets demolished by the urban renewal.

Unusual restaurants developed in the late 1800s. Vegetarian restaurants were popular, and a new type of "industrial restaurant" sold food compressed into small balls, sort of like the food pills we imagine and the nutritional drinks we see today. While the industrial restaurant did not catch on, chophouses were ubiquitous. Gage & Tollner's on lower Fulton Street was a chop and oyster house in 1902. Tom Ivory had one at Orange and Fulton Streets in 1852, and there was also an Eagle House at the corner of Cranberry Street in 1827.

The Childs restaurant chain, founded in 1889, was the first sanitary cafeteria chain and grew to about 125 locations in the New York area by the 1930s. There was one in the Garfield Building at Court and Remsen Streets

until its host was demolished for 26 Court Street. The chain evolved into hotel and fast-food operations.

Chinese restaurants, initially known as "chop suey houses" (in their Chinese-American incarnation), made their appearance around 1900. There was one on the north side of Montague Street between Court and Clinton Streets in the 1920s. Italian restaurants such as Celona's on Clinton and Pierrepont Streets also began to appear in the 1920s.

Montague Street's first restaurant, Toynbee's, a saloon near the southwest corner of Court Street, opened in 1854. Its owner, Thomas Toynbee, brought a lawsuit to invalidate a prohibition law authorizing the seizure of alcohol owned by saloonkeepers. The case went all the way to the state's highest court, the Court of Appeals, which agreed with lower courts that the law was unconstitutional.

Figure 27. Blume's, shown in 1915, at 294 Fulton Street near Clark Street was a junk store, a common type during New York's poor period, with the Fulton Street el. *Brian Merlis Collection.*

Neighborhood Retail

Every neighborhood needs normal consumer service businesses, known as mom and pop stores, and the Heights had many to meet the needs of its wealthy and middle-class clientele. Of course, there were many commonplace businesses in the area also, such as a stable on Fulton Street near Fulton Ferry. Blume's (figure 27) was a junkshop, a type common in New York during its extended depression.

The Montague Street Business Improvement District (BID) was organized in 1998 to support commercial development. Businesses, property owners, civic organizations and elected officials are members. It is headquartered at 57 Montague Street. BIDs are city programs under which businesses within certain districts are assessed taxes to support related activities.

HIGH-RISES AND DECLINE

The Coming of Subways, Cars, Trucks and Modernism: 1875–1935

An editorial writer for the *Wall Street Journal* wrote in the 1920s, "For the apex of the society of the Heights, which was genuine enough, you have to go back to the time before the motor car appeared and the servant girl disappeared." This was quoted in William Everdell and Malcolm MacKay's 1973 book, *Rowboats to Rapid Transit: A History of Brooklyn Heights*.

They added that high-rise apartment houses didn't help either. Figure 1, 33 Willow Street, is an early apartment building. Apartment buildings changed the character of the neighborhood both physically and economically by replacing the fleeing wealthy with middle-class people. At the same time, townhouses went out of fashion, so a strange phenomenon took place: what had been exclusive became undesirable, and the new multiple-dwellings became what was desired—in part because they were "modern."

THE GREAT BRIDGE: HENRY PIERREPONT AND MAYOR SETH LOW

We do not discuss the Brooklyn Bridge in detail here because it has been extensively reported elsewhere and because it is not in the Heights. The principal connections to the neighborhood are that its construction was observed and supervised by Washington and Emily Roebling from their house at 110 Columbia Heights (figure 2) and that the opening celebrations were held at the Brooklyn Academy of Music on Montague Street (see chapter 6).

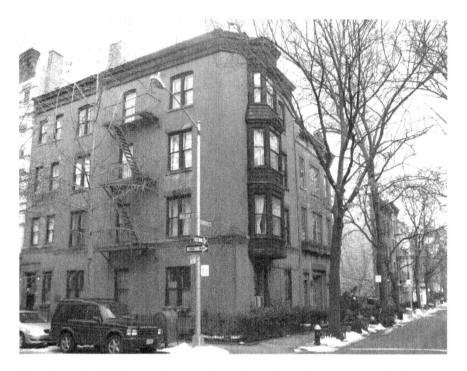

Figure 1. No. 33 (–37) Willow Street carries a plaque identifying it as one of the first apartment buildings in the city. It was built in 1886 to a design by A.F. Norris. *Robert Furman photograph.*

It is worth noting that the German immigrant Johann (John) Roebling loved America so much that he named his son for our first president.

The opening of the Brooklyn Bridge was not only the death knell for the steam ferries that served Brooklyn, but it also began the decline of the Heights since it pushed development farther out into Brooklyn, especially to the newer neighborhoods of Park Slope, Prospect Heights and Bedford-Stuyvesant. According to the 1890 U.S. census, seven years after the bridge opened, Park Slope had become the wealthiest neighborhood not only in Brooklyn but in all of America!

In the 1880s, a system of elevated steam and then electric trains assisted this process by providing public transportation to these areas. The new els and streetcars connected to trains that shuttled over the bridge from the Sands Street Station on Adams Street near the Heights. In addition, the bridge moved the department store district to lower Fulton Street from the vicinity of Fulton and Clark Streets (see chapter 8), since that area was now more conveniently located.

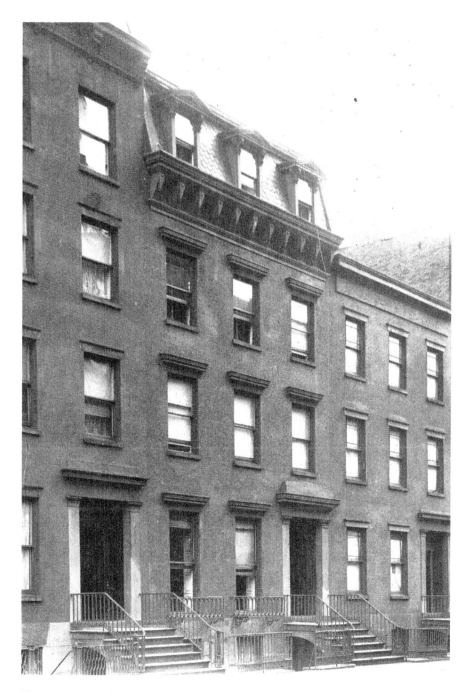

Figure 2. No. 110 Columbia Heights, *center*, from which the Roeblings supervised the construction of the Brooklyn Bridge. The most historically important house in the Heights was razed for BQE construction. *Brian Merlis Collection.*

In 1883, Henry Pierrepont sought to delay the opening of the bridge since he recognized that his fortune and position were at risk. He was successfully resisted, however, by Republican reform Brooklyn mayor Seth Low (chapter 4, figure 29). Strangely enough, as one of Brooklyn's most prominent citizens, Pierrepont was a director of the New York and Brooklyn Bridge Corporation. He had gone so far as to enlarge and modernize the Fulton Ferry Terminal in the 1860s while the bridge was under development.

An associate of Mayor Low's was Darwin R. James, grandfather-in-law of Underwood Typewriter heiress Gladys Darwin James. She advocated for the construction of the Brooklyn Heights Promenade in the 1940s and endowed local preservation and neighborhood stabilization efforts. Darwin James helped organize the Brooklyn Bureau of Charities, the Association for Improving the Condition of the Poor and the Brooklyn Industrial School Association, and he served as secretary of the New York Board of Trade and Transportation.

James was also an active Republican and served two terms in Congress. His major achievement in the House was blocking the passage of a bill to allow the unlimited coinage of silver (free silver), a Democratic Party measure supported by silver-mining western states, intended to allow economic expansion and inflation by increasing the money supply at a time when it was limited by the amount of gold available (the gold standard). Today, the issue is little remembered except for occasional calls for its restoration from the far right and William Jennings Bryan's "Cross of Gold" speech, in which he advocated for "free silver" as the losing Democratic presidential candidate in 1896, 1900 and 1908.

A historically significant but underappreciated local resident of a totally different stripe was Lucy Burns of 39 Pierrepont Street, who, with Alice Neal, led the successful effort to pass the women's suffrage constitutional amendment, which took effect for the 1920 general election. Born in 1879 to Irish Catholic parents who favored educating women, she attended Packer, graduated from Vassar College and took graduate courses at Yale and in Europe. In London, she got involved in the ongoing suffrage struggle, joining demonstrations and getting arrested. At a London police station, she met Alice Neal, and the two went on to lead the militant wing of the American suffrage struggle.

In 1912, she returned to America and joined the National American Woman Suffrage Association (NAWSA) (see chapter 7 for its earlier history), and the two led its Congressional Union, calling for the defeat of whatever

party was in power to hold them responsible for inaction. This militant position led the Union to separate from NAWSA in 1914 in spite of the election of Carrie Chapman Catt as president in 1915. They formed the National Women's Party to lobby and agitate for a constitutional amendment. They picketed the White House after President Woodrow Wilson vacillated on the issue and were arrested as they continued picketing after the United States declared war in April 1917. Their efforts were seen as unpatriotic attacks on national defense, leading to more severe treatment for what would today be constitutionally protected as a First Amendment right to petition for a redress of grievances. They were sent to the Occoquan Workhouse and, during a "Night of Terror," were beaten and force-fed after engaging in hunger strikes.

The resulting public outcry led the Wilson administration to introduce the Susan B. Anthony women's suffrage constitutional amendment. (This is why she is most identified with the effort although she died in 1906.) It was passed by both houses of Congress in 1918 and was ratified by a sufficient number of states to become effective in 1920. Burns had lived in Washington during the struggle but afterward returned to the Heights and lived quietly with her family until her death in 1966.

THE EVOLUTION OF THE COURT-FULTON-MONTAGUE STREET AREA

The corner of Montague and Court Streets has been the center of the Borough Hall area since the beginning of its development in the 1840s. Over the years, the buildings on Court Street have become larger and higher. The first ones were of the scale and design of contemporary residential buildings (figures 3 and 4)—i.e., four stories, which was the maximum height for walk-ups at the time. As elevators and then steel-frame construction came into use, they grew taller.

Among these earlier structures were the first Mechanics Bank Building on the northwest corner (figure 3) and the initial Brooklyn Trust Company on the northeast corner of Montague and Clinton Streets. Later high-rise office buildings made possible by elevators included the Continental Insurance Company Building on the southwest corner of Montague and Court Streets and the Phoenix Insurance Company Building next door at 12 Court Street. They were demolished in the 1920s for 16 Court Street. The Garfield Building (which dates from the early 1880s) on the northwest

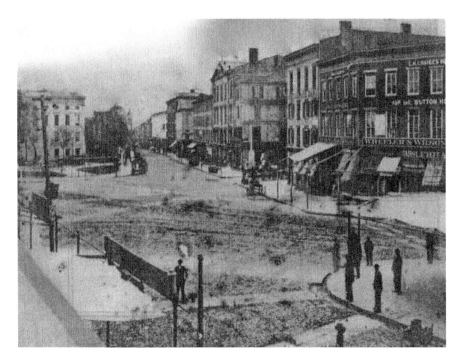

Figure 3. Here we look south along Court Street from Pierrepont Sreet in 1860. City hall is at left, and we see the Fulton, Montague, Washington and Pierrepont Street area, which was already a downtown but a far cry from what it later became. Note the cobblestone street with concrete walkways. The building with the flag is Montague Hall, on Court Street between Montague and Remsen Streets. To its right across Montague is the Mechanics Bank. *Brian Merlis Collection.*

corner of Court and Remsen Streets went down in the 1920s for 26 Court Street (figure 5). The heights of the Continental, Phoenix and Garfield were limited by the use of cast iron for framing.

Numbers 16 and 26 changed hands in the 2000s and were modernized by the new owners. They are now inhabited by lawyers, politicians, unions and those who lobby and serve them. Among the attorneys with offices at 26 Court Street was Fabian Palomino, who served as former governor Mario Cuomo's senior adviser during his tenure.

In 2011, the City University of New York rented a large space in 16 Court Street for administrative use, indicating that major tenants find this older building attractive. When they were new, these structures were part of the "Wall Street of Brooklyn" and housed insurance companies and brokers and related businesses (see chapter 8). The Democratic Party of Kings County maintains offices there.

Top: Figure 4. Here we look west along Remsen Street from in front of city hall on a particularly cold day in 1870. The structures on Court Street are typical walk-up office buildings of the time. *Brian Merlis Collection.*

Bottom: Figure 5. A stately parade of 1920s high-rise office towers marches down Court Street from Montague Street, many of which are among the finest specimens of their type. From the right, they are 16, 26 and 32 Court Street. They are included in the Borough Hall Skyscraper Historic District. In the foreground is Columbus Park with its signature statue of the great explorer whose memory is honored by Italian Americans. This is a 1968 photo, but everything remains as shown. *Brian Merlis Collection.*

Figure 6. The surviving Temple Bar Building at Court and Joralemon Streets in 1904 with the Dime Savings Bank at right. The Temple Bar has the greatest mansard roof in Brooklyn. A horse and a trolley with its tracks are visible in the street, as is a corner of Borough Hall on the right. *Brian Merlis Collection.*

The home office of the Dime Savings Bank of Brooklyn was in an 1883 Egyptian-style building on the southwest corner of Remsen and Court Streets until its small scale doomed it (figure 6). In 1916, the bank moved to a Neoclassical structure on DeKalb Avenue and Fulton Street, and its former home was replaced by 32 Court Street, the U.S. Title Guarantee Company Building, completed in 1918 (figure 5). It had considered erecting its own office building on the site.

To the immediate south of the Dime Savings Bank was a four-story 1860s office building called the Hamilton Building, which was the initial home of the Brooklyn

Figure 7. No. 66 Court Street is what we call Gothic Deco and is one of the city's great buildings, shown here circa 1955. It is part of the Borough Hall Skyscraper Historic District. *Brian Merlis Collection.*

Historical Society. It was replaced in 1901 by the Temple Bar Building at 44 Court Street, the first steel-beam high-rise in Brooklyn (figure 6).

Other 1920s vintage office towers include 66 Court Street (figure 7), the 1927 Deco Gothic Brooklyn Chamber of Commerce Building, perhaps the greatest unknown building in the city. It was converted into a residential co-op in 1978, indicating the relative strength of that market for old high-rises over commercial use at that time. The entrance was moved around the corner to more residential 75 Livingston Street. Its inclusion in the Borough Hall Skyscraper Historic District was opposed by the cooperators.

HIGH-RISE MONTAGUE STREET

Originally a residential street when development began in the 1840s, in the 1890s Montague Street began to be converted for retail and commercial uses, with many of the old houses having storefronts added. High-rises also began to go up at this time (see later section titled "The Evolution of Montague Street").

The first skyscraper in Brooklyn was the ten-story Franklin Trust Company (chapter 8, figure 9) building that went up in 1891 and still stands at 166 Montague Street. It was converted into housing in 2010 and is a Renaissance Revival masterpiece by George L. Morse.

On the southeast corner of Montague and Clinton Streets first stood a Second Empire–style federal courthouse for the Eastern District of New York (chapter 6, figure 12), which was raised from four to six stories and reclad in the Beaux Arts style in the 1890s for the Brooklyn City Rail Road Company (figure 8). The company operated most of the streetcars in Brooklyn (see chapter 4). This structure was later reduced to a couple floors, a common practice during the Heights' extended depression. As the local real estate market grew strong in the 1980s, its height was gradually increased until it was replaced by a nine-story apartment building in 2011.

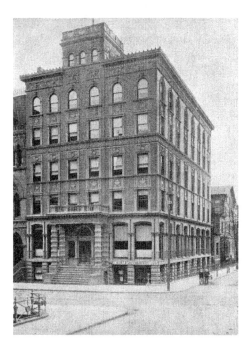

Figure 8. The Brooklyn City Rail Road Company operated most of the elevated and trolley lines in the borough by 1897, when its lovely Beaux Arts headquarters on the southeast corner of Montague and Clinton Streets was photographed. The Brooklyn Art Association is to the left. *Brian Merlis Collection.*

The Lawyers Title Insurance Company Building stands at 188 Montague Street, across from 189 Montague Street, the 1891 Brooklyn Real Estate Exchange (figures 9 and 10), which goes through the street to 148 Pierrepont Street. It originally matched the façade of 189 Montague Street, but the lower two floors have been

Right: Figure 9. The Beaux Arts Brooklyn Real Estate Exchange at 189 Montague Street, built in the 1890s, had a matching façade on Pierrepont Street that, although altered, survives. This façade on Montague Street was erased in a modernization. From *The Eagle and Brooklyn*, 1898.

Below: Figure 10. Montague Street looking east to Fulton Street from Clinton Street in 1920. On the left are a tailor and real estate office, the Real Estate Exchange, the Mercantile Library and the Mechanics Bank Building. On the right are the former Art Association building occupied by the Home Insurance Company and Aetna Insurance. *Brian Merlis Collection.*

modernized. It had housed the Long Island College Hospital Women's Health Center but, as of March 2015, is scheduled for demolition and/or conversion into a hotel.

In 1930, the Art Deco National Title Guaranty Building (chapter 8, figure 14) by Corbett, Harrison & MacMurray was erected (it was later the Bank of the Manhattan Building and the Chase Building). This is probably the surviving masterpiece office building on Montague Street and one of the great Art Deco buildings in the city.

The great one that did not survive was the Mechanics Bank Building of 1905 and 1907 (see chapter 8) (figure 11), which replaced the pedestrian townhouse-type headquarters the bank had previously occupied on its

Figure 11. The second Mechanics Bank Building went up in 1905, with the curved section at right added in 1907. Given that it was included in demolition plans dating from the 1930s, we must conclude that it was condemned simply because it predated 1920, i.e., it was not "modern." A sliver of the Continental Insurance Building is at left, and the New York Title Insurance Company is on Montague Street next door to the Mechanics Bank. *Brian Merlis Collection.*

northwest corner of Fulton and Montague Streets. It took advantage of the curve of Fulton Street to display a lovely profile to the world. Although it was ten stories tall, it was included in the Cadman Plaza urban renewal in the 1930s because it was of pre-modern design, in spite of the Dodgers' locating their front office there in 1938 and due to the weakness of the commercial real estate market in the 1940s. It also blocked the widening of Cadman Plaza West. It was Venetian Gothic on the lower floors and Beaux Arts on the top two, a combination that was surprisingly effective aesthetically.

The block between Fulton (Cadman Plaza West), Montague, Pierrepont and Clinton Streets has been part of the central business district since its earliest days. The first buildings there were four stories, the same scale as contemporary residences.

Commercial Pierrepont Street

Pierrepont Street between Cadman Plaza West (Fulton Street) and Clinton Street has been altered more often than any other block in the Heights. Its commercial character spread west from Fulton Street and later from neighboring Montague Street, which became the civic and business capital of Brooklyn.

The eastern block and a quarter of Pierrepont Street has been commercial since at least the 1870s, when low-rise buildings often housed stores. The Long Island Historical Society opened at the corner of Clinton Street in 1883 (chapter 6, figure 8), joined by the Brooklyn Savings Bank (chapter 8, figure 10), the Brooklyn Club (chapter 6, figure 54) in the nineties, later by the Crescent/Century Club in 1905 (chapter 6, figure 17) and the Brooklyn Trust Company (at least its rear) in 1915 (figure 12), which were larger-scale institutional structures. At the same time, small stores continued to do business on the block between Fulton and Clinton Streets until they were pushed out by both large-scale commercial development and later the Cadman Plaza urban renewal.

A popular type of New York restaurant in the mid- to late nineteenth century was the oyster bar, since the mollusks were native and plentiful. Former *New York Times* food critic William Grimes, in his *Appetite City*, estimated that there were one hundred such places in Brooklyn. One we know of in the Heights was George Werner's Oyster House at 159 Pierrepont Street in the 1870s. In the 1850s, Scottish journalist George Mackay reported that when he visited New York, he sampled "oysters pickled, stewed, baked, roasted,

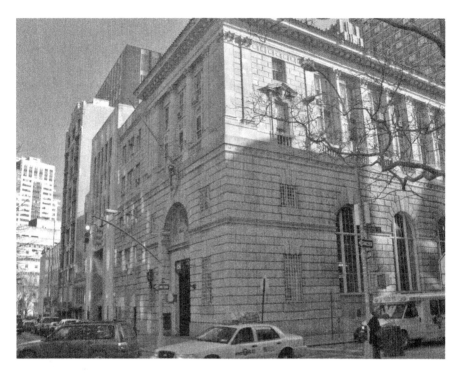

Figure 12. The south side of Pierrepont Street today between Cadman Plaza West and Clinton Street shows buildings that mostly display their backs, including the Brooklyn Trust Company and People's Trust Company bank buildings, but also a few office buildings such as the rear of the Real Estate Exchange building. The upper floors, formerly the offices of real estate law firm Cullen and Dykman, are being converted for residential use. *Robert Furman photograph.*

fried and scalloped; oysters made into soups, patties, and puddings; oysters with condiments and without condiments; oysters for breakfast, dinner, and supper; oysters without stint or limit—fresh as the fresh air, and almost as abundant." The trade ended in the 1920s due to harbor pollution.

Chophouses, an English import, were also popular in Brooklyn in the 1870s, which boasted a dozen such steak houses, many of long standing. They usually had a tiny bar up front featuring beers and ales, mahogany tables in the rear and a large selection of British newspapers.

The finest, circa 1875, was Barney McElroy and John C. Force's Turnover Club on Pierrepont Street. An English immigrant, Force was the celebrity restaurateur of his age. He was also a lover of British culture, especially Shakespeare, and hung a copy of J.M.W. Turner's *Fighting Temeraire* on the wall.

Today there is an abrupt shift from large buildings to townhouses as you proceed west along Pierrepont Street from Cadman Plaza West, past Clinton Street, the Brooklyn Historical Society and St. Ann's School. This stretch is broken only by the occasional older high-rise apartment building. Of course, absent the historic district, large-scale buildings would probably have continued their otherwise inexorable march down the street, as has occurred on Remsen Street between Court and Clinton Streets, which is mostly not in any historic district.

Commercial Remsen Street

Remsen Street, initially residential, began to become commercial in 1857 with the construction of the Greek Revival headquarters of the Brooklyn Gas Light Company (figure 13 and chapter 11, figure 19) at 184 Remsen Street. In 1860 came Hooley's Opera House (figure 13), a burlesque theater that occupied the southwest corner of Court Street.

In 1915, the Brooklyn Union Gas Company, the Gas Light Company's successor, added a splendid Greek Revival structure at 176–80 Remsen Street (chapter 11, figure 19). Francis Morrone describes this building by Frank Freeman as being in classical mode and as an attractive, yet simple, eight-story structure in tripartite composition with a wide granite base, in

Figure 13. The south side of Remsen Street between Court and Clinton Streets in 1868. No. 180, the Greek Revival building in the center with the pediment, was the headquarters of the Brooklyn Union Gas Company. It survived until 2004, when it was demolished for a classroom building for St. Francis College. A theater, known as "Hooley's Opera House," is at left. At the time, "opera house" was used to describe any theater, regardless of its interest in high culture. The western part of the block was mostly fashionable and residential. *Brian Merlis Collection.*

347

the center of which is a projecting portico with two Roman Doric columns. Above is a row of six Ionic columns that balance the top and bottom. It has Italianate features such as Tuscan arched windows. Both of these became part of St. Francis College in the 1960s when the gas company moved to 185 Montague Street (see chapter 11). The 1915 structure survives, but the 1857 one does not.

On the south side of the street is 186 Remsen Street (chapter 11, figure 18), which has had many principal tenants over the years. This 1887 Romanesque beauty by the Parfitt Brothers was built by A.A. Low and Company (see chapter 4). It originally rose to eight floors but was cut down to seven around 1950. It is included in the Borough Hall Skyscraper Historic District, although the owner seeks to alter or demolish it.

THE EVOLUTION OF MONTAGUE STREET

Montague Street evolved in several stages since its development began in the 1840s with the construction of the Episcopal Church of the Holy Trinity (chapter 6, figure 28). The block between Court Street/Cadman Plaza West and Clinton Street has been most altered over the years since it has always been commercial. Initially residential (figures 15 and 16) with several mansions from Henry Street west, the street was occupied mostly by townhouses and was semi-rural at its western end, with few buildings on the north side of the street on the block between Hicks Street and Pierrepont Place until after the turn of the twentieth century.

The Dripps 1867 street map (chapter 8, figure 3) indicates that the north side of the street between Hicks Street and Pierrepont Place had only two houses on it, one of them a farmhouse. The rest of the land was occupied by the backyards of the houses on Pierrepont Street and the Misses Whites' Garden. A modern remnant of this is the shared backyard of 36 Pierrepont and the Casino Mansions Apartments at Montague and Hicks Streets. By the beginning of the twentieth century, this location was becoming urban, as the land was sold off, mostly for apartment house development. The following series of pictures captures the evolution of Montague Street. Figure 14 shows its initial commercial development between Clinton and Court (Fulton) Streets. See chapter 6 for some of the specific buildings.

When it was residential, Montague Street housed the Beattys, Bensons, Moores, Hutchinsons, Raynors, Devlins and Booths. Dr. S. Fleet Spier had a

sanitarium at 162 Montague, and a Dr. Cullen lived on the corner. (Numbers begin at 57 on the north side and 62 on the south because the street once went down to the river. There was a townhouse at 58 Montague.)

Benjamin Franklin Tracy, secretary of the navy from 1889 to 1893 and a Medal of Honor winner as a brigadier general at the Civil War Battle of the Wilderness, lived at 148 Montague, and his house was later remodeled as a tailor's shop. He had previously been the U.S. attorney for the Eastern District of New York (Brooklyn, Queens, Nassau and Suffolk Counties) and a major power in Republican politics. Another area resident was R.M. Hooley of the eponymous theater on Remsen Street. Clearly, many existing buildings in the historic district were degraded before it was established, as the area transitioned from residential to retail uses.

A practice of the time was for American heiresses to marry relatively poor European nobility, of whom the best-known example is Jennie Jerome of Cobble Hill and later Manhattan, who married the Duke of Marlborough's second son, Randolph Churchill, and became the mother of Winston. Two young women who lived on Montague Street who became countesses are good examples; Kate Parks became Madame de

Figure 14. Here we look west on Montague Street from just west of the corner of Court/ Fulton Street in 1915. We see, at right, on the north side of the street, the Mercantile Library, the Real Estate Exchange and the People's Trust Company. At left are the edge of the Continental Insurance building and the Title Insurance Trust Company. *Brian Merlis Collection.*

Figure 15. Nos. 107 and 109 Montague Street in 1915 contained two storefronts. The one on the left was for rent and had housed a grocer, and the other was a dry cleaner and tailor. These beautiful façades, once of residences, have been reduced to plain white walls. *Brian Merlis Collection.*

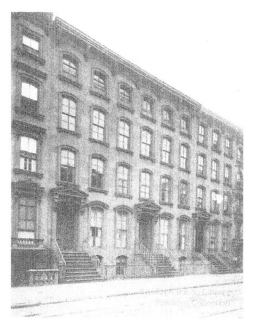

Figure 16. From right, nos. 140, 138 and 136 Montague Street in 1903. At the time this photograph was made, this was a normal Italianate townhouse row because Montague Street between Clinton and Henry Streets was still mostly residential. The Brooklyn Heights Seminary, a private school, occupied 138 and 140. Today this stretch on the south side of the street is commercial. All three houses have had ground-floor storefronts added. No. 140, *at left*, has also had a first-floor bay window added. The cornices above the entries have been removed on 138 and 140. No. 136, *at right*, is the best preserved of the three. *Brian Merlis Collection.*

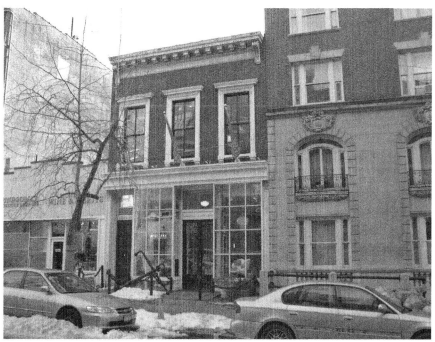

Figure 17. The anachronistic 76 Montague Street. A lone mid-nineteenth-century largely unaltered survivor. The fate of the anchor is undecided. *Robert Furman photograph.*

Moussilye and lived in a villa on the Seine, and Marianne Tardy married an aristocrat and lived in Italy.

The Dickinson house, built opposite today's Hotel Bossert on Montague and Hicks Streets in 1854, has a fascinating commercial history. The storefront was originally a grocery and later a pharmacy. Upstairs was a school conducted by Cummings & Taylor.

But the great part was downstairs. Thomas Dilverd, a black dwarf, operated an oyster house in the cellar in the late 1800s. He had worked as a waiter for a wealthy local family and later joined Christy's Minstrels, a blackface musical group, in which he appeared as Japanese Tommy and also impersonated the great Swedish soprano Jenny Lind. New Yorkers knew Lind from her engagement at Castle Garden at the Battery, sponsored by P.T. Barnum.

Other old-time restaurants on Montague Street included George Schmitt's Chop House in 1894, a Chinese restaurant at number 190 in the 1920s; Foffe's, whose exterior plaque survives; and Patricia Murphy's Candlelight Restaurant, an elegant American restaurant in the style of Gage & Tollner's, that also had a branch in Westchester County into the 1960s.

An interesting survivor is the low-rise mid-nineteenth-century commercial building at 76 Montague Street (figure 17). It is an amazing anachronism, although the anchor is scheduled for removal.

CARS, SUBWAYS AND APARTMENT HOUSES

After the turn of the century, cars became the playthings of the rich, and townhouses had no space for garages or driveways. By 1910, horseless carriages were all the rage, and Henry Ford's Model-T promised freedom to the masses. Rich people began to abandon the older townhouse neighborhoods for suburban districts such as Victorian Flatbush (which has driveways), Garden City in Nassau County and Manhattan's Park and Fifth Avenues and Sutton Place.

The opening of the first subway line to Brooklyn in 1908 by the Interborough Rapid Transit Company (IRT), now the Lexington Avenue line (the local station is at Borough Hall), ended the Heights' physical isolation and thereby its exclusivity, causing many wealthy people to leave. Thus, as far as the wealthy were concerned, one of the prime engines of Brooklyn's growth possessed the downside of bringing in too many middle-class people.

Figure 18. The Eighth Avenue Subway Line (A and C trains), formerly part of the city-operated Independent Line, was constructed in the 1920s and 1930s. It runs deep under Cranberry Street on its way to a tunnel under the East River. Crews and a steam shovel building it are shown in this 1928 photo. *Brian Merlis Collection.*

Figure 19. A still-existing "Fulton Street" sign in the High Street subway station of the A and C lines. *Robert Furman photograph.*

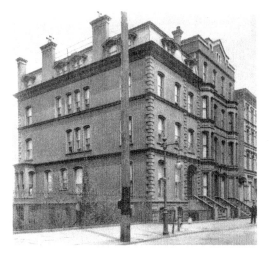

Figure 20. Nos. 152, 150 and 148 Columbia Heights are shown here in 1914. Nos. 150 and 148 still exist. No. 152, at left, torn down for subway construction, was a splendid Italianate mansion. Its site is part of the vacant land that once was Fort Stirling Park. Its quoins (projecting decorative end blocks) were particularly noticeable and attractive. *Brian Merlis Collection.*

There are three stations in the Heights itself. The first was the Court Street–Borough Hall station of the Broadway Line (R train) of the Brooklyn Rapid Transit Company (BRT) (later Brooklyn-Manhattan Transit Corporation or BMT) on Montague Street between Court and Clinton Streets (see chapter 4). There followed the Clark Street station of the Seventh Avenue Line (IRT) in the basement of the St. George Hotel (2 and 3 trains), constructed in 1922 under community pressure; and the High Street station of the Eighth Avenue Line (A and C trains) (IND) at Cadman Plaza West and Cranberry Street, vintage 1928, with its eastern entry on Adams Street near Concord Village.

The IND (Independent) was the original city-operated line. Local construction is shown in figure 18. The old IRT and BMT lines were run by private companies regulated by the city, which owned the system. The High Street station contains the last visible indication of the fact that it was at Fulton Street; several original tile signs say this rather than "Cadman Plaza West" (figure 19). A lovely house at 152 Columbia Heights was demolished around 1915 for Seventh Avenue IRT line construction (nos. 2 and 3 trains) (figure 20).

The proposal for a promenade never died. In 1903, a realtor and an architect—noting that the only place where the average person could experience the wonderful view of Manhattan and the bay was from the Montague Street ramp and the viewing area around it—proposed a promenade called Harbor View Esplanade or Terrace Park, labeled Beecher Park on the developers' map, which was to run from Joralemon to Middagh Streets. It didn't get built, however.

Although the Manhattan Bridge of 1909 carries subway trains, it was the first bridge built to be automobile-friendly and required the creation of Flatbush Avenue Extension to connect Flatbush Avenue proper at its beginning at Fulton Street (current street signs still say this) to the new bridge. The extension facilitated the flow of traffic between the boroughs and farther out into Brooklyn, pushing development south into Flatbush. An earlier proposed version of the extension would have connected Flatbush Avenue to the Brooklyn Bridge.

HIGH-RISE APARTMENT BUILDINGS

In the late 1880s, high-rise apartment buildings began to go up on Montague Street and elsewhere in the Heights, including the matching Queen Anne–style Grosvenor and Berkeley (figure 21) of 1886 at 115 and 111 by the Parfitt Brothers and the 1887 Arlington at 62 Montague Street (figure 23) designed by Montrose Morris, the first building on the south side of the street

Figure 21. The Grosvenor and Berkeley apartments at 111 and 115 Montague Street, in this modern shot, date from 1886. They are Queen Anne–style buildings by Parfitt Brothers. *Robert Furman photograph.*

Right: Figure 22. No. 2 Montague Terrace replaced the Seney-Litchfield Mansion. *Robert Furman photograph*.

Below: Figure 23. No. 62 Montague Street, when new, featured a glass awning. It was called the Harbor View Apartments. *Brian Merlis Collection*.

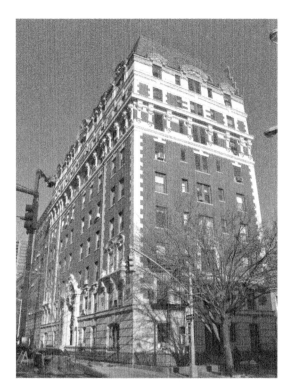

Left: Figure 24. No. 95 Pierrepont Street today. *Robert Furman photograph.*

Below: Figure 25. No. 60 Pineapple Street is an unknown but brilliant Beaux Arts apartment building. *Robert Furman photograph.*

east of Montague Terrace. There were apartment buildings before, but they were on the scale of their townhouse neighbors (figure 1). Others included 2 Montague Terrace (figure 22), which replaced the Seney Mansion; 95 Pierrepont Street (figure 24); and 60 Pineapple Street (figure 25).

By the early twentieth century, high-rises had become the preferred housing for middle-class arrivistes, while the wealthy began to abandon brownstone Brooklyn for wealthy districts in Manhattan, southern Brooklyn and suburban areas. Like their compatriot office buildings, apartment buildings gave the neighborhood a temporary lift but undermined the position of the townhouses they began to replace, leading to overall deterioration.

DECLINE

By 1910, it became clear that the neighborhood was in decline, and reactions varied. Some wished to take advantage of it, while others sought to reverse the tide. The *New York Times* reported in three articles published from January through April 1910 that the commercial growth of Montague Street into the "Wall Street of Brooklyn," the construction of hotels like the Bossert, new office buildings and high-rise apartments, the development of southern Brooklyn and Eastern Parkway and the subway system were causing the area to deteriorate. On January 30, the *Times* stated, "To speak plainly, the glory [of the Heights] rests more upon tradition than reality, although the Heights, to the old Brooklynites, still stands for all that is best in a select and high-class residential community. And the Heights has not yet lost this flavor of older days." No one seemed to notice or state that the townhouse had become unpopular.

In 1910, the old county courthouse on Joralemon Street between Court Street and Boerum Place (chapter 5, figure 28) was deemed too small for its caseload, so the judges sought sites for a new building. Unlike Manhattan's Tweed Courthouse, it was demolished and replaced in 1960. They proposed the two blocks between Court and Clinton Streets and Livingston and State Streets, which would have required the demolition of Packer. The community successfully opposed the move, and litigating attorneys seconded the opposition with the opinion that the proposed location was too far from the Borough Hall area.

The Brooklyn Heights Association (BHA) was organized on February 2, 1910, to reverse the trend and, specifically, to improve the Brooklyn Bridge approaches—a project that took fifty years—and to hasten the development

of what became the Eighth Avenue subway line. At the first meeting, Dr. Newell Dwight Hillus noted that property values in the Heights were going down. It was further stated that for years the Heights had been aiding the rest of Brooklyn and that it was time that it helped itself.

The BHA is perhaps the oldest operating civic association in the nation, although the Park Slope Civic Council dates to 1896. It scored its first major victory in 1928 when it convinced the city to add a station to the new Eighth Avenue subway line (A and C trains) at High Street. It may have helped persuade the city to add the Clark Street station to the Seventh Avenue line. In 1931, the BHA successfully opposed the creation of an airport on Governors Island (a bridge from Red Hook would have been required) and, in 1940, began its still-ongoing tree-planting program with one thousand saplings.

Brooklyn was the fastest-growing city in America in 1922 but mostly in new areas such as Crown Heights, Flatbush and southern and eastern Brooklyn. But this much-touted statistic disguised the fact that old Brooklyn was becoming a slum, which would become painfully obvious as the years passed and the dominance of the modernist, park city ideal *rus in urbe* (country in the city) championed by architect and urban philosopher Le Corbusier and implemented by Robert Moses, combined with the ubiquity of cars and trucks, undermined the viability of the nineteenth-century city and its Victorian housing stock.

The 1920s real estate boom saw the replacement of many of the Heights' mansions with new and wildly popular high-rise apartment buildings. At the same time, the limitation of immigration by federal law stopped the flow of predominantly Irish girls who served as cheap labor in the great houses of the neighborhood, rendering their operating costs untenable as wages consequently rose. Cutting off immigration also hurt the cities that were their first haven.

The Triumph of Modernism

Modernist design, originated by Germany's Bauhaus school, took advantage of new techniques such as steel-frame construction and eliminated ornament with the motto "form follows function." Technology had begun to influence design. Cars, trains and airplanes needed to be aerodynamic, and sometimes obsolescent technologies, like steam locomotives, were dressed up in wonderful streamlined costumes to render

Figure 26. The Beaux Arts Fougera was an early luxury apartment building at 200 Clinton Street at Atlantic Avenue. It was developed by E. Fougera, a pharmacist who manufactured period remedies for commercial distribution. This 1897 view is from the southeast corner of Clinton Street and Atlantic Avenue. From *The Eagle and Brooklyn*, 1898.

them modern. The excitement they generated was contagious to houses. Rockefeller Center, New York's first deco modernist development, led, in the late 1940s, to the International School of design, the predominant style for Manhattan skyscrapers.

The triumph of modernism led to the Fougera (figure 26), a vintage 1890 Beaux Arts apartment building, being reclad in 1920s Art Deco, then the last word in modernism, with the name dropped and the simple address of 200 Clinton Street becoming its moniker (figures 27 and 28). One of the finest Art Deco buildings is 80 Cranberry Street (figure 29), which replaced the former Brooklyn Armory in the 1920s.

The dominance of the automobile paradigm was so total that the *Brooklyn Eagle* itself advocated it, thereby contributing to its own demise. The editors believed that the growth of Nassau and Suffolk Counties would make Brooklyn the capital of Long Island. In point of fact, Brooklyn had been the downtown of all of Long Island in the 1920s and '30s, a status it lost with the triumph of suburbanization in the 1950s. By that time, no one needed

Figure 27. The Fougera was reclad in Art Deco thirty years after it was built because Victorian design had become hopelessly old-fashioned and unpopular. This view is from north of the corner of State and Clinton Streets in 2011. The preference became for spare, clean exteriors without Victorian interior and exterior clutter. The modern preference supports the former but not the latter. *Robert Furman photograph.*

to come into the city anymore to see movies or eat in restaurants, especially with the development of huge shopping malls such as Green Acres and Roosevelt Field in Nassau County and the Cross County Shopping Center in Westchester in the early 1960s.

The exodus of the old upper class led to declining property values and an influx of working-class immigrants, principally Italian-Americans, whose language and manners were not popular with the remaining wealthy except perhaps as targets for their efforts at uplift. But by the 1920s, the aristocracy's numbers were so depleted that such efforts had gone by the boards.

In 1925, America's greatest man of letters, Edmund Wilson (who had clearly spent a substantial amount of time in the area—one wonders who he was visiting), wrote (and we may want to excuse the great man's prejudices—or maybe not):

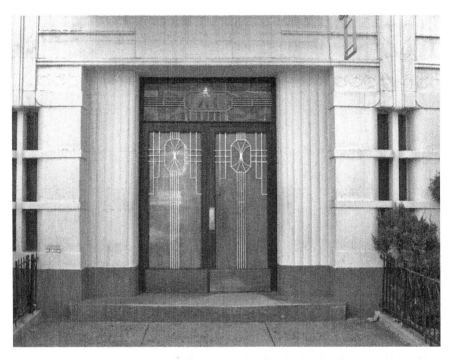

Above: Figure 28. Stained glass in the transom above the door of 200 Clinton Street is a wonderful example of Art Deco glasswork. *Robert Furman photograph.*

Right: Figure 29. This attractive Art Deco apartment house at 80 Cranberry Street replaced the former Brooklyn Armory. Its site was the most historical in the Heights, having once contained the Apprentices' Library. *Robert Furman photograph.*

THE RISE, FALL AND REBIRTH OF AMERICA'S FIRST SUBURB

The pleasant red and pink brick houses still worthily represent the generation of Henry Ward Beecher; but an eternal Sunday is on them now; they seem sunk in a final silence. In the streets one may catch a glimpse of a solitary well-dressed old gentleman moving slowly a long way off; but in general the respectable have disappeared and only the vulgar survive. The empty quiet is broken by the shouts of shrill Italian children and by incessant mechanical pianos in dingy apartment houses, accompanied by human voices that seem almost as mechanical as they. At night, along unlighted streets, one gives a wide berth to drunkards that sprawl across the pavement from the shadow of darkened doors; and I have known a dead horse to be left in the road—two blocks from the principal post office and not much further from Borough Hall—with no effort made to remove it for nearly three weeks.

The Great Depression almost killed the neighborhood. Both great mansions and comparatively modest townhouses had begun to be converted into rooming houses in the 1920s, but during the Depression, many of their inhabitants were alcoholics, drug addicts and prostitutes. One-third of the houses in the area were vacant due to foreclosure. Seth Faison, born in 1924, reports that his father bought 43 Remsen Street in 1929 for $30,000, but two or three years later, a similar house a few doors down the block sold for $3,000. His mother sold the house for $16,000 in 1945, the amount still due on the mortgage. So while new high-rise apartment buildings were popular, the area's basic housing stock was becoming slums, leading political leaders to call for their demolition.

During his sojourn in the Heights in the 1950s, Truman Capote wrote in his memoir, *A House on the Heights*:

By 1910, the neighborhood, which comprises sly alleys and tucked-away courts and streets that sometimes run straight but also dwindle and bend, had undergone fiercer vicissitudes. Descendants of the Reverend Beecher's stiff-collared flock had begun removing themselves to other pastures and immigrant tribes who had first ringed the vicinity at once infiltrated en masse. Whereupon a majority of what remained of the genteel stock, the sediment in the bottom of the bottle, poured forth from their old homes, leaving them to be demolished or converted into eyesore-seedy rooming establishments.

Capote's prejudice, couched in lyricism and reminiscent of Wilson's commentary, is painful. In the memoir, he described an establishment like Blume's (shown in chapter 8, figure 27), a used furniture or junk store on Fulton Street that was in the shadow of the el until 1940. Such stores were common in mid-twentieth-century New York when more respectable establishments were fading.

The history of 70 Willow Street itself, where he lived, is an example of decline. See chapter 7 for its earlier history. Banker William Putnam owned the house in the late 1800s. He was a trustee of the Brooklyn Museum and bequeathed Rembrandts and Monets to it. His daughters, Caroline and Lillian, like some other society ladies, actively opposed women's suffrage. After the last descendant of the family left in 1940, the house was vacant until 1944, when it was purchased by the American Red Cross, which used it as a classroom building. The organization taught arts and crafts to the blind and held cooking classes for the wives of returning veterans. See chapter 10 for the house's subsequent Capote-era history.

Figure 30. No. 84 Montague Street today, an interesting Art Deco building. *Robert Furman photograph.*

Chapter 10
ARTISTS AS AGENTS OF GENTRIFICATION

1910–1966

T hroughout the first half of the twentieth century, the Heights' faded
elegance and low rents attracted struggling authors, poets, musicians,
photographers and painters. They recognized the inherent quality and
quaintness of the old houses that most people disdained and loved the charm
of and views from the neighborhood.

These authors included Henry Miller, who grew up in Williamsburg (figure
1) (*Tropic of Cancer*, 91 Remsen Street [where there is a new small plaque],
Garden Place and Love Lane at Henry Street). Thomas Wolfe of Asheville,
North Carolina (figure 2) (*Look Homeward, Angel* and the wonderfully humorous
short story *Only the Dead Know Brooklyn*), lived at 5 Montague Terrace, where
he wrote *Of Time and the River* (a plaque was placed in 1983 [figure 3]—he
had previously lived in Cobble Hill). The modernist poet e.e. cummings also
lived at 5 Montague Terrace. The photographer Walker Evans (figure 4)—
best known for his Depression-era photo essay *Let Us Now Praise Famous Men*,
a portrait of rural poverty, with text by novelist and film critic James Agee—
lived in the Heights, as did the well-known horror novelist H.P. Lovecraft,
who lived at 169 Clinton Street from 1925 until 1926, when he wrote *The
Horror of Red Hook*.

Hart Crane, best known for his poem about the Brooklyn Bridge called
The Bridge, lived at 110 Columbia Heights (chapter 9, figure 2) (demolished)
in the 1920s, while John Dos Passos (*U.S.A.* and *Manhattan Transfer*) later dwelt
there. This was the most historic house in the area. Washington and Emily
Roebling lived there during the construction of the Brooklyn Bridge and

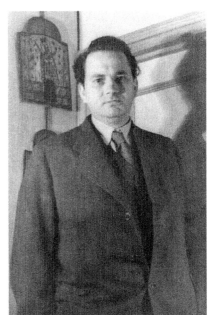

Left: Figure 1. Henry Miller. *Library of Congress.*

Right: Figure 2. Thomas Wolfe. *Library of Congress.*

supervised work from its rear parlor after he was disabled by what was then called "caisson disease," which we now call "the bends." Emily personally transmitted his orders to the workers. She is honored with the name of a small park, Emily's Garden, near Fulton Ferry Landing.

Other artists who lived in the Heights in the 1930s included the etchers Joseph Pennell and John Taylor Adams; sculptors Maurice Sterne and Robert Laurent, who, according to B. Meredith Langstaff in his *Brooklyn Heights: Yesterday, Today, Tomorrow of 1937*, were a couple; John Cunning; Fred Gardner; Stefan Hirsch; Arnold Hall; A.R. Harris; Max Hermann; Raymond Skolfield; Theodore Schneider; Rudolf Scheffler (all German refugees); William Sanger; Anna Frost; Frank Gervasi; Virginia Griswold; Charles Griswold; G.W. Gage; Emily Grace Hauks; Eugene, Arthur and Nell Choate; Sigvard Mohn; Robert K. Ryland; H.B. Tschudy; William Thon; Ferdinand Warren and William Willner, on State Street; William Starkweather; George Childs; Adolph Gottlieb (figure 5) at 115 State Street; Standford Stone; Gunnar Molin; and many others, including the art critic Helen Appleton Read and curators Marie Appleton and Joseph Appleton.

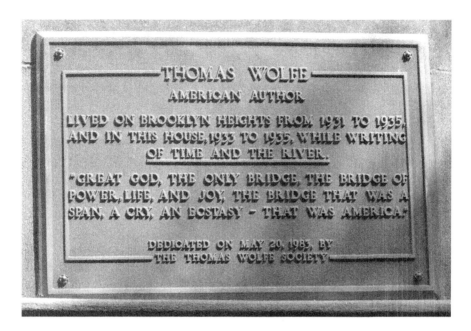

Above: Figure 3. The plaque on 5 Montague Terrace for author Thomas Wolfe, who lived in the Heights from 1931 until 1935 and in this house from 1933 to 1935. *Robert Furman photograph.*

Below: Figure 4. Photographer Walker Evans. *Library of Congress.*

Joseph Penell, quite well known in the 1930s, maintained his studio on the top floor of the Hotel Margaret.

The former Ovington Brothers Carpet Co. (chapter 8, figure 23) building on the southwest corner of Clark and Fulton Streets was an artists' studio from the 1930s into the '60s, the institutional embodiment of the flourishing neighborhood creative scene. Tenants included Benjamin Eggleston; sculptor Isabel Moore Kimball, who had a piece in the Botanic Garden; Ogden Pleissner, who had work in the Metropolitan and Brooklyn Museums; black World War I veteran and painter of black subjects Harry Roseland; Beulah Stevenson; and Andrew Schwartz (circa 1937). In the 1950s and '60s, luminaries included Jules Feiffer (figure 6), Norman Mailer and David Levine.

But the best-known person who worked there was a man who called himself Emil Goldfus but who was actually Soviet spy Colonel Rudolf Abel, the highest-ranking KGB agent ever captured. His real name was Vilyam (William) Genrikovitch Fisher. He entered the United States illegally in 1947 or 1948, taking the name Goldfus from a dead Canadian baby. He worked with the Rosenberg-Greenglass spy ring. When Fisher was arrested in 1957, the hotel room and photo studio that he lived in contained multiple pieces of modern espionage equipment, including cameras and film for producing microdots, cipher pads, hollow cuff links, shaving brushes, shortwave radios and numerous "trick" containers. He took advantage of local scenery by doing dead drops of microfilms for his Soviet handlers in Prospect Park and was exchanged in 1962 at a border bridge in Berlin, Germany, for the U-2 spy pilot Francis Gary Powers, whose shoot down ruined a United States–Russia summit conference between President Dwight Eisenhower and Soviet premier Nikita Khrushchev in 1960, partly because the United States lied about Powers being on a spy mission. Fisher died in 1970 and was honored on a Soviet postage stamp in 1990.

Truman Capote described the reaction in the neighborhood to Fisher's capture, writing, "Know where they caught him? Right Here! Smack on Fulton Street! Trapped him in a building between David Semple's fine-foods store and Frank Gambuzza's television repair shop. Frank, grinning as though he'd done the job himself, had his picture in *Life*; so did the waitress at the Music Box Bar, the colonel's favorite watering hole."

His arrest is portrayed in the new film *Bridge of Spies*, which was shot in the Heights in September 2014. The movie, directed by Steven Spielberg, stars Tom Hanks as a lawyer drafted into acting as a go-between in the negotiations to free Powers.

Left: Figure 5. New York–born artist Adolph Gottlieb in a self-portrait. *Robert Furman Collection*.

Below: Figure 6. Jules Feiffer in 1958 with proof sheets from his first book, *Sick, Sick, Sick*. *Library of Congress Picture Collection*.

Above: Figure 7. The plaque on 1 Montague Terrace for W.H. Auden. *Robert Furman photograph.*

Left: Figure 8. W.H. Auden is shown here circa 1938 with writer Christopher Isherwood, best known for the *Berlin Stories*, on which *Cabaret* is based. *Robert Furman Collection.*

A plaque (figure 7) on 1 Montague Terrace notes that the great British poet W.H. Auden (figure 8) lived in the Heights from 1939 to 1941 and in that house in 1939 and '40, when he wrote *A New Year's Letter*. There is no physical remnant or memorial, however, to the Heights' greatest example of artistic and bohemian life to which the plaque alludes: February House (the birth month of many of the members and a name the erotic novelist, memoirist and diarist Anaïs Nin claimed in her diaries to have coined), the artists' commune that flourished at 7 Middagh Street (figure 9) from 1940 until 1944 in a house demolished in 1945 for the Brooklyn-Queens Expressway.

Again, the deterioration of the neighborhood allowed struggling artists to stake out their territory amid its faded elegance. Organized by gay magazine editor George Davis, the commune was a response to World War II (the British residents sought to avoid military service, which would have created problems for gay soldiers and sailors).

Residents included European expatriates Auden ("September 1, 1939," *The Age of Anxiety*) and his lifelong Brooklyn-born companion, Chester Kallman; painter Pavel Tchelichew; composer Kurt Weill (*The Threepenny Opera, The Rise and Fall of the City of Mahagonny* and *September Song*) and his wife, the singer and actress Lotte Lenya (figure 10), today best remembered for her performance as Pirate Jenny in *The Threepenny Opera*, in the original Broadway cast of *Cabaret* and as the somewhat closeted Sapphic agent Colonel Kleb in the early James Bond film *From Russia with Love*. Davis married Lenya after Weill's death. Also residing there were composer Benjamin Britten and his lifelong companion, tenor Peter Pears, and American authors Carson McCullers (figure 11) and Paul and Jane Bowles (*The Sheltering Sky*). They were joined by the ecdysiast Gypsy Rose Lee (figure 12), who indulged her artistic pretenses by writing a

Figure 9. No. 7 Middagh Street was the February House artists commune. It was demolished for BQE construction. *Robert Furman Collection.*

detective novel called *The G-String Murders* and made a substantial financial contribution to improve the group's solvency. The Broadway musical and film *Gypsy* are loosely based on her life.

They lived a bohemian lifestyle, with sex of every preference and type (most of the members and visitors were gay or bisexual), drinking and creativity, interrupted by cruising for sailors at the bars downtown and near the navy yard. McCullers was inspired to write *The Member of the Wedding* and *The Ballad of the Sad Café* by hanging out in a navy yard bar on Sands Street. Britten began his opera *Peter Grimes*, and Auden got the idea for *The Age of Anxiety*, which Leonard Bernstein (figure 13) later adapted as a symphony.

Figure 10. Lotte Lenya (1898–1981) lived in February House. *Library of Congress.*

Visitors included Anaïs Nin, composer and critic Virgil Thomson, composers Bernstein and Aaron Copland (figure 14) and the great surrealist artist Salvador Dali (figure 15). Along with his wife, Richard Wright (*Native Son* and *Black Boy*) stayed for a year, but the couple decided they wanted a more conventional milieu in which to raise their baby. In 1941, Carson McCullers wrote in *Vogue* magazine, "Brooklyn, in a dignified way, is a fantastic place. The street where I live has a quietness and sense of permanence that seem to belong to the nineteenth century…It is strange in New York to find yourself living in a real neighborhood."

From the 1940s through the '60s, local celebrities included the late Arthur Miller (*Death of a Salesman* and *The Crucible*), who lived at 102 Pierrepont Street in the 1940s, later at 62 Montague Street and then at 155 Willow Street (which has a sequoia tree in its backyard). When he was married to Marilyn Monroe, he resided at 31 Grace Court (figure 16), where he wrote *Salesman*. He sold the house to black historian and activist W.E.B. DuBois (figure 17). Both were leftists (communists), and DuBois was a founder of the NAACP who also wrote *The Souls of Black Folks* and *Black Reconstruction in America*. Miller met Marilyn Monroe at a party at 84 Remsen Street, the home of the late Norman Rosten, later a poet laureate of Brooklyn. Among the other local lefties in the early

Left: Figure 11. Carson McCullers (1917–1967). *Library of Congress.*

Right: Figure 12. Gypsy Rose Lee. *Library of Congress.*

1950s were roommates Lee Hays of the Weavers, who wrote "If I Had a Hammer" and "Kisses Sweeter Than Wine," and Earl Robinson, author of "The House I Live In" and the "Ballad for Americans," recorded by artists as diverse as Paul Robeson and Bing Crosby.

Dan Wakefield, in *New York in the '50s*, a memoir of his youth and career as a writer, said, "The novelist Jane Mayhall lived with her husband, Leslie Katz, in Brooklyn Heights, which I thought of as a suburb of Greenwich Village, a quiet bedroom community where writers lived in reasonably priced apartments near a pleasant boardwalk with a view of the water"—which has to be the understatement of the last century!

The late Norman Mailer wrote *The Naked and the Dead* when he lived at 102 Pierrepont Street in the late 1940s and later dwelt at 142 Columbia Heights until 2001. A lesser-known short-term resident was the late critic and memoirist Alfred Kazin, who lived at 91 Pineapple Street in the late 1940s and '50s. He was one of the "New York Intellectuals" who were of working-class Jewish background and immersed themselves in leftist politics at the City College of New York in the 1930s. Devoted to political ideology and fervor, some, like Irving Kristol and Norman Podhoretz, migrated from being followers of Leon Trotsky to becoming the theoreticians of neo-

Figure 13. Leonard Bernstein (1918–1990). *Library of Congress.*

Figure 14. Composers
Aaron Copland (1900–
1990) and Benjamin
Britten around 1950.
Robert Furman Collection.

Figure 15. Surrealist artist Salvador Dali as a young man in 1934. *Robert Furman Collection.*

conservatism because they opposed communism in both incarnations. Less political than the others, Kazin was principally a literary critic known for such books as *On Native Grounds* and *A Walker in the City*.

While their neighbors would have been aghast at the suggestion, this set the scene for later gentrification since the writers gave the neighborhood artistic cachet. This became important later with the rise of the yuppies: wealthy young professionals who did not share the anti-materialism of the bohemian artists but still sought at least the appearance of hipness, especially after the cultural revolution of the 1960s, and sought to share in it by living where artists had resided. In addition, since many of the artists were gay, this set the scene for the neighborhood having a large homosexual population from the 1950s until many were priced out of the market by the 1980s.

From 1955 to 1965, author Truman Capote (figure 18), best known for the nonfiction novel *In Cold Blood*, lived in the basement of 70 Willow Street,

Left: Figure 16. No. 31 Grace Court today, where Arthur Miller lived with Marilyn Monroe. It was later owned by W.E.B. DuBois. The house, originally no. 9, dates from 1857 and had a stucco façade added. *Robert Furman photograph.*

Right: Figure 17. William E. Burkhardt DuBois, scholar and co-founder of the NAACP. *Library of Congress.*

where he wrote *Breakfast at Tiffany's* and began *In Cold Blood*. This had been the Adrian Van Sinderen House (chapter 7, figure 2) and was owned by the well-known stage designer Oliver Smith from 1953 until his death in 1994. Capote recalled a spiral staircase and described the house as follows in *A House on the Heights*:

> *There were twenty-eight rooms, high-ceilinged, well-proportioned, and twenty-eight workable, marble manteled fireplaces. There was a beautiful staircase floating upward in white, swan-simple curves to a skylight of sunny amber-gold glass. The floors were fine, the real thing, hard lustrous timber; and the walls! In 1820, when the house was built, men knew how to make walls—thick as a buffalo, immune to the mightiest cold, the meanest heat.*

Capote was a friend of society girl Bee Dabney, who later became Mrs. Charles Francis Adams, descendant of presidents and of a nineteenth-

Figure 18. Truman Capote around the time he lived in 70 Willow Street. *Robert Furman Collection.*

century diplomat. He said she was one of the models for Holly Golightly, the main character in *Breakfast at Tiffany's*. Jackie Kennedy once joined him for lunch. The late George Plimpton said in his introduction to the 2001 edition of Capote's memoir *A House on the Heights* that he recalled being driven to the house by Capote. As an outre declaration, Capote began the book, "I live in Brooklyn. By choice." This quote appears on current neighborhood directional signs. The 2005 film *Capote* indicates the author lived in Brooklyn but shows 70 Willow Street as one of a row of anonymous Italianate brownstones and does not mention that it was in the Heights, much less the address. Two parties are shown at the author's residence that could not have been at 70 Willow Street, given the absence of the spiral staircase. The only neighborhood reference in the film is Capote mentioning a conversation with Norman Mailer. In 2012, the house was purchased for $12.5 million, then a record price for a Brooklyn single-family home, by Dan Houser, owner of Rockstar Games, who got rich on the "Grand Theft Auto" franchise.

The late actor Rod Steiger (*On the Waterfront, In the Heat of the Night* and *The Pawnbroker*) and his then wife, actress Claire Bloom, lived there, as did Jules Feiffer (figure 6) and *Angela's Ashes* author Frank McCourt (20 and 30 Clinton Street, demolished by the Cadman Plaza urban renewal, and 73 Atlantic Avenue, over Montero's) when unknown. The late film actor Gregory Peck (*To Kill a Mockingbird, Gentlemen's Agreement*) owned the A.A. Low House in the late 1950s and early '60s as an investment through his White Fathers Film Foundation. Other writers who lived in the Heights in the recent past include the late novelists Nelson Algren (*The Man with the Golden Arm*) on Henry Street and Raymond Kennedy (*Columbine*) at 24 Joralemon Street, the Riverside building. The late Pulitzer Prize–winning poet Philip Levine once lived here and maintained an apartment in the area. Dan Stevens, an English actor portraying Matthew Crawley in the BBC-PBS series *Downton Abbey* and also appearing in Shakespeare productions at BAM, now lives in the Heights, according to an October 2014 post on the Brooklyn Heights Blog.

In 2014, an apartment at 22 Pierrepont Street, reported as owned by the late Soviet exile poet Joseph Brodsky, was sold by his estate to the documentary filmmaker Errol Morris and his wife, art historian Julia Sheehan. Brodsky was a prominent Soviet dissident forcibly exiled in 1972. He won the Nobel Prize for literature in 1987, taught at area colleges and died in 1996.

Although filmed in New Jersey, *On the Waterfront* portrays events in Red Hook involving the International Longshoremen's Association (ILA), a Mafia-dominated union. The film is associated with Arthur Miller's *The*

Crucible because its director, Elia Kazan, "named names" when he testified about his leftist past before Congress (the persecution of communists being deemed similar to the falseness of witch trials), as well as his participation in organized crime.

A line in Bob Dylan's song "Tangled Up in Blue" on the album *Blood on the Tracks*, of 1976, which mostly concerns the breakup of his marriage, goes:

> *I lived with them on Montague Street;*
> *A basement down the stairs.*
> *There was music in the cafes at night*
> *And revolution in the air.*

If this is literally true, it would have to have been during the early 1960s, but Dylan biographies indicate that he lived in and around Greenwich Village when he first came to New York in 1961. Of course, he could have meant MacDougal Street, and the musical bard is well known for fabulating the facts of his life. Some locals indicate, however, that the statement is accurate.

Andy Gill and Kevin Odegard shed some light on this in their 2004 book, *A Simple Twist of Fate: Bob Dylan and the Making of Blood on the Tracks.* Here is what they say about the subject lines:

> *The second verse finds him involved in a liaison with a married woman (as was Sara when Bob first met her), which ends in failure...leading smoothly into the Bohemian wonderland of the sixth verse, where Montague Street in Brooklyn is a hotbed of intellectual activity with "music in the cafes at night and revolution in the air." But then darkness intrudes into paradise—the references to "dealing with slaves" and how the girl "froze up inside" are surely metaphors for hard drugs—and our man ends up on the move again.*

So it may have been that he became involved with a couple who lived in the Heights and stayed with them in a *ménage à trois* (heterosexual version), which, as is usual with these arrangements, are unsuccessful given human possessiveness.

Other popular music figures who have lived in the Heights include brothers Harry and Tom Chapin, who grew up here, though Harry moved to Long Island as an adult. A park is named for Harry (see chapter 11), who had major hits with his songs "Taxi" and "Cat's in the Cradle" and was killed in a car crash on Long Island. Tom is a children's song specialist. The

late Jeff Buckley, son of folk-rock icon Tim, also lived in the neighborhood. The 2014 film *Greetings from Tim Buckley* portrays Jeff's search for the father he never knew.

According to former Boerum Hill denizen and novelist Jonathan Lethem, the beat icon Herbert Huncke lived here in the 1980s when the area was still a bit marginal and hung out in Clinton Street Books, where Lethem worked. Huncke may have been the source of the term "beat." He was an associate of Allen Ginsberg and appears in the fiction of William S. Burroughs and Jack Kerouac. Other authors who lived in the Heights included Kahlil Gibran of Willowtown and James Purdy.

A new generation of artists now lives in the Heights, including the 2010 Whiting Writers Award playwright David Adjami, actor Paul Giamatti and Icelandic rocker Bjork. Dublin actor Gabriel Byrne lived on Garden Place for a few years. Lena Dunham, creator and star of the HBO series *Girls* and of several films, also lives in the Heights.

BIG GOVERNMENT SOLUTIONS

Robert Moses and Urban Renewal: 1935–1975

In 1931, the *Eagle* reported that a scheme had been developed by the Regional Plan Association to build a high-rise apartment development atop the bluff at Columbia Heights to replace numerous unwanted townhouses.

The implementation of the sort of slash-and-burn urban planning embodied by Robert Moses would have ruined the area. Clearly, the dominant opinion was that the old was useless and should be replaced by the new and that the area's land was worth much more than the houses on it. It was then even proposed to demolish the old and unsightly Borough Hall and General Post Office and replace them with modern structures because, while most of the post office was built in the 1930s, it copied the design of the original 1883 section. It is also reported that in 1942 Robert Moses wished to build a highway across Brooklyn via Montague Street, which would have resulted in the demolition of the new Appellate Division court building on Monroe Place—not to mention inflicting a fatal wound on the area—but the community successfully fought it. In spite of increasing deterioration, the old society elements published a blue book as late as 1940, containing the names of 850 socially prominent persons.

There was, however, abandonment of buildings, mainly factories, all over the neighborhood, especially in the northern and southwestern parts, which had once been dynamic industrial districts (figure 1) (see chapter 8). Moreover, residential sections of the area had become truly seedy, and drug addicts, alcoholics and prostitutes continued to find shelter in area rooming houses.

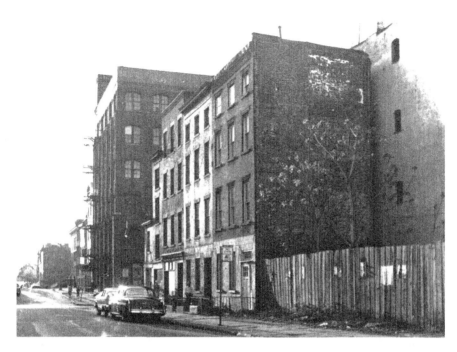

Above: Figure 1. A former Low Brothers factory on Middagh Street was an abandoned eyesore in the 1950s. *Brian Merlis Collection*.

Below: Figure 2. The Cinart Theater was a porn house. "Art film" was sometimes a euphemism for pornography because it often meant erotica. *Brian Merlis Collection*.

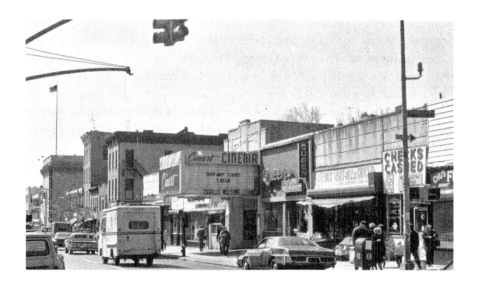

In the 1950s, children were warned not to venture south of Livingston Street because prostitutes plied that part of Court Street, enabled by an X-rated movie theater that survived until the 1980s (figure 2).

Planning a New Downtown

Clearly, the neighborhood was in trouble, but what to do about it? The answer from government, instigated by community leaders, was to replace the seedy parts—to tear down the old, deteriorating sections. Starting in the 1930s, the city began to plan the wholesale demolition of much of the Heights and adjacent Downtown Brooklyn. Much of the area between the Brooklyn and Manhattan Bridges, and the north Heights along Fulton Street, was to be cleared for new government buildings. While the specific uses changed over the course of various plans, the areas slated for demolition remained the same except for the preservation of most of the block between Pierrepont, Fulton, Monroe Place and Clark Streets. The area slated for demolition included the eastern half of the north side of Montague Street between Fulton and Clinton Streets and the entire area from Pierrepont Street north and west to Henry Street.

The Cadman Plaza urban renewal was actually first proposed in 1928 by a coalition of major business and community leaders called the Brooklyn Bridge Plaza Association. It was composed of the Brooklyn Chamber of Commerce, the Brooklyn Real Estate Board, the Alliance of Women's Clubs and many ministers. It was an outgrowth of the effort begun in 1910 by the Brooklyn Heights Association to replace the entry to the Brooklyn Bridge (see chapter 1), especially the Sands Street Station, from which trolleys shuttled across the span. The design somewhat resembled what was proposed by John B. Slee in 1942 (figure 3) in that it surrounds Washington and Fulton Streets with heroic-scale government buildings resembling what was built by Hitler and Stalin.

While the urban renewal plans were ostensibly the product of the borough president's office, they were actually developed by Robert Moses, who, under Mayor Fiorello LaGuardia, began his reign by bringing in federal funds for park, highway and urban renewal projects.

On August 30, 1936, the first urban renewal plan was revealed by borough president Raymond Ingersoll (for whom the main branch of the Brooklyn Public Library at Grand Army Plaza was originally named) at a meeting at Borough Hall via a model.

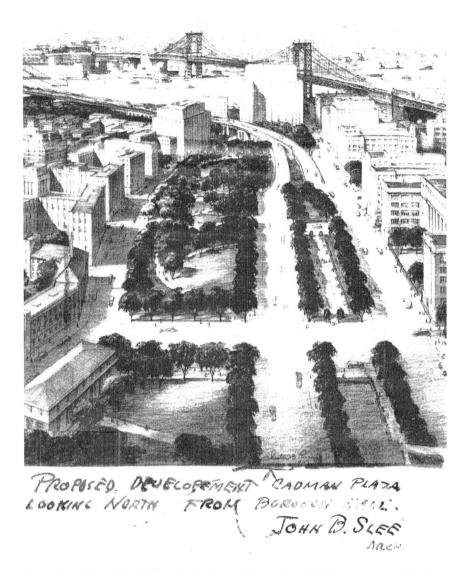

PROPOSED. DEVELOPEMENT CADMAN PLAZA
LOOKING NORTH FROM BOROUGH HALL.
JOHN B. SLEE
ARCH

Figure 3. Architect John B. Slee visualized what the completed 1942 proposal would look like. A park and auto approach from the Brooklyn Bridge is surrounded by government buildings. The Manhattan Bridge is at top right. *Robert Furman Collection.*

Opposite: Figure 4. The area that would become Cadman Plaza Park in 1930 before it was demolished. Pierrepont Street is at bottom, and the Eagle Building and General Post Office are at right on Washington Street. The building in the center with the turret is the Hotel Clarendon. The Sands Street el station for service over the Brooklyn Bridge is in the center background. The Fulton Street el and its branch to Sands Street are at left and center. *Brian Merlis Collection.*

He proposed a park to run from the beginning of Washington Street at Fulton Street north to a new Brooklyn Bridge automobile approach that was to replace the Sands Street el station opposite Middagh Street in the Heights. It featured a new version of Liberty Street to run the park's entire length and divide it in two. It would also eradicate the former department store district (see chapter 8), which had become garages, flophouses, other low-end commercial uses and abandoned buildings (figure 4).

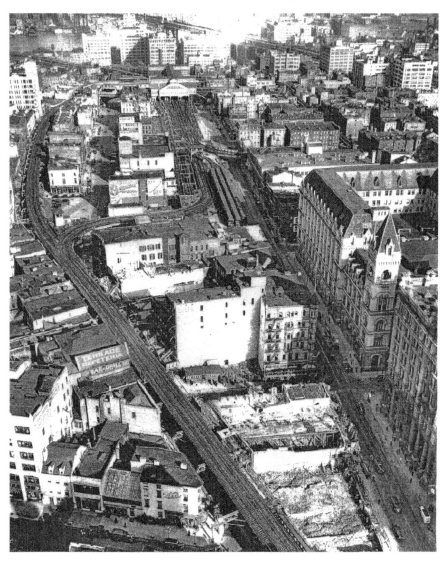

The park was named Cadman Plaza Park to honor the late Bedford-Stuyvesant Congregational pastor and popular radio minister S. Parkes Cadman, who some saw as the successor to Henry Ward Beecher. History obviously disagrees. Cadman is forgotten, and Beecher rides high in the light of his abolitionism and foibles.

In response, the Brooklyn Heights Association proposed to close Liberty Street and to carry bridge traffic directly onto Fulton Street through the park, rather than have it filter through Fulton, Washington and Liberty Streets. This version was eventually pursued, and an initial version of the park was opened in 1939, though it was later remodeled.

A great building destroyed for the park was the Brooklyn Savings Bank branch on Fulton and Concord Streets (figure 5). Although across Fulton Street from the Heights, it deserves mention because it was an 1845–46 Minard Lafever masterpiece: an Italianate palazzo with Greek Revival details.

On Sunday, December 7, 1941 (of all days), the *Brooklyn Eagle* published a much larger scheme for the demolition of much of downtown and the Heights. This was projected on the basis that New Deal federal largesse would continue to flow to the city. However, World War II would change many things.

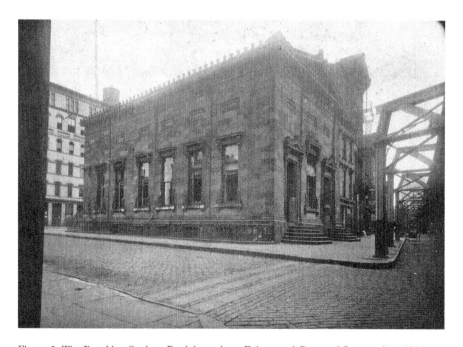

Figure 5. The Brooklyn Savings Bank branch on Fulton and Concord Streets circa 1915. *Brian Merlis Collection.*

The proposed urban renewal district ran from the intersection of Henry and Fulton Streets south to Clark Street, where it jogged to the east to include the northern half of the block bounded by Monroe Place and Clark, Fulton, Clinton and Pierrepont Streets. It proposed razing everything on the block between Tillary, Clinton, Fulton and Pierrepont Streets (except for the Brooklyn Savings Bank) and the eastern half of the block between Pierrepont, Clinton, Montague and Fulton Streets. East of Borough Hall, it disposed of all the structures between Liberty, Washington and Adams Streets up to Prospect Street. Surprisingly, perhaps, the high-rise Mechanics Bank Building on Montague and Fulton Streets was included in the urban renewal, indicating that anything of pre-modern design was deemed undesirable but also to accommodate the widening of Fulton Street into Cadman Plaza West.

Envisioned in the plan along Adams Street were a new Transportation Building; another for the New York State Tax Commission; a new park occupying the block between Concord and Nassau Streets; north of that, a block of new buildings for Long Island University to supplement its then-existing campus on the block between Johnson and Tillary Streets (now NYC Technical College); and finally a new building of unspecified use. Tillary Street was to be widened.

Proceeding south along Fulton and Henry Streets from their intersection were to be three blocks of new buildings of unknown use (called "Apart") and then, between Clark and Orange Streets, a two-block campus for Polytechnic Institute. On the aforementioned Monroe Place property was to be a new campus for Brooklyn Friends School (then adjacent to the meetinghouse on Boerum Place). The block below Pierrepont, Fulton, Tillary and Clinton Streets was to be mostly parkland with a new Brooklyn Heights Library. The block between Pierrepont, Clinton, Montague and Fulton Streets was to be given over to a new county courthouse and hall of records (now the county clerk's office) to replace the old one on Joralemon Street across from Borough Hall.

Away from this area, the only change would be a municipal building addition on Livingston Street to the south of the existing structure on Joralemon Street. This would have replaced the former Brooklyn Polytechnic buildings. The planners also projected a new jail on Boerum Place behind the criminal courts building. Most of the proposed site uses would change over time. The war that began for the United States that day would postpone the project and lead to revisions.

A new version was proposed for the northern section in 1942, entitled *Suggestions for Cadman Plaza, Bridge Terminal and Lower Fulton Street, Brooklyn,*

N.Y. The major change in this plan was the addition of the block between Fulton, Henry, Hicks and Doughty Streets to the demolition district, but no new highways were proposed. It was accompanied by a sketch of what the area would look like by architects Slee and Bryson.

The *General Plan for Downtown Brooklyn by the NY City Planning Commission and Borough President John Cashmore* and *A Study of the Brooklyn Civic Center and Downtown Area* were published in 1944. Parts became official policy by being added to the city master plan. In November of that year, the City Planning Commission published *Rezoning Brooklyn Civic Center and Downtown Area Study*, which delineated proposed uses for the sites. While all of these plans were ostensibly produced by different agencies and individuals, they were actually the product of Robert Moses. The first plan for Cadman Plaza Park presented by borough president Raymond Ingersoll on August 30, 1936, was called Brooklyn Bridge Plaza.

There were many changes in this version. For the first time, the Brooklyn-Queens Expressway was plotted, and at its eventual position. The Brooklyn Bridge approach and exit were moved a block east from the Washington-Liberty Street area to Adams Street, where it was, in fact, constructed. A High School of Specialty Trades was projected for the crook of the approach's arm between Washington and Adams Streets and from Sands Street south to Concord Street. The county courthouse proposed for Montague Street was moved to a site between Adams and Washington Streets immediately northeast of Borough Hall, where it was eventually built. A domestic relations court was proposed for the triangle of Clinton, Fulton and Pierrepont Streets, and the library that had been planned for that location was moved to the site of the old Mercantile Library on Montague Street, where the court building had been proposed. The domestic relations court, now renamed the family court, was, in fact, built on Adams Street. Its building was converted into a high school in 2009. It moved to a new building on Jay Street at that time that also houses the Criminal Division of the New York State Supreme Court. The Brooklyn Heights Branch and Business Library was completed at the southern intersection of Cadman Plaza West and Clinton Street south of Tillary Street in the 1960s (figure 6).

City and municipal courts were proposed for a site immediately east of Borough Hall. The Transportation Building was moved from there to a part of the former tax commission site. The projected state tax building and campuses for Polytechnic University, Brooklyn Friends School and Long Island University were deleted from the plan, and the schools were built elsewhere, while a new building for an unknown purpose was projected

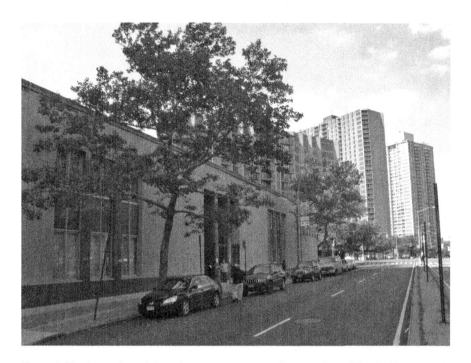

Figure 6. Northerly view of the urban renewal area on Cadman Plaza West looking toward Clinton and Clark Streets includes the Brooklyn Heights Branch and Business Library and three Cadman Plaza North buildings. *Robert Furman photograph.*

for a site south of the new high school. A new headquarters for the fire department was planned at the corner of Willoughby and Jay Streets; it is now in Metrotech. Uncommitted sites remained in the Heights, and new ones were added on the downtown side.

The Promenade and the BQE

Construction of the Brooklyn Heights Promenade (figure 7) would have to wait until Robert Moses's Brooklyn-Queens Connecting Highway (Brooklyn-Queens Expressway or BQE) was planned. In 1939, according to an article by Henrik Krogius in the *Brooklyn Heights Press & Cobble Hill News* of October 7, 2010, a topographical engineer named Fred Tuemmler at the Department of City Planning mapped a route for the highway along Furman Street, with the northbound section cantilevered above the southbound part

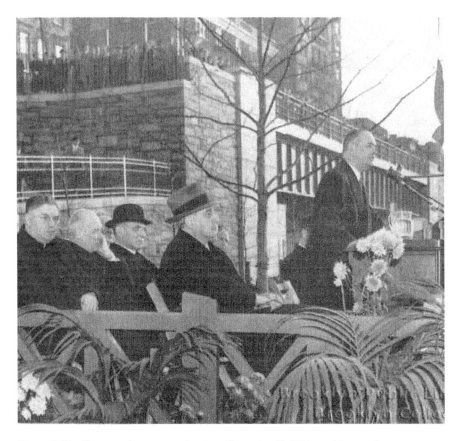

Figure 7. The Promenade was completed on December 7, 1951, and its opening ceremony was presided over by borough president John Cashmore, who characterized Robert Moses (center) as "the modern Leonardo da Vinci." Where is Councilmember Genevieve Beavers Earle, not to mention the community activists responsible for it? Most of the attendees were local ministers. From Chester A. Allen's *Our Brooklyn*, 1954.

but without a promenade on top. This indicates, at least, that people in responsible positions were thinking about building the highway before the war in unconventional ways. (Much of what follows is based on Krogius's article and subsequent book.)

The highway runs up Hicks Street between Hamilton and Atlantic Avenues to avoid the Brooklyn docks, which were then economically crucial, and the master builder had planned to continue that route through the Heights. This would have destroyed much of the neighborhood, including the new Appellate Division (chapter 6, figure 13), so the community got up in arms when the plan became known during World War II. The *Brooklyn*

Eagle reported this on September 19, 1942, with the headline "Plan for Express Highway Is Shocking." Since this approach was already known to the community, the Brooklyn Heights Association began to work back channels and got the route moved to the shoreline.

The one public hearing on the project was held by the City Planning Commission, of which Moses was a member, on March 13, 1943, and the association made a strong presentation suggesting a pedestrian walkway to cover the highway. Influential here was Heights resident Ferdinand Nitardy, the vice-president for engineering for local company E.R. Squibb & Sons (chapter 8, figure 4), who received a much more sympathetic reception than did other locals, such as Wall Street attorney Roy Richardson, due to the company's influence. Another important witness was former city corporation counsel Paul Windels, who acted as a liaison between Mayor LaGuardia and Robert Moses and, according to Krogius, felt the route would create a "Chinese wall" between the Heights and the waterfront.

Moses was initially determined to follow his original plan because the community had defeated his Brooklyn Battery Bridge proposal in 1939 when they got Eleanor Roosevelt to oppose it. As war approached, Secretary of War Harry Woodring characterized the proposed bridge as an overwater obstruction to the passage of large ships from the navy yard. (The political nature of this is clear in that Woodring, a former Democratic governor of Kansas, had no jurisdiction over the U.S. Navy—there was a separate cabinet-level secretary of the navy at that time. The secretary of war supervised the army and air corps, then part of the army.)

The remaining Heights aristocrats wanted the top of the highway to be private gardens for their abutting houses, something the more publicly inclined Moses would not accept. This element was made public in a letter from Borough President Cashmore (who was—technically speaking—in charge of the project) to Nitardy (who led the privatization faction) on April 13, 1943.

Richardson and other leaders got the engineering firm of Andrews and Clark to develop an alternate plan for the highway that included the double-decked highway with a promenade above, which was known to Moses and company at the time of the public hearing. S. Starr Walbridge claimed in a letter to Krogius in 1982 that it was "soley [*sic*] my idea to use cantilevers to support [the] Brooklyn Queens Expressway along Columbia Heights and it was soley [*sic*] my idea to have a cantilevered pedestrian walk, or promenade, above the upper road."

Construction of the BQE-Promenade lasted from 1946 until 1953 and, of course, did have a physical price tag attached. The quaint old Penny Bridge

was removed (figure 8), as was the ramp down to the water, along with the long-abandoned A.A. Low House greenhouse (chapter 4, figure 13). In the south Heights, there was extensive demolition, including the western part of the Riverside houses on Joralemon Street.

In addition, as the highway moved east in the north Heights, all of the houses on the west side of Columbia Heights north of Pineapple Street were

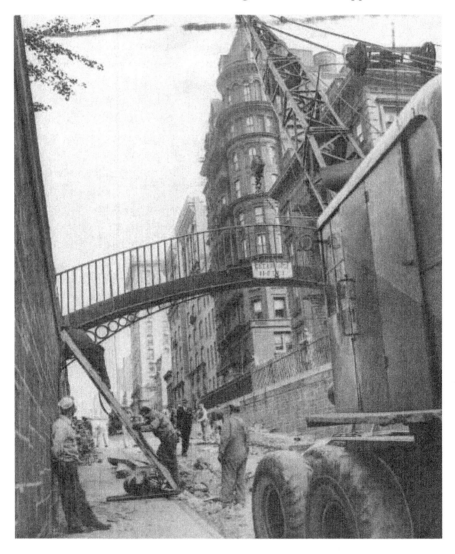

Figure 8. The price of the Promenade: the demolition of the Penny Bridge in 1946. *Brooklyn Public Library.*

removed (numbers 2 to 136), including the ones at 80 and 82 Columbia Heights (figure 9). Perhaps the most historically significant house in the area, 110 Columbia Heights (chapter 9, figure 2), where Washington and Emily Roebling lived and from which they observed and supervised Brooklyn Bridge construction, was torn down. Hart Crane and John Dos Passos later dwelt there (see chapter 10). Everything on the west side of the block between Willow, Cranberry and Middagh Streets and Columbia Heights was razed, as well as Poplar Street west of Hicks Street (figure 10).

A prominent wealthy resident who aided in the process of getting the Promenade built was Underwood typewriter heiress Gladys Darwin James

Figure 9. Nos. 80 and 82 Columbia Heights were grand in this 1928 picture. They were demolished for the BQE. No. 80, on the left is Queen Anne, and no. 82 on the right is Ruskinian. *Brian Merlis Collection.*

Figure 10. Poplar Street to the river was totally razed for the BQE. Shown here in a Berenice Abbott photograph. *Robert Furman Collection.*

(figure 11) (1903–1975), who pointed out to Moses that the harbor view from the bluff was unparalleled and should be available to the public. The late Darwin Rush James III had given Moses his first job, so Darwin's widow had access and influence. She married Darwin R. James III (see chapter 9), son of businessman, associate of Seth Low, politician and Presbyterian evangelical Darwin R. James II. In 1948, the couple moved from Long Island into the late Harriet White's house at 2 Pierrepont Place (chapter 4, figure 15), where Gladys lived for the rest of her life.

To stabilize them economically, as investments, and to prevent block assemblage by developers, she purchased the A.A. Low House (chapter 4, figure 15) (3 Pierrepont Place, which she later sold to Gregory Peck) along with others on Columbia Heights, which was reported in *Rowboats to Rapid Transit,* the 1973 history of the neighborhood by William Everdell and Malcolm MacKay. At that time, Gladys was still alive, so she was called "Mrs. X." It has been reported that she owned the Henry Pierrepont House

Figure 11. Gladys Darwin James, *standing*, is shown here in a *Brooklyn Eagle* photo in 1953 along with, *from left*, Mrs. William H. Good, Mrs. Robert W. Blum and Mrs. Hollis K. Thayer. At this time, proper women used their own names only until they were married, at which time they became their husbands' "Mrs." It was normal for women to meet and organize separately at this time. Mrs. Blum and her husband, a founder of Federated Department Stores for A&S and the grandson of Abraham Abraham, were admitted to membership in the Heights Casino in an exception to its restriction against Jews (see chapter 6). *Robert Furman Collection.*

at 1 Pierrepont Place (chapter 4, figures 12 and 15) and that she "traded" this site for the Promenade and playground, but this is unlikely since the house was abandoned at that time (figure 12). Her father was typewriter manufacturer John Thomas Underwood (1857–1937).

Underwood emigrated from London to America as a teenager in 1873. He joined his father in John Underwood & Company. Beginning in that year, they pioneered the manufacture of typewriter supplies, carbon paper and other accessories to support the early machines, which were first manufactured commercially by E. Remington & Sons. John Underwood and his brother Frederick moved from New Jersey to Brooklyn a decade later. In 1895, John bought the patent to Franz X. Wagner's invention

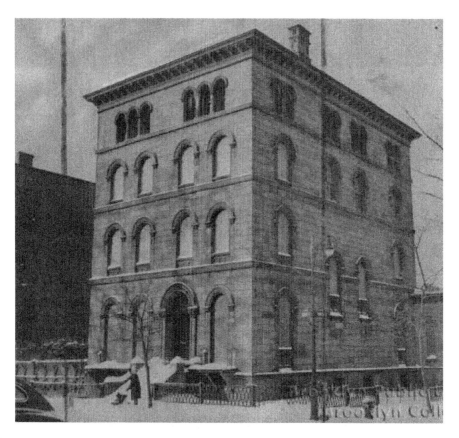

Figure 12. The Henry Pierrepont mansion stood forlorn and abandoned in 1945 and was demolished the following year. Note the aesthetic effectiveness of the reduced window heights as you look up. *Brooklyn Public Library.*

of the "front-stroke" machine, which, unlike previous models, enabled the user to see what was being typed. The new Underwood typewriter revolutionized the industry. By 1915, the Underwood factory in Hartford, Connecticut, was the largest of its kind in the world. A state-of-the-art Underwood typewriter was featured in the 1939 New York World's Fair to represent the "World of Tomorrow."

Another person who may have influenced the decision about where the highway and Promenade would be built was Heights historian B. Meredith Langstaff, who told Krogius in 1981 that he ran to see Moses when the highway plan was revealed and persuaded him not to tear through the area at Hicks Street but instead to go with the promenade concept. Michael Capuano of the landscape firm of Clarke and Rapuano,

which designed the gardens behind the esplanade, also claimed credit for the cantilever concept.

In 1953, before the highway opened, the Port Authority, which owned the piers and stores, wanted to reserve the right to erect new seventy-foot-high warehouses on the west side of Furman Street to replace the existing fifty-foot buildings. This would have blocked the view from the Promenade. The resulting neighborhood furor led to a then-rare Borough Hall town meeting, at which Beep Cashmore and other officials evaded the issue, in spite of pressure to support a height limitation. Henrik Krogius wrote to Robert Moses, who, as city construction coordinator, actually controlled such matters, that no building should rise above eye level or else it would obstruct the view from the Promenade. Moses replied that "spot-zoning"—i.e., a height limitation affecting only one location—was not an acceptable practice for the City Planning Commission. This was done anyway in 1974, and today it seems outrageous to suggest that permanent structures might have been built that would have blocked that incredible view, which, as of 2015, has happened anyway with the Pierhouse building in Brooklyn Bridge Park.

A small plaque on a flagpole near the Montague Street entrance honors Genevieve Beavers Earle, the first female city councilmember. She was an at-large councilmember (an old arrangement under which two candidates from different parties got one seat each borough-wide) who lived in the Heights and facilitated the opposition. She also led the fight for the Pierrepont Playground (figure 13). This may be considered the anti–Robert Moses monument. Former council speaker Christine Quinn mounted a photo of Earle's inauguration by Mayor Fiorello H. LaGuardia in her conference room in city hall because she was the first female councilmember. Earle was elected as a Fusion Party candidate along with Mayor Fiorello LaGuardia, but she later became the Republican leader of the council (LaGuardia was a progressive Republican).

It may not be possible, absent a complete record search of the history of Promenade development, to discern whose idea it was and who deserves most of the credit for making it happen, and human nature being what it is, most will say they were responsible or that they were not influenced by others (as did Moses). Ernest J. Clark, the project engineer, stated that the promenade concept evolved through a collaborative team effort. This seems credible. What we can say is that we are truly grateful that it did get built. Lewis Mumford wrote of the northern end of the Promenade (figure 14):

There is one place where the new Brooklyn promenade rises to a breathless architectural climax. At the northern end, it terminates in a small circle surrounded by a stone wall. From one side of this circle a reverse spiral leads upward in a ramp to the street. Within the circle there are benches and trees, all arranged in the same circular pattern, while the stone pavement consists of contrasting textures—broken stone, hexagonal blocks, cobblestones—forming complicated patterns which the eye could play for hours at a time if it were tired of looking across the bay. The embankment and the ramp is planted with rhododendrons, and the concentrated effect of the complex forms and textures, the dynamic rhythm of the space itself, are almost too good to be true. Here, abstract geometry, landscape gardening, and architecture, along with the tactile value of sculpture and painting, unite in a deeply satisfying composition. Perhaps it is just as well to leave my account of these great reconstructions at this point. When one has reached a moment of perfection, there is no use pushing any further.

Figure 13. Pierrepont Playground today is a popular place for small children to recreate. Admission is restricted to children and their caregivers. *Robert Furman photograph.*

Figure 14. The sitting area at the north end of the Promenade. It was, and still is, considered very special. *Robert Furman photograph.*

When you exit the Promenade at the northern end, you encounter the Fruit Streets Sitting Area, between Orange and Middagh Streets, another beautiful oasis of tranquility (chapter 8, figure 4). This was enabled by the highway's shift to the east, which also left vacant land for Harry Chapin Park, on the northeast corner of Middagh and Columbia Heights.

At the south end, the Promenade terminates at Remsen Street, where an auto turnaround provides a fantastic view of the city (figure 15). The Promenade is a lovely place that—until you look down—conceals the fact that it is the roof of a highway.

Amazingly, from a contemporary, preservationist point of view, in 1945 the Pierrepont Mansion was a white elephant that lay abandoned, the area's low point (figure 12). The *Brooklyn Eagle* reported that the city housing commissioner had proposed placing homeless veterans there. As part of BQE-Promenade construction, it was demolished, and its lot became the site of Pierrepont Playground (figure 13). If it had survived into the brownstone era, its market value today would be at least $20 million, given its spectacular views and architecture.

Figure 15. The southern end of the Promenade at Remsen Street with its view of lower Manhattan. *Robert Furman photograph.*

Quite a few biographies and works of historical fiction, such as *Jennie*, a popular life of Winston Churchill's mother Jennie Jerome, who grew up in Cobble Hill, suppose that the Promenade existed in her time, the mid-nineteenth century, because it is so perfect and permanent that it obviously should have been built earlier.

Enacting Urban Renewal

The end of the war brought the great era of modernism and social engineering. A nation flush with victory and wealth thought it could solve any problem and enthusiastically looked forward to—and even worshipped—the future (probably because the immediate past had been so bad). At the same time, there was a housing shortage, which became clear when families that had doubled up during the Great Depression and put off marrying and having children now wanted and—unlike right after World War I—could afford their own dwellings. There had been little residential construction during World War II.

The older Protestant population that left the area after 1890 was replaced principally by Italian and Irish American families. Landlords subdivided houses into railroad flats and single rooms, often adding fire escapes to comply with the Multiple Dwellings Law. A 1943 newspaper survey showed only a few blocks of high-rent housing near Montague Street, as, farther away, prices dropped to among the lowest in the borough.

Not surprisingly—given the attitudes of Edmund Wilson (see chapter 9) and Truman Capote toward Italian Americans—racism began to rear its ugly head in the form of fear of Puerto Ricans, who were beginning to occupy rooms on the border zone of Atlantic Avenue. At the same time, neighboring Fort Greene was becoming predominantly black. But the Latinos initially did not live in the Heights because no one would rent to them.

As manufacturing and shipping moved to the suburbs due to the ascendancy of trucks, a new population exodus began with the construction of Levittown in the potato fields of Nassau County. Aircraft manufacturers that had grown up on Long Island before and during the war, such as Grumman and Republic, needed new workers for Cold War contracts. But this time, those migrating out of the area were not replaced by foreign immigrants, as they had been in the past.

Brooklyn's population reached almost 2.8 million in 1950, a level it would never again attain (it has come back to 2.5 after falling to 2.3 million in 1980). The housing shortage was solved by moving people to the suburbs and high-rise construction (see the introduction).

Because of the restrictions of the National Origins Quota system, the principal immigrants coming to New York in the 1950s were poor blacks from the South and the Caribbean, as well as Puerto Ricans. Spreading north from the Spanish seamen's area on Atlantic Avenue, Latinos began to make their homes in the heart of the Heights on such blocks as Joralemon Street between Henry and Hicks Streets, where unscrupulous owners cut up houses to create tiny apartments for large families.

The results of these social and demographic trends and the war were the baby boom; the institution of permanent rent controls and urban renewal; and the replacement of old, declining areas with new housing and offices, as federal dollars provided by Title One of the Housing Act of 1949 began to flow to the endangered cities. New York City and State pursued their own housing programs for the middle class and poor to prevent the city's abandonment.

Title One was a public-private partnership that provided part of the site acquisition funds for new middle-income housing and for commercial and

public development. Robert Moses, as he had earlier, became the master of milking the federal cow, but this time, the law, passed by a Republican Congress, required that he work with private developers for all of the new projects. A new urban renewal plan produced before the law's passage projected that year still showed mostly new government buildings.

In the 1950s, per the site demolition plan outlined in 1944 and later, the eastern half of the block between Montague, Pierrepont, Clinton and Fulton Streets was condemned, as was the entire huge one to the north bounded by Pierrepont, Clinton and Fulton Streets. This was the downtown part of the plan that affected the Heights.

In 1954, the *Downtown Brooklyn/Civic Center Improvement Plan* called for several additional government buildings in Brooklyn Heights. These included a new Welfare Building at the north end of the site. Another government building was projected for the north side of Tillary Street above the post office. In addition, the entire block between Pierrepont, Clark and Fulton Streets and Monroe Place was scheduled for demolition. For the first time, Concord Village (which had already been built) is shown. The plan would later be almost completely recast.

The northeastern corner of Montague and Fulton Streets (Cadman Plaza West) saw the removal of the Mechanics Bank Building (chapter 9, figure 11) in 1959, possibly because the commercial real estate market was so depressed that skyscrapers were deemed unprofitable. (The owners of the Manhattan Trust Co. building had considered reducing it to three stories in 1948.) Joe's Restaurant (chapter 8, figures 25 and 26), still famous (like Lundy's of Sheepshead Bay) for its shore dinners, was next door to Mechanics at the corner of Pierrepont Street and also fell the same year.

In the 1960s, the Brooklyn Savings Bank (chapter 8, figure 10) on the northeast corner of Clinton and Pierrepont Streets was torn down because this masterpiece was also old. This site remained vacant until the 1980s, when a back-office building for Morgan Stanley and other companies was erected with the address 1 Pierrepont Plaza (figure 16).

In the early 1960s, Mechanics was replaced by a four-story home for the Brooklyn Savings Bank, which has since been occupied by many fiduciaries (figure 17). It is this structure that carries the plaque honoring Jackie Robinson and Branch Rickey, although the momentous event took place in the Mechanics Bank Building. It still bears the chiseled inscription "Founded 1827," a poor souvenir of Brooklyn Savings, which had been Brooklyn's second-oldest bank, begun in the Apprentices' Library (see chapter 6, figure 1, and chapter 8).

Figure 16. The north side of Pierrepont Street looking east from Clinton Street toward Cadman Plaza West today shows the 1 Pierrepont Plaza office building. *Robert Furman photograph.*

The urban renewal was described in the Cashmore/Moses paper as follows, and it certainly sounds like Robert Moses:

> *It is not a visionary picture of the glorified "city beautiful" type. It is a practical, realistic program to provide adequately for the movements of existing and future traffic, to make available desirable sites for necessary public buildings and to clear away blight and restore property values, an enterprise to participate in the redevelopment of the section in conformity to a comprehensive, integrated plan.*

No one would disagree with his statement that the project lacked vision.

Moses was rationalizing the fact that the project's design was dishwater dull. The "City Beautiful" movement, derived from the 1892 Chicago World's Columbian Exposition, gave us the wonderful Manhattan Municipal Building by McKim, Mead and White and Surrogate's Court, while the architecture of the 1950s was utterly pedestrian. Moses here was expressing the spirit of the time and his disdain for the old.

Figure 17. The north side of Montague Street between Cadman Plaza West and Clinton Street today shows an early 1960s bank building and, to the left, the former Brooklyn Union Gas Company building, 1 Pierrepont Plaza and the office building at 187 Montague Street. To the right is a park-like vacant corner enwrapped by Pierrepont Plaza. *Robert Furman photograph.*

The well-known architect and critic Lewis Mumford stated in "From Blight to Beauty" in the *New Yorker* magazine of April 25, 1953, "It is the biggest piece of redevelopment the municipality has ever attempted. If well done it will provide a positive example for the reconstruction and modernization of the rest of the city."

ST. FRANCIS COLLEGE AND THE BROOKLYN UNION GAS COMPANY

As part of the urban renewal, the Brooklyn Union Gas Company shifted from Remsen Street (figure 19) to 189 Montague Street between Clinton Street and Cadman Plaza West (figure 17), a new building constructed on the site of the Brooklyn Mercantile Library, which now serves as the local headquarters of Spain's Banco Santander. It had once been the neighborhood-oriented

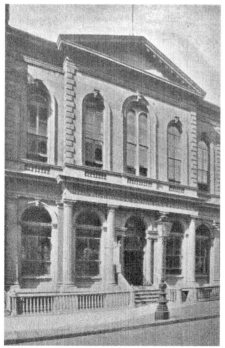

Above: Figure 18. The south side of Remsen Street between Court and Clinton Streets today shows 186 Remsen (the Low Building); the Frank and Mary Macchiarola Academic Center of St. Francis College; the 1915 Brooklyn Union Gas Company headquarters, now part of St. Francis; and the 1960s main building put up by the college. *Robert Furman photograph.*

Left: Figure 19. The original headquarters of the Brooklyn Union Gas Company at 180 Remsen Street was a lovely Greek Revival building demolished by St. Francis College for its new academic center. *Brian Merlis Collection.*

Independence Community Bank. In the 1980s, when the gas company took over the failing Long Island Lighting Company, it also occupied the Franklin Trust Building (chapter 8, figure 9), changed its company name to Keyspan and moved to a new home in Metrotech on Jay Street.

St. Francis College, a Catholic institution, began as a grade school and started giving degrees in 1884. In 1902, the primary and secondary divisions became St. Francis Academy. It has been city policy since the time of Robert Moses to support the development of educational institutions. Thus, in 1962, as part of the urban renewal, St. Francis moved from 35 Butler Street to Remsen Street, into the two former headquarters buildings of the Brooklyn Union Gas Company at 176 and 180 (figures 18 and 19). It also built a new main building by razing several houses that had been converted for commercial use, as well as the William Hester House next to the former Spencer Memorial Church (figure 20). The college demolished the original Greek

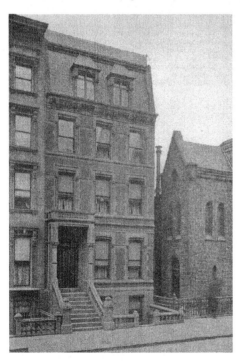

Revival gas company building at 180 Remsen Street (figure 19) in 2004 to construct a new classroom and library building dubbed the Frank and Mary Macchiarola Academic Center (figure 18) for its late president. As a posthumous preventive, the former Gas Company building at 176 Remsen Street was granted landmark status in 2011.

Buildings for the related Diocese of Brooklyn and Catholic Charities were raised on the block's Joralemon Street frontage (figure 21). St. Francis also built a teaching brothers' residence there to replace the Behr house, which it had sold in 1976. More small-scale buildings were destroyed in the process. The college also occupies several houses on Joralemon Street to house teaching nuns.

Figure 20. The William Hester House on Remsen Street in 1897, when it was a paradigm of luxury and fine design. Spencer Memorial Church is at right. This once-elegant Beaux Arts house was razed by St. Francis College in the 1960s. From *The Eagle and Brooklyn*, 1898.

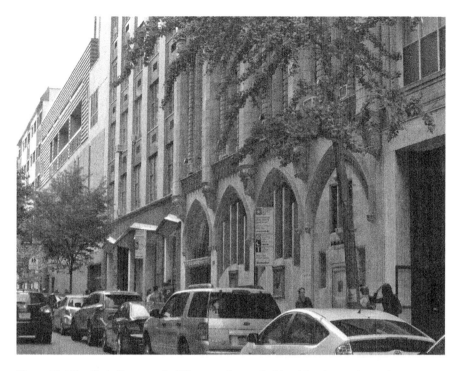

Figure 21. The Catholic center buildings on the north side of Joralemon Street between Court and Clinton Streets include, *from right*, the Diocese of Brooklyn, Catholic Charities, a teaching brothers' residence and the back of St. Francis College. *Robert Furman photograph.*

The Cadman Plaza Development

Robert Moses planned Title One Cadman Plaza housing to complement the new offices and courts envisioned for the Civic Center. His Slum Clearance Committee had wanted to begin planning Cadman Plaza in 1956, but a lack of federal funds delayed the program until 1959, when the committee published a typical Moses glossy brochure for the project. The plan proposed closing Pineapple, Orange and Cranberry Streets between Henry and Fulton Streets to create a "superblock" on which Moses could impose his project. Site acquisition costs were estimated at $4,500,000, and total expenses were stated at $15,444,615. Seventy-seven buildings were to be razed—all but two of which were deemed substandard because they were old.

New York has a long history of slum clearance. The onset of massive Irish and German immigration in the 1840s caused concern about the horrific conditions in which newcomers lived, which reached a crescendo

with the second wave of Italians and Eastern Europeans from 1880 until 1914. The city began to pass tenement house regulations to outlaw these buildings, which were often wooden shacks in the backyards of old buildings lacking sun, air and toilets (see chapter 6: Alfred T. White and Uplift). This effort was quite successful and later involved the construction of new public housing by government and unions.

Those, like Robert Moses, educated in the history of housing reform learned these lessons well and applied them to the new postwar immigration from the South and Puerto Rico, regardless of the type of housing stock the new poor inhabited.

The area from Henry, Clark and Fulton Streets all the way up to Old Fulton Street at Middagh was officially deemed blighted by the Slum Clearance Committee in the late 1950s and condemned, along with both sides of Clark Street between Monroe Place and Fulton Street, in part because the former Church of the New Jerusalem on the corner of Monroe Place was abandoned (chapter 6). Included were the Ford Mansion at No. 97 (see chapter 13) and the townhouses at 109 and 111 (figure 22).

In the 1960 census, of the 366 dwelling units on the west side of Fulton Street to Henry Street, 60 percent of the apartments were deemed "substandard and unfit" (because poor people lived there). This was crucial because such a finding was a precondition for obtaining federal funds for site acquisition for slum clearance under Title One.

To cover the site, Moses proposed a four-hundred-foot-long twenty-story apartment building between Clark and Poplar Streets, with 536-car underground parking garages. Of the 722 units, 64 percent would be "luxury" studios (then called "efficiencies") and one-bedroom apartments. It would have resembled the Kips

Figure 22. Nos. 109 and 111 Clark Street in 1922. No. 109 was Gothic Revival, and no. 111 was Greek Revival. These lovely houses were torn down for the Cadman project. *Brian Merlis Collection.*

Bay development on the middle East Side of Manhattan. There were also to be five small retail buildings at the southern end. Proposed sponsors included Sean Pierre Bonan, T. Roland Berner and Bonan's Bonwit Construction Company.

Unlike the earlier downtown scheme, the Cadman Plaza plan engendered massive local opposition. Seeking to identify with neighborhood stability, residents characterized the plan as a "dormitory for transients."

On April 11, 1959, the Community Conservation and Improvement Council (CCIC, pronounced "Kick"), the brownstoners' pressure group, held a mass meeting at the Hotel Bossert attended by four hundred residents who roundly condemned the plan. By wrapping themselves in the cloak of being pro-family, because they wanted co-operative two-bedroom apartments, the preservationists made disagreement by politicians difficult. The Brooklyn Heights Association and both Democratic political clubs (see chapter 13) also agreed. Feeling how the political winds were blowing, the normally silent but powerful Democratic district leader Frank Cunningham said, in his inimitable jargon, "How can the Heights develop if they don't give the young families a chance?" Development powerhouse Roger Starr, head of the Citizens Housing and Planning Council, supported giving the neighborhood alternative due consideration. Most significantly, Borough President Cashmore turned neutral on the project.

By the late 1950s, however, with preservationism becoming influential and the federal law's 1954 amendments allowing for "the rehabilitation and modernization of existing housing" as an alternative to site clearance, the city's Housing Redevelopment Board called for a different approach. In addition, in response to opposition to a twenty-block urban renewal plan between Eighty-seventh and Ninety-seventh Streets on the Upper West Side of Manhattan, Mayor Robert F. Wagner commissioned a report in the mid-1950s that supported housing rehabilitation as at least a partial alternative to site clearance. In 1956, City Planning Commission chair James H. Felt said that "rehabilitation was a practical, desirable and economically feasible approach" to improving the area in question. As we shall see in chapter 13, Felt was sympathetic to historic preservation. Thus, preservation acquired administrative respectability and, with the adoption of a city law that allowed "rehabilitation and conserving" of old buildings during urban renewals, a legal structure for enactment. Moses, however, had "grave doubts of the financial feasibility of the rehabilitation of brownstone structures."

This scenario was part of Mayor Wagner's plan to ease Moses out of office in preparation for his 1961 reelection campaign as a "reformer."

On March 1, 1960, Moses withdrew from urban renewal, a huge victory for preservationists. His Slum Clearance Committee was replaced by the Housing and Redevelopment Board under the chairmanship of Milton Mollen.

CCIC found alternative developers willing and able to build on the community's terms, demonstrating the practicality of its ideas. They proposed saving some buildings and providing middle-income (Mitchell-Lama) cooperative apartments. In response, in 1961, the city proposed a mix of townhouses and middle-income high-rises. This proposal was accepted by the community because the brownstoners perceived that the entire project was too far along to be stopped.

In February 1959, an architectural consultant to the City Slum Clearance Committee stated that it was considering adding half of the block on the east side of Monroe Place down to the apartment building at number 24 to the urban renewal. (In point of fact, it had always been considered part of the proposal because it was a block from Fulton Street and mostly consisted of townhouses.) The community fought back and stopped the project at the abandoned New Jerusalem church and its rectory (6 and 8 Monroe Place).

An interesting footnote to this is that according to Martin L. Schneider, neighborhood activists sought to induce Congregation Mt. Sinai, then based in Boerum Hill, to move into the Church of the New Jerusalem building (chapter 6, figure 34) and obtained the city's support for the plan, which, however, was unsuccessful.

In 1959, an outside alternative was presented that threatened the accommodation the community had reached with the city. Columbia University professor Percival Goodman, brother of social philosopher Paul, who also taught at the university, proposed adding 173 units of low-income housing and a new P.S. 8 to the mix. This was in response to the battles over school integration being fought in the South, especially in Little Rock, Arkansas.

At that time, many people felt that neighborhoods should be racially and economically integrated and that government power should be used to effectuate this. There was much hand-wringing and liberal guilt, especially among parents of young school-age children. There was a real issue, however, with regard to where children should be educated, with many wanting public education for its democratizing ability but realizing that P.S. 8 was inadequate. In order to achieve integration, P.S. 8 was "paired" with P.S. 7 in Fort Greene in 1964. That school primarily served the Farragut Houses low-income project. (Formerly white and wealthy) Fort Greene became the

poorest neighborhood in the city in the 1960s, largely due to the closure of the Brooklyn Navy Yard. Farragut was built to house navy yard employees but, with its closure, became a dumping ground for the poor.

While many brownstoners supported the plan, with its attendant school busing, the results were unsatisfactory, with the Heights children sent to P.S. 7 receiving an inferior education. There were enough wealthy brownstoners to support a new private school, and St. Ann's was founded in response to this need in 1965, leaving the poorer kids in the ghetto school. As in other areas, schools, like retail, improved in response to local conditions, so that P.S. 8 eventually became a good school. In 1961, Mollen opposed the integration plan in large part because enabling federal funds had dried up.

The site was cleared in 1964. The project was built in three parts: the first, completed in 1967, was Cadman Plaza North (figures 17 and 23), between Clark and Middagh Streets, by Morris Lapidus, designer of flamboyant Miami Beach hotels such as the Fontainebleau, and developed by the Moses-backed Sean Pierre Bonan, and including a theater across Clark at Monroe Place. In 1973, there followed Cadman Towers, north of Middagh Street, sponsored by Max Mishkin of Mutual Housing Sponsors, along the lines suggested by the community, with Mitchell-Lama state/city assistance. It was designed by Glass and Glass and William Conklin of Whittlesey and Conklin. Their Whitman Close Townhouses of 1968 (figure 24) were added to soften the impact of the massive high-rises. These last two won an award from the New York State Association of Architects for what architecture critic Paul Goldberger called a "skillful interplay of towers and low-rise units." The zigzagging towers are aesthetically dynamic.

As part of Robert Moses's car fetish, the urban renewal included the widening of local streets to accommodate the additional traffic expected from the adaptation of the Brooklyn Bridge to the automobile. In the 1960s, Fulton Street, whose name had been changed to Cadman Plaza West in 1967 (Washington Street became Cadman Plaza East north of its beginning at Johnson Street), was widened on both sides, requiring the demolition of the buildings abutting it, such as the Mechanics Bank Building, Joe's Restaurant and the Ovington Building. This turned out to be overkill in that Cadman Plaza West never carried the number of cars the widened street could bear, and the effort just shifted the heavy traffic to Court Street, which could not be widened, creating a bottleneck. Consequently, Henry Street became the major southbound through street.

Notable victims of the urban renewal included a building on Fulton and Cranberry Streets that was once Rome Brothers Print Shop, where

Opposite, top: Figure 23. Cadman Towers and its plaza. *Robert Furman photograph.*

Opposite, bottom: Figure 24. The Whitman Close Townhouses at Cadman Plaza West and Cranberry Street are the only part of that development in scale with the area. This picture shows them in a pleasant plaza. *Robert Furman photograph.*

Above: Figure 25. The former Rome Brothers Print Shop, where Walt Whitman had the first edition of *Leaves of Grass* printed, was demolished for the Cadman Plaza development. It was located on the southwest corner of Fulton and Cranberry Streets and is shown here in 1946. *Robert Furman Collection.*

Right: Figure 26. The plaque on the former Rome Brothers Print Shop Building held until its demolition. *Brian Merlis Collection.*

Whitman's *Leaves of Grass* was first printed in 1855 (figure 25) and that was commemorated by a lovely Art Deco plaque placed by the Authors' Club (figure 26).

This important structure in a pleasant area was replaced in the pursuit of what we now perceive as high-rise suburbanized modernism but was then the ideal of a city in a park, exemplified by Tudor City and Stuyvesant Town in Manhattan, perhaps the best local examples. Today we look at it in the quaint Heights and say, "What is this doing here?" It is shocking how much upper Fulton Street and the east side of Henry Street resembled today's chic Henry Street (figure 27).

The Cadman Plaza development was not the only new construction in the Heights under the urban renewal. Most of both sides of the upper block of Clinton Street between Pierrepont Street and Cadman Plaza West was condemned, and these buildings (figure 28) were replaced by other modern apartment buildings, the Brooklyn Heights Branch and Business Library and parts of the Cadman Plaza development proper (figure 6).

Figure 27. This is the only panorama we have seen of the east side of Henry Street in the area razed for the Cadman Plaza development. The image dates from 1952. Note the Greek Revival–style houses in center. The St. George is at left. The west (left) side of the street survives. Unlike its current incarnation, it was a vital urban scene. *Brian Merlis Collection.*

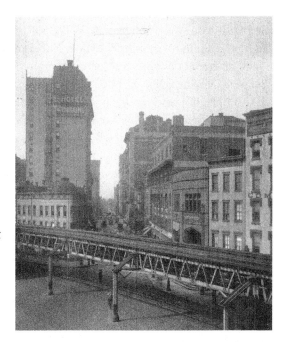

Figure 28. Clinton Street looking south from Fulton Street in 1922. Note the Hotel Touraine at left and the Brooklyn Bank building at right. Everything here was razed for the Cadman Plaza Urban Renewal. *Brian Merlis Collection.*

Truman Capote also described another local institution, an antique store called Knapp's at Fulton near Pineapple Street, the sort of old-fashioned warren of musty shelves in small rooms typical of New York in the 1950s and so rare today. (Figure 27 in chapter 8 is of Blume's, a similar store.) Since it was a tenant in one of the group of buildings on upper Fulton and Henry Streets, it was demolished in the urban renewal.

ANALYSIS

The Cadman Plaza urban renewal was one of the largest ever undertaken, and to us it seems disastrous in that it destroyed the urban fabric and vitality of upper Fulton Street, along with numerous notable buildings. Attitudes at the time were anything but sympathetic to preserving old buildings. Lewis Mumford, the leading Modernist critic, planner and architect, described the area as "covered by grimy buildings waiting for vandalism or the wrecker's ball to level them." It is doubtful that sandblasting them would have changed his mind.

New York City "reform" comptroller Joseph McGoldrick called the project "a program of complete rejuvenation as well as the removal of

the blight from this mongrel area." While parts of the area certainly were blighted, calling it "mongrel" recalls Nazi racial theories or at least suggests a lack of respect for the stylistic diversity of groups of old buildings and a preference for modernist uniformity.

Appropriately and strangely enough, Robert Moses in 1955 averred that the urban renewal would be "to Brooklyn what the great cathedral and opera plazas are to European cities. It would be as much the pride of Brooklyn as the Piazza San Marco is the pride of Venice and the Place de la Concorde the cynosure of Paris." Pride of authorship aside, these remarks suggest that he had an aesthetic tin eye.

But as the 1960s progressed and the plans were implemented, it became clear that they were not working. As white ethnics were replaced by blacks and Puerto Ricans who could not find the unskilled jobs that had moved

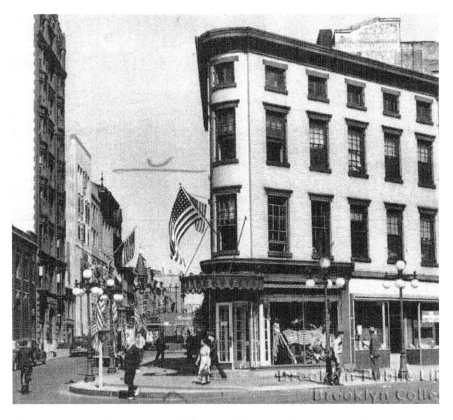

Figure 29. The northwest corner of Fulton and Pierrepont Streets in 1942 showed small-scale, flag-bedecked (for World War II patriotic display) commercial buildings, razed to widen the street. *Brooklyn Public Library Collection.*

to the suburbs and Sunbelt, the cities became poorer, population fell and urban renewal promised only sterility and segregation. A World War II–era view of Pierrepont and Fulton Streets suggests the urban renewal swept with too broad a brush and perhaps should have been restricted to the severely deteriorated blocks of the far north Heights, where small unwanted industrial buildings predominated. The photo shows a corner most of us would today see as charming and quaint (figure 29).

However, a comparison of the 1898 view entitled *Pierrepont Place, Leading to Columbia Heights* (chapter 4, figure 30) with the same view today (chapter 4, figure 31) highlights Robert Moses's more democratic vision for the area at a time when the old aristocratic and exclusivity paradigm was gone. Pierrepont Playground replaced the Henry Pierrepont Mansion, and the private park called the Misses Whites' Garden was replaced by luxury high-rises in 1948. But aesthetically, the 1897 scene is certainly superior.

The Power Broker

We believe that Robert Caro got it mostly wrong in his flawed but exciting picture of Robert Moses and his time: *The Power Broker: Robert Moses and the Fall of New York*. He does not write history but instead a prosecutor's brief, a form fitted to our overcritical times. Caro's principal concern is with Moses's power, and he criticizes his highways, but we could not have done without them. You can criticize their routing, but they were placed to protect the working waterfronts, which were then economically crucial. His analysis is poor, too. If the Cross-Bronx Expressway contributed to the decline of the Bronx, why didn't the Prospect Expressway and I-278 (the highway to the Verrazano Bridge) do this in Brooklyn? Perhaps the Bronx declined because of its housing stock (old walk-ups, apartment buildings and few private homes), distance from the city, patterns of upward mobility and the lack of foreign immigration (immigration has reversed the tide). The Grand Concourse was abandoned by the middle-class Jews who had lived there in the 1960s, and this was not due to the highway. The apartment buildings were old, the neighborhood was changing and Co-Op City and the suburbs were beckoning.

The subtitle *Robert Moses and the Fall of New York* is a false and misleading statement. While it was published before the fiscal crisis of 1975–78, the title silently attributes "the fall of New York"—i.e., the fiscal crisis and the

city's general decline—to Moses, but the Triborough Bridge and Tunnel Authority's (Moses's agency) bonds were always good (unlike those of New York City and New York State) because they were backed by tolls. The proposition that the highways, bridges and tunnels he built, along with the urban renewals, caused the city's decline is simply untrue, nor does Caro make a case that they did.

It was borrowing by Republican governor Nelson Rockefeller and Mayor John Lindsay to meet ballooning expense and capital budgets and fiscal trickery, such as fraudulently putting expense items in the capital budget, that caused the fiscal crisis of 1975. Blaming Robert Moses for New York's decline is an example of liberals' refusing to admit their errors, such as spending more than they were taking in and ignoring the business and residential tax base of the city.

New York's decline was due to its deindustrialization because of trucks and the other factors discussed here: cars and suburbanization, modernism and cutting off immigration. This had more long-term effects in places like Cleveland, Newark, Camden and Detroit, which have had much more difficulty in recovering than has Brooklyn. The inability of the public, financial and corporate sectors to compensate for the loss of entry-level unskilled and semi-skilled industrial jobs, which moved to other areas, and union protection of the ones that remained as their salaries and benefits escalated were also factors.

Caro's examination of urban renewal is similarly flawed. He states that the areas demolished in Manhattan were communities and implies that Lincoln Center and Stuyvesant Town were mistakes. Does anyone really believe that the projects that anchored the redevelopment of the Middle East Side after the removal of the Third Avenue El and the Upper West Side were disasters? And that the creation of Lincoln Center, which might be the world's greatest unified cultural center, was an error? What *was* a catastrophe because it swept with too broad a brush was the new Civic Center and Cadman Plaza, which mindlessly demolished the county courthouse, Hall of Records, Mechanics Bank Building and everything else of pre-modern design, and Caro—Manhattanite that he is—doesn't mention them. While some of the old industrial buildings were undesirable, the Cadman Plaza housing was unnecessary: the buildings would have been rehabilitated by the brownstoners and converted into housing or replaced by private developers one by one. The combined effect of Moses's excesses, the reaction against them and Caro's critique has resulted in a rejectionist attitude in the city against

any major development, an attitude that threatens to turn us into a cowering second-class borough afraid of our own shadow.

Before the current upsurge in new construction, it was possible to maintain that preservationism has inhibited growth, and it has stopped arguably good projects such as Westway, or the West Side stadium. But the real estate industry is now embarked on a campaign to gut the landmarks law, which invalidates their argument because of a sea of debatable development.

THE FAR NORTH HEIGHTS

The far north Heights, especially Poplar Street, was devastated by BQE construction, so that only one block—the one surrounded by Henry, Poplar, Hicks and Old Fulton—remains relatively intact. Pushed up against the Brooklyn Bridge, Old Fulton Street and the expressway, the area became an enclave.

Figure 30. Nos. 1, 3, 5, 7, 9 and 11 Willow Street are modern versions of townhouses built on land left over from BQE construction. This part of Willow Street runs at a diagonal to the street's normal north–south route. *Robert Furman photograph.*

Figure 31. The Fulton Street side of 75 Poplar Street, showing the backs of the buildings, with the former Newsboys Home at right. *Robert Furman photograph.*

Small-scale co-ops, which resemble modern versions of nineteenth-century townhouses, were constructed along rerouted Poplar Street to try to recapture some of what was lost (figures 30 and 31). In spite of many false starts, new owners are again trying to develop luxury housing in the vacant former Eighty-fourth Precinct at 72 Poplar Street, which was replaced by a new building on Tillary Street. The old police station was purchased for real estate development in 2005.

There is barely audible evidence of the influx of working-class families into the Heights: the evolution of a local speech pattern among people who grew up there in the 1950s. While older people and the offspring of the college-educated do not show it, working-class baby boomers do. The pattern contains a combination of old-style Brooklynese with more sophisticated elements that became a period Brooklyn Heights accent.

BASEBALL AND BROOKLYN HEIGHTS

1840–1958

A s part of the urban renewal, the Mechanics Bank Building on the northwest corner of Fulton and Montague Streets (chapter 9, figure 11), which had housed the Dodgers' front office since 1938, was razed in 1958. History was made in that building in 1947 with the signing of Jackie Robinson (figure 1) by General Manager Branch Rickey. The bank itself had been absorbed by the Brooklyn Trust Company, part of a continuing trend toward bank consolidation and of them going national and now, international.

Strangely enough, in the era of high-rises, this notable ten-story structure was replaced by a four-floor building whose first tenant was the Brooklyn Savings Bank. On its wall is a 1998 plaque (figure 2) that tells the story of Jackie Robinson and Branch Rickey integrating baseball. The Dodgers held many of their annual dinners in the Hotel Bossert (chapter 6, figure 44), including the one when they finally won the World Series in 1955 (figure 3). The Bossert wasn't the Dodgers' exclusive hotel for visiting players, many of whom stayed at the Towers Hotel (chapter 6, figure 46).

The major symbol of Brooklyn's decline is the departure of the Dodgers for Los Angeles in 1958. The Brooklyn Trust Company, the team's bank, is now the Chase branch at Montague and Clinton Streets (chapter 8, figure 12). The bank's general counsel, Walter O'Malley—although a civic leader (he was a vice-president of the Brooklyn Club—see chapter 6) and a major stockholder in the Long Island Railroad and Brooklyn Union Gas Company (see chapter 11)—came to own the team and move them.

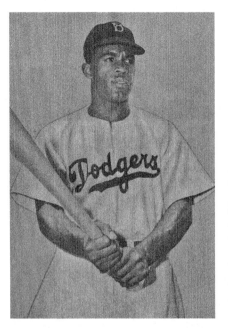

Left: Figure 1. Jackie Robinson. A major chapter in American history took place in 1947 in the Mechanics Bank Building on Montague Street when Dodgers general manager Branch Rickey signed Jackie Robinson. *Library of Congress Picture Collection.*

Below: Figure 2. This plaque honors Jackie Robinson and the Dodgers integrating baseball in 1947. It is on a newer building in the same location as the Dodgers' headquarters. *Robert Furman photograph.*

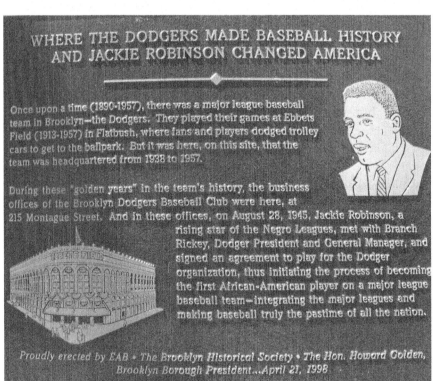

WHERE THE DODGERS MADE BASEBALL HISTORY
AND JACKIE ROBINSON CHANGED AMERICA

Once upon a time (1890-1957), there was a major league baseball team in Brooklyn—the Dodgers. They played their games at Ebbets Field (1913-1957) in Flatbush, where fans and players dodged trolley cars to get to the ballpark. But it was here, on this site, that the team was headquartered from 1938 to 1957.

During these "golden years" in the team's history, the business offices of the Brooklyn Dodgers Baseball Club were here, at 215 Montague Street. And in these offices, on August 28, 1945, Jackie Robinson, a rising star of the Negro Leagues, met with Branch Rickey, Dodger President and General Manager, and signed an agreement to play for the Dodger organization, thus initiating the process of becoming the first African-American player on a major league baseball team—integrating the major leagues and making baseball truly the pastime of all the nation.

Proudly erected by EAB • The Brooklyn Historical Society • The Hon. Howard Golden, Brooklyn Borough President...April 21, 1998

Figure 3. The victory party for the Dodgers' World Series win in 1955 at the Hotel Bossert. *Brian Merlis Collection.*

As his condition for staying in Brooklyn, O'Malley demanded that the city build a new, larger stadium with adequate parking and deed it over to him, as Los Angeles had promised to do and eventually did. The proposed new stadium site was Atlantic Terminal, but Robert Moses was uncooperative about using eminent domain to further private interests, and Mayor Robert F. Wagner felt the demands were extortionate and that if he had complied with them he would have been impeached. The city offered a new stadium in Flushing Meadow Park, which pleased neither Dodger fans nor O'Malley because it was in Queens, where the new National League New York Metropolitans or "Mets" would obtain a city-financed (but owned) stadium in 1965.

This and the Brooklyn Trust branch are not the only Heights sites crucial to baseball history. A plaque (figure 4) on 133 Clinton Street (figure 5) notes that it was the clubhouse of the Brooklyn Excelsiors (figure 6), an amateur club founded in 1854 that was the first in Brooklyn and U.S. champions in 1860 when the sport was in its infancy and known as the "New York game." This team began its professionalization.

Left: Figure 4. This plaque notes the importance of the Brooklyn Excelsiors. *Robert Furman photograph.*

Below: Figure 5. No. 133 Clinton Street was the home of an exclusive private club that became the baseball champion Brooklyn Excelsiors and later reverted to its previous use. *Robert Furman photograph.*

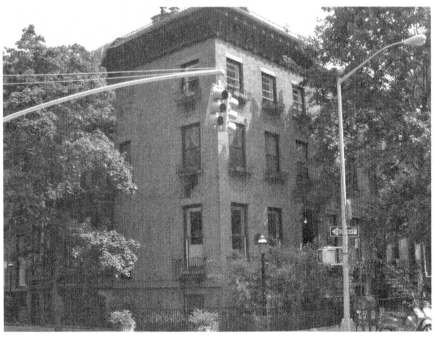

According to the plaque, they started out as the Jolly Young Bachelors and then the Bridegrooms, names redolent of the old aristocracy, indicated by the membership of young men with names such as Pearsall and Polhemus. From 1854 until 1859, they played in what would become Carroll Park, then in a field at the end of Court Street in Red Hook. From 1866 on, they played at the Capitoline Grounds (the first fully enclosed ballpark), built on a former pond (which had been used for ice skating) between Halsey Street

Figure 6. The Brooklyn Excelsiors were the national baseball champions in 1860. Their former clubhouse is at 133 Clinton Street. *Library of Congress Picture Collection.*

and Putnam, Marcy and Nostrand Avenues in Bedford-Stuyvesant. They eventually became the Dodgers, and the building and organization of the Excelsior Club became a social club by 1874, which persisted into the 1930s.

Baseball: An Illustrated History, by Geoffrey C. Ward and Ken Burns, reports that the Brooklyn Excelsiors played the Atlantics for the championship of the city of Brooklyn on August 20, 1860. The Atlantics were a working-class nine and went on to become the dominant team of the 1860s. The Brooklyn Niagaras fielded baseball's first star, James Creighton of 307 Henry Street, who is credited by the plaque with inventing the legal fastball and curveball. He later moved to the Brooklyn Stars and then the Excelsiors. In 1862, he died of a ruptured bladder after hitting a home run. Another Brooklynite, William Cummings, came up with the concept of the curveball at age fourteen and, in 1867, while playing for the Excelsiors, went on to beat a Harvard College team with this innovative pitch. Another player invented the bunt.

Chapter 13

RENAISSANCE AND SALVATION: THE BROWNSTONERS

1908 to Present

THE JEHOVAH'S WITNESSES

In 1908, a religious sect known as the Watchtower Bible Society, begun in 1876 as the Bible Student Association, decided to take advantage of the availability of cheap, unwanted industrial buildings in the north Heights, setting the stage for the neighborhood's modern revival. In 1931, 25 and 30 Columbia Heights became the organization's national headquarters under its new name, the Jehovah's Witnesses, and began to concentrate on that street. In 1969, they began printing their tracts in the former early twentieth-century E.R. Squibb & Sons factory (chapter 8, figure 4). They distributed their pamphlets on the street and door to door to solicit new members and soon purchased more buildings, including the former Leverich Towers Hotel (chapter 6, figure 46) in the 1970s and later the Hotel Bossert (chapter 6, figure 44), leased in 1983 and purchased in 1998 for the use of members visiting from out of town. They restored these buildings to their former physical glory.

In the 1960s and '70s, the group built new structures: 119 Columbia Heights (figure 2), Kingdom Hall on Columbia Heights and another at Willow and Orange Streets. This building established the principle at the Landmarks Preservation Commission that a structure could utilize modern design as long as it complements the historic district. Originally proposed as a twelve-story building, it was reduced to the scale of the LH-1 fifty-foot height limit.

Figure 1. In the 1980s, Ian Bruce Eichner built this structure, which respects the context of the area, on the site of the Hotel Margaret at 97 Columbia Heights. He sold it to the Jehovah's Witnesses. *Robert Furman photograph.*

The Standish Arms Hotel at 169 Columbia Heights was damaged in a serious fire in 1966 and was leased by the Witnesses in 1981. In the early 1980s, under the supervision of the Landmarks Commission, Ian Bruce Eichner constructed a new contextual building at 97 Columbia Heights (figure 1) on the site of the Hotel Margaret (chapter 6, figure 48), which had burned down in 1980. He sold it to the Witnesses. The BHA sued to enforce the LH-1 rule, but the court decided that older tall buildings may be replaced by structures of a similar height. The Witnesses used to own 360 Furman Street, a former warehouse and office building on the East River. In 2004, they sold it for $205 million; it is now an apartment complex designated One Brooklyn Bridge Park.

In the 1980s, their expansion was seen as a threat by many Heights residents since they took advantage of their tax-exempt position to escape property taxes and regulation. Since then, they have been both a better neighbor and less obtrusive, so that the only routine sight of them is their street workers and formerly shuttle buses to "Furman" or "York."

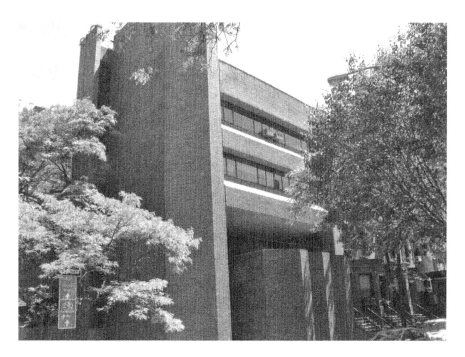

Figure 2. No. 119 Columbia Heights, completed in 1969, is a Witnesses' building that resembles the Ford Foundation headquarters in Manhattan. *Robert Furman photograph.*

The group's best-known members are the musical Jackson family, the tennis-playing Williams sisters, the pop singer Prince, guitarist George Benson, detective author Mickey Spillane and President Eisenhower.

Their growth has been halted by the extraordinary run-up in real estate values over the past twenty years. A deal to sell the Bossert for student housing, which had been on the market since 2008, collapsed during the real estate downturn, but a new one to convert it into a regular hotel has been effectuated (see chapter 6).

In 2004, the group moved its publishing and shipping facilities to Wallkill, New York, and in 2009 purchased a large site in Ramapo in Rockland County, where the Jehovah's Witnesses plan to move their administrative functions, leading to their total departure from the Heights as the real estate market improves and they sell off their properties—another suburban relocation.

Willowtown

In the 1920s, as the previous industrial uses began to fade, the southwest Heights, from State to Joralemon Street and west of Hicks Street, began to become primarily residential. Italian immigrants (figure 3) were the newcomers then who were, of course, looked down on by much of the surviving WASP establishment. In addition, Spanish sailors began to settle along the western section of Atlantic Avenue and State Street. The sole remnant of this immigration is Montero's Restaurant on Atlantic Avenue and Hicks Street. Later came an influx of Puerto Ricans.

Riverside (figure 4) and the "workingmen's cottages" at 7–13 Columbia Place (figure 5) and other lower-income housing served as the basis for this transformation, since the area was and remains a bastion of the working and middle class (see chapter 6's section on Alexander T. White for Riverside's history).

The construction of the Brooklyn-Queens Expressway made Willowtown an enclave by cutting it off from the shoreline that had formerly defined it. This is most clearly evident at the corner of State

Figure 3. The colonnade row at 43–49 Willow Place in 1946, when Willowtown was an Italian-American working-class district. But the jobs were disappearing. *Brian Merlis Collection.*

Figure 4. The Columbia Place façade of Riverside today, 4 through 30 Columbia Place. Note the patterned brickwork on the roofline and the perforated metal railings on the balconies. *Robert Furman photograph.*

Street and Columbia Place, where the expressway rises on its way to the Promenade cantilever.

The fact that there is a steep dropoff down to the shore along Joralemon Street and on Columbia, Willow and Garden Places and Grace Court, which we do not see elsewhere in the Heights, also contributed to the area becoming a separate neighborhood known as "Willowtown."

In 1876, the First Unitarian Church on Pierrepont Street constructed a Gothic Revival chapel at 26 Willow Place (figure 6) to minister to the local workers in a then-industrial area. Alfred T. White and his family endowed a kindergarten there (see chapter 6).

The building served as a public school between 1928 and 1942. It also was reportedly a brothel during World War II and was used as a furniture factory from 1947 until 1956.

One of the chapel's tenants in the 1950s was the South Brooklyn Neighborhood Houses (SBNH), a social work agency funded to fight a gang outbreak. It also provided free classes and a gymnasium. Directed by Dick

Figure 5. Nos. 7, 9, 11 and 13 Columbia Place are vintage 1848 frame houses. They are the survivors of a nine-house "cottage row" built for workingmen. *Robert Furman photograph.*

Mendes, workers learned the neighborhood and attempted to stabilize it, setting the stage for gentrification.

In 1952, SBNH organized a committee of local volunteers to raise funds to build a playground on the building's roof. They held a block festival and became a block association, perhaps the first in the city, called the Willlowtown Association.

In 1956, Heights resident A.J. Burrows bought the abandoned factory at 26 Columbia Place and requested a variance from the city Board of Standards and Appeals to use the vacant building for metal and electronics manufacturing. Burrows was quoted as saying, "Most of our work is by hand. We don't create any soot or smoke, and we're quieter than many of our neighbors…I'm just as interested in the good of Willow Town as anyone else. After all, don't I own property there?" Neighbors organized against the effort because they felt it would set back their efforts to create a viable residential community. The board allowed the factory to open with strict limitations: no sign on the door, no unloading from the street and no use of street-side doors for business. The company functioned there from 1956 until 1962 and employed twelve people.

Figure 6. The Willow Place Chapel at 26 Willow Place, built by the First Unitarian Church, was converted into a community center by Alfred T. White and was named after him. It now houses the Heights Players, St. Ann's Preschool and other groups. *Robert Furman photograph.*

Following the success of Concord Village, middle-income rental housing on the Downtown Brooklyn fringe of the Heights at Adams and Jay Streets north of Tillary Street, which opened in 1951, local bankers asked Robert Moses to consider such developments elsewhere in Brooklyn.

The de-industrialization of the neighborhood resulted in derelict buildings, giving it the earmarks of a slum and causing the city to seek to apply its one-size-fits-all solution: the bulldozer and urban renewal. Thus, in the 1950s, plans were hatched to tear down Willowtown for luxury housing and to build the Cross-Brooklyn Expressway to run along Atlantic Avenue.

In 1956, Moses's Slum Clearance Committee announced a plan to demolish nine blocks in Willowtown for a privately sponsored upper-income development, with the displaced working-class population moving to new and existing projects below Atlantic Avenue. Moses quietly lobbied the Board of Estimate (composed of the three citywide elected officials and the five borough presidents), which then controlled land use, for a

$275,000 planning grant and to get the project going before the community had a chance to organize. He also had quietly acquired properties near the highway and had already demolished some of the buildings. But by that time, Willowtown was a mixed area of the elderly, immigrants and new homeowners. Word leaked out of Moses's plans in July 1956, and the neighborhood at SBNH, with the assistance of the Brooklyn Heights Association, immediately swung into action, contacting politicians and newspapers to oppose it. In April 1957, the group also came up with an alternative involving rehabilitation of old buildings.

In response to neighborhood pressure, the signature Moses aggressive defensiveness came into play. Replying to a low-key letter from an old-line widow, he stated, "All we designated at this early stage was an area for study including what you must agree are some very rundown slum buildings…It looks as [if] we must anticipate here another one of those general, premature, ill informed attacks on a proposal before it even reaches the publication stage." People were no longer seeing old houses as "very rundown slum buildings" simply because working-class and poor people lived there. He abandoned his plans.

In 1961, the neighborhood sought to develop a community center in the Unitarian Chapel with the assistance of Heights doyenne Gladys Darwin James and the chief executive of the Lincoln Savings Bank. The A.T. White Community Center opened in the former chapel in 1962 (the name was bestowed in 1967). It still houses the Heights Players, a well-respected amateur theatrical company. The former Columbia House, which backs up onto the chapel, was added to the center in the 1980s. Other original tenants included the Brooklyn Heights Community Nursery School and the Roosa School of Music. The St. Ann's School Preschool is now a principal tenant. The auditorium was named the Kaufman Auditorium to honor the foundation that paid off the building's mortgage not long after the community obtained control in 1962.

In 1960, the Willowtown Association joined with the BHA in support of establishing the Brooklyn Heights Historic District. However, the Willowtown Association was not successful in the 1970s in preventing Long Island College Hospital from taking over Upper Van Voorhees Park at Hicks Street and Atlantic Avenue as the site of a parking garage. The project was supported by the Cobble Hill Association, which got three vest-pocket parks on nearby Henry Street, since state law requires that lost parkland be replaced.

However, in 1996, Willowtown obtained the conversion of Atlantic Playground into Palmetto Playground at State Street and Columbia Place,

with new equipment and landscaping, improved basketball courts, a dog run and a community garden. Some of the funds came from the sale of Upper Van Voorhees Park.

In 2013, the playground's name was changed to Adam Yauch Playground in honor of the late Beastie Boy who grew up in the area. Known as "MCA," Yauch, who died in 2012 of cancer at age forty-seven, was the bass player for this rap group that produced the local anthem "No Sleep Till Brooklyn."

THE BEGINNINGS OF GENTRIFICATION

One of the few examples of old-time preservation is the gutting of a Greek Revival house on Joralemon Street to serve as a subway power substation, with its façade preserved—exactly the sort of thing that some decry for being allowed by the Landmarks Preservation Law.

At the neighborhood's low point in the 1940s, some investors began to see the possibility for profits in investing in old houses. The best known of these investors were Mildred and Donald Othmer. He taught at Polytechnic University. They lived frugally and invested with Warren Buffett but also bought houses around the Montague Street Promenade entrance, which they sold as prices rose. When they died in the 1990s, they left an estate approaching $1 billion to Polytechnic University, Long Island College Hospital (LICH) and the Brooklyn Historical Society. This good fortune was of dubious value to these institutions, which overexpanded and got themselves into trouble. Poly merged with New York University, LICH has closed and the historical society has associated with NYU and gone through many changes of administration in its efforts to obtain solvency.

A lesser-known example of local speculation is that the actor Gregory Peck owned the A.A. Low House between 1957 and 1960 via his White Fathers Film Foundation, Inc. He sold it to Darwin and Gladys James that year, who moved there from Long Island and also owned 178 Columbia Heights. It was bruited about the area at the time that landlords were demolishing buildings to avoid paying higher real estate taxes. Henrik Krogius reports that the owners of the high-rise at 1 Pierrepont Street purchased 222 Columbia Heights, the Cornell-Low House (chapter 4, figure 13), and demolished it in the 1950s to prevent an apartment building from obstructing their tenants' views. Its site was a sunken garden in the 1960s operated by the Brooklyn Heights Garden Club until purchased by Ian Bruce Eichner in 1977 (see below).

In Martin L. Schneider's (figure 7) phrase, the yuppies of the 1950s began to take advantage of low property values in Greenwich Village and Brooklyn Heights, areas they found charming, quaint and convenient. Otis Pratt and Nancy Pearsall (figure 8) moved to the Heights in 1956 and were among the first brownstoners. They were soon joined by others. Not everyone wanted to live in a high-rise or suburbia. As their numbers reached critical mass, they sought to become a force for physical preservation and political change.

The brownstoners came up with the answer to the urban crisis: homesteading in older areas of unwanted but gorgeous old townhouses that they purchased cheaply and fixed up themselves. This pattern was replicated around the city, in Greenwich Village, Park Slope, Cobble Hill, Fort Greene, Flatbush and the rest of what we consequently have come to call Brownstone Brooklyn, and then citywide and nationally. Today, while the national paradigm remains the suburb, there is a significant minority who treasure the Victorian townhouse and the urban values of community and neighborliness. They were assisted in the 1960s and '70s by the Brooklyn Union Gas Company's Cinderella Program, which rehabilitated deteriorated old buildings in strategic locations and then sold them to prospective homeowners.

In a world coming to resemble the gray monotony of the new Civic Center and a series of shopping malls, or else the hustle-bustle of corporate Manhattan, the Heights suggested streets you could explore not knowing what you would find, sure you would luck onto something different at every street corner or crook in the road. And as they said, it was only five minutes from Wall Street. Truman Capote ably stated the appeal of the Heights to the first brownstoners in his *A House on the Heights*:

> *These houses bespeak an age of able servants and solid fireside ease, invoke specters of bearded seafaring fathers and bonneted stay-at-home wives: devoted parents to great broods of future bankers and fashionable brides. Brave pioneers bringing brooms and buckets of paint, urban, ambitious young couples, by and large mid-rung in their Doctor–Lawyer–Wall Street–Whatever careers, eager to restore to the Heights its shattered qualities of circumspect, comfortable charm.*

The *New York World Telegram and Sun* reported in 1957:

> *If the current trend continues in another 10 years the Heights will be inhabited almost exclusively by artists, writers and sculptors, some bankers,*

Left: Figure 7. Martin L. Schneider in front of his Monroe Place townhouse in 1960. From Martin L. Schneider's *Battling for Brooklyn Heights*.

Below: Figure 8. Nancy Pearsall and Otis Pratt in 2014. *Robert Furman photograph*.

brokers and lawyers, and predominantly by commercial artists, press agents and people in television and advertising. At least partly because of this new infiltration, the fifty-odd blocks of mostly Victorian buildings that make up the Heights on the eminence opposite Downtown Manhattan are looking up—property values are up, and rooming houses are giving way.

Suleiman Osman quotes the following statistics in his *The Invention of Brownstone Brooklyn: Gentrification and the Search for Authenticity in Postwar New York*:

A full 36 percent of Heights residents moved there in the years 1958–60 alone...Between 1950 and 1960, the number of workers listed in the census as "professional and technical" or "manager, official or proprietor" rose from 40 to 48 percent, while in the rest of Brooklyn it fell from 23 to 20 percent...In the same decade, the number of Heights residents with some college education rose from one in three to 40 percent, compared to only 12 percent in Brooklyn as a whole.

Osman discusses the uncomfortable topic of the treatment of previous tenants by gentrifying newcomers, many of whom evicted simply because they didn't want to be landlords. Of course, others regarded tenants as a way of subsidizing their ownership by paying a large portion of the building's expenses. The older, poorer tenants might be replaced by more upwardly mobile stakeholders who were often younger versions of themselves.

In the 1950s, a low vacancy rate and high land acquisition costs conspired to produce only luxury housing in the private market in Manhattan while Brooklyn and Queens were seeing large-scale developers like Samuel Lefrak and the Donald's father, Fred Trump, build middle-income, unsubsidized housing. The echo of this in the Heights was much lower housing costs, especially comparing new apartments in the city to old houses in the neighborhood. In 1958, a new three-bedroom co-op in Manhattan could be purchased for $15,000, plus $175 per month in maintenance charges, compared to an entire four-story house in the Heights for $30,000 (but the latter required extensive renovation, which you might mostly do yourself).

In January through April 1957 alone, six houses on Sidney Place were converted from rooming houses to single-family. Several families united to buy rooming houses and flip them to new arrivals at comparatively low prices.

The Heights possessed a new ethos, what NYU English professor and local resident David Boroff called the via media, the middle course between city and suburb (of course, the Heights developed as a pre-automobile suburb).

He wrote, "Theirs is the vitality of the city without the penalties of big-city life, the grace of suburban living without its invasion of privacy. They dismiss the Great City as 'phony' and the suburbs as 'conformist.' Brooklyn, they insist, has the best of both worlds. Many streets had displayed several boarded-up houses to the world, plus a rooming house. By 1959, all of them were restored, and most were owner-occupied."

Gentrification further had the effect of reducing the general shabbiness of the neighborhood evident in photos from the 1920s on. Stores and services catering to the new element emerged, such as the St. George Playhouse, later the Heights Cinema; a dance studio on Montague Street featuring a fine arts gift shop; and art galleries all over the area, of which one survives. In fact, Hicks Street in Willowtown featured six galleries, known as the Hicks Street Artists Group, along with a coffeehouse, which still prospers.

Not everyone who moved there was a yuppie—many were beatniks: the bohemians, hippies or hipsters of the time. They built on the base of the artists, both gay and straight, who had preceded them, from the early twentieth century on but especially during the low-priced 1930s. Becoming tenants more than owners, they gave the neighborhood local color and a touch of eccentricity that was appealing to the professionals and businesspeople who were the core of the movement. The *Brooklyn Heights Press* reported, "The Heights is becoming a 'second village' and displaced Villagers have been pouring in since. They are among the Heights' most fervent devotees." The neighborhood was where beatniks moved when they got married, a "kind of Greenwich Village with a little less noise and a little less dirt," according to local Bertram Wolfe.

A strong gay subculture developed in the neighborhood in the 1940s and '50s. There was a gay bar, Danny's, on Montague Street and a local chapter of the Mattachine Society, the low-key pre-Stonewall group. Most importantly, gays were accepted, albeit with a lot of sarcastic scorn. The *Heights Press* noted in 1949, "We have no complaints about those 'dears' who are also in the area (although not as many as in Greenwich Village). They're a harmless lot, keeping pretty much to themselves."

But by the 1960s, resentment against a growing, public gay presence began to emerge amid police harassment and complaints about public trysting at a time when homophobia was still prevalent. This was also a result of families displacing gay tenants from gentrified houses. For a time, the Mattachine Society urged a boycott of the *Heights Press*. In the 1970s, a new newspaper, the *Phoenix*, owned by Mike Armstrong, who was later a public relations man for borough president Howard Golden,

explicitly catered to brownstoners, was much more tolerant and started a "Gay Voices" column, as the gay liberation movement began to demand that they be treated like anyone else.

During the 1970s, the Hotel Pierrepont, when it was seedy, housed a gay bathhouse called Men's Country, which occupied the basement and two full floors—the kind of place that was actually a trysting venue. Surviving ones were later closed down by the city health department as the AIDS epidemic spun out of control in the early 1980s. Men's Country also held dances. Among the groups playing the venue was the punk group the New York Dolls, whose front man was David Johansen. Given that the gay scene has always been an artistic incubator, this club is considered culturally significant.

But neighbors were not friendly, given that the Heights was a residential neighborhood. On September 24, 1973, the *New York Times* reported about Men's Country, "It consists of a pool, sauna and dance floor in the basement and rooms and meeting places on the upper two floors. The club advertises regularly in underground sex papers, according to local residents. On recent nights, a constant stream of men, singly and in couples, could be seen entering and leaving the club between 8:00 p.m. and 1:00 a.m."

Today, homophobia has declined, and while the local gay community is smaller, it is generally accepted. The major gay organization in brownstone Brooklyn is the Lambda Independent Democrats, a political club founded in 1978 by activists from Boerum Hill that remains a strong voice in party affairs. It lacks a clubhouse but has worked successfully on issues such as gay marriage.

In 1959, the Love Lane Garage applied for a variance to allow the enlargement of the doors on a plumbing supply storage business maintained in four carriage houses. The brownstoners objected because they wanted the area to be completely residential and considered industrial businesses a blight. The request was rejected.

In 1958, the brownstoners started a Reform Democratic club, the West Brooklyn Independent Democrats (WBID), to democratize politics and break the cozy relationship between Borough Hall, developers and the (still) corrupt Democratic organization. It was kicked off by a press conference at the Hotel Bossert attended by Eleanor Roosevelt and former governor and senator Herbert Lehman, who were sponsoring the effort to develop reform politics in New York. Leaders included Philip Jessup, Joseph Broadwin (who still lives in the area) and future Landmarks and City Planning commissioner Beverley Moss Spatt. They sought to take over the political leadership of

the Third Assembly District from the old Frank Cunningham organization. Club president Philip Jessup averred, "We are tired of one-man rule. One-man rule is the rule of the regular Democratic organization. Year after year the De Sapios and Cunninghams are allowed to hold on to their positions as party bosses." (Carmine De Sapio was a Greenwich Village Democratic district leader and New York county leader who epitomized boss control of the party. He was defeated in 1965 by Ed Koch, who went on to become a congressman and three-term mayor).

The 1970 census led to a redistricting that combined the Heights and South Brooklyn* into a new Fifty-second Assembly District, where it remains. That district now contains most of brownstone Brooklyn, including Park Slope and Carroll Gardens. The old Third Assembly District club was succeeded by the Mazzini Democratic Club on Union Street in Park Slope, led by "the sheriff" James V. Mangano, chief clerk of the State Supreme Court, who controlled the State Assembly and Senate seats, and, most importantly, city councilmember Thomas J. Cuite, the majority leader (the equivalent position to today's speaker). Cuite was an Irish American who lived in Windsor Terrace. Mangano gave his relatives important positions. His son Guy Mangano was the chief judge of the Appellate Division on Monroe Place, and Guy's son and namesake is a Supreme Court judge. Guy Sr.'s son-in-law Anthony Caracciolo was the district leader of the Fifty-first Assembly District in the late 1970s and Tom Cuite's senior aide. There is a shrine to Jimmy Mangano on the sixth floor of the old Supreme Court building.

WBID's high point was the 1972 reformist wave born of Senator George McGovern's anti–Vietnam War presidential candidacy. The group's success that year was aided by the unsuccessful congressional candidacy of Allard K. Lowenstein against longtime incumbent John Rooney. Lowenstein was a reformist gadfly who led the successful "Dump Johnson" movement and was elected to one term in the House of Representatives representing a district in Nassau County in the Johnson landslide year of 1964. WBID helped elect Heights attorney Carol Bellamy (figure 9) to the State Senate,

* An obsolete term, originally referring to the southern part of the original city of Brooklyn, south of Atlantic Avenue to Sixty-sixth Street. It was used until the 1970s to refer collectively refer to Park Slope, Boerum Hill, Cobble Hill, Carroll Gardens and, sometimes, Red Hook. It has been recently revived to describe southern Brooklyn neighborhoods (Gravesend, Brighton Beach, etc.), leading to some confusion since the term is also still used in its traditional sense to describe Red Hook and vicinity.

Figure 9. Senator Edward Kennedy (left) and then Congressman (later Governor) Hugh L. Carey, with Carol Bellamy (second from left) and Michael Pesce (second from right) in 1972, the year they were elected state senator and assembly member, respectively. *Courtesy of Judge Michael L. Pesce.*

along with Italian immigrant and lawyer Michael Pesce to the State Assembly from the still surviving Carroll Gardens–based Independent Neighborhood Democrats.

Bellamy was the paradigm of the new feminist woman who went on to become city council president (the equivalent position to today's public advocate), director of the Peace Corps under Bill Clinton and head of UNICEF, the United Nations' children's organization. Upon her elevation to council president, she was succeeded in the State Senate by WBID president Martin Connor, who served from 1978 until 2008 and was its Democratic leader for much of his tenure. Jimmy Mangano retired as district leader and chief clerk, and Councilman Cuite did not seek reelection in 1985. WBID shut down in 1990 in a dispute about whether to endorse the incumbent borough president Howard Golden, a regular Democrat.

THE BROWNSTONERS AND THE BROOKLYN HEIGHTS HISTORIC DISTRICT

There was significant new private apartment construction and townhouse modernization in the Heights from the 1940s to the '60s, and the brownstoners perceived that the historic character of the neighborhood was endangered. Otis Pearsall reported that on Willow Street alone, eight 1830s houses were razed between his arrival in 1956 and 1958, which caused him to begin seeking legal protection for the neighborhood's old houses.

Pearsall was from an old Brooklyn and Long Island family, still lives in the area and represents the Brooklyn Museum on the City's Public Design Commission. He led the preservation effort and traces its beginnings to a discussion with Jack Blum, son of the A&S president, who was a local homeowner in 1958, while the Pearsalls leased a basement apartment at 143 Willow Street. One late summer Saturday afternoon, they discussed the need for "aesthetic zoning" to protect the area. Clay Lancaster, a nationally known architectural historian who also resided in the area, organized a building survey and inventory of the neighborhood, which he wrote up as *Old Brooklyn Heights, New York's First Suburb.*

In 1958, the brownstoners formed a new organization called the Community Conservation and Improvement Council (CCIC) because of the reluctance of the BHA to embrace this new cause. Its leaders were Pearsall, Schneider and William R. Fisher, who was also active with the BHA, and they began meeting in the undercroft of the First Unitarian Church, then led by the Reverend Donald McKinney (chapter 6, figure 36), a veteran of the civil rights movement. They sought precedents and found two: the Beacon Hill Historic District in Boston and New York State's Bard Law, a one-paragraph enactment of 1956 that empowered cities to adopt local laws to protect "places, buildings, structures, works of art, and other objects having a special character or special historical or esthetic interest or value." It was written by Albert S. Bard (figure 10), the grand old man of preservation.

Albert Sprague Bard (1866–1963) (figure 10) was an attorney and civic activist concerned with the aesthetics of the city and honest government. Besides writing the Bard Law, he fought the proliferation of billboards, obtained their regulation, opposed Robert Moses on the Brooklyn Battery Bridge (see chapter 11) and helped save Castle Clinton in Battery Park. In 1897, he was a founder of the Citizens Union (see material on Seth Low in chapter 4) and president of the Municipal Art Society. In the 1920s, he unsuccessfully opposed the construction of the West Side Highway in Manhattan.

There was also substantial prior documentation of the area's architectural value, such as Huson Jackson's 1952 *Guide to New York Architecture*, prepared in association with the American Institute of Architects (AIA), the Municipal Art Society (MAS), the Society of Architectural Historians and Professor James Grote Van Derpool for an AIA convention; and *New York Landmarks*, the MAS's index of architecturally notable structures and others.

Preservation immediately engendered wide neighborhood support and was deemed newsworthy. The *Brooklyn Heights Press*, whose owner, Richard J. Margolis, supported the effort, published CCIC's Statement of Objectives in December 1958. It included the initial suggestion

Figure 10. Albert Bard. *Courtesy Sigma Chi Fraternity.*

for historic zoning, which attracted attention in part because of CCIC's rivalry with the better-established BHA. By February 1959, with the support of architectural historian Henry Hope Reed, CCIC and the BHA, they jointly announced their proposal for historic zoning.

The Municipal Art Society was instrumental in supporting preservation. CCIC wrote to its president, George Hopper Fitch, in February 1959. In response, Fitch appointed a subcommittee of the Committee on Historic Architecture to support the effort. It consisted of committee chair Alan Burnham, Reed and Bard, then ninety-two years old.

A well-attended town meeting on the proposal was held at the Hotel Bossert on April 21, 1959, and was publicized that morning by a *New York Times* article. It was hoped that a landmarks law might be added to the new Zoning Resolution then pending, and such a proposal had been drawn up by local zoning attorney Arden Rathkopf. But hearings in April and May indicated a lack of support from Planning Commission chair James Felt.

On April 23, the *Brooklyn Heights Press* published the first of six articles by Clay Lancaster that became his book. The material had earlier been presented by Lancaster in a neighborhood talk sponsored by the Junior League with color slides and was repeated at the Long Island Historical Society, the Brooklyn Museum and Brooklyn Friends School.

At the fifty-first annual meeting of the Brooklyn Heights Association on May 15, John Codman, a Boston realtor who had been instrumental in obtaining historic district status for Beacon Hill, pointed out that preservation would encourage neighborhood stability by providing for the reuse of old buildings and was therefore not naïve or idealistic.

There was a response from the city in July. Mayor Robert F. Wagner appointed a Committee for the Preservation of Structures of Historic and Esthetic Importance, chaired by Geoffrey Platt, to work with the City Planning Commission to develop a citywide preservation proposal.

Making elected officials into preservationists was clearly the next step. In October, CCIC met with City Planning Commission chair James Felt, who was supportive but felt that the Heights could not be designated a historic district absent a citywide enabling law. At the behest of Gladys Darwin James, the members met with Harmon Goldstone and Geoffrey Platt, both later Landmarks Commission chairs, at her home at 2 Pierrepont Place. They were mayoral committee members who were close to its chair. They arranged a meeting with Platt, who agreed with Felt.

On May 2, 1961, the *New York Times* ran an article by critic Brooks Atkinson characterizing the proposed Cadman Plaza high-rises (see chapter 11) as a plan that would upset the area's scale. He called the small houses a place where "children have a normal life in the gardens, on the stoops or in and out of the houses. The residents do not want this style of living replaced by what Professor James calls a 'dead-level apartment world, a one-class residential dormitory.'" He had read a pamphlet by Brooklyn College art professor Martin S. James, who, with Eric Salzman, was a leader of the North Heights Community Group, an organization that fought the Cadman Plaza plan.

The Museum of the City of New York sponsored a walking tour of the area on September 10, led by Henry Hope Reed, with a second on October 15 as part of the annual meeting of the National Trust for Historic Preservation in the city. Participants were given notes from Lancaster's forthcoming book, which appeared in December and received an illustrated review in the *New York Times*. The Municipal Art Society presented the book with a citation at city hall on May 15, 1961.

The BHA and the historical society held a luncheon in March 1962 with Congressman Hugh Carey, Borough Historian James "Jamie" Kelly and two officials from the National Parks Service, which supervises listings for the National Register of Historic Places. The next step was for the now merged organizations to submit the plan to the mayor and all other relevant elected

officials, which was done in April 1962 and included a proposed citywide statute, the boundaries of the proposed district and building research. The proposed Landmarks Preservation Law was drawn up by attorneys Allan McGrath and Otis Pearsall. This received supportive press coverage from three of the city's then six dailies.

Political support began to flow in the person of the late congressman (and later governor) Hugh L. Carey, who represented the area and endorsed the proposal at the BHA's annual meeting in 1962. That same month, in response to the uproar over the proposed demolition of Stanford White's Penn Station, the mayor upgraded the landmarks committee to the Landmarks Preservation Commission, giving it the form it still possesses. The *New York Herald Tribune* reported, "Builders of high-rise apartment houses have their eyes on the Heights, and Geoffrey Platt, Chairman of the Landmarks Preservation Commission, believes the district should have first priority in any effort to preserve what is left of old New York." In the summer of 1962, Pearsall, Felt and three others appeared on an episode of a WCBS-TV public affairs show dedicated to the issue.

The preservationists collected two thousand signatures—including those of a third of the affected property owners—supporting designation. But Congressman Carey opened the door to success by having Mayor Wagner appoint Heights organizer Bill Fisher to the Landmarks Commission.

The boundaries of the proposed district were controversial. The Cadman Plaza Urban Renewal Area had to be excluded because it was simply too far along to be stopped, although it included such major properties as the site of the Rome Brothers Print Shop (chapter 11, figure 25), where Walt Whitman's *Leaves of Grass* was first printed (even today, buildings of historical rather than architectural importance are problematic for the commission). The *New York Times* announced on July 21, 1963, that, among other things, the commission had tentatively designated a Brooklyn Heights Historic District as worthy of preservation.

That year, the activists began a project to salvage parts of buildings slated for demolition under the urban renewal. They obtained part of the fence of 97 Clark Street, the forty-foot-wide Ford Mansion (figure 11), which they planned to use in the restoration of the Peter C. Cornell House at 108 Pierrepont Street (chapter 5, figure 13) but that ended up in the Sculpture Garden of the Brooklyn Museum. An expedition into the doomed buildings, including 109 and 111 Clark Street (chapter 11, figure 22), yielded Federal and Greek Revival wood and marble mantels, a scroll-shaped mahogany newel post and a three-story circular stairway

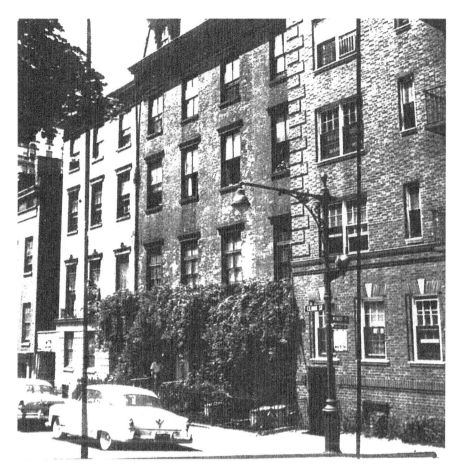

Figure 11. The Ford Mansion, 97 Clark Street, circa 1955. *Photograph by Clay Lancaster, courtesy Warwick Foundation.*

with wrought-iron posts and railings. These were displayed at the historical society and sold off. While we may find this offensive, it was better than their total loss, which was the alternative.

The block between Cadman Plaza West, Clinton and Pierrepont Streets was similarly excluded from the district although it contained the wonderful Brooklyn Savings Bank by Frank Freeman (chapter 8, figure 10)—a great loss. The late Eli Wilentz, of 56 Middagh Street, proprietor of the Eighth Street Bookshop in Greenwich Village, collected letters in favor of the bank's preservation from literary lions Robert Frost, Carl Sandburg, Marianne Moore and Arthur Miller, the latter two sometime Brooklyn residents. Although it qualified for four of the six points listed for National Register

status, it was turned down. (This would not have conferred protection—only cachet and a tax break.)

There was also consideration given to excluding the Court Street frontage below Livingston Street, the Montague Street commercial strip, the west side of Henry Street between Pineapple and Middagh Streets and the northernmost block in the Heights. Seeing that support for the district was stronger than they had imagined, the organizers kept these inside the proposed district. But the commercial blocks from Joralemon to Clark Streets west of Court Street were excluded since the priority at the time was protecting townhouses and churches (see below for the Borough Hall Skyscraper Historic District).

The BHA began to act as a Landmarks Commission in exile, organizing a Design Advisory Council to advise and assist homeowners in appropriate restoration strategies and advertising this to the neighborhood.

Although the proposed landmarks law, having gone through several revisions, was deemed ready for enactment in early 1963, it was not introduced into the council until October 6, 1964, probably due to political opposition from developers acted on by the Democratic organization that then controlled the council (and still does). For example, the price of the support of the Queens Democratic organization for Speaker Christine Quinn, elected in 2002, was that the chairmanship of the Land Use Committee, the council's most important, be a Queens member.

A public hearing on the proposed act was held on December 3 and was preceded by the delivery of a copy of Lancaster's book to every council member. Pearsall testified that Brooklyn Heights, "saved by the East River from the development experienced by similar areas in downtown Manhattan, and left behind as Brooklyn expanded out into its open areas," was "the finest remaining microcosm of our city as it looked more than one hundred years ago." He itemized the two greatest enemies of preservation: demolition of old houses for apartment-house development and ill-conceived modernization.

The neighborhood was designated a National Historic Site in January 1965, and the law was finally enacted by a unanimous council vote on April 6 and signed by Mayor Robert F. Wagner (figure 13). Apparently, it had become clear that preservation could save marginal areas and was therefore good for the real estate business.

Opposite: Figure 12. The Brooklyn Heights Historic District, established 1965. *Robert Furman Collection.*

BROOKLYN HEIGHTS HISTORIC DISTRICT

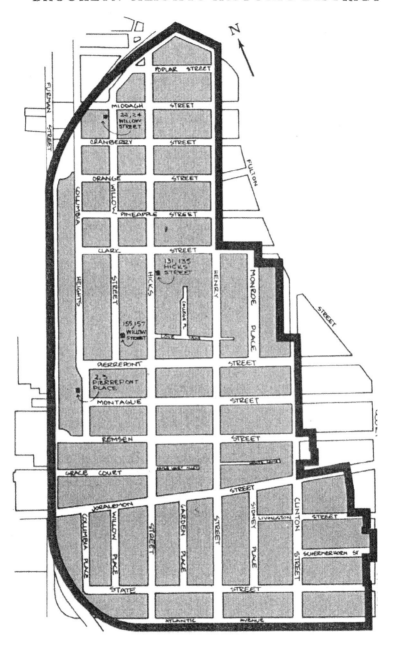

Figure 13. Mayor Robert F. Wagner signing the landmarks law in April 1965. From Martin L. Schneider's *Battling for Brooklyn Heights*.

A public hearing on the Heights historic district designation (figure 12) was held by the Landmarks Commission on November 17, and just six days later, it issued its three-page designation decision. Thus was historic preservation set into decisive motion in New York City. Amid overwhelming support, there was an indication of things to come in the opposition of two major local institutions that were, not coincidentally, major property owners: St. Francis College and the Watchtower Society. The college had purchased the Behr mansion and feared the effects of designation but later withdrew its opposition.

The law should have been enacted earlier. In 1964 alone, many buildings were lost, condemned for the urban renewal. Included are the following razed for the Cadman Plaza development and listed in the Lancaster book: 29 and 89 Henry Street, 8 Monroe Place, 29 and 31 Clinton Street and 91, 93, 95 and 97 Clark Street (figure 11).

At the time the law was enacted, the preservationists heard that the Watchtower Society planned to purchase as much as possible of the block bounded by Columbia Heights and Clark, Willow and Pineapple Streets

in order to construct a twelve-story "community facility," a zoning device allowing larger buildings than would otherwise be allowable. While the landmarks law did not address zoning within historic districts, the fact that the law forbade demolition within historic districts except under very limited circumstances mitigated against the plan. The Heights consulted with Beverly Moss Spatt, then a planning commissioner, and the planning department issued an opinion in agreement with the preservationist position. It appeared to prevent the proposed action.

In order to permanently solve the problem of new out-of-scale construction in the Heights, activists requested a fifty-foot height limit for new construction—that figure being selected since it was the approximate height of existing houses. The City Planning Commission responded that, again, it did not wish to adopt a rule for one neighborhood and proposed a range of choices for height limits: fifty, seventy and one hundred feet. The Heights was able to obtain enactment of the rule by convincing borough president Abe Stark of the justice of the cause. Such matters were then decided by the Board of Estimate, where items that affected one borough were decided by the borough president. The Heights thus became the first LH-1, or fifty-foot, Limited Height District.

The neighborhood was able to reach a compromise with the Jehovah's Witnesses, who gave up the twelve-story building but were allowed to build new structures behind the streetwall that barely exceeded the height limit (figure 1).

Maintaining the Gains

The brownstoners got the law amended to require that new buildings put up on vacant land in historic districts be in character with the district. But the history of this part of the law has been mixed. In 1980, developer Ian Bruce Eichner purchased the site of 222 Columbia Heights for $30,000 and presented a design to the Landmarks Preservation Commission for a luxurious modernist house (figure 14) that would utilize the proportions of the old Cornell-Low House. The community sought a retro design more in keeping with the area, but the commission nevertheless issued a Certificate of Appropriateness.

A bright spot in preservation is that many houses that were "modernized" in the 1950s and '60s have been restored to their original form under the

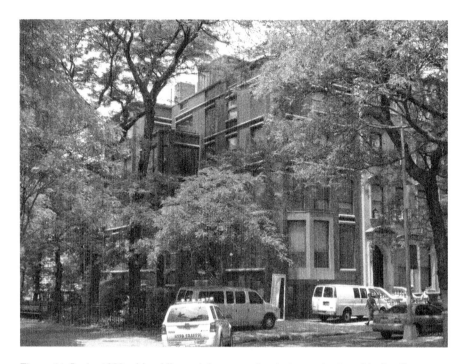

Figure 14. In the 1980s, this oddly reminiscent modernist house developed by Ian Bruce Eichner rose at 222 Columbia Heights on the Cornell-Low House site but retained its contours. *Robert Furman photograph.*

supervision of the Landmarks Commission. The landmarks law thus had the positive effect of encouraging restoration of old houses, although this is not required (it legally freezes conditions at the point of designation). Among early restorations were clapboard installation on shabby 31 and 33 Middagh Street (rather than the existing stucco) and 38 and 40 Hicks Street. Number 157 Columbia Heights received the old balcony from 97 Clark Street, and the doorway of 100 Hicks Street was replaced with an era-appropriate one. Lead from the transom and sidelights of 157 Willow Street was restored, and in 1976, the stoops of 45 Sidney Place and the Hastings House at 36 Pierrepont Street were returned to their original condition. Another example is 36 Grace Court (chapter 5, figure 21), which, except for its window frames, is unrecognizable as a restoration. It won a Lucy Moses Prize from the New York Landmarks Conservancy.

Other parts of the neighborhood had similar outcomes, including Willowtown, where new houses more in character with the historic district were built, such as 5 Columbia Place (36 Joralemon Street). Of course, as

indicated herein, many stoop removals, such as the particularly attractive one on the Richard Salter Storrs House at 80 Pierrepont Street, remain unremedied. Vandalism remains a problem, the most notorious example of which is the theft of one of the cast-iron urns from the front of 46 Monroe Place. In addition, the frieze windows of the A.A. Low House (chapter 4, figure 15) at 3 Pierrepont Place were cut down in 1968. Recently, an opinion has grown up and been implemented by the commission that modernist structures might be more interesting than mediocre imitation brownstones.

The above may serve and is intended to serve as a guide to other neighborhoods and perhaps cities interested in historic preservation, with the caveat that the Heights had then, as it does now, a rather unusual core of professionals and power brokers not found everywhere.

Maintaining the area's respectability has been a long-term struggle. A topless bar called Club Wildfyre at 71 Pineapple Street, west of Henry Street, operated in the 1970s and '80s and remained a blight even after it closed under neighborhood pressure, since its building remained a slum. A vacant lot next door at 173 Pineapple is now occupied by a small apartment building, which, while recognizably contemporary, is remarkable for its respect for its physical context.

A worse case was the Hotel Pierrepont, which was a haunt for prostitutes during its period as a single-room occupancy hotel in the 1970s. It may have been controlled by Harlem drug Kingpin Leroy "Nicky" Barnes. The *New York Times* reported on September 24, 1973, that a neighbor said, "It's unbelievable. The whores shout down from the windows to their pimps on the sidewalk and the pimps shout back. Sometimes the girls hang out of the windows stark naked…Drunks and addicts stagger across the street, urinate on our walls, then sit nodding on our steps. Men come at all hours of the night shouting and looking for the prostitutes and there are fights and knifings right here in front of my house."

One of the ugliest structures in the city is the multiplex theater building at 106 Court Street at Schermerhorn Street (figure 15) (although this is an opinion not universally shared). In its bulk and coloration, it simply does not work and is a modern blight. It is just outside the historic district.

Developers have sought to alter buildings in the historic district to increase their upper-end marketability. The owner of the former Mason Peaks Candy Factory (chapter 8, figure 6) on Henry and Middagh Streets has been allowed, over BHA objections, to build in its sculpture garden.

This privilege was also granted at the Riverside Building, but the state Department of Housing and Community Renewal prevented it since the

Figure 15. This multiplex theater building at 106 Court Street at Schermerhorn Street is, in our opinion, an architectural disaster. Architect and activist Jane McGroarty calls it an "argyle sock." The attempts to provide some visual interest with bands of varied color and texture are unsuccessful. In fact, a simple wall or a continuation of the motif of the lower, store floor would have been much better. Fortunately, its location on the edge of the Heights on a major commercial street minimizes its impact. *Robert Furman photograph.*

apartments are rent-controlled. The building at 135 Joralemon Street (chapter 5, figure 2) is the only Federal wooden house in the south Heights and was the subject of a successful "demolition by neglect" action by the Landmarks Commission. It has since been restored.

An unusual case in preservation is 100 Clark Street. This five-story 1890 building with a mansard roof was partially demolished and evacuated by the New York City Buildings Department over the Memorial Day weekend in 2008 on an emergency basis because of serious structural problems. The BHA and the Landmarks Commission managed to limit the destruction to the top two floors. It was sold in November 2010, and in 2014, owner Newcastle Realty Services announced it would go ahead with reconstruction of the building with the support of the Landmarks Commission in a modern version of the original structure.

In honor of the bicentennial of the nation's independence in 1976, a sign about Fort Brooklyn was placed in front of the Appellate Division of the New York State Supreme Court on Monroe Place. It stated that when 60 Pierrepont Street was constructed in 1848, a body with a European sword used by Americans was unearthed. The sign is gone.

The New Immigrants and Atlantic Avenue

Since the 1940s, a vibrant Near Eastern neighborhood has flourished on both sides of Atlantic Avenue in the Heights and Cobble Hill. These immigrants from Syria and Lebanon came to Brooklyn because the construction of the Brooklyn-Battery Tunnel razed their former home turf on West Street in lower Manhattan, where they had begun to assemble in 1890 and where St. Joseph's was their church. The community was initially composed of Christian Arabs migrating from Aleppo, Syria and, later, Lebanon and Israel. With the rise of Arab nationalism, they began emigrating from other countries as well.

There were also people who came to America for the reasons most immigrants do. With the termination of the national origins immigration quota system in 1965, Muslims have joined their Christian brothers and sisters here, and the neighborhood has expanded toward Third and Fourth Avenues as property values in the original zone have skyrocketed.

In 1903, the newcomers purchased 295–97 Hicks Street in Cobble Hill and converted these houses into a church. In 1944, the disused former Church of the Pilgrims building at Remsen and Henry Streets became Our Lady of Lebanon Maronite Rite Roman Catholic Cathedral (figure 16), under the leadership of Father Stephen Mansour. The spires damaged in the Great Hurricane of 1938 were removed. The church also purchased the building next door at 113 Remsen Street.

In 1942, the Art Deco French ocean liner *Normandie*, which had been the height of international elegance in the 1930s, burned and capsized at its berth on the Hudson River while undergoing conversion into a troopship. It had been seized as enemy property of the collaborationist Vichy French regime. At the time, it was thought by many that the fire was an act of sabotage, fears of a German "fifth column" having been whipped up as war propaganda. There was an active pro-Nazi German-American element, especially in Manhattan's Yorkville neighborhood,

Figure 16. Our Lady of Lebanon in 1954. It is the same today. *Brian Merlis Collection.*

of which the best-known organization was the German-American Bund. Although it was quickly discovered that the fire was caused by sparks from a workman's oxyacetylene torch, the myth survived and was portrayed in the Alfred Hitchcock film *Saboteur,* in which actor Norman Lloyd, portraying the arsonist Frank Fry, smirks as he passes the pathetic, capsized and burned wreck.

Left: Figure 17. The medallions from the dining room doors of the capsized French liner *Normandie* were mounted on new brass doors on Our Lady of Lebanon. These Henry Street doors sport six medallions. *Robert Furman photograph.*

Right: Figure 18. The Remsen Street doors show four medallions. *Robert Furman photograph.*

In 1945, brass doors from the ship's dining room were purchased at auction by the church. Since they did not fit the building's entranceway, new doors were purchased (which replaced the old wooden ones) (figures 17 and 18), and the ten medallions from the ship's dining room were rearranged on them. Nine show Norman cities, and one portrays the sister ship *Ile de France*, which remained in service until the 1960s, when it was replaced by the SS *France*. New stained-glass windows replaced the original Tiffany ones removed to Plymouth after the merger with Pilgrims. They were made in the new "Gemmaux method" by Jean Crotti in 1953. But problems developed with them in the 1950s, so they were replaced with new windows by the Lebanese artist Saliba Douaihy.

The church's pastor is the Very Reverend James A. Root. The church is also the Mother Church of the Diocese of St. Maron, whose bishop is the Most Reverend Gregory John Mansour. Besides serving as a religious home for the Near Eastern Christian community, it also houses the Brooklyn Autism Center. The church has recently developed an interest in the Congregational Church of the Pilgrims, the previous occupant of its

building, and has begun to research its abolitionist history. I have assisted in this process so that it is not forgotten.

Over the years, the church has been a cultural center for New York's Arab community. Meyer Berger, a *New York Times* columnist, reported on July 6, 1953, that the renowned Egyptian violinist Sami El Shawa, the "Prince of the Violin," played at the Brooklyn Academy of Music and the St. George Hotel to an audience of Maronite Catholics, principally from Lebanon, although his music was based on Koranic themes. At the time, there were about fifty thousand Arab-Americans in the New York area.

Over the years, many ethnic food stores, clothing stores and restaurants have located here. The oldest and most famous is Sahadi Importing Company (figure 19), which is known worldwide. It is the sort of place New Yorkers tend to take for granted, offering fine quality fresh food and imports at low prices, but it is also an establishment to which people from other places flock since they don't exist elsewhere. It was founded on Washington Street in Manhattan in 1895 and moved to Atlantic Avenue in 1948 as the Arab community relocated to Brooklyn. It now occupies much of the buildings at

Figure 19. Sahadi Importing Company, nos. 187, 189, 191 and 193 Atlantic Avenue. *Robert Furman photograph.*

Figure 20. Store owner Charlie Sahadi in front of his display case of thirty-seven different types of olives. *Robert Furman photograph.*

187, 189 and 191 Atlantic Avenue. The owners are Bob and Charlie Sahadi (figure 20), who take great pride in this world-class operation. Another well-known store is Damascus Bakery. The Atlantic Avenue commercial district, which featured many antique stores in the 1970s and '80s, continues to hold its own in the face of economic competition and gentrification.

In 1974, the first Atlantic Antic was held along the avenue between the waterfront and Flatbush Avenue. Begun as an ANTiques and Crafts fair, it has become a street fair with the decline of the large antiques district along the avenue. Thirty-five Antics have been held, every September, with the exception of 2001 because of the 9/11 terrorist attacks. They draw hundreds of thousands of people and are the second-largest public event in Brooklyn after the West Indian Day Parade on Eastern Parkway held on Labor Day.

NEWER HISTORIC DISTRICTS

The Fulton Ferry Historic District, designated in 1977, includes a few buildings on the Heights side of Old Fulton Street, most notably the original Romanesque Revival Eagle Warehouse (now apartments), by Frank Freeman. (In former times, the northern boundary of the Heights was Fulton Street, but with the construction of the BQE, the line has moved south to the highway. We continue to utilize the old one here for pre-expressway purposes.) The Brooklyn City Rail Road Building at 8 Old Fulton, of 1861, which was separately designated a landmark in 1973, is a notable structure in the Fulton Ferry Historic District. It is an Italianate brick building with a cast-iron façade.

Most significantly, on September 14, 2011, the Landmarks Commission approved the Borough Hall Skyscraper Historic District (figure 21), ratified by the council in 2012, comprising twenty buildings on Pierrepont, Montague and Court Streets, as well as Borough Hall and the Municipal Building on Joralemon Street between Court and Boerum Place/Adams Streets.

First proposed by the Brooklyn Heights Association and Heights sage Otis Pratt Pearsall, this action was necessary because of the lack of protection for parts of the Heights omitted from the original historic district and the demolition by St. Francis College of the lovely mid-nineteenth-century Greek Revival former Brooklyn Union Gas Company headquarters on Remsen Street.

Included are such iconic buildings as the Temple Bar at 44 Court Street (chapter 9, figure 6); the Deco-Gothic Brooklyn Chamber of Commerce Building at 66 Court, now 75 Livingston (chapter 9, figure 7); 16, 26 and 32 Court Street (chapter 9, figure 5); the Neo-Gothic Diocese of Brooklyn headquarters at 191 Joralemon Street (chapter 11, figure 21); the Brooklyn Law School residence hall at 184 Joralemon; the A.A. Low & Brother building at 186 Remsen (chapter 11, figure 18); and the Lawyers Title Company Building at 188 Montague. Also included in the district are the low-rise 1920s Lawyers Mortgage Company Building at 186 Montague and 193 Joralemon Street.

The principal source of opposition to designation was from the cooperators at 75 Livingston Street who, like other homeowners, are concerned about possible increased costs and their freedom to alter their property.

The modern-façade offices at 200 Montague Street (ironically, this is a blank-wall modernization of two lovely turn-of-the-century buildings), 175 Remsen Street, 186 Joralemon Street and 50, 52, 56 and 60 Court Street are included as non-contributing structures to provide contiguity.

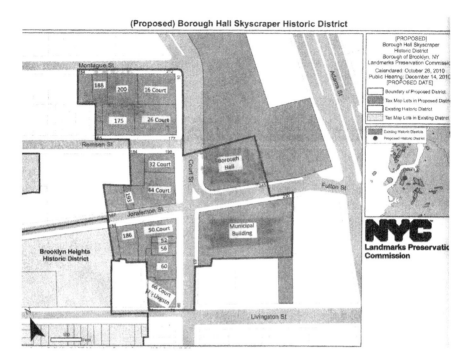

Figure 21. The Borough Hall Skyscraper Historic District. For clarity, we have added building names and addresses to this LPC-produced map.

Borough Hall, already an individual landmark, was added to the district, along with the (in my opinion) stultifying Municipal Building.

Omitted from the district is the "bank row" on the north side of Montague Street near Clinton Street between Cadman Plaza West and Clinton Street, including the Brooklyn Trust Company (Chase) building (chapter 8, figure 12), the People's Trust Company (Citibank) (chapter 8, figure 13) and the National Guaranty Trust Building (chapter 8, figure 14), which Heights activists had sought. A demolition permit was granted in March 2015 for 189 Montague Street, possibly for conversion into a hotel. This is indicative of developers nibbling around the edges of the neighborhood and replacing low-rise buildings with larger ones where they are unprotected. Other examples include the replacement of the Brooklyn Heights Business Library and several buildings on the north side of Remsen Street and the south side of Montague Street between Court and Clinton Streets, which are all absent from any historic district.

On January 4, 2011, the Landmarks Commission held a special hearing on 186 Remsen Street, one of the buildings included in the Skyscraper District. This was occasioned by the owners' statement that it was "unstable," indicating a possible desire to demolish or greatly alter it. However, the owners agreed to not take any action until the commission acted, so the designation renders their concerns moot. The commission noted that 186 Remsen was built in 1887 by A.A. Low and Brothers, the family firm, and was reduced in height by one story around 1950.

The former Brooklyn Union Gas Company headquarters building at 180 Remsen Street (chapter 11, figure 18), adjacent to the Borough Hall Skyscraper Historic District and now part of St. Francis College, was separately granted landmarks status by the LPC on May 10, 2011.

BROOKLYN BRIDGE PARK

Brooklyn Bridge Park (figure 22) has been under development for twenty-five years as an alternative use for the mostly disused piers on Furman Street below the Promenade. In 1983, a representative of the Port Authority of New York and New Jersey contacted Tony Manheim, who was then president of the Brooklyn Heights Association, to solicit ideas for the piers, since they were deemed no longer viable. Manheim, Otis Pratt Pearsall and former BHA president Scott Hand worked out a park plan that was presented to the community and the Port Authority and formed an organization to effectuate it called the Brooklyn Bridge Park Coalition, with offices at 334 Furman Street.

At this writing, the park is under construction and includes some unusual amenities, such as a marina and the restoration of some of the original wetland shoreline. A high berm separates the park from and conceals the BQE from park visitors. An Italian restaurant called Fornino's opened on top of Pier Six north of Atlantic Avenue in 2014. A pedestrian bridge from Squibb Park in the north Heights has been completed but was closed because it was unstable.

The sticking point throughout the process has always been how to pay for the park's upkeep since the New York City Department of Parks is chronically short of funds. Parks is always a candidate for budget cuts in lean times since it is a lower-priority agency than the police, fire and education departments. The state and city have therefore planned to build luxury housing to help support the park, the modern version of the panacea of urban renewal.

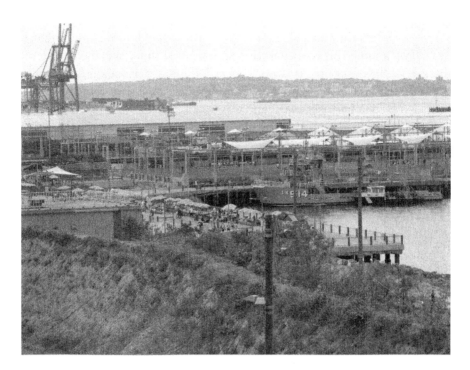

Figure 22. Pier One in Brooklyn Bridge Park. *Robert Furman photograph.*

New York State constructed a new state park northeast of Old Fulton Street called Empire State Park, including the DUMBO tobacco warehouse, to be part of Brooklyn Bridge Park. The late assemblywoman Eileen Dugan obtained $250,000 for a feasibility study in 1997, which concluded that an on-site conference hotel could pay the expenses for the main part of the park, Piers One through Six. However, the Empire State Development Corporation decided that not only would normal park maintenance need to be paid for by on-site uses but also that site maintenance, especially keeping the pier pilings stable, would be included in the park's financial burden, which massively raised the estimated costs.

In 1986, the Port Authority and City Planning Commission proposed building several fifteen-story apartment towers. The Authority attempted to do an end run around the activist community, which opposed the proposed height, to obtain local support by requesting approval from Community Board Two, which—after several hearings and much debate—opposed the proposal.

The Brooklyn Bridge Park Development Corporation is considering devoting property tax revenue from buildings owned by the Jehovah's

Witnesses (when they are sold and rezoned for private housing) for park use instead of adding this money to the city's general fund. But the timing of the sale of this property is open to question, as it may take a long time. Some locals continue to oppose the construction of housing in the park; the Brooklyn Bridge Park Defense Fund was established to this end.

During construction in 2010, the project was taken over by the city due to the state's fiscal difficulties, with the controlling entity called the Brooklyn Bridge Park Development Corporation, as it has been. The board is composed of veteran park and political activists such as Joanne Witty; former senator Martin Connor, who prevailed on former governor George Pataki to support it; and current state elected officials.

Toll Brothers City Living and Starwood Capital Group plan to construct two glass buildings, called Pierhouse (figure 23), at 60 Furman Street in the park grounds, containing 125 one- to five-bedroom condo apartments to sell from $800,000 to $5 million to finance park maintenance. This became a major issue in 2014 because it obstructs the view of the Brooklyn Bridge from the Promenade, which is protected by a "view corridor." Another apartment building is planned for the south end of the park, which is more controversial because it would be a high-rise.

Figure 23. Pierhouse is the controversial condo building planned for Brooklyn Bridge Park. *Developer image.*

The house at 80 State Street was, from 1990 until 2003, owned by the city, which gave use of it to the schools chancellor as his primary residence. With the dissolution of the Board of Education and the sale of its former headquarters at 110 Livingston Street, the house was auctioned off to a private owner in 2003.

After a renovation during which it was closed for many years, Squibb Park, at the shoreline at the fruit streets (Cranberry, Pineapple, Orange), named for the nearby former drug manufacturing plant and its founder, was reopened in October 2010 as a skateboard venue. A bridge to connect Squibb to Brooklyn Bridge Park was constructed and was open until it developed instability problems.

Conclusions

Figure 24 is the world-famous iconic view of Manhattan from the Brooklyn Heights Promenade.

Today, Brooklyn Heights has completed its metamorphosis from shabby gentility into one of the most desirable and expensive neighborhoods in New York City. Current problems remain: neighborhood preservation in the face of possible overdevelopment and commercial sterility as sky-high rents outprice neighborhood merchants who are increasingly replaced by national chains. An interesting phenomenon in the modern history of the Heights is the conversion of almost everything to residential uses, including churches, office buildings, garages and former factories, under the influence of landmarking, which prevents demolition, the collapse of demand for other non-store uses and a strong residential real estate market; witness the conversion of the upper floors of the Brooklyn Trust Company Building (Chase) into apartments.

Although not as prominent as it was in its glory days, the neighborhood's quaint charm continues to draw numerous famous people here such as PBS announcer Tom Stewart, who is the host of the BHA's annual meetings; attorney Barry Scheck; movie historian Neal Gabler, who hosts PBS's *Cinema 13*; historian Ron Chernow, who won the 2010 Pulitzer Prize in History for a biography of George Washington; and educational reformer Diane Ravitch. The *Wall Street Journal* columnist and Ronald Reagan speechwriter Peggy Noonan lived here for a few years. Maggie Haberman, daughter of former *New York Times* columnist Clyde Haberman and herself a senior reporter

Figure 24. Thousands of New Yorkers spontaneously gathered here after September 11, 2001, to grieve. Note the pre-9/11 photo of Lower Manhattan in this 2002 view. The warehouses have been razed for Brooklyn Bridge Park. *Robert Furman photograph.*

for *Politico*, and her husband, reporter Dareh Gregorian, son of Carnegie Foundation president and former New York Public Library president Vartan Gregorian, also live here.

Another significant resident is Theodore Roosevelt IV, the great-grandson of the president, who worked as an investment banker but has been active in local, state and national affairs as a moderate Republican (technically, he is Theodore Roosevelt V, since the president's father was Theodore Roosevelt Sr.). He held an unpaid state office as a member of former Republican governor George Pataki's State Parks Commission for New York City, along with the chairmanship of the Brooklyn Bridge Park Conservancy. He addressed the 2000 Republican convention that nominated George W. Bush and was associated with former New Jersey governor Christine Todd Whitman, who was Bush's Environmental Protection Agency director until she resigned in protest. In 2004, Roosevelt quietly did fundraising for the Democratic nominee, John Kerry, as a member of Republicans for Kerry, indicating the national decline of moderate Republicans.

The neighborhood also has many fine restaurants, especially on Henry Street between Cranberry and Middagh Streets in the north Heights, which formerly were located solely on Montague Street. The first was Henry's End, a gourmet venue featuring farm-raised game animals. There is also an Italian restaurant called Noodle Pudding. They were joined by Le Petit Marche, a nouveau French place, which won a design award from the Brooklyn Heights Association but was closed by the city health department and did not survive after it reopened. Two others have since occupied the space (figure 25). The block also sports the Brooklyn Heights Wine Bar. Jack the Horse nearby on Hicks Street is a highly rated newcomer. In addition, some old standard restaurants, such as Armando's on Montague Street, have been reborn as upper-end houses, although old-fashioned American restaurants such as Patricia Murphy's Candlelight Restaurant and, more recently, Foffe's and Capulet's on Montague (where Judy Garland is said to have performed impromptu) are gone, the latter replaced first by Clover Hill, mostly notable for its name, and then by Café Buon Gusto.

Figure 25. The restaurant row on the west side of Henry Street between Cranberry and Middagh Streets in March 2012. From left, it included the Brooklyn Heights Wine Bar, the Rawalpindi Indian restaurant, Noodle Pudding and Henry's End. The low-rise at the far right at the corner of Middagh Street, which housed the *Brooklyn Eagle*, has been demolished. *Robert Furman photograph.*

The Pierrepont House restaurant survived into the 1980s in the office building at 153 Pierrepont Street. A coffee shop called Woerner's on the north side of Remsen Street between Court and Clinton Streets was famous as the dwelling place of politicians, including Meade Esposito, the leader of the Democratic Party in the 1970s. Since it closed, its function has been filled by the Park Plaza Diner on Cadman Plaza West in the Cadman Plaza development, which benefits from its location near the new court buildings.

Montero's, a Spanish restaurant and former sailors' bar on Atlantic Avenue, still survives. In addition, the neighborhood has lost numerous bars because of lower drinking rates and higher rents. As in other gentrified areas, small, moderately priced independent places are being replaced either by chain stores or upper-end venues.

Entertainment and the arts continue to thrive, although not as avidly as they once did, with the continued prosperity of the Heights Players, an amateur theatrical group that presents its shows at the Willow Place community center. Movie theaters have included the now-closed Heights Cinema on upper Henry Street, which changed hands because of criminal charges brought against the former owner, and the first-run multiplex theater on Court Street between State and Schermerhorn Streets (which might be the ugliest building in the city), not to mention several art galleries. There was an art fair on the Promenade in the 1970s and '80s. Several area churches sponsor concerts, including St. Ann's of the Holy Trinity and Grace Episcopal.

Commercial development pressures are being felt on upper Henry Street. Low-rise commercial buildings on its west side between Pineapple and Poplar Streets are being replaced by larger ones within the context of the fifty-foot height limit. The taxpayer buildings housing the *Brooklyn Eagle* and the Heights Cinema have been replaced under the supervision of the Landmarks Commission and the Brooklyn Heights Association. The newspapers have moved to DUMBO. A new contextual apartment building on the southwest corner of Poplar Street was completed in 2012 with the cooperation of the aforementioned organizations. The apartment conversion of the former Mason-Peaks Candy factory into thirty-eight luxury condos is complete, which will restore its former lobby, along with putting up a new building in its courtyard.

Commercial development may provide an opportunity to redevelop the Brooklyn Heights library (chapter 11, figure 6). Its central air conditioning system requires replacement, which is too expensive for the Brooklyn Public Library, but it is proposed to sell its air rights to a developer who would

replace the neighborhood library portion of the building, with the business library moving to Grand Army Plaza. This is clearly controversial.

The neighborhood has been a longtime favorite with movie companies for location production, including a scene from *The Godfather* in the former St. George Hotel bar, where Don Corleone's (Marlon Brando) enforcer Luca Brasi is killed. The etched glass fish near the door are especially poignant since the family later notes that he "sleeps with the fishes." A black comedy homage to this film, John Huston's 1985 *Prizzi's Honor*, was largely filmed here. An Italian wedding scene was filmed in and outside of St. Ann's of the Holy Trinity, standing in for a Catholic church, and a Mafia confab takes place in the A.A. Low House. Jack Nicholson's hit man character resides in 57 Montague Street. Many of the exterior shots of *Moonstruck*, in which Cher's character's family lives in 19 Cranberry Street (chapter 4, figure 27), were filmed here, though the interiors were shot in Toronto, which often stands in for New York for economic reasons. Parts of many other movies have been shot in the neighborhood, including the Woody Allen film *Bullets Over Broadway* and Martin Scorsese's *Taxi Driver* and *The Age of Innocence*, in which an outdoor winter scene was shot on Remsen Street on a blistering July day using fake snow. Interior shots of the Coen brothers' *Burn After Reading* were done on the first floor of 104 Willow Street. It seems that there is always a movie or TV shoot going on, especially of the New York standby *Law and Order* franchise, which also uses Borough Hall to portray a courthouse, as do many feature films, including everything from the 1994 Arnold Schwarzenegger vehicle *Eraser* to *The Notorious Bettie Page*. An unusual shoot was *Men in Black 3*, which took over much of the neighborhood in May 2011, during which Will Smith's monster trailer elicited many disparaging comments. What was remarkable, however, was that Court Street from Montague Street to Atlantic Avenue was filled with 1960s vintage cars.

The *Brooklyn Eagle* has been reborn as a daily and weekly newspaper focusing on real estate and legal notices. The same company, Everything Brooklyn Media, founded by L. Dozier Hasty and the late Fred Halla, also publishes the *Brooklyn Heights Press* and *Cobble Hill News*. There are numerous other local newspapers covering Brooklyn and the Heights in particular, including the *Brooklyn Paper* and the *Courier*, which were purchased in 2009 by Rupert Murdoch's News Corporation. The Queens-based *Star* also covers the area. Prominent among new media sites is the Brooklyn Heights Blog operated by John Loscalzo, which posted parts of this book.

The Brooklyn Heights Association, under the leadership of effective presidents and, since 1989, Executive Director Judy Stanton, is influential

in the 1970s development of the area, especially on issues involving the City Landmarks Preservation and City Planning Commissions. Stanton has announced her intention to retire in August 2015.

Although it does not have a significant nonwhite population since segregation in New York City is based mostly on economics, the neighborhood is today more ethnically diverse than ever, since there are now wealthy people and strivers of every ethnic group. There are now three synagogues in the Heights, and the First Unitarian Church (see chapter 6) is a haven for Christian-Jewish intermarriages. It dropped the Church of the Saviour part of its name in 2010 to indicate that it is no longer Christian.

When Brooklyn is called the "borough of churches" (previously the "city of homes and churches"), we think of the religious diversity of the twentieth century and today. But nineteenth-century Brooklyn was overwhelmingly Protestant and proper, which may be seen in the huge number of Dutch Reformed, Methodist, Baptist, Lutheran, Episcopal and Presbyterian churches that are underutilized or demolished or have been shared with or sold to new arrivals or for other uses. But Brooklyn Heights and Cobble Hill, which were the capital of the WASP establishment, are the only areas in Brooklyn where this ethnic heritage is preserved, in large part because some stayed into the 1950s and '60s, but also because institutions such as the Heights Casino still function. The yuppie influx gathers in response to this ethos and projects it into the future, but its roots are in a dim and distant past of farms, country houses, churches and gardens.

While the Heights does not possess the amazing galaxy of stars of the mid-nineteenth century, it is now a wealthy neighborhood of law partners, Wall Street brokers, doctors and trust-fund babies, with the occasional movie star thrown in. The Heights has come full circle from its urban beginnings as a home for the elite to a neighborhood in decline facing the bulldozer and now back to much of what it once was. The quality of its housing stock has been, in large part, responsible for its renaissance. But we can also see that just like today, the early developers and officials, although they planned a model community, chose to ignore its past as they rushed headlong into the future. While the Philip Livingston House burned, Four Chimneys was razed to construct a ramp down to the river to accommodate a ferry service that was never profitable, is only a memory and whose only physical remnants are the jog of Columbia Heights at Montague Street and a variety store on Clark Street called Penny Bridge. The Cornell-Pierrepont House, which had been George Washington's

headquarters during the Battle of Brooklyn, would certainly have been landmarked had it survived and should have been moved in 1846.

As in most neighborhoods in New York City, the Heights experiences either feast or famine in real estate. The model is always that either nothing is desirable or everything costs too much, which is the situation today. The effect of this is to lock the middle class out of the neighborhood, not to mention the working poor. While this price pressure creates upward movement in previously undesirable areas, such as Bedford-Stuyvesant, the price is the loss of economic diversity in wealthy ones. While the Jehovah's Witnesses organization is selling property, Brooklyn Law School and Educational Housing Associates have bought several houses and hotels to serve as dormitories.

Brooklyn went from country to the fourth-largest city in America in a mere forty years from the founding of the village in 1816; in 1880, it was the third largest. It was created by the Revolution, immigration and, perhaps most significantly, modes of transportation: steam ferries, omnibuses, trolley cars, canals, railways and bridges. Its decline in the twentieth century was principally due to the means of transportation that superseded them—cars and trucks, which accelerated the trend toward suburbanization and modernism—and the suspension of most foreign immigration between 1924 and 1965. Its recovery, beginning in the 1950s, was due less to government policy than to private initiative—i.e., the realization that old houses were lovely and cheap (in fact, government policy initially embraced destruction because of the availability of federal funds for that purpose only). Brooklyn Heights embodies this history. A means of vertical transportation—the elevator—enabled the construction of the high-rise apartment buildings that rendered townhouses undesirable, but it was the trucks that were most responsible since they shifted the manufacturing and distribution base of the economy to suburbia.

BIBLIOGRAPHY

Most out-of-print sources available at Brooklyn Collection, Brooklyn Public Library, 10 Grand Army Plaza, Brooklyn.

AKRF, Inc. Research Report on the Potential Underground Railroad Associations of the Duffield Street and Gold Street Properties in Downtown Brooklyn. Appellate Division, Supreme Court, State of New York, Pamphlet on Bicentennial Observances, 1976.

Allen, Chester A., with the Kings County Trust Company. *Our Brooklyn: A Series of Articles on Brooklyn's Rich Historical Heritage*. Brooklyn, NY: Kings County Trust Company, 1954.

Applegate, Debby. *The Most Famous Man in America: The Biography of Henry Ward Beecher*. New York: Doubleday, 2006.

Ballon, Hillary, and Kenneth T. Jackson, eds. *Robert Moses and the Modern City: The Transformation of New York*. New York: W.W. Norton & Company, 2007.

Berger, Meyer. *Meyer Berger's New York*. New York: Random House, 1960.

Bergman, Jerry. *Jehovah's Witnesses and Kindred Groups*. New York: Garland Publishers, 1984.

Bordewich, Fergus M. *America's Great Debate: Henry Clay, Stephen A. Douglas, and the Compromise That Preserved the Union*. New York: Schuster, 2012.

———. *Bound for Canaan*. New York: HarperCollins, 2006.

Brinkley, Douglas. *The Wilderness Warrior: Theodore Roosevelt and the Crusade for America*. New York: Harper, 2009.

Brooklyn Bridge Plaza Association. *Program for Unveiling of Bronze Tablets.* October 24, 1929.

Brooklyn City Directory. Various years. www.bklyn-geneology-info.com/ directory.

Brooklyn Eagle. Brooklyn and the Eagle. Brooklyn, NY: Brooklyn Eagle, 1898.

Brooklyn Eagle. Numerous articles, Brooklyn Public Library, Eagle online and on paper for items after 1902.

Brooklyn Eagle. Numerous articles from the current incarnation.

Brooklyn Heights Association. Directory and Service Guide, 1985.

Brooklyn Kindergarten Society. *Brooklyn Kindergarten Society, 1891–1991.* Brooklyn, NY: self-published, 1992.

Brooklyn Life Magazine. Brooklyn, NY, 1909–1910.

Brooklyn Savings Bank. *Old Brooklyn Heights, 1827–1927.* Brooklyn, NY, 1927.

Burrows, Edwin G. *Forgotten Patriots: The Untold Story of American Prisoners during the Revolutionary War.* New York: Basic Books/Perseus, 2008.

Calendar, James H. *Yesterdays on Brooklyn Heights.* New York, 1927.

Capote, Truman. *A House on the Heights.* New York: The Little Bookroom, 1981.

Caro, Robert. *The Power Broker: Robert Moses and the Fall of New York.* New York: Random House Vintage, 1975.

City Register of Property, Kings County, for ownership of certain houses.

County Clerk, Kings County, Copied Maps, Real Estate Maps of Livingston (1803) and Pierrepont (1845) Properties.

Deak, Gloria G. *Picturing America, 1497–1899.* Princeton, NJ: Princeton University Press, 1988.

Dylan, Bob. *Chronicles.* Vol. 1. New York: Simon & Schuster, 2004.

Everdell, William R., and Malcolm MacKay. *Rowboats to Rapid Transit: A History of Brooklyn Heights.* Brooklyn, NY: Brooklyn Heights Association, 1973.

Faison, Seth. Interview, recollections of Brooklyn Heights.

Federal Writers' Project, Guilds Committee for Federal Writers' Publications, Inc. *WPA Guide to New York City.* 1939. Reprinted, New York: Pantheon Books, Random House, New York, 1982.

Furman, Avrah S. Interview, reminiscences of growing up in Brooklyn Heights.

Furman, Gabriel. *Antiquities of Long Island (Monuments and Funeral Customs).* N.p.: Nabu Press, 1875.

———. *Notes Geographical and Historical Relating to the Town of Brooklyn in Kings County on Long Island.* 1824. Reprinted Brooklyn, NY: Renascence Publishing, 1968.

Gallagher, John J. *The Battle of Brooklyn, 1776.* Rockville Centre, NY: Sarpedon, 1995, 2003.

Gill, Andy, and Kevin Odegard. *A Simple Twist of Fate: Bob Dylan and the Making of Blood on the Tracks.* Cambridge, MA: Da Capo Press, Perseus Books, 2004.

Goldstone, Harmon H., and Martha Dalrymple. *History Preserved: A Guide to New York City Landmarks and Historic Districts.* New York: Schocken Books, 1976.

Grimes, William. *Appetite City.* New York: Farrar, Straus, Giroux, 2009.

Hamill, Pete. *A Drinking Life.* New York: Little, Brown & Co., 1994.

Hazelton, Henry Isham. *The Borough of Brooklyn and Queens, the Counties of Nassau and Suffolk, Long Island, New York, 1609–1924.* Vol. 3. New York: Lewis Historical Publishing, 1925.

Hilonowitz, Lawrence, executive director of Kings County Tenants' Coalition. Recollections, interview.

Hodges, Graham Russell Gao. *David Ruggles: A Radical Black Abolitionist and the Underground Railroad in New York City.* Chapel Hill: University of North Carolina Press, 2010.

Hoogenboom, Olive. *The First Unitarian Church of Brooklyn: One Hundred Fifty Years.* Brooklyn, NY: First Unitarian Church, 1987.

Huntington, Edna, librarian of the Long Island Historical Society. *Historic Brooklyn.* Commissioned by the Brooklyn Trust Company, Brooklyn, NY, 1941.

Jacobs, Jane. *The Death and Life of Great American Cities.* New York: Vintage Books USA, 1962.

Johnston, Henry P. *The Campaign of 1776 Around New York and Brooklyn.* Brooklyn, NY: Long Island Historical Society, 1878.

Julius, Kevin C. *The Abolitionist Decade, 1829–1838.* Jefferson, NC: McFarland & Co., Inc., 2004.

Krogius, Henrik. "The Promenade at 60: The Curious Way It Came About." *Brooklyn Heights Press & Cobble Hill News,* October 7, 2010.

Kurland, Gerald. *Seth Low, the Patrician as Reformer, the Patrician as Social Architect.* New York: Twayne Publishers, 1971.

Lancaster, Clay. *Old Brooklyn Heights, New York's First Suburb.* Rutland, VT: Charles E. Tuttle Co., 1961. 2nd ed., with a new foreword and photographs, New York: Dover Publications, 1979.

Langstaff, B. Meredith. *Brooklyn Heights, Yesterday, Today, Tomorrow.* Brooklyn, NY: Brooklyn Heights Association, 1936.

Leslie, T., J.W. Leslie and W.F. Chichester, *Brooklyn General and Business Directory, 1840–41.* www.bklyn-geneology-info.com/directory.

Lockwood, Charles. *Bricks and Brownstone*. New York: McGraw-Hill, 1972.

MacKay, Malcolm. *The First Eighty Years: The Heights Casino*. New York: Fred Weidner & Son, 1987.

———. Recollections of Brooklyn Heights, interview.

Manbeck, John. Various columns in the *Brooklyn Eagle*, 2005–2010.

McCloskey, Henry, City Clerk, City of Brooklyn. *Manual of the Common Council of the City of Brooklyn* (McCloskey's Manual). N.p., 1863–67.

Merlis, Brian, and Lee Rosenzweig. *Brooklyn Heights and Downtown Brooklyn*. Volume I, *1860–1922*. New York: Israelowitz Publishing, 2001.

Moffat, R. Burnham. *Pierrepont Genealogies from Norman Times to 1913, with Particular Attention Paid to the Line of Descent from Hezekiah Pierpont, Youngest Son of Rev. James Pierpont of New Haven*. N.p.: private printing, L. Middleditch Co., 1913.

Morrone, Francis, photography by James Iska. *An Architectural Guidebook to Brooklyn*. Salt Lake City, UT: Gibbs-Smith, 2006.

Morrone, Francis. Interview on Heights architectural styles.

New York City Department of Parks, website on Underwood Park.

New York City Landmarks Preservation Commission, text by Andrew Dolkart and Matthew Postal. *New York City Landmarks*. 3rd ed. Hoboken, NJ: John Wiley and Sons, 2004.

Nin, Anaïs. *Diaries, 1936–44*. Out-of-print.

Osman, Suleiman. *The Invention of Brownstone Brooklyn: Gentrification and the Search for Authenticity in Postwar New York*. New York: Oxford University Press, 2011.

Our Lady of Lebanon Maronite Cathedral. "History of Our Lady of Lebanon." Brooklyn, NY, 2006.

Pearsall, Otis Pratt. Various articles on the development of the Brooklyn Heights Historic District and oral history.

Pelzer, James E., Appellate Division, New York State Supreme Court. Sign and press release, August 26, 1976.

Perris, William. *Brooklyn Atlas of 1855*. Brooklyn, NY, 1855.

Roberts, Robert B. *New York's Forts in the Revolution*. Madison, NJ: Fairleigh Dickinson University Press, 1980.

Robinson, Elisha. *Atlas of the City of Brooklyn*. Brooklyn, NY, 1880, 1886.

Rosebrooks, Lois, historian of Plymouth Church of the Pilgrims. Network to Freedom application.

Ross, Peter. *History of Long Island*. New York: Lewis Publishing Company, 1902.

Sanderson, Eric W. *Mannahatta: A Natural History of New York City*. New York: Harry N. Abrams, Inc., 2009.

Schecter, Barnet. *The Battle for New York*. New York: Walker and Company, 2002.

Schneider, Martin L. "Battling for Brooklyn Heights" series. *Brooklyn Heights Press*, 1995 (later a book, published 2010).

Snyder-Grenier, Ellen. *Brooklyn: An Illustrated History*. Philadelphia: Temple University Press, 1996.

Sproule, George S. *A Plan of the Environs of Brooklyn*. Ann Arbor: University of Michigan, Clements Library, 1783.

Starfield, Martin J. *Highlights of Brooklyn Heights*. New York: Goodmark Distributors, 1987.

Stiles, Henry. *A History of Kings County*. New York: W.W. Munsell & Co., 1884.

———. *A History of the City of Brooklyn*. New York: W.W. Munsell & Co., 1869.

Stiles, T.J. *The First Tycoon: The Epic Life of Cornelius Vanderbilt*. New York: Alfred A. Knopf, 2009.

Stonehill, Judith, and Francis Morrone. *Brooklyn: A Journey Through the City of Dreams*. New York: Universe Publishers, 2004.

Storrs, Richard S. *The Obligation of Man to Obey the Civic Law: Its Ground and Its Extent. A Discourse Delivered December 12, 1850, on the Occasion of the Public Thanksgiving; in the Church of the Pilgrims, Brooklyn, N.F. by Richard S. Storrs, Jr., Pastor of the Church*. New York: Mark H. Newman and Co., 1850. On the website of the Samuel J. May Anti-Slavery Collection.

Strong, Martha Prentice. *Saga of 1 Grace Court*. N.p.: privately printed, 1946.

Tippins, Sherrill. *February House: The Story of W.H. Auden, Carson McCullers, Jane and Paul Bowles, Benjamin Britten, and Gypsy Rose Lee, Under One Roof in Brooklyn*. New York: Mariner Books, 2006.

Topographical Unit, Office of the Borough President. *Street Grading Surveys, 1800–1860*.

U.S. Census Bureau. Census reports, 1900–2000.

Wakefield, Dan. *New York in the '50s*. New York: St. Martin's Press, 1992.

Walker, Wendy, ed. *The Social Vision of Alfred T. White*. New York: Proteus Gowanus, 2009.

Ward, Geoffrey C., and Ken Burns. *Baseball: An Illustrated History*. New York: Knopf Publishing, 1994.

Weiss, David Ansel. "From the Brooklyn Aerie." Published weekly in the *Brooklyn Eagle*.

Weld, Jonathan. Oral history of the White and Weld families.

White, A.T. "Sun-Lighted Tenements: Thirty-Five Years as an Owner." *National Housing Association Publications* 12 (1912).

Whitman, Walt. "Brooklyniana." *Brooklyn Standard Newspaper*. Later published in Whitman's *New York*. New York: New Amsterdam Books, 1963.

Wilder, Craig Steven. *A Covenant with Color: Race and Social Power in Brooklyn*. New York: Columbia University Press, 2000.

Willowtown Association. "A History of Willowtown and the Willowtown Association." www.willowtown.org/history.

Wyatt-Brown, Bertram. *Lewis Tappan and the Evangelical War Against Slavery*. Cleveland, OH: Press of Case Western Reserve University, 1969.

ABOUT THE AUTHOR

 obert Furman is a lifelong New Yorker who attended the High School of Music and Art, City College of New York and New York University Law School. He has been a Brooklyn civic and political activist since 1972, serving as vice-chair and Land Use Committee chair of Community Board Six in 1977–79. More recently, he founded three nonprofit corporations dedicated to American Revolution commemoration and community preservation. As part of his Revolution activities in 2000, he supervised an archaeological scan in Prospect Park that may have located the bodies of American soldiers who died there during the Battle of Brooklyn and addressed the NYS Convention of the Daughters of the American Revolution in 2001 and a NYS Archives Partnership Trust NYS history conference in 2005. This is his third book.

This book is dedicated to Otis Pratt Pearsall, who has given unselfishly of his time and knowledge in the preparation of this work. He is the one world historical person who still lives in the Heights since he is more responsible for the NYC Landmarks Preservation Law and the designation of Brooklyn Heights as the first historic district than anyone else.

CPSIA information can be obtained
at www.ICGtesting.com
Printed in the USA
BVOW06*1311291217
504021BV00003B/5/P